From Enchantment to Rage

From Enchantment to Rage

The Story of Surrealist Cinema

Steven Kovács

Rutherford · Madison · Teaneck
Fairleigh Dickinson University Press

London and Toronto: Associated University Presses

Associated University Presses, Inc.
Cranbury, New Jersey 08512

Associated University Presses
Magdalen House
136-148 Tooley Street
London SE1 2TT, England

Associated University Presses
Toronto M5E 1A7, Canada

Library of Congress Cataloging in Publication Data

Kovács, Steven.
　From enchantment to rage.

　Bibliography: p.
　Includes index.
　1.　Surrealism in motion pictures. I. Title.
PN1995.9.S85K6　　　　　791,43'090'1　　　　　77-74393
ISBN 0-8386-2140-6

Grateful acknowledgment is made to the publisher of *Artfourm* for permission
to reprint "An American in Paris: Man Ray as Filmmaker" that had ap-
peared in a slightly different form as: "Man Ray as Film Maker"
(Parts I and II), *Artforum*, November and December 1972, ©1972, Cali-
fornia Artforum, Inc.

Printed in the United States of America

Contents

Acknowledgments 7

Introduction 9

1 The Poets Go to the Movies 15

2 Robert Desnos: The Visionary as Critic 48

3 Dada Comes in at Intermission: Picabia and René Clair on *Entr'acte* 65

4 An American in Paris: Man Ray as Filmmaker 114

5 What the Surrealist Film Might Have Been: Artaud and the Cinema 155

6 The Fulfillment of Surrealist Hopes: Dalí and Buñuel Appear 183

7 Conclusion: The Dream Vanishes 250

Appendix: The Films of Man Ray 261

Selected Bibliography 283

Index 289

Acknowledgments

My fascination with Surrealist cinema was awakened when I was a graduate student at the Fogg Museum of Harvard University. Professor James S. Ackerman, Associate Professor Michael Fried, and the late Professor Frederick B. Deknatel all encouraged me in the pursuit of my interest. I was able to carry out the necessary research in Paris, Cambridge, and New York, thanks to a generous two-year traveling fellowship granted by the Kingsbury Fund through the Department of Fine Arts. The Fogg Museum further contributed to this book by stressing the importance of the work of art in the writing of art history. That emphasis was so pervasive that when I turned to film I used that approach, structuring my work around specific films in several case studies.

The person who provided me with the greatest assistance in the field of cinematic history was film historian and critic Román Gubern of Barcelona. He channeled me in the right direction at the very beginning and made helpful suggestions all along the way. Professor Standish Lawder of the University of California at San Diego and Professor Paul Bénichou of Harvard University also offered valuable comments. The final form of the manuscript is the result of numerous changes both large and small suggested by the editorial department of Associated University Presses.

I was provided with two different kinds of inspirations by a couple of veterans of the movement I investigated. René Clair kindly answered my questions and readily talked about his life and work. The late Man Ray displayed his uncompromising Dadaist attitude in our several encounters.

In supplying the material I needed, the Department of Film of the Museum of Modern Art in New York was most helpful. Thanks to Associate Curator Eileen Bowser, Ms. Mary Corliss, and Mr. Charles Silver I was able to view the films repeatedly, make a shot-by-shot analysis of Man Ray's films, and take most of the photographs included as illustration. Mme. Marie Meerson, Mlles. Marie Epstein and Sybille de Luze provided similar help at the Cinémathèque

in Paris. In my archival work I am especially indebted to M. François Chapon, head librarian of the Bibliothèque Littéraire Jacques Doucet of Paris and his assistant Mlle. Jasinski, who assisted me in every way possible. Thanks are also due to the generally courteous and helpful staffs of the Bibliothèque Nationale, Bibliothèque d'Arsenal, and Bibliothèque d'Institut des Hauts Études Cinématographiques of Paris, especially for those rare flashes of human compassion across the barriers of bureaucracy. The bearded runner at I.D.H.E.C., whose name I unfortunately do not know, was particularly helpful in supplying ordinarily inaccessible material.

A number of close friends have provided me with inspirations of various sorts. It was Stephen Owen who introduced me to the poetry of Robert Desnos and other Surrealists many years ago. Gene Bell's commitment to the discovery of the role of politics in the arts offered a shining example. John Michalczyk provided me with an immediate example in the area of film scholarship through his work on André Malraux's film *L'Espoir*. And last, but certainly not least, my thanks to Kitty for helping with questions regarding French literature and culture, for translating difficult passages, for offering sound criticism about the final form of the manuscript, and for making the two years of work a lot happier.

Introduction

The subject of this study is the relationship between Surrealism and cinema during the main phase of the movement. It attempts to examine two central questions. First, what was the nature of the Surrealists' interest in movies? Second, how did their movies reflect the aims and concerns of the movement? In chapter 1 I treat primarily the first question while chapters 2-6 deal with the second thorough case studies of the most important films and film scenarios produced by the Surrealist movement.

A strict definition of the subject determined the films and filmmakers discussed in this work. I wanted to examine the original Surrealist movement in Paris that reached its most active and brilliant phase between 1923 and 1930, between the circumstances leading to Breton's first Surrealist Manifesto and his second, between the formation of the initial group and the first massive turnover. This is the phase Maurice Nadeau designated as the heroic and reasoning periods of Surrealism. All of the movies discussed were made during this eight-year span. My discussion of the Surrealists' interest in the cinema overlaps at both ends, of course. The loose collaboration of poets that coalesced into a group by 1923 began to form immediately after World War I. Some of those interested in the cinema continued to work with it in various ways through the early 1930s. This brief time span should be understood, therefore, only as the crest of a predominantly literary and philosophical wave whose vitality is accurately indicated by the existence of an official organ: *Littérature* (1919-1924), *La Révolution Surréaliste* (1924-1929), *Le Surréalisme au Service de la Révolution* (1930-1933). Thus, while film production coincides with the most active phase of the movement, interest in film roughly corresponds to the fifteen years of official publications.

All of the films discussed have two characteristics in common. They were made by members of the group and they were appreciated by the group for being Surrealist. I only extended my definition in the case of *Entr'acte*, and then with a particular end in mind. The movie was conceived by Francis Picabia,

9

who was a regular contributor to *Littérature* and a close friend of the young poets. Because he was one of the leading Parisian Dadaists and because the Surrealists had participated in Dada, which they considered to be their parent movement, the movie had a great significance for them. I chose to discuss the film in an effort to establish certain relationships between Dada and Surrealism in the realm of the cinema. That relationship becomes crucial in the evolution of Man Ray's films. The other figures were members of the movement at various periods. It is their films that are the subject of this study: Man Ray's *Le Retour à la Raison, Emak Bakia, L'Étoile de Mer, Le Mystère du Château de Dés,* Antonin Artaud's *La Coquille et le Clergyman,* Salvador Dali's and Luis Buñuel's *Un Chien Andalou* and *L'Âge d'Or.*

No other films satisfy the two preconditions stated above. As far as films by Surrealists are concerned, Georges Hugnet's *La Perle* of 1929, which attempted to be Surrealistic in a very elementary way, was never even mentioned by his Surrealist colleagues. Those films which were made by new adherents to the group after 1930, by men such as Jacques Brunius, also go unmentioned by Breton's initial group. As for films praised by the Surrealists, they included a number of commercial productions: American comedies such as those of Mack Sennett and Charlie Chaplin, serial adventures such as *Vampires* and *Fantômas,* German films—especially *The Cabinet of Dr. Caligari,* Russian revolutionary film—highlighted by *The Battleship Potemkin.* Their catholic taste and criteria are discussed especially in chapter one and the conclusion.

Clearly, a number of films usually associated with those treated in this study are missing. Fernand Léger's *Ballet Mécanique* of 1923 and Marcel Duchamp's *Anemic Cinema* of 1925 are usually cited in the same breath as Man Ray's *Emak Bakia* simply because all three men were artists who tried their hand at movies. Yet the movies themselves are very different. Basically neither Léger nor Duchamp dealt with psychological material which would have attracted the interest of the Surrealists. Mechanical play and abstraction were the subject of the former, exploration of three-dimensionality and verbal puns, the aim of the latter. Hans Richter is also often mentioned as the artist who experimented most with the cinema. Of greatest interest to us may be his *Ghosts Before Breakfast* of 1928, which, despite its late date, communicates the spirit of Dada in which Richter participated ten years before. He came to Paris only in 1926, when he met Man Ray and was introduced to the Surrealists. His short *Filmstudie* of that year reflects his interest in Surrealism, for he based it on a dream. Essentially an abstract film, it has one surrealistic moment in a rotation of eyeballs. Richter was to create a truly interesting film twenty years later in *Dreams That Money Can Buy* (1944-46) through his collaboration with Alexander Calder, Fernand Léger, Marcel Duchamp, Man Ray, and Max Ernst, in which several sequences recall the Surrealistic preoccupations of the 1920s. A number of film historians group Surrealist films with impressionistic experimental French films of the 1920s, such as the *cinéma pur* of Henri Chomette, Alberto Cavalcanti's *Rien que les Heures,* or some of Germaine Dulac's essays. The case is not simply that the two groups have nothing in common, but that the Surrealists actively and passionately de-

nounced this direction in filmmaking. Both Buñuel and Artaud decried impressionistic abstraction, a point of view that was the basis of Artaud's violent quarrel with Germaine Dulac over the execution of his *La Coquille et le Clergyman*. The one other film that is often placed in the ranks of Surrealist films is Jean Cocteau's *Le Sang d'un Poète*. Although it is in some ways rather similar to *Un Chien Andalou*, Cocteau's aims are very different from those of Buñuel and Dalí. Never having been a member of the group, he did not claim his film to be Surrealist.

The Parisian Surrealist movement quickly spread all over the world. Abroad it had its strongest impact in the visual arts in Belgium. As in the time of Symbolism and Neo-Impressionism Brussels became an important artistic center for a movement which had started in Paris. Among the activities, a number of Surrealist-inspired movies were made, such as *La Mort de Vénus* of 1930 by Henri Storck and Felix Labisse, Roger Livet's *Fleurs Meurtries* of 1930, and *L'Espace d'une Pensée* and a short documentary, both long since missing, made by Paul Nougé and René Magritte in 1928. Since then Surrealism has left its mark on enough reels of experimental and commercial film to fill a warehouse.

But the heritage of Surrealism cannot be measured by looking for its traces among so many motion pictures. The movement has had too great an impact on our culture for us to be able to account for it by enumerating so many films, directors, or scenes that are surrealistic in inspiration. For Surrealism—like Cubism, Futurism, or Expressionism—has had such a pervasive influence on our contemporary sensibility and has been joined so readily with the vestiges of those other isms that it would be futile to try to isolate its many offspring. In the acceptance and diffusion of the goals of the movement the very notion of Surrealism has undergone a transformation. ''Surrealistic'' has become a part of our everyday vocabulary, referring to the bizarre, the fantastic, the incongruous. Thus, our understanding of the term is related to, but certainly not identical with the movement which appropriated it.

Previous studies on the subject have lumped together Surrealist films made as much as fifty years apart, a feat comparable to discussing Picasso and de Kooning under the heading of Cubism, or Aristophanes and Neil Simon in a work on comedy. They are examples of genre criticism, based on a formalistic, idealistic conception of art, which addresses the hows rather than the whys, and which is more interested in the evolution of a type over generations or even centuries than in the actual historical conditions of production of those works. Such criticism is valuable in tracing those themes and forms which are universal to man, but it fails to account for the particular conditions which gave birth to these creations.

I have attempted a historical approach to the evolution of Surrealist cinema in order to rediscover the fundamental sources and salient features of the original movement and of its manifestations on the screen. As every critical work, this volume itself is part of an ongoing polemic in the evolution of ideas located in a particular historical moment. As such, it is a reaction specifically against the ahistorical criticism which has been repeatedly applied to Surrealist

cinema, and more generally against the discussion of genres which dominate the study of film.

My historical perspective is developed through case studies of specific films. With different films I examine the circumstances of their origin, the aesthetic goals of their creators as manifested in other media, their relations to other, unrealized film projects, the internal logic of the works, critical reaction to them, and ultimately their place within the Surrealist movement. Because each case differs from every other, I have not embraced any one methodology to the exclusion of others. My only guiding principle was not to reject any information which might be useful in the interpretation of my subject. Behind this approach lies the fear that the study of film is being parceled out among so many schools of academic thought and the conviction that insofar as cinema, like the other arts, reflects the boundless wealth of human experience, it can no more be explained by a set of rules than can life itself.

From Enchantment to Rage

1

The Poets Go to the Movies

Surrealism was the first major literary and artistic movement seriously to concern itself with the cinema. It occupies that landmark position because of its auspicious timing with respect to the birth, initial elaboration, and first revival of motion pictures. In the new age of cinema, as children and adolescents, the future Surrealist poets came under the spell of the flickering pictures along with millions all over the world. They were born around the turn of the century, precisely at the moment when the new medium first created its own light of day. They belonged to the first generation that grew up with movies as a fact of everyday life. One of their number, Robert Desnos, appraised the particular mood of his generation:

> Generations are born under specific signs: all the activity of an epoch is guided by it, including love, liberty, life and poetry. There were those born under the cockades of 1789, to the clamors of 1793, in the rancour of Thermidor, Brumaire, or of December, in the enthusiasm of 1848.
> We were born under the sign of the Universal Exposition. The Eiffel Tower had dominated Paris for eleven years, opening the era of what was called a renaissance and which was but a strangely spiritual attempt and condemnation of the triumph of matter over spirit. . . .
> We had just been born. . . .An impatient desire of love, revolt and the sublime tormented us. . . .For us and only for us had the Lumière brothers invented the cinema. There we were at home. That darkness was the darkness of our rooms before going to sleep. Perhaps the screen could match our dreams.
> Three films were not inferior to this mission: *Fantômas,* for revolt and liberty, *Les Vampires,* for love and sensuality, *Les Mystères de New York,* for love and poetry.[1]

All three of these movies were serials which became wildly popular in the

teens. It is only too appropriate to begin an investigation of the Surrealist concern with the cinema by conjuring up a mental picture of adolescents sitting on the edge of their seats as they thrill to adventure after wondrous adventure unfolding on the screen. They were filled with a sense of awe which in ten years they would relate in their dreams, poems, and stories, but for the moment they sat watching expectantly those precursors of Captain Marvel and Flash Gordon.

The Themes of Surrealist Interest in Films

It is significant that among the various kinds of movies available to the public in the teens the future Surrealists preferred serials.[2]. In *Le Trésor des Jesuites,* a play they wrote together in 1929, Louis Aragon and André Breton feature characters from their favorite movie serials. The prologue ends with the following remembrance of the halcyon days of serials:

> TIME: What is it that remains?
> ETERNITY: That which finds a marvellous echo in life. . . .Wait, since you are interested in the cinema, I will have you witness the apotheosis of a forgotten genre regenerated by everyday events. One will soon understand that there was nothing more realistic and more poetic at the same time than movie serials, which only recently used to create joy in those strong of spirit. It is in *Les Mystères de New York,* it is in *Les Vampires* that it will be necessary to seek the grand reality of the century. Beyond fashion, beyond taste. Come with me. I will show you how one writes history. [*Loud to the public*] 1917: [3]

The fervent enthusiasm of these two men for serials a decade later reflects the impact they had on the entire group. What endeared this genre to them was its ability to evoke and sustain a sense of mystery and suspense. Since suspense is built up through time and since the different episodes of a serial are spread out in time, the serial is the ideal form for the creation of suspense.[4] Producers recognized this quality of serials as early as 1913, when they attempted to heighten the inherent suspense by cutting the individual segments at the point of greatest expectation, thereby creating the "cliff-hanger" effect. They further sought to heighten suspense by treating appropriately thrilling topics: the spectacular adventures of that mastermind of crime Fantômas, the escapades of Musidora and Pearl White in detective-story settings, or Houdini's daredevil deeds. In all of these serials there is a hint of other-worldliness that particularly captivated the Surrealists. Houdini's appeal lay not in his skills but in his ability to go beyond the usual limitations of human existence. It was Pearl White's beauty that made her detective episodes stand out from the ordinary, just as the suggestion of Musidora's vampirism made her somewhat of a supernatural creature. Even Fantômas was more than the sum total of his crimes. He was but the personification of the force of evil, a phantom of darkness as his name would imply. The nature of the appeal of Fantômas was

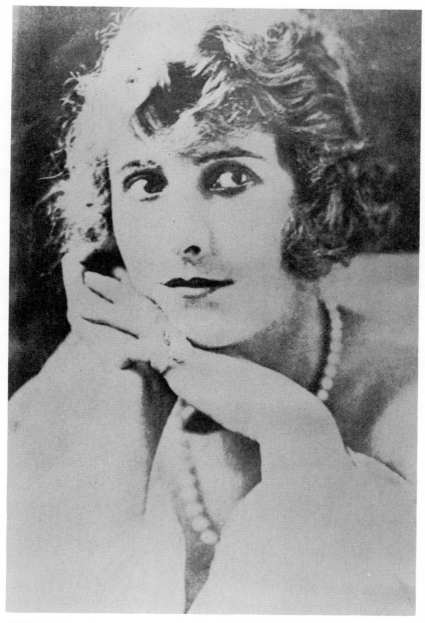

Pearl White, star of *The Exploits of Elaine (Les Mystères de New York)* and idol of the young poets.

explained by Philippe Soupault: "I liked *Fantômas* a great deal. But what attracted me in these works was much more the strange poetry, the mysterious atmosphere they expressed than the 'elevated' deeds and exploits of

Pearl White in *The Black Secret* (1919).

policemen.''[5] It was this fascination with the mysterious that made Breton appreciate Murnau's *Nosferatu*, in particular "the phrase that I could never see appear on the screen without a mixture of terror and joy: 'When he was on the other side of the bridge, the phantoms came to meet him.' ''[6]

Of the subjects of the serials what struck the Surrealists' imagination most was the Vampire as played by Musidora. She enchanted her viewers in her black leotard which she wore on her escapades. Her impact was so great that Georges Hugnet featured a group of similarly clad women in his one rather un-

Fantômas matches wits and bullets with Juve the detective.

successful attempt to create a Surrealist film in 1929 entitled *La Perle*. René Magritte was also captivated by her as a number of his paintings demonstrate.[7] Aragon and Breton made Musidora the heroine of their play about serials. In it she is the mistress of one of the soldiers on the front and her beauty is such that a picture of her is sufficient to start the soldiers dreaming. When she is plotting something she disguises herself as Mario Sud, the anagram of Mad Souri, the name by which she is known to her lover, which is but a variation of Musidora.[8] Feuillade's *Vampires* made such a deep impression on Aragon that he was inspired by it to write a novel entitled *Vampires* in 1922-23. In it he explained why the series exercised such power over him and his contemporaries:

> All that had to do with war, its illustration, its exhibitionism of horror, repulsed us so violently that I do not believe I am lying when I say that never was war further from the heart of young men than during these days when it dominated the adults. We were attracted to all that this imposed morality deprived from us: extravagance, feasts, the grand orchestra of vices, the picture of woman as well, but made heroic, a sacred adventurer. There is a specific document of that state of mind, it is that to which I want to come. The idea that an entire generation creates of the world is formed at the movies, and it is a film which sums it up, a serial. A youth fell entirely in love with Musidora in *Vampires*. . . .
> At this astonishing point of moral confusion that men lived, how could those who were young not recognize in these splendid bandits their ideal and their justification?. . . . The papers denounced the cinema as a school of

crime. . . . Yes, the young ran where they were called by crime, the only sun which was not yet tarnished. To this magic, to this attraction was added the enchantment of a great sexual revelation. . . . There is an idea of voluptuousness which belongs to us and which came to us by this way of light, between the images of murder and swindle, while men were dying elsewhere, without our even taking notice.[9]

Indeed, the chief reason for her appeal was the erotic desire she aroused in her viewers. Her criminal exploits only made her more attractive to poets who were already seduced by the pure black ideal of crime. She was literally the first vamp of the movies and, in fact, the expression might have been coined after her.

But the Surrealist poets fell in love with Musidora because she was a creature of the cinema. They considered the movies to be inherently erotic, and with reason. In the cinema they sat observing every movement of beautiful actresses in splendid costumes. More often than not the movies were love stories, and then as now the camera would linger over poignant love scenes. The ability of the screen to magnify characters and draw out the most heartrending scenes was in effect an exaggeration of both space and time, used most often to emphasize the amorous and erotic. Being surrounded by darkness and reduced to a passive state, viewers were all the more susceptible to the highly concentrated erotic message of the screen. In one of the first articles he wrote as a film critic Desnos ascribed the eroticism of the screen to its almost narcotic subjugation of the mind:

One of the most admirable factors of the cinema and one of the causes of hate felt for it by imbeciles is its eroticism. These men and women, luminous in the dark, perform actions which are stirring to the point of sensuality. To imagine it, their flesh becomes more concrete than that of the living, and while they undergo on the screen the most irrevocable fate, in the mind of the sensitive spectator they take part in a different kind of miraculous adventure. Among cerebral narcotics the cinema is becoming the most powerful: the double scenario follows its course in an atmosphere superior to that of opium, while, partaking of two themes, acts and deeds flash abruptly as dazzling points of contact.[10]

Like Aragon, he too saw the erotic appeal of movies as a soothing antidote to the realities of modern bourgeois existence. "It is in this cinematographic eroticism that we should seek consolation from all that is deceiving in the artificial life of banality."[11] The movies provided such a superior alternative for Desnos that he sought to transpose the amorous adventures of the screen to real life. He finished his article with the thought, "During intermission we shall look for him or her among our neighbors who will be able to carry us away in an adventure equal to the crepuscular dream of the cinema."[12] André Breton similarly praised the cinema for its erotic force. In *Nadja* he mentioned seeing a nude woman in a movie theater wander from one row to another, a vision that still haunted him twenty-five years later when he wrote about the cinema.[13] In fact for Breton the superiority of the cinema lay in its power to evoke feelings of amorous desire:

No doubt that desire and love are the principal charges of this mystery. "To a hundred fifty million people, each week," writes René Clair, "the screen speaks of love. . . .And we ask if these representatives of love are not one of the essential charms of the cinema, one of the secrets of enchantment that it exercises over the crowds." We are surprised that he is not any more certain of it. What is most specific in the means of the cinema is its ability to make concrete the powers of love which remain, in spite of everything, deficient in books, because of the fact that nothing in it can render the seduction or distress of a look, or of certain priceless vertigos. . . .The cinema is alone in extending its empire there and that will amply suffice for its consecration.[14]

With their heightened amorous sensibility the Surrealists were among the first to express the erotic experience of going to the movies. In 1922 Jacques Rigaut declared, "I am in love with Mae Murray,"[15] and since then millions have fallen in love with the stars.

The Roots of Surrealism—The Impact of
Apollinaire, Vaché and Delluc

At the outset the cinema offered the young poets a fulfillment of those romantic aspirations that all youths share. Love, sensuality, mystery, suspense, and poetry were evoked for them by the flickering shadows. These young men preferred serials, but only because they exemplified the best that movies had to offer. From the very first they were involved in the substratum of film, rather than in its potential to become a highbrow artistic form. They were attracted by the exclusive features of the new medium, and were left cold by current attempts to harness films to the traditional narrative forms of the novel and the play. It was the intensity of sensations created by the movies that made of the poets devotees of film. That intensity was a function of the nature of the new medium. In future years, despite their changing views about the role of movies, whether acting as critics or filmmakers, the Surrealists would concern themselves with the intrinsic properties of film. As such, they were part of a large group of movie enthusiasts worldwide who were interested in the development of film not as a vehicle for the other arts, but as a medium in its own right. Yet their unique aesthetic resulted in films very different from those of other innovators.

One crucial determining factor of the Surrealists poets' interest in film, in fact of the Surrealist movement as a whole, was the fighting of the most horrendous war yet in the history of mankind during their most impressionable years. At first the young men withdrew from the conflict: some deserted, but all objected to the fighting. They retreated into their private dreams, which were fueled by the magical events on the silver screen. Then, as now, movies were the medium of escapism par excellence. But they did not withdraw completely: they recognized and condemned the false nationalistic morality which formed the rationale for the massive bloodshed. They began to idolize everything that went against the standards of bourgeois morality. Accordingly, they embraced the welter of vices, in spirit if not in actuality, and applauded their slightest suggestion on the screen. In their initial years of creativity

after the war they were too concerned with the romantic blossoming of their own imagination. But they did not forget their impressions of the war. With the passage of years, their political allegiance was tested by the growing polarization of European society between Communism and Fascism. All of their activity became progressively more political and moral, including their work with the cinema. They began to emerge from their adolescent self-indulgence. Instead of love, they sought the depiction of liberty, instead of mystery, revolt, instead of dreams, action. But that transformation is precisely the subject of this discussion.

Although the Surrealist movement is often dated from 1924, the year Breton issued his *Surrealist Manifesto* and the year of the founding of the journal *La Révolution Surréaliste*, its roots go back as far as the end of World War I. Some of the most characteristic activities of the group, such as automatic writing and recording of dreams, began in 1922-23, when the circle of poets already included most of those who would be in the official group around Breton. A slightly smaller group can be traced back to the years 1920-21, when Dada had its brief though exuberant fling in Paris. The future Surrealists were the leading members of Paris Dada and carried not a small part of their Dada outlook and spirit into Surrealism. Yet Dada was not the initial guiding spirit of the group, but merely an attractive cause which they embraced while it lasted. What may be said to have been the core group was the banding together of Louis Aragon, André Breton, and Philippe Soupault in the spring of 1919 to publish a modern literary review called *Littérature*. Indeed it is this magazine which should be regarded as the first "Surrealist" journal, for it attracted around its nucleus of editors the men who would be the regulars of the movement, and it served as the organ for the group's writings, demonstrations, and other activities. It is here, for example, that the first dreams are published. The journal appeared more or less regularly until 1924, when *La Révolution Surréaliste* replaced it. There is little difference between either the list of contributors or the material presented in the two journals.

Littérature grew out of the avant-garde literary scene which flourished in Paris during the war. A number of journals represented that spirit which manifested itself in the creation of new poetic and artistic forms while expressing outrage at the war. Of these magazines *SIC* is probably the direct predecessor of *Littérature*. This literary journal, published by Pierre Albert-Birot, appeared monthly between 1916 and 1919. Its numbers contained the writings of the established avant-garde of Guillaume Apollinaire, Max Jacob, and André Salmon, but it also featured young poets. Aragon, Breton, and Soupault all published their first pieces in this journal. As it has become quite clear, the Surrealists of the 1920s and 1930s started as poets in the teens. Whatever other cause they were to espouse in the coming years, they were writers first and foremost. Like the avant-garde literary groups of their youth, they began to publish a journal which, under two name changes, would remain their chief organ through the 1920s and early 1930s. As young poets they looked with admiration to the literary avant-garde of their day, especially to its

most prominent member, Guillaume Apollinaire.

Apollinaire had been the single most dynamic figure in the Parisian literary and artistic avant-garde since 1900. He had started a number of literary journals, gathered around him a group of poets, and took an active part in the artistic developments of his day. He was one of the first to recognize the significance of Cubist painting. It was he who coined the word "surrealism" in describing his play *Les Mamelles de Tirésias* of 1917. At all levels of intellectual and artistic activity he fought for modernity of expression to reflect the new spirit of his day. It was only natural that those poets who reached maturity during the war years avidly followed him and his example. All three founders of *Littérature* were proud to have known him and expressed their admiration for and debt to Apollinaire. In an essay written in 1917 André Breton called him a "prodigious gift of wonder."[16] Louis Aragon reminisced years after his death: "At the time I was twenty, Guillaume Apollinaire was just about the single heir to the world of clouds, and his words had in our hearts the profound echo that the words of Charles Baudelaire had for other generations."[17] Philippe Soupault published a panegyric of Apollinaire and wrote a preface for some of his poems.[18] In an article dedicated to him he wrote,

> If it can be expressed this way, I would say that Apollinaire was contagious. He did not have to offer explanations, no need to convince. He declared and we believed him. . . .
> I am most grateful for the fact that during a few years he knew how to give color to his time, an aspect to life. I see a flame. And it is he who is at the center with a little moustache, a double chin, white teeth, and a high and short forehead.[19]

In the formation of the young poets' tastes he was undoubtedly a seminal force.

Apollinaire was idolized by the young poets precisely because he espoused with passion all modern phenomena, including such popular forms of expression as the phonograph, detective novels, and the movies. His own involvement with movies was rather extensive, and in a sense he played the role of pioneer in legitimizing this form of expression as he had done in recognizing Cubism. Apollinaire launched a monthly journal of literature and the arts in 1913 called *Les Soirées de Paris*. In it he assigned a column on movies to Maurice Raynal called "Chronique cinématographique," which appeared, if not regularly, frequently enough. The step was revolutionary, for this was the first nonprofessional journal to begin reviewing movies. It took the regular Parisian papers another half dozen years before they conferred similar recognition on the new medium. In 1916 Apollinaire expressed his views on the cinema when he was interviewed by Pierre Albert-Birot, publisher of *SIC*:

> [T]here is today an art which can give birth to a sort of epic sentiment through the poets' love of lyricism and through the dramatic truth of situations, and that is cinematography. The true epic was that which was recited to an assembled group, and nothing is closer to the people than the cinema.

He who projects a film plays today the role of the minstrel of yesteryear. The epic poet shall express himself by means of the cinema."[20]

Apollinaire's enthusiasm for the movies took him as far as writing a poem entitled "Avant le cinéma," and including an ingenious incident about the possible uses of film in his story "The False Messiah Amphion or Stories and Adventures of the Baron Ormesan."[21] In it the Baron is a charlatan who has executed various fantastic schemes for making money. He recounts how he once founded a film company which became tremendously successful as a result of getting some spectacular footage of the President of the Republic getting out of bed or the birth of the prince of Albania, all by bribing the right servants. His most spectacular stunt involves the separate ambush of a couple and a man in order to enact a crime in front of the camera. The man is forced to stab the lovers in order to produce the first real murder on the screen. It turns out that the couple were members of high society, so that their brutal murder is highly publicized by the press. Yet, although the film is advertised as showing their murder, the police remain incredulous while the movie has sensational success at the box office.

Apollinaire even became interested in the making of films. He expressed enthusiasm for Léopold Survage's project for an abstract film on the evolution of colors and forms,[22] and even wrote a script for a film in collaboration with his friend and colleague André Billy. The scenario, La Bréhatine, was never produced and the story is as melodramatic as were most of the movies and plays of the day, yet the sections written by Apollinaire reveal a concern for its adaptation to the screen while showing once again his fascination with the merging of art and life.[23] It is the story of a novelist writing a serial about the love affair of a girl in the country. Because he generally bases his story on an actual situation and because the girl recognizes herself in the story, fiction and reality intermingle to the point that she commits suicide. Apollinaire's instructions of dissolve and superimposition at strategic moments where the narrative flows from the novelist's page to real life suggest that the film would have had a certain cinematic strength.

Not only did Apollinaire express a vibrant interest in movies, but he communicated it to his friends and followers. In her tribute to him only days after his death, Lucie Faure-Favier wrote about him as "Dear Guillaume Apollinaire who loved the cinema so much, who discovered in it a thousand new insights. . . . whom I saw so often with his young wife applaud the adventures of Fantômas like a child, how he had laughed at the misadventures of the Poète malheureux."[24] Fernand Léger recalled that it was Apollinaire who had introduced him to Charlie Chaplin.[25] Apollinaire's influence in legitimizing movies in avant-garde circles can best be seen in the frequency with which movies were treated by his colleagues and followers in literary journals. Max Jacob, Apollinaire's close friend, had written a poem as early as 1914 in Les Soirées de Paris in which he wrote, "To the thought-out theater of François de Curel, / We prefer the cinema with its natural colors."[26] He applauded the vir-

tues of movies over the stage again four years later in Pierre Reverdy's new literary journal *Nord-Sud*: "Now the cinema continuously revitalizes the sensations our age gives us of ourselves, or rather it takes the place of our lazy minds in creating them. The mirror offered by the theater which tries to enlarge us into heroes deforms us; the photographic mirror enlarges us without trying to by exteriorizing us, by recreating us."[27] In the same journal Pierre Reverdy asked if movies were an art form. He concluded,

> In art, pleasure and surprise are connected and we can say that that which no longer surprises us is no longer pleasurable. The value of a work is probably in direct proportion to the quality and above all the *duration* of surprise it can give.
> I have experienced before such a film an emotion *more intense* and at least as pure as before works of art I liked.[28]

Another of Apollinaire's disciples was Pierre Albert-Birot, founder of *SIC* and sponsor of his play *Les Mamelles de Tirésias*.[29] In one of *SIC*'s last numbers he called the cinema "a work conceived for the masses" and used the term "surreal" in connection with movies: "Because the cinema has permitted for some time the realization of a large number of surrealities, I see it naturally as subject for the poet."[30] Having said as much, he presented his scenario for a movie, "2 + 1 = 2 (Première étude de drame cinématographique)." For the most part, however, the cinematic interest of poets around Apollinaire never materialized in film scenarios.[31]

Just how important the cinema was to Apollinaire's followers is illustrated by a publication which also happens to throw an interesting sidelight on the birth of the Surrealist movement. In October of 1924 the first and only issue of a magazine called *Surréalisme* appeared under the direction of Ivan Goll. Its associates consisted of an illustrious group of young writers, such as Pierre Albert-Birot, René Crevel, Paul Dermée, and Pierre Reverdy, and the painter Robert Delaunay. They attempted to follow the direction in literature, morality, and aesthetics as set out by Apollinaire years before. Thus, they named their movement after a neologism invented by him and included his name among the list of editors. They published a "manifesto of surrealism" in which they defined their aims, simply stating "that transposition of reality to a superior (artistic) level constitutes Surrealism."[32] An example of this creative aesthetic was an act of Apollinaire himself: "Max Jacob relates that one day Apollinaire simply noted the sentences and words heard in the street, and made a poem of them."[33] They were motivated to articulate their position as much because of their disapproval of the nascent Surrealist group around Breton as because of their appreciation of Apollinaire. They declared, "That counterfeit of surrealism, that certain ex-Dadas invented in order to continue to 'épater les bourgeois,' will be quickly put out of circulation. Their 'psychic mechanism based on the dream and the impartial play of thought' will never be strong enough to ruin our physical organism

which teaches us that reality is always right, that life is truer than thought."[34] In fact, they were sorely mistaken, for their movement expired with its first breath of life while Breton's Surrealism was just beginning its active phase with the publication of his *Surrealist Manifesto* and the appearance of the first number of *La Révolution Surréaliste*. This ephemeral impulse is of further interest to us because its manifesto is immediately followed by a discussion of the cinema as an example of "surrealism." Conforming to their positivist belief in the superiority of reality, the members of the group saw the cinema to be the most objective medium.

> Film transcribes events which occur materially in reality and elevate them to a more direct state, more intense, more absolute: surrealist.
> The movie maker creates only by coordinating: he is only an intermediary between nature and camera. All the rest (scenario, stage set, actors) counts for nothing. Film is the most realistic art possible, pure art. Films of imagination are impure. *Doctor Caligari* is impure, because it introduces falsified elements into a world where all is not equally falsified. Men remain too natural in a cardboard landscape.[35]

Just as their conception of life and literature was a far cry from that of Breton's Surrealism, so too their expectations of films were radically different from those of the Surrealists, as we shall see. This evanescent group that formed around Goll was the last to claim to follow Apollinaire's teachings. The poet had been dead for six years and during that time Dada had made its indelible impact on a large part of the young literary circle that had looked to him. As a late manifestation of Apollinaire's objectives, however, that single issue of *Surréalisme* faithfully reflects his interest in the movies: "Until the beginning of the twentieth century, the *ear* had decided the quality of poetry. For the last twenty years, the *eye* has been taking its revenge. This is the century of film."[36]

Apollinaire's enthusiasm for movies was part of a more general passion for all modern art forms which expressed the new spirit of his age. Other new genres were the detective novel and the American adventure novel, whose heroes enchanted him as much as did the movies. In *Les Soirées de Paris* these heroes are the center of attention: an article on Nick Carter and Buffalo Bill, a poem by Blaise Cendrars called "Fantômas," and numerous references by others to Pierre Souvestre's and Marcel Allain's thirty-two episode *Fantômas*.[37] "La Société des Amis de Fantômas" was founded at this time by Apollinaire, Max Jacob, Picasso, and Maurice Raynal. When, of course, the two modern modes of film and detective novel came together in Feuillade's serialized *Fantômas*, no word of praise was sufficient to extol the grandeur of the spectacle. Maurice Raynal certainly tried: "Oh nobility! Oh beauty! There are subjects which overwhelm you, and whose serene majesty, like inimitable splendor, leaves the spectator gasping, eyes bulging and lips silent."[38] After describing a scene in which Fantômas turned off the gas flame, then turned on the gas to kill a marquis, Raynal exclaimed: "How simple it is, how grand!"

With these words he voiced the very premises of Apollinaire's aesthetics, which considered the hero of the popular novel by his simplicity and grandeur to be the modern epic hero. Philippe Soupault remembered Apollinaire's own estimations of these novels:

> We know his taste for detective novels and especially for *Fantômas*, which he considered as one of the masterpieces of the literature of imagination. I remember having heard him often speak of this book in lyrical terms and praise the authors of this epic for having found the tone of Homer and of the *Song of Roland*. He could discover in these heroes of the twentieth century, especially in Juve, all the mystery of his time.[39]

We have seen before that Apollinaire had considered the cinema also to be an epic form. This attempt, to create the modern epic, is really not too far removed in spirit from Baudelaire's concept of the "heroism of modern life" expressed two generations earlier. Aragon's comparison of the influence of Apollinaire and Baudelaire on different generations is worth reconsidering. Apollinaire's passion for the hero of the popular novel ignited a similar passion in his colleagues and in his young followers. To a large extent it was his influence that aroused the future Surrealist poets' interest in serial movies, and ultimately it was he who had inspired in them a heroic view of their age.

If Guillaume Apollinaire personified the new spirit, Jacques Vaché embodied absurdity and personal revolt to the Surrealists. André Breton had met him in a military hospital in Nantes in 1916 and the two became best of friends. Of Vaché's influence Breton wrote,

> In literature, I was successively seized by Rimbaud, Jarry, Apollinaire, Nouveau, Lautréamont, but it is to Jacques Vaché that I owe the most. . . .I knew that I shall belong to no one with that same abandon. Without him perhaps I might have been a poet; he foiled that plot of obscure forces in me which leads one to believe in something as absurd as a vocation.[40]

It was Vaché who had appeared in the aisles on the opening night of Apollinaire's *Les Mamelles de Tirésias* with a revolver in hand, threatening to shoot at the audience. Breton recalled this act in his *Second Surrealist Manifesto* when he declared that "the simplest surrealist act consists of walking down the street, revolver in hand, and firing at random into the crowd."[41] Vaché became a legend to the Surrealists when he committed suicide with an overdose of opium only two months after Armistice.

In addition to everything else Jacques Vaché also helped turn the attention of future Surrealists towards the cinema, mainly through his influence on André Breton. Breton's love of movies dates from the year he spent in Nantes with his friend. He recalled how on Sunday afternoons the two of them would go into a theater in the middle of the program and would stay only as long as it remained interesting. When they had had enough, they would go on to another, and yet another, until they had seen all that Nantes had to offer. As Breton wrote of their movie-hopping, "I never knew anything more *magnetiz-*

ing. . . .The important thing was that we left 'charged' for several days."[42] He also recounted how "with Jacques Vaché we would install ourselves in the orchestra of the Folies-Dramatiques in order to dine, open boxes, cut bread, unscrew bottles, and talk out loud as at a table to the great amazement of the spectators who did not dare to say a thing."[43] For the two of them movies were both a stimulant and a wondrous new toy. The Vaché legend that evolved after his death was linked to movies. In a letter to Breton three days after Armistice Day, Vaché expressed a feeling of euphoria unmatched in any of his other correspondence. This letter became one of the chief relics in the Surrealists' cult of Vaché, a letter that all Breton's friends knew by heart:

> I shall leave this war gently idiotic, perhaps in the manner of those splendid village idiots (I am hoping). . . .or rather . . .or rather. . .I shall play a beautiful film!—With crazy automobiles, you know what I mean, with bridges that give way, and with large hands that crawl on the screen toward some document!. . .useless and invaluable!—With such tragic conferences, in evening dress, behind the palm tree that listens!—And then Charlie, naturally, who grimaces, with peaceful eyeballs. The Policeman who is forgotten in the trunk!!!
> —Telephone, shirt-sleeves, with people who hurry, with those bizarre decomposed movements—William R. G. Eddie, sixteen years old, billions dressed in Negroes' livery, such beautiful ash white hair, and a tortoise-shell monocle. He will get married.
> I shall also be a trapper, or thief, or seeker, or hunter, or miner, or leadsman—Arizona Bar (Whisky—Gin and mixed?), and beautiful exploitable forests, and you know those handsome riding breeches with automatic pistols, being well shaved, and such beautiful hands of solitaire. All that will end up in a fire, I tell you, or in a saloon, fortune won—Well.[44]

The first breath of freedom after years of military service unleashed in Vaché this flow of dynamic images taken directly from the movies. He could not hide his anxiety about staying in the army, for he exclaimed after his lyrical outburst, "—My friend, how am I going to bear these last months of uniform?"[45] And he concluded with "There will be rather amusing things to do when released in liberty AND BEWARE!"[46]

The letter seems to be a premonition of his suicide, the act of a man excited by the prospect of total liberty after confining military service. In his attempt to liberate himself he sought complete release from his physical limitations by giving himself to death through opium. Perhaps speculation on the motives for Vaché's death lies outside the bounds of this investigation. Yet the poets who were Breton's friends idolized Vaché as a martyr of his personal revolt. In search of total liberty, they surely recognized Vaché's own attempts to liberate himself first through cinematic metaphors, then through opium. No other than Louis Aragon considered the movies as an intoxicant in an article written only five months after Vaché's death: "Oh my friends, opium, shameful vices, the drunken orgy have passed from the vogue: we have invented the cinema."[47]

Jacques Vaché's passion for the movies was only part of his appeal for An-

dré Breton and the young poets: Louis Delluc's appeal to Louis Aragon, on the other hand, lay precisely in his overall involvement with the cinema. Delluc occupies an important place in the history of film. He was not the first outspoken advocate of the movies: that title belongs to Ricciotto Canudo, who had written as early as 1911 in his "Manifeste des sept arts," "*We need the cinema to create the total art towards which all the others have always been directed.*"[48] Neither was Delluc the first film theoretician in France. That position belongs to his lifetime friend, Léon Moussinac, who collaborated with him on his first film journals and in 1925 published *Naissance du cinéma*, the first theoretical work on film to appear in France. Yet Delluc had a greater impact than either of these men because he was a committed crusader for film. A decade after Canudo's call for an elite club of film enthusiasts, Delluc formed a *Ciné-Club* for the masses on the model of sport clubs. His columns on film reached the public regularly through a couple of film journals he created or headed, and a number of Parisian dailies for which he wrote. Although not exactly a theoretician he wrote critically about movies, setting out certain aesthetic standards for them. He put his ideas into action by writing and shooting a number of films which were to act as a major influence on French filmmaking until the coming of talkies. As his biographer wrote of him, "Rather than the head of a school, Delluc was an 'awakener.' "[49]

One of the thousands in whom Delluc helped awaken a sense of the cinema was Louis Aragon. The poet had written to the cineast during the war and they quickly became friends. In March of 1918 Aragon published a poem about Charlie Chaplin in *Le Film,* a journal that was then headed by Delluc.[50] Among his first published articles are "Du décor" and "Du sujet," dealing with the aesthetics of film and appearing in the same popular weekly only a few months later. In his introduction to "Du décor" Delluc praised the interest in movies that he saw among young poets of avant-garde journals such as *SIC*. "It is there, I confess, that I found the most distinct understanding of movies. The audacious young spirits are at home in the cinema. They recognize in it the first realization of their research."[51] What impressed Delluc in Aragon's article was not that certain views reflected his own ideas, but that Aragon manifested both a love and critical appreciation of movies. It is important to keep in mind that Delluc had not converted Aragon and his friends to the movies, but merely inspired among them a more critical view of the medium.

Aragon's article bears examination because it is the first critical text on movies to be written by any of the future Surrealist circle. First, Aragon sees the cinema as a modern medium of expression. "We shall no longer be astonished by Bayreuth or by Ravenna with Barrès. The names of Toronto or of Minneapolis seem more beautiful to us. Someone has spoken of the magic of the modern."[52] That someone was not only Apollinaire but Delluc as well, the Delluc who that same year in the same journal praised a factory in a movie for providing "the modern enchantment of metallurgy."[53] Among the precursors of this modern expression Aragon identifies Picasso, Braque, Juan Gris,

and Alfred Jarry, but he sees the cinema as a more immediate vehicle of this modernity: "Only the cinema which talks directly to the people could impose these new sources of human splendor on a rebellious humanity, on him who searches for his heart."[54] Aragon devotes a significant portion of his article "to analyze the feeling which transports us, to reason in order to discover the cause of this sublimation of ourselves."[55] He points to the ability of the screen to impress upon our imagination an object by magnifying it.

> The new attraction is not the spectacle of eternally similar passions, nor—as one had liked to believe—the faithful reproduction of nature that Cook's Agency brings to our door, but the magnifying of such objects which our feeble mind could not elevate to the superior life of poetry without the artifice of the screen.[56]

Aragon sees this sensibility best utilized in American productions.

> All our emotion exists for those dear old American adventures which relate daily life and raise to the level of the dramatic a banknote on which attention is focused, a table on which a revolver lies, a bottle which at times would become a weapon, a handkerchief revealing the crime, a typewriter which is the horizon of a desk, the terrible ticker-tape unreeling with magic numbers which make bankers rich or kill them.[57]

He continues to explore the psychological bases of this particular feature of the cinema in the following way:

> Children, poets without being artists, stare at an object until their attention makes it grow, so much that it occupies their entire visual field, takes a mysterious aspect, and loses relationship with anything outside it. Or they repeat a word untiringly, so much and so well that it is stripped of all meaning and remains an agonizing senseless vocable, which results in tears. Likewise on the screen those objects which just now were pieces of furniture or stub books are transformed to the extent of assuming menacing or enigmatic meanings. The theater is powerless to evoke similar emotive concentration. To endow with a poetic value that which did not possess it, and to limit at will the field of the lens in order to intensify the expression are two features which help make of the cinema the appropriate terrain of modern beauty.[58]

After such investigation of the intrinsic power of the cinema, Aragon points to the genius of Charlie Chaplin in making the inanimate world participate as a protagonist in his films: "The stage set is the very vision of the world for Chaplin, with the discovery of the mechanism of its laws, which haunts the hero to such a degree that by an inversion of values all inanimate objects become a living being for him, every human person a mannequin with a lever."[59] He then states what the movies are not: adherence to exact reproduction of life, a succession of beautiful photographs, and the theater are all antithetical to the cinema. He closes the article by calling on avant-garde artists to help create the modern medium that the cinema should be. He envisions

films made by them which will challenge public opinion and taste by their courage.

> What a beautiful thing is a film booed by the crowd! I have only heard the public *laugh* in the movies. It is time that their faces be whipped so we may know if there is blood under the skin. The cinema still lacks the consecration of catcalls in order to have the attention of men of heart. Obtain that, so finally the purity may appear which inspires spit.[60]

Aragon's article demonstrates above all his enchantment with the movies and his desire to see them become a provocative medium in the hands of the avant-garde. Although the article is not a repetition of Delluc's ideas, similarities do exist between the views of the two men. Certain attitudes are part of the avant-garde mentality of the day, such as belief in a modern spirit, the emphatic distinction made between cinema and theater, or the popularity of Chaplin—all views which found their place in Delluc's writings.[61] The extent of the influence of Apollinaire and Delluc on Aragon and his fellow poets is further indicated by their continued idealization of Chaplin and even Sennett into the mid-1920s, when these masters of comedy were no longer producing the quality and quantity of film which had made their reputation a decade earlier. Many other of Aragon's preferences are related specifically to Delluc's aesthetic viewpoint of film. The very premise of the article was set out two months before in Delluc's regular column: "Decor in cinematographic art is a grave danger. In believing to bring it to perfection they will heavily compromise it. . . .Truth will be in *real* interiors, or at least in real walls."[62] He felt as strongly as Aragon that photography and cinema were not to be confused: "The great resources of ignorants. . . .is to substitute the cinema with photography. Good-bye, *photogénie*!. . . .*Photogénie,* on the contrary, is the harmony of the cinema and photography!"[63] All in all, Delluc espoused a seemingly paradoxical position about film. He preferred the truth of film to the illusion of the theater.[64] Yet he favored actors assuming a masklike countenance in order to communicate a certain emotion. "To make a mask out of a face is actually the surest way of obtaining a talented actor's powerful expression."[65] He sought to express human emotions in a particularly stirring manner, and this is exactly what he achieved in the handful of movies he made before his untimely death. Thus, he stylized the real, exaggerated the true in his exploration of the cinematographic medium. This aesthetic underlies Aragon's own viewpoint of film. Taking the concrete reality of the everyday just one step beyond emerges in his praise of modern cities as setting for movies, in the elaboration of his idea that focusing on an object dramatizes its value, and in his vision of Chaplin as a protagonist who reveals the true nature of things by exaggerating their less apparent features. It was this basic similar outlook which made Aragon share Delluc's high opinion of Robert Wiene's *The Cabinet of Doctor Caligari.*[66] In fact, *Doctor Caligari* became a favorite of all the Surrealist poets. A few years after the movie's release in Paris, René Crevel condemned its imitators and praised the movie itself:

Nothing is more lamentable than a systematic deformation out of which many, overwhelmed by the success of *Caligari,* seem to want to make a style of cinema. What is more plainly laborious, for example, than some *Crime and Punishment* where all the houses were askew, as if lopsided walls could better reveal the disorder of souls. Instead of a drama we had a subterfuge and not the least grotesque at that. *Caligari* on the other hand was a perfect work. . . *Tricks* cannot take the place of the real interior poetry.[67]

Crevel, too, reiterated Delluc's demand for powerful emotions being expressed on the screen. Like Delluc he accepted the exaggeration of these emotions, but not their reduction to simple formulas.

As Delluc himself noted, he was drawn to the group of young poets around avant-garde journals, while they in turn looked to him for inspiration. In the columns of *Littérature* of 1919 and 1920 Aragon reviewed his fiction as well as both his books of film criticism, while Soupault waxed poetic about his first movie.[68] Delluc's influence was felt until his death the same year that saw the official birth of Surrealism. When four of Delluc's film scripts were published in 1923 as *Drame de cinéma* René Crevel praised his work for its literary merit from a characteristically Surrealist point of view.

The exact narrative, without a useless phrase, has the power of a poem created with the fewest words and the greatest emotion. From a literary point of view, I believe that these cinematic dramas through the example of such a rich precision will result in the hate of all grandiloquence and of all verbalism, and that M. Delluc will hasten the reign of mysterious simplicities.[69]

While immediately after the war Delluc had helped arouse serious interest in the cinema, a few years later he was credited with paving the way for Surrealism itself, a feat which the young poets were all too ready to attribute to all whose lives or works inspired them.

The Poets Begin to Write for the Screen

Earlier I made the point that Surrealism was above all a literary movement which grew out of Parisian avant-garde journals of the teens and which continued to have a single main literary organ through its most vigorous phase until the demise of *Le Surréalisme au Service de la Révolution* in 1933. The original group were primarily writers and poets, and throughout their lives they would continue to express their beliefs, support causes, and explore the realm of the imagination through literary means. When their interest in the cinema was aroused they began to experiment with writing for the movies. Perhaps it was Apollinaire who implanted the idea of writing film scenarios in their minds, for Soupault's first effort in this direction came very shortly after the famous speech "L'Esprit nouveau et les poètes," which he delivered at the Vieux-Colombier Theater on November 16, 1917. He exhorted the poets to participate in the making of movies:

It is strange that at a time when the popular art par excellence is the cinema, a book of images, the poets have not tried to compose images for meditative and more refined spirits who are not satisfied with the coarse imagination of film producers. These will refine themselves, until the day when the phonograph and the cinema will have become the only forms of expression in use. Then the poets will have a freedom unknown to this day.[70]

In the January 1919 issue of *SIC,* Soupault published the first attempt at a film scenario, entitled "Note 1 sur le cinéma." In a preface he emphasized the notion widely held among the avant-garde that *"we separate the art of the cinema from the art of the theater."*[71] He then characterized the essence of film in the following way:

Its power is fantastic because it reverses all natural laws: it ignores space, time, upsets weight, ballistics, biology, etc. Its eye is more patient, more penetrating, more precise. Therefore it belongs to the creator, the poet to make use of this power and of this wealth neglected until now because a new servant is at the disposal of his imagination.[72]

He then proposed that his *poème cinématographique* called "Indifference" be filmed by whoever has the material means to do so. This "poem" is really half a page of prose describing the author's experience of fantastic occurrences, at once surrealistic and cinematic: rocks are inflated, a man suddenly appears who first changes into a woman, then an old man, objects gather around the narrator until he jumps away from them over houses, the hands of a clock turn faster and faster. Soupault was to write a number of these cinematographic poems through the early 1920s and two of them were even filmed by Walter Ruttmann.[73]. The impetus for writing these poems was later specified by Soupault: "I felt that the cinema could allow me to express myself more quickly and intensely than writing a sort of surrealist lyricism."[74] Yet while these works were intended to be put to film, they are closely related to literary works of Apollinaire's circle which contained cinematic elements. From the early teens there was an incursion of cinematic ideas into their work. A montage effect has often been noted in the rapid succession of images of some of Apollinaire's poems such as "Zone." American movie characters crop up in a number of poems by him and his followers. As we have seen, allusions were made to movies in the titles of several works by poets around him which had nothing to do with the cinema.[75] For them "cinematic" came to mean magic freedom as exemplified by the rapid unfolding of extraordinary images which defy space and time on the screen. Soupault himself was to assume such liberty in the first movie reviews he wrote for *Littérature,* which consisted of his free associations triggered by a movie he had just seen.[76] He also wrote poems entitled "Photographies animées," in which each sentence, written on a separate line, described a different scene or action.[77] Here too the movies provided the impetus for a loosening of traditional literary forms. His *poèmes cinématographiques,* whatever their cinematic potential, are a freer mode of expression. Like Delluc's simply written scenarios, they have a literary value of their own.

Louis Aragon also dealt with the cinema in his literary work. Among his first poems are two written about Charlie Chaplin.[78] He had planned to write a film scenario entitled "La Main chaude" in 1920.[79] In *Anicet ou le panorama* a *roman-à-clef* of 1921, the movies appeared once again. A chapter titled "Mouvements" is devoted to the cinema and presents characters who are in reality Breton, Vaché, and himself.[80] The two friends, Anicet and Baptiste Ajamais, the fictional versions of Aragon and Breton, are set apart from the older generation who sit in cafes by their love of roaming the streets of Paris. Their ramblings take them to movie theaters in the afternoon, where they talk aloud during the projection. They carry on a lively discussion about the value of the cinema in which Anicet affirms its timeliness by pointing to its lack of theatrical morality and its emphasis on action, as in the films of Pearl White. Baptiste argues that the cinema only offers Anicet an excuse for his own inactivity. Then a newsreel begins, showing a large and important wedding. Anicet is stupified to recognize in the bride his love, Mirabelle. At one point she looks into the camera with such tenderness that he knows she is looking at him. As he silently suffers in his seat he recognizes a man in the picture whose face shows a similar pain. Baptiste remarks that they resemble each other. Gradually Anicet's identity is submerged into that of his likeness on the screen until the narrative simply focuses on his double. This episode in which film and reality are inextricably confused is only the most obvious evidence of the influence of the cinema on Aragon's writing. Straight burlesque elements taken from American comedies and cinematic effects such as dissolves appear throughout the book.[81] That he thought of his early literary works in cinematic terms is further revealed by his letter to Jacques Doucet in which he referred to his famous novel, *Le Paysan de Paris,* as "our film."[82]

After Soupault's early attempt at film scenarios no one else wrote one until 1923, when Benjamin Péret's *Pulchérie veut une auto* appeared in *Littérature*.[83] Péret was the most humorous of Surrealist poets, whose whimsicality is typified by a poem he wrote ten years later which consisted entirely of movie titles.[84] In his single film scenario he displays the uproarious humor with which his poetry abounds. The story opens with Pulchérie, a maid, dreaming of a young man with a car. She meets Glouglou, who takes her for a ride in an old car that constantly misfires. The wind blows off her hat and he runs after it in cavalier fashion. She gets behind the wheel and accidentally runs him over several times. He gets up and runs after the car, which goes ever faster. The car collides with another with such an impact that the two drivers are thrown from their seats into the other car. Pulchérie finds herself in a field of bulls, which start to play with her car by picking it up with their horns and hurling it across the field. After she is tossed about, a third bull comes from the side and throws the car in the pond. She emerges covered with slime, vomiting a black liquid full of frogs. When he comes to her assistance she is furious and gives him such a slap that he falls backward into the pond. After such a preposterous opening the plot thickens: the children who were entrusted to Pulchérie have been abducted. Glouglou begins a door-to-door search. At

one house a boxer answers the door and uses him as a punching bag. In another he is caught by a huge crab which must be put to sleep with a large dose of chloroform for him to escape. Meanwhile, the parents receive ear, nose, tooth, toe in the mail which supposedly come from their children. Glouglou's escapades continue. Afraid of knocking on doors, he climbs down a narrow chimney which elongates him. He ends up in a sewage pipe from which he emerges opposite the house where the kids are kept. He sneaks into the house, but the guard, Pandanleuil, discovers him and ties him up in a big cauldron. Glouglou's tears put out the fire and he bites through the rope to escape. He walks up dusty stairs on his hands so as not to leave footprints. He comes upon Mère Volauvent, the wicked old woman who stole the children. Glouglou jumps into her skirt, lifts her up, and throws her down the staircase. She bounces down the stairs like a rubber ball, ending up head first in the pot. Pandanleuil appears again and a fight ensues in which Glouglou wins out. Although victorious, he is unable to break out of the house, which has caught on fire. As he desperately tries to force the door, he falls back on Pandanleuil's body, which has become bloated from the heat, and bursts it. He pulls the guts out and ties them to the window. As he starts to lower one of the kids he burns his hands and drops him to the ground. The other kid bounces on a jet of water until a fireman covers the hose with his hands. As Glouglou climbs down, the gut breaks, but he manages to hold on to the top half with one hand and to the bottom half with the other. The firemen pull on him, tearing him in two. Then they cut off his remaining half with a long pair of scissors and put him back in one piece with giant nails. At the end the children are reunited with parents, Glouglou with Pulchérie. Like Soupault's *poèmes cinématographiques*, Péret's scenario is at once cinematic and surrealistic. But, as is typical of Péret, it is also fantastically humorous. While much of the comedy is the creation of the author, much of it comes straight from American slapstick, a genre that was a favorite of the Surrealists.

That the silent screen achieved its highest form in its comedies has never been questioned. Box-office success and contemporary witnesses bear that out. The Surrealist poets, favorably disposed toward all forms of popular art, were especially enthusiastic about this highly developed new genre. Aragon praised Chaplin on several occasions; Soupault was amused by Harold Lloyd and many years later wrote a book about Chaplin in which he depicted him as the hero of modern times:

For the millions of human beings who go to the movies the character created by Chaplin had become a friend. He enjoyed a popularity and affection that no creature born of human imagination has known, be that Don Quixote or Tom Thumb, Robinson Crusoe or the Good Little Devil. He lived with greater intensity than all the legendary figures who, from north to south and from west to east, enchant children and adults alike. Chaplin was the hero of our times, a universal hero, the man who made the world laugh and who also made it cry.[85]

Buster Keaton and Mack Sennett were also great favorites of the group. Already in 1922 Breton saw the promise of Surrealism in these American movies "where for the first time the burlesque of modern life erupts, in a spirit devoid of bitterness, as in those Mack Sennett Comedies, which are the most mysterious thing the cinema has yet proposed."[86]

The Emergence of a Critical Stance

The poets' honeymoon with the cinema ended by the time of the declaration of the first *Surrealist Manifesto*. Twenty-five years later Breton wrote of this period as his "age of the cinema" which comes at a particular time in life, then passes. He might just as well have been speaking for his whole group, for the initial passion of these years settled down to a more critical relationship. The harbinger of this change was Louis Aragon. Like his friends, he had expressed his unmitigated passion for the cinema after the war. He had marveled at the magic of the close-up, had accepted film as an inherently erotic medium, and had recognized in it an alternative life of the imagination. His adulation of movies crystallized into a specific perspective just before Surrealism was launched as an official movement. Answering a questionnaire in *Le Théâtre et Comoedia Illustré* in the spring of 1923, he echoed the final truculent flourish of his 1918 article on film, in which he had asked for movies that would whip the spectators. He condemned the inanities of movies of his day and called for much more potent formulas:

> I like films without stupidity in which they kill each other and make love. I like films where people are beautiful, with magnificent skin, you know, that we can see close up. I love the Mack Sennett comedies with women in bathing suits, German films with magnificent romantic scenes, the films of my friend Delluc where for an hour men and women long for each other, until the spectators begin to bang their seats. I like films where there is blood. I like films where there is no moral, where vice is not punished, where there is no Fatherland and little soldiers, where there is no Breton girl at the foot of a Calvary, where there is neither philosophy nor poetry. Poetry is not to be sought, it is to be found, and somewhere other than at Gance or L'Herbier, these elementary school types. I like, very simply, films where they kiss on the mouth at every turn.
> I would like that true films be created, without hypocrisy. Technical perfections interest me only secondarily. I would like to see, for example, the Marquis de Sade's *Justine* brought to the screen or Guillaume Apollinaire's *Onze mille verges;* but one can do even better by inventing. I would like to see films made such that suddenly in the dark a woman would get up and say as she threw off her clothes, "To the first of these gentlemen!" Then the cinema would be worth a *man's* while and he would lose his time and thought there voluntarily.[87]

In this summary Aragon sounds for the first time some of the issues that would characterize the films of the Surrealists in coming years. An exuberant follower of Delluc, he does not confuse his work with that of his contem-

poraries. Such perceptivity is nothing less than remarkable. The "impressionist school" of filmmakers in the 1920s were all close friends of Delluc, directors such as Marcel L'Herbier, Abel Gance, Germaine Dulac, and a little later Jean Epstein, who soon began to look to him as a model. Ever since then they have been seen as an easily definable group with similar aims and results. Georges Sadoul's authoritative history of French cinema only gives this grouping a critical and historical sanction. It is all the more amazing that Aragon intuitively distinguished Delluc's films, in which everything was done to express certain powerful emotions, from the works of others, in which cinematic techniques were often used for their own spectacular ends. This exact same differentiation was made by Luis Buñuel when he discussed his Surrealist films: "In reality, this is a revolt against the avant-garde film, where you have only the impressionistic and camera effects."[88] Aragon mentioned the relative unimportance of technical bravura: in Buñuel's films that attitude is a working premise. Furthermore, Aragon at this point is concerned about the content of films: he wants to see those timeless staples of the movies, sex and violence, and without any moralizing to vitiate them. If he developed the taste for stories where crime triumphs in serials such as *Vampires* and *Fantômas*, he suggested a further refinement in movies made of Sade's *Justine* or one of Apollinaire's erotic novels. In this respect, too, Aragon touched on major themes that Buñuel was to utilize in *Un Chien Andalou* and *L'Âge d'Or*. These two films revolve around sexual desire and violence. Buñuel referred to his first film as a "passionate appeal for murder," while he adapted a scene from Sade in the second.

It is revealing that while Aragon had begun to demand a more critical attitude toward films, Breton continued to indulge in an exuberant extolling of their virtues. Although in many areas of Surrealist activity he offered the necessary leadership, he failed to evaluate films and to encourage their production by the group. His infatuation with films never went beyond the initial immersion in movies that he and Vaché had experienced in their days of theater-hopping in Nantes. Although he expressed his preference for serials, American comedies, and certain other films, he was able to get "charged" from any movie that offered some sort of excitement. He even loved to go see movies that he condemned at some higher, critical level: "I must say that I was always spiritedly drawn by the treasure of imbecility and common looniness which, thanks to [French films], finds the way to flicker each week on Parisian screens."[89] Breton described the state induced by the movies with great precision across the time span of twenty-five years.

We would only see in the movie, whatever it happened to be, the lyrical substance which demanded to be stirred in the bulk and by chance. I believe that what we considered to be the highest in it, to the point of making us lose interest in all the rest, was its *power of deracination* [*dépaysement*]. This deracination is at several stages, that is to say, admits of different landings. The *marvel,* next to which the merit of a given film is a trifle, resides

in the ability of the newcomer to abstract himself from his own life when his heart tells him to do so, at least in big cities, as soon as one of these weakened doors which face the black are cleared. From the moment he takes his seat until the moment he slides into the fiction which unfolds before his eyes, he passes by a critical point as captivating and unseizable as that which unites wakefulness with sleep (the book and even the play are incomparably slower in producing this click).

The temptation to make this deracination last and grow to the point of impossibility is so great that it was able to lead us, my friends and me, on the way to paradoxical attitudes. It was precisely a matter of *surpassing* the stage of the "permitted" which, nowhere like in the cinema, seemed to invite me towards the "forbidden."[90]

Always ready to set up philosophical categories Breton invented the term "super-deracination" (*sur-dépaysement*) for the experience resulting from a bad movie.

Still on the road to a growing deracination, there was a time when I looked for gratification in the most miserable cinematographic productions. I found it above all in French films. . . .A super-deracination is awaited here, no longer from the transfer of a natural act of current life in a consecrated place to an *other* life, which it defiles, but from the greatest possible discordance desired between the "lesson" the film claims to give and the disposition of the person who receives it.[91]

As an illustration of this super-deracination Breton mentions the incident of the nude woman who walked around in the aisles during the performance of a stupidly religious film. As he sets it up, while in deracination the viewer comes to identify with what passes on the screen so strongly that he begins to experience that in a very real psychological sense, in super-deracination the viewer is similarly jolted from his usual conscious state but now to a state of subconscious revolt. The distinction, however, is not essential to understanding the Surrealists' conception of the cinematic experience. These remarks were written by Breton long after the Surrealists' "age of the cinema," and as a result there is more than his usual effort to categorize experience. Besides, super-deracination is mentioned only in passing. What emerges most clearly from Breton's comments is his belief in the transcendent experience offered by the movies, an experience he names deracination. His belief is so strong in it that, despite his staunch anticlericalism, he compares the movies to traditional religion: "There is a way of going to the movies as others go to church and I think that, from a certain point of view, totally independent of what is given, it is there that the only *absolutely modern* mystery is celebrated."[92] Clearly such a total acceptance of movies was antithetical to the evolution of a critical attitude toward the cinema. But Breton's lack of guidance could not stop the emergence of a polemical view of the role of film.

The period of active interest in making Surrealist films coincided with the most active phase of Surrealism. All of the films discussed here were made between 1923 and the early 1930s. The immediate postwar years were the period

of formation for the literary group that Breton came to direct in the mid-1920s. They were also the years of the poets' greatest enthrallment with the cinema. About the same time that the literary circle turned into a cohesive movement, the initial enthusiasm with movies peaked and it began to be translated into actual cinematic productions. The nature of the poets' interest changed. Their "age of the cinema" had entered a new phase.

During this high period of Surrealism the poets were more actively involved with the cinema as a concretion than as an idea. They developed a more critical attitude toward film, whose germs were contained in Aragon's response to the questionnaire of 1923 in which he specified the kind of subject matter he wanted to see in films. More and more the poets' interest was the message rather than the medium. While right after the war they praised Chaplin for his beautiful films, in 1927 they chose to defend his sense of morality. They issued a manifesto in *La Révolution Surréaliste* called "Hands off love!" in which they defended Chaplin against charges of immoral behavior leveled at him during his divorce case.[93] They praised him for not abiding by the conventions of a bourgeois marriage and for pursuing his sexual desires wherever they led him. They recalled how in one of his movies he dropped everything when he saw a beautiful woman and followed her. Nothing could have made a greater impression on the Surrealists, for whom pure desire was perhaps the highest virtue. Thus, they took his side not merely because he was their favorite actor and director, but because his divorce case brought up issues which lay closest to their heart. Just at this time when the movement was gaining political consciousness the poets were introduced to the new Russian revolutionary cinema in Eisenstein's *The Battleship Potemkin*. Immediately after it was shown, *La Révolution Surréaliste* carried the following slogan in large print: *"Le Cuirassé Potemkine,* VIVENT LES SOVIETS!"[94] Aragon wrote about this movie which was banned from public theaters:

> *The Battleship Potemkin* is the most beautiful film that has ever been made. That is why you will not see it. It is absurd to still say that it is a film. Let us leave that word to Mary Pickford. . . .This film contains no stars. . . .It is the work of Russian workers who make nothing.[95]

Georges Sadoul recalls how Paul Éluard's hands shook from emotion the first time he talked about the movie. As Sadoul made it clear, "What caused our enthusiasm in *Potemkin* was less its (admirable) form than its subject. In front of us opened the perspectives of a revolutionary cinema."[96] Inspired by the examples of Russian cinema, the poets began to see movies in political terms. Sadoul recounts how Aragon and Breton saw King Vidor's *Hallelujah!* to be a racist film. René Crevel and Paul Éluard harshly criticized René Clair's *À nous la liberté* for treating the situation of workers lightly.[97] They condemned the easy resolution of the film, which ends with boss and worker going off as two happy-go-lucky tramps, leaving behind an empty factory and the workers out fishing.

The Surrealist poets' critical approach to film was precipitated by a growing concern with their political and moral position. It was assisted by certain other factors. After years of going to the movies, they became more and more critical of what they saw. Film criticism as such had become a more developed form with the writings of Léon Moussinac, whose *Naissance du cinéma* of 1925 was the first truly theoretical work on film in French, and who wrote a regular weekly film column in *L'Humanité* from 1923 on. Furthermore, the poets had to deal with those several movies which were made by their colleagues and which are the subject of this study. Finally, their intensive passion for movies dating from after the war attracted a number of new adherents who were interested in the production or criticism of film as much as they were in poetry and art, men such as Luis Buñuel, Salvador Dalí, Jacques Brunius, Georges Sadoul, Jean Ferry, Albert Valentin, Georges Hugnet, Jacques and Pierre Prévert, and Roland Tual. As a result, they too were tempted to try their hands at making movies. Their efforts failed dismally so that, despite their several attempts, none of the original group succeeded in producing a movie.[98] In fact, of the early group only Pierre Unik actually participated in the shooting of a movie, Luis Buñuel's *Las Hurdes*. Indeed there is a clear-cut difference between the founders of Surrealism and those who joined the group around 1930. The original group consisted of poets who fought their battles in poems, novels, and manifestoes. They formed an avant-garde literary movement and as such their one weapon was the word. The younger group was not literary per se. They were more at ease in other media and often collaborated in enterprises that were neither particularly literary nor Surrealist. The very nature of Surrealism was undergoing a change.

Towards a Theory of Surrealist Cinema

Unlike the Surrealist movement with its manifestoes, proclamations, and directives personally overseen by André Breton, Surrealist cinema was an evolving, fluid, at times contradictory phenomenon. That lack of direction was the result of a great number of forces which actively shaped the movement as a whole. The absence of a program for film articulated by Breton, the gradual evolution of the aims of Surrealism, the wide range of personalities assembled under the Surrealist banner, not to mention the vagaries of film production in the hands of nonprofessionals, all account for the disparate, often confusing sum total of film projects planned and films produced by the Surrealists. Yet despite such complicating factors, certain attitudes and tendencies emerge from the poets' own accounts which reflect their tastes and hopes for film and help determine the erratic history of Surrealist film.

The unique contribution of the Surrealists to the evolution of film might be recognized most easily by mentioning the kinds of movies they did not make. Although they wrote panegyrics about serials, encomia about comedies, and paeans to the direct revolutionary films of the Soviet Union, they imitated none of them. Thus, they were not tied to the already existing cinematic

genres, but instead attempted to discover the essence of cinema through their own independent experimentation. They defined their efforts not only in opposition to the volume of films flooding the movie theaters, but also in contrast to the new style of avant-garde filmmaking. They objected to the banal subjects and conventional narrative of the former and the technical virtuosity and visual abstractions of the latter. They demanded stories and themes worthy of depiction in a style appropriate to them. The mere utilization of flashy cinematic style could not redeem what was innately uninteresting or unimportant. They were too concerned with the subject matter set out in the manifestoes and literary efforts of the movement ever to abandon them in their films.

Accordingly, the thrust of Surrealist film projects was not in the direction of technical experimentation. Whenever we notice a cinematic trick, it has a specific function in terms of the themes of the film. Buñuel went as far as to eliminate consciously all technical bravura in his work. Rather, they attempted to evoke the unique properties of the cinema the way they understood them to be. As did many of their contemporaries, they also noted the immediacy of this new medium. They sought to create in their spectators the most powerful kinds of feelings, which for them were always linked to specific sensations. They did this in part by attempting to convey the world of senses and emotions in all their richness in visual terms. Thus, vertigo, speed, dreams, accidents, anger, erotic desire, itching, pain, music, and noise were all suggested in their various film scenarios. Often the visual translation fails to render the strength of the sensation they sought. Occasionally they reach the heights of poetry, as in the evocation of physical and psychological terror with the slashing of the eyeball which opens *Un Chien Andalou*, or in the creation of a desire for a mysterious woman in *L'Étoile de mer*.

That the Surrealists did not succeed more often in creating memorable, haunting sequences may best be explained by the fact that for them the cinema was an exquisite toy and nothing more. Their commitment was to painting, poetry, and drama first. Movies were another potential form for expressing their ideas, but by no means the only or even most important one. It took Luis Buñuel, a filmmaker by taste, training, and vocation, to create films which have not only expressed Surrealist concerns, but which have become artistic landmarks in the history of film.

Both the failure and success of these films derive from their close ties to the aims and methods of Surrealism as they appeared in print and on canvas. The films exhibit many of the same concerns that abound in Surrealist texts. The themes of love, revolt, mystery, poetry, and dreams characterize the literature and painting of the movement as well as its films. Heavy emphasis on a psychological probing of characters may also be found in all forms of Surrealist art. Specific motifs are carried over from literature to film: the importance of the Parisian streets as setting for the stories, chance encounters, the mystery of night, the irrationality of phenomena, the idealized woman as embodiment of love. While Surrealism comprised both painters and poets, it was

the literary men who formed the core of its program and gave it its direction. As a result, the transposition of elements was mainly from literature to film and it usually resulted in films that were too literary, not because these motifs were inherently literary, but because the filmmakers were generally more interested in the ideas they wanted to express than the medium with which they sought to express them.

But the strengths of Surrealist cinema may also be traced to its literary antecedents. In order to jar the reader's sensibility, not only for the purpose of creating emotions of a high intensity, but also for opening new realms of perception, the Surrealists would juxtapose the most unlikely images in their poetry and paintings. Lautréamont's definition of beauty became a guiding principle of Surrealist aesthetics: "Beautiful as the meeting of an umbrella and a sewing machine on an operating table." This method found its way into the making of films to create some of the most startling sequences on celluloid and a new visual vocabulary for succeeding filmmakers. The juxtaposition of the banal and the sublime, pleasure and terror, dreams and life became the very syntax of the films. At their best the movies operated as a series of jolts to the viewer to awaken feelings normally beyond the reach of conventional methods. By systematically offering the unexpected, the films pushed the viewer to a heightened sense of reality—surreality.

These bizarre juxtapositions made their appearance in every element of the film. They took place in the composition of frames, in the creation of contradictory scenes, in the use of clashing visual and sound effects, and in the joining of disparate thematic elements. Perhaps the most significant reversal was the departure from the rational progression of events to create a narrative incomprehensible on the basis of any previous literary convention. That purposeful move away from temporal order was directly inspired by the dreams with which the Surrealists were so totally preoccupied. Like the Romantics before them, they drew upon their dreams for images and feelings inaccessible to them during their waking state. But for the Surrealists dreams were only one way of transcending reality. In their work they did not seek to reproduce dreams, but to create artistic vehicles which would function as dreams in dislocating the senses. That dislocation was most drastically brought about by the elimination of logical temporal progression in their narratives. That innovation marked as significant a breakthrough in the conception of time as Cubism had accomplished in the conception of space. The pioneering of spatial abstraction by Cubist painters finds its counterpart in the introduction of temporal abstraction by Surrealist poets, for just as the canvas was the necessary medium for revolutionizing our expectations of spatial relationships, so the narrative of literature was the medium for transforming our expectations of temporal progression. No doubt the fact that the Cubist revolution preceded the Surrealist gave that movement impetus for breaking traditional modes. The jumbled narrative of Surrealist fiction had the purpose of disorienting the reader to create the sense of mystery sought by the writers. Because of the predominance of literature in Surrealism and because of the

temporal nature of film, the relationship between the two was especially close. As a result, film also utilized temporal dislocations to create that sense of heightened reality and transcendent mystery.

The following exegeses are complicated by the complex nature of these films. They involve the paradox of attempting to recognize the rationale of these creations of irrationality. At times a fundamental order may be discovered hidden by the apparent irrationality of the films. In those instances the relationship between manifest and latent content is a function of the conscious and unconscious workings of the mind. Often the exegeses reveal those two levels of consciousness at work. Yet the Surrealists also utilized chance in their work, and where they did, it becomes impossible to discover any more basic structure which might shed light on the films. Thus, the discussion will oscillate between discovering various levels of meaning and on occasion admitting the absence of meaning in the works.

One final comment is in order about the evolution of Surrealist cinema. Like the entire movement of which it is a part, it also grew from the absurdist anti-art of Dada to the highly affirmative program of Surrealism. Even in the lifetime of Surrealism, it experienced the changes that were transforming the movement from one year to the next. The major direction of that change was toward politicization. From the early personal preoccupations of the Surrealists with love, the mysteries of the unconscious, and individual revolt, the group gradually achieved a political and social awareness which they incorporated into all their work. The Surrealist film also evolved toward a more comprehensive political maturity.

NOTES

1. Robert Desnos, *Cinéma*, ed. André Tchernia Paris, 1966, pp. 153-54. Louis Feuillade created the *Fantômas* serial in 1913-14, *Les Vampires* in 1915-16. *Les Mystères de New York* was the French title of either *The Exploits of Elaine* or *The Clutching Hand*, both directed by Louis Gasnier and starring Pearl White, which was released in France in 1916. (All quotations from the French were translated by the author).

2. In addition to Desnos' preferences, André Breton, Jacques Prévert, and Georges Sadoul spoke highly of the 1919 American serial *The Master of Mystery* with Harry Houdini. Georges Sadoul, "Souvenirs d'un témoin," *Études cinématographiques* "Surréalisme au cinéma", nos. 38-39 Spring 1965, p. 12. Breton also mentioned another favorite serial with Pearl White, *The Laughing Mask* of 1915, known in France as *Le Masque aux dents blanches*. André Breton, "Comme dans un bois," *L'Âge du cinéma*, nos. 4-5 August-November 1951, p. 27.

3. Louis Aragon and André Breton, "Le Trésor des Jesuites," *Variétés* "Le Surréalisme en 1929" (June 1929), pp. 47-61.

4. In fact, the word "suspense" is a variation of "suspend" or "to cause to hang up"; in Latin *sus—pendere*. Suspense is thus created when action is suspended.

5. Philippe Soupault, "Le Vogue des films policiers—*La Maison de la flèche*," *L'Europe Nouvelle*, January 31, 1931.

6. André Breton, *Les Vases communicants* Paris, 1955, p. 50.

7. For an excellent study of the influence of *Les Vampires* and *Fantômas* on Magritte's work, see José Vovelle, "Magritte et le cinéma," *Cahiers de l'association pour l'étude de dada et surréalisme*, no. 4 1970, pp. 103-13.

8. In Feuillade's serial, the heroine appeared as Irma Vep, an anagram of Vampire.

9. Louis Aragon, "Vampires," unpublished manuscript no. 7206-10 of the Jacques Doucet Foundation as quoted by Roger Garaudy, *L'Itinéraire d'Aragon* Paris, 1961, pp. 25-26.

10. Desnos, *Cinéma*, p. 101.

11. Ibid., p. 102.

12. Ibid., p. 103.

13. Such a chance meeting with a beautiful nude woman obsessed Breton as the most erotic experience he could imagine. He begins the paragraph where he recounts his seeing the nude in the movies with the observation, "I have always unbelievably wished to meet at night, in the woods, a woman beautiful and nude." André Breton, *Nadja* Paris, 1949, p. 46. Significantly, his most thorough discussion of films, written in 1951, is entitled, "Comme dans un bois."

14. Breton, "Comme dans un bois," p. 28.

15. Jacques Rigaut in *Littérature*, n.s., no. 1 March 1922, p. 18.

16. André Breton, "Guillaume Apollinaire," *Les Pas perdus* Paris, 1924.

17. Louis Aragon, "Beautés de la guerre et leurs reflets dans la littérature," *Europe*, December 1935, p. 474, as quoted in Garaudy, *L'Itinéraire d'Aragon*, pp. 70-71.

18. See Philippe Soupault, *Guillaume Apollinaire* Marseille, 1927, and Guillaume Apollinaire, *Les Épingles*, intro. Philippe Soupault Paris, 1928.

19. Soupault, "Guillaume Apollinaire," *La Revue Européenne*, January 1, 1926, pp. 1-10.

20. Pierre Albert-Birot, "Interview Albert-Birot—Apollinaire," *SIC*, nos. 8-10 August-October 1916.

21. See Apollinaire, "Avant le cinéma," *Nord-Sud*, no. 2 April 15, 1917 and Apollinaire. "L'amphion faux-messie ou histoires et aventures du baron d'Ormesan." *L'Hérésiarque et cie* Paris, 1910.

22. Apollinaire in *Paris-Journal*, July 15, 1914.

23. For the presentation of the scenario, see Guillaume Apollinaire and André Billy, *"La Bréhatine, cinéma-drame,"* *Archives des lettres modernes*, no. 126 1971. For an excellent discussion see the accompanying article by Alain Virmaux, *"La Bréhatine et le cinéma: Apollinaire en quête d'un langage neuf."*

24. Lucie Faure-Favier, "Ceux que mes yeux on vu,. . . ." *Le Film*, November 19, 1918.

25. "It was Apollinaire who took me to see Chaplin during a leave at the front. . . . Apollinaire told me: 'All the same there is something here. . . . Come see.' " Fernand Léger, in "Spécial Charlot," *Chroniques du jour*, nos. 7-8 December 1926. A caricature of Chaplin later appeared in Léger's *Ballet Mécanique*.

26. Max Jacob, "Printemps et cinématographe melés," *Les Soirées de Paris*, no. 23 April 15, 1914.

27. Max Jacob, "Théâtre et cinéma," *Nord-Sud*, no. 12 February 1918.

28. Pierre Reverdy, "Cinématographe," *Nord-Sud*, no. 16 October 1918. Apollinaire's impact on Reverdy's thought is here clearly demonstrated. In a famous lecture entitled "L'Esprit nouveau et les poétes" delivered at the Vieux-Colombier Theater on November 26, 1917, in which Apollinaire set out the new tendencies in the arts, he emphasized the point that *"Surprise is the great new spring,"* First published in *Mercure de France*, December 1, 1918.

29. Albert-Birot published a special number of *SIC* in memory of Apollinaire at the beginning of 1919. Among those who contributed works in homage of the poet were Louis Aragon, André Billy, Blaise Cendrars, Jean Cocteau, Paul Dermée, Louise Faure-Favier, Max Jacob, Francis Picabia, Pierre Reverdy, André Salmon and Tristan Tzara. See *SIC*, no. 37-39 January and February 15, 1919.

30. Pierre Albert-Birot, "Du cinéma," *SIC*, nos. 49-50 October 15-30, 1919.

31. In the late teens a number of Apollinaire's associates published literary works which were called cinematic, but in fact had nothing to do with the medium. Cinema was used rather as an idea or metaphor to be applied to certain poems and

works of prose. These include Paul Dermée, *Films* Paris, 1919; Tristan Tzara, *Cinéma calendrier du coeur abstrait* Paris, 1920; Pierre Albert-Birot, *Cinéma, poémes et drames dans l'espace* Paris, 1920; and Max Jacob, *Cinématoma* Paris, 1920. The titles themselves testify to the vogue of movies in the avant-garde.
32. "Manifeste de surréalisme," *Surréalisme*, October 1924.
33. Ibid.
34. Ibid.
35. "Exemple de surréalisme: le cinéma," ibid.
36. "Manifeste du surréalisme," ibid.
37. See especially *Les Soirées de Paris*, no. 22 March 15, 1914 and no. 25 June 15, 1914.
38. Maurice Raynal, "Chronique cinématographique," *Les Soirées de Paris*, no. 26 July-August 1914.
39. Soupault, "Quand Apollinaire contait. . . ." in Apollinaire, *Les Épingles*.
40. Breton, "La Confession dédaigneuse," *Les Pas perdus*, p. 9.
41. Breton, "Second manifeste du surréalisme," *Manifestes du surréalisme* Paris 1971 p. 78.
42. Breton, "Comme dans un bois," p. 27.
43. Breton, *Nadja*, p. 44.
44. Jacques Vaché, "Letter to André Breton, November 14, 1918," *Les Lettres de guerre* Paris, 1949.
45. Ibid.
46. Ibid.
47. Aragon, "Louis Delluc: *Cinéma et Cie,*" *Littérature*, no. 4 June 1, 1919:16. The specific connection between Aragon and Vaché is not merely conjectural. Vaché knew of Aragon's first article on the cinema. He wrote in his famous letter, "I have read L.A.'s article on the cinema [in *Film*] with as much pleasure as I can for the time being." Vaché, "Letter to Breton, November 14, 1918." It is unthinkable that Aragon could have compared the movies to opium so soon after Vaché's death without having Vaché in mind.
49. Ricciotto Canudo, "Manifeste des sept arts," *L'Usine aux images* Paris, 1927.
49. Marcel Tariol, *Louis Delluc* Paris, 1965, p. 84.
50. Aragon, "Charlot sentimental," *Le Film,* March 18, 1918.
51. Louis Delluc's introduction to Aragon, "Du décor," *Le Film,* September 16, 1918, p. 8.
52. Aragon, "Du décor," p. 8.
53. Delluc, "Notes pour moi," *Le Film*, January 28, 1918. On another occasion Delluc referred to film as "perhaps the only modern art form." Delluc, "Le cinquiéme art," *Le Film*, May 13, 1918.
54. Aragon, "Du décor," p. 9.
55. Ibid.
56. Ibid.
57. Ibid.
58. Ibid.
59. Ibid.
60. Ibid., p. 10.
61. In addition to his faith in modernity, Delluc had only the highest praise for Charlie Chaplin. See Delluc, "L'Expression et Charlie Chaplin, *Le Film,* April 2, 1918, and his book *Charlot* Paris, 1921. He often expressed his contempt for the theatrical in movies, as he did in his praise of American films: "By their irresistible authority the latest American films contribute all the more to turning French cinema away from the theater which has contaminated it so long with its faults and traditions." Delluc, "Notes pour moi," *Le Film,* November 26, 1917.
62. Ibid., July 29, 1918.
63. Delluc, "Photographie n'est pas photogénie," *Photogénie* Paris, 1920.
64. In his first article for *Le Film* Delluc wrote: "Truth in the theater is impossible. It is indispensable in the cinema." Delluc, " 'Illusion' et illusions," *Le Film,* June 25, 1917.
65. Delluc, *Photogénie.*
66. If Delluc's praise of *Dr. Caligari* with its expressionistic stage sets appears to

contradict his demand for true interiors, we must remember that he was a proponent of the cinema, not its rigorous theoretician. He was drawn to *Caligari* because it portrayed and evoked strong emotions, precisely what he aimed to do in his own films.

Exactly how important *Caligari* was for Aragon is indicated by his outline of major events in the history of the avant-garde that he published in the September 1922 issue of *Littérature*. Under the title of "Projet d'histoire littéraire contemporaine," his references to movies include the advent of the cinema with Charlie Chaplin and *Les Vampires* during the war, the films of Delluc in 1920-21, and *Dr. Caligari* afterwards.

67. René Crevel, "Enquête," *Les Cahiers du mois* "Cinéma," nos. 16-17 1925, pp. 144-46.

68. See Aragon, "Louis Delluc: *Cinéma et Cie*," *Littérature*, no. 4 June 1, 1919; "Louis Delluc: *La Danse du scalp*," no. 7 September 1919; "Louis Delluc: *Photogénie*," no. 16 September-October 1920; and Soupault, "*La Fête espagnole, par Louis Delluc*," no. 13 June 1920.

69. Crevel, "*Drame de cinéma, par Louis Delluc*," *La Revue Éuropéenne*, no. 3 May 1, 1923, pp. 109-10.

70. Apollinaire, *L'Esprit nouveau et les poètes* Paris, 1946.

71. Soupault, "Note 1 sur le cinéma," *SIC*, no. 25 January 1918.

72. Ibid.

73. Ruttmann's two short films of Soupault's cinematographic poems were made in 1922 and were destroyed during the bombing of Berlin. Information obtained from Soupault's unpublished letter of August 4, 1967 as cited in Alain Virmaux, "*La Bréhatine*." Soupault wrote a number of cinematographic poems, five of which appeared in *Les Cahiers du mois* nos. 16-17, pp. 180-82.

74. Jean-Marie Mabire, "Entretien avec Philippe Soupault," *Études cinématographiques*, no. 38-39, p. 30.

75. See footnote 31.

76. See Philippe Soupault, "Les Spectacles: *Une Vie de chien*, Charlie Chaplin," *Littérature*, no. 4 June 1919; "*Charlot voyage*—Charlie Chaplin," no. 6 August 1919; "*L'Homme aux yeux clairs*—William Hart," No. 9 November 1919.

77. Philippe Soupault, "Photographies animées," *SIC* (October-November 1918).

78. Louis Aragon, "Charlot sentimental," *Le Film*, March 18, 1918, and "Charlot mystique," *Nord-Sud*, no. 15 May 1918.

79. A notice in *Littérature*, May 1920, announces that "La Main chaude (film)" by Louis Aragon is soon to appear in its pages. No further trace has been found of this project.

80. In a later preface written to the book Aragon specifies that from Chapter IV on Anicet is really himself, while Harry James is Vaché since that was how he signed his letters to Breton. Aragon, "Avant-lire," *Anicet ou le parorama* Paris, 1964. André Breton's identity behind Baptiste Ajamais appears from the context of the chapter. Nicholas Carter, the popular dime-novel hero, appears in another chapter.

81. For a more detailed discussion of the cinematic elements in Aragon's early novels and plays see Marguerite Bonnet, "L'Aube du surréalisme et le cinéma: attente et rencontres," *Études cinématographiques*, pp. 93-95.

82. Cited by Garaudy, p. 146.

83. Benjamin Péret, *Pulchérie veut une auto* (film), *Littérature*, n.s., no. 10, May 1, 1923.

84. Péret, "L'Escalier aux cent marches," *De derriére les fagots* Paris, 1934.

85. Soupault, *Charlot* Paris, 1957.

86. Breton, "Caractères de l'évolution moderne et ce qui en participe," *Les Pas perdus*, p. 210.

87. Aragon's answer to "Appel à la curiosité," *Le Théâtre et Comoedia Illustré*, April 1923.

88. Unpublished notes of the Columbia University Extension Film Study course, Museum of Modern Art, New York, April 10, 1940, p. 8.

89. Breton, *Les Vases communicants*, pp. 112-13.

90. Breton, "Comme dans un bois," pp. 27-28.

91. Ibid., p. 29.
92. Ibid., p. 28.
93. "Hands off Love!," *La Révolution Surréaliste,* no. 9-10 October 1, 1927, pp. 34-37.
94. *La Révolution Surréaliste*, no. 8 December 1, 1926, p. 36.
95. Aragon, "Le Croiseur *Potemkine*," *Clarté* 5, no. 4 October-December 1926.
96. Sadoul, "Souvenirs d'un témoin," p. 16.
97. René Crevel and Paul Éluard, "Un Film commercial," *Le Surréalisme au Service de la Révolution*, no. 4 December 1931, p. 29.
98. In 1929 Breton had plans for adapting Barbey d'Aurevilly's *Rideau cramoisi* to the screen with Albert Valentin's assistance. Aragon had also planned to shoot a film with Valentin in 1930 based on his scenario *Le Troisième Faust*. In 1934 Soupault wrote *Le Coeur volé* for Jean Vigo, which was not produced because of Vigo's death. In 1935 Breton and Éluard improvised a scenario called *Essai de simulation du délire cinématographique* for Man Ray which was abandoned when the camera jammed.

2
Robert Desnos: The Visionary as Critic

Apart from a few abortive attempts at producing films and writing a handful of pieces on movies, the original group of Surrealist poets stopped actively considering the cinema from the mid-1920s on. Philippe Soupault and Robert Desnos were the only two exceptions, and of the two it was Desnos who became the unofficial spokesman for Surrealist cinema.[1] Coming to the literary circle in 1921, he started writing about films in 1923, at the time when the core group was losing its initial passion for the movies. During the next decade Desnos actively promoted the cinema as both critic and writer of scenarios. One of his poems was the source of a film by Man Ray. His opinions not only reflect the attitude of the Surrealists towards movies, but often actually helped shape them. His cinematic writing forms the link between the poets' early love of movies and their later critical approach.

When Robert Desnos entered the ranks of the Surrealists he electrified them by his custom of slipping into a semiconscious state and then creating hauntingly beautiful lines of poetry through free association. For the Surrealists he provided a vivid example of the poetic power of the subconscious. But for Desnos this exercise contained a total conception of reality in which dream and life were one.[2] He wrote,

> When I close my eyes a marvellous world . . . opens for me. It does not disappear when I open them. Dear double life! When I talk like everybody else, I also talk to fabulous creatures. They believe me to be here and calm; I am also elsewhere, in disrupted regions unknown by all.[3]

He was able to transcend everyday reality in other ways as well. In ''Journal d'une apparition'' he recounts the regular visit of a woman to his room while he is asleep over a three-month period. She appears so real to him that he feels anxious whenever he sleeps elsewhere, fearing that she will be disappointed in

not finding him there.[4] On another occasion he wrote,

> Yes, phantoms exist. Before knowing their names, the characters whom I
> have just mentioned have visited me. I always knew that they were part of
> my mythology and when anyone named them to me for the first time, I
> knew immediately that we had known each other for a long time.[5]

How real these phantoms were to him is indicated by the converse of this idea:
his desire to see Paris dotted with statues of all sorts. He wished to see statues
without pedestals occupying various places: Baudelaire with his elbows on the
parapet of Île Saint-Louis, Courbet turning his back on the Vendôme Column
while smiling at beautiful women, the Meunier chocolate girl leaning against a
wall.[6] In effect, he wanted to populate Paris with ghosts the way his mind was
filled with them. Desnos' imaginary life is absolutely crucial for understanding
him as a man and a poet. His imagination moved him to extremes of sensation
and made him push usual psychic experiences to their limit.

Desnos' powerful imagination had been at work as long as he could
remember. He reminisced about the deep emotions of his childhood:

> I would play alone. My six years lived in a dream. The imagination nour-
> ished by maritime catastrophes, I would navigate on beautiful ships towards
> ravishing lands. The floor-boards imitated the tumultuous waves to the
> point of deception and I would transform at will the chest of drawers into a
> continent and the chairs into deserted islands. Hazardous crossings! Now
> the ship Vengeur would sink under my feet, now the Méduse would founder
> in a sea of polished oak. I would then swim by the strength of my arms
> towards the beach of the carpet. This is how I felt one day my first sensual
> emotion. I identified it instinctively with the pangs of death and since then
> on each voyage I acknowledge dying, drowned in an ocean wave.[7]

Desnos' extraordinary mind was nourished by such physical and emotional
sensations which he would carry with him throughout his life. His sensuality
was ruled by these childhood memories: "I have never been able to make love
without reconstituting the innocent dramas of my youth."[8] In a more general
sense, sensuality became a function of his imagination:

> Love has not changed for me. I could lose myself in the deserts of vulgarity
> and stupidity, I could assiduously frequent the worst representatives of false
> love, and yet passion has saved for me its flavor of crime and of powder. I
> dream of nothing as much as to be separated from those whom I love most,
> so I may conquer their tenderness, though it be at the risk of suffering cruel-
> ly because of their absence.[9]

While all the Surrealists were tinged with a bit of romanticism, Desnos was
totally romantic in inspiration. He idolized the actress Yvonne Georges to such
an extent that his later wife, Youki, recalled, "For him she was not a woman,
but an immaterial creature."[10] He looked to nineteenth-century Romanticism
with special fondness. His "Confession d'un enfant du siècle" was styled after
Musset's preface to his novel by that name, which is one of the most important

manifestoes of Romanticism. In it he mentioned Victor Hugo's predominant influence on his youth. When he visited Havana in 1928 he urged the disenchanted youth he met to return to the Romantic authors because they were living in a totally romantic ambience.[11] He also talked at length about the guiding force of his life, erotic passion, couched in the metaphor of the stormy sea. His obsession with tempest on the ocean recalls the Romantics' vision of the human soul as a boat tossed about by the waves of passion.

> For years I have waited for the shipwreck of the beautiful ship with which I am in love. I have seen so many whirlwinds pile up in the sky that for a long time the catastrophe should have swept down upon that too calm sea. When it comes, it is certain that it will be terrible and fabulous.

The tempest, I shall be its author and one of its victims.[12]

Indeed the violent sea appears more consistently in Desnos' writing and poetry than does any other similar image.[13] It stands not only for erotic passion but all passions that move man. For a person to be a human being he must be moved by the storms of his soul, often to be completely overwhelmed so that he will be forced to fight against drowning. "Revolution, tenderness, passion, I mistrust those whose lives you do not upset, those whom you are unable to lose and to save."[14]

Desnos wrote of passion as a tempest not in order to create a mediating literary image, but to communicate the violence of his feelings. Thus, he pursued the amorous to the point of the erotic. He wrote a short compendium of the giants of erotic literature, and his poems, short stories, and novels abound in erotic episodes. Since for him the erotic was a liberation of love, he wrote his novel *La Liberté ou l'amour!* about totally free characters steeped in eroticism.

The tides of passion that swept Desnos threw him into the political and social struggle waged by the Surrealists. His own revolutionary outlook was of the most romantic, heated, and utopian kind. He was one of the chief collaborators of number 3 of *La Révolution Surréaliste,* whose theme was the liberating violence of the Orient. He wrote "Description d'une révolte prochaine" in which he set out his revolutionary vision:

> [F]or a revolutionary there is only one regime possible: THE REVOLUTION, that is to say, THE TERROR.
> Its establishment interests me and only its advent still gives me hope today for the disappearance of the scoundrels who encumber life. The existing infernal atmosphere will get the better of the noblest impulses. Only the guillotine by its menacing blows can thin out that crowd of adversaries bumping into us. Ah! may the friendly machine of deliverance finally stand on a public square. Too long has it served the ends of the riff-raff.[15]

His revolutionary fervor led him to collaborate on the early political manifestoes of the Surrealists, although he stayed clear of party affiliation.

If Desnos' powerful imagination is one of the keys to his interest in movies,

his fascination with modern phenomena is the other. Like the other Surrealists, he too was enchanted by the magic of modernity that Apollinaire had so often praised. In an article on "Imagerie moderne," he applauded the popular novel: "I would like to mark today with a poetic pointer—before snobism lays hold of it and it will do so—certain covers of popular novels: *Nick Carter, Sâr Dubnotal, Buffalo Bill, Texas Jack,* and above all *Fantômas.*[16] He recognized the influence of these works on movies: "Let us indicate without insisting the extraordinary influence of this imagery on the development of the cinema and let us stop at the influence that it had on modern vision, and above all on manners."[17] He went into greater detail about the nature of the influence of the novel which was the favorite of both Apollinaire's circle and of the Surrealists:

> Certainly *Fantômas* looms among this literature as one of the most stupendous monuments of spontaneous poetry. . . . The whole period that preceded the war is described there with a precision which results in a lyrical phenomenon. International intrigues, the life of little people, aspects of capital cities and particularly of Paris, worldly manners such that they are, that is to say such that people imagine them, bourgeois morals, police morals, and the presence for the first time of the marvellous which is proper to the twentieth century, the natural use of machines and of recent inventions, the mystery of things, of men, and of destiny.[18]

Desnos looked to Fantômas as he looked to all the modern means of communication for their profound effect on the public.

> He was beautiful, seductive, elegant. . . One could love him and, if he was a romantic ideal for many boys, undoubtedly he was a romantic and sentimental ideal for many little girls and even adolescents. Feminine sensuality of 1929 certainly owes much to this apparition in the dream-erotic universe of children of yesterday which even influences the moral conception of our epoch. Because every man, consciously or not, seeks to be a seducer and consequently attempts to respond to the masculine ideal of women.[19]

It was not simply Fantômas' sex appeal that caused him to have such an impact on a whole generation. According to Desnos, the erotic was a function of manners:

> Gestures of love alter more than one would want to admit. Sexual reflexes depend on the cut of clothes and of hair, and on ethnological variations. Modern love is not a fiction, and the least difference between the past and present opens up an abyss as vast as that which separates the forms, however close, of the love of ferns from that of men.[20]

Thus, all modern forms of communication imparted an erotic content to the public. No wonder that he was so fascinated with those forms. He recognized, for example, that "if Fantômas was the animator of all these revolutions, he was powerfully seconded in his psychic effect by the posters which . . . were

stuck on the walls.''[21] He had a great record collection of American jazz, Cuban rumba, Argentine tango, and Portuguese fado. From 1932 he worked at the radio. He immediately understood that the medium offered immense possibilities. He introduced numerous innovations, including exciting radio shows such as ''Fantômas'' and clever slogans and ads set to music, which became the most popular tunes in France. Conversely, he set commercial jingles to already existing tunes because he felt that such an updating would rejuvenate them. He believed that art belonged to the people and that great art could be born as advertisement.[22] He tried to reach the people through his poems written in argot. His commitment to popularizing art through the radio was retold by Youki:

> Robert's ambition—and how many times he repeated it to me—was, outside of his pure poetic work, to create songs which could sweep through the streets, to be whistled by a boy pedaling a carrier tricycle, for example, or murmured from ear to ear by lovers.
> ''How difficult it is to write an easy thing,'' he would tell me. ''It is absolutely necessary to popularize art.''[23]

On the air he found a way to popularize art that had been denied to him on the screen.

The cinema engaged a number of Desnos' passions besides being the best means for the popularization of art. During a period of eight years between 1923 and 1930 he wrote film criticism for a number of periodicals, including *Paris-Journal, Journal littéraire, Le Soir, Le Merle,* and *Documents.* In them he did not merely review movies but elaborated a morality and an aesthetics of the cinema. Why his articles on films are not simply evaluations is due to the fundamentally moral position of the Surrealists and the importance Desnos attributed to movies as a medium of expression and communication. The cinema, more than any other form, reflected the poetic, moral, and political situation of the day. Desnos found it only natural to discuss everything that was even remotely related to movies.

First and foremost, movies were an experience to Desnos comparable in every way to dreams. Among his collected essays on film, two are devoted entirely to that subject, while the idea appears in all of his writings.[24] In ''Les rêves de la nuit transportés sur l'écran,'' he exclaimed, ''How can one not identify the darkness of the cinema with the darkness of night, films with dreams!''[25] In one of his earliest essays, ''Le Rêve et le cinéma,'' he discussed dreams as the highest form of cinema.

> There is a cinema more marvellous than all the others. Those who are gifted with dreaming know well that no film can equal in the unforeseen, in the tragic that unquestionable life to which their sleep is consecrated. The taste for and love of the cinema springs from the desire to dream. For lack of the spontaneous adventure which our eyelids allow to escape at awakening, we go to darkened halls in search of the artificial dream and perhaps the stimulant capable of populating our wasteland nights. I would like to see a

director take fancy to this idea. On the morning of a nightmare, he would write down exactly everything he remembered and would reconstitute it down to the smallest detail. It is no longer a question of logic, of classic construction, nor of flattering the public's lack of understanding, but of things seen, of a superior realism, since it opens up a new domain to poetry and to dream.[26]

When Desnos wanted to praise a movie, he likened it to a dream. He called *Moana,* Robert Flaherty's 1926 documentary of the South Pacific, "one of the most beautiful dreams we could have made."[27] Or, in applauding a Chaplin retrospective he commented, "The logic which these ups and downs of life obey is related to that of dreams."[28] In a panegyric of Hollywood he praised the movie capital for being "the last refuge of tumultuous emotions of the human spirit."[29] This freedom emanated from the dream lived by its actors and actresses. "Possessed by the dream to which they are subjected, they are not heroines only by virtue of a scenario which is often inferior to their strange beauty, but also by temperament."[30]

If dreams resembled films, they did so in their most miraculous and liberating aspects. Movies, like dreams, offered a way of transcending reality: they provided a new adventure for modern man.

The perfect night of the cinema does not offer us merely the miracle of the screen, neutral landscape where dreams are projected, but it also offers us the most congenial form of modern adventure. . . . If the adventure of the film is worth the trouble of identifying with those who participate in it, if for lack of an arresting adventure, the smile of a woman, the seductive glance of an assassin inspires in us a rather beautiful story, the hall and spectators vanish. The seated dreamer is carried away into a new world next to which reality is only a fiction of minor interest.

But if, having come to participate in the miracle, the screen only offers celluloid protagonists and calico spectacles, hold out your hand and it will doubtless meet a fellow hand, move your knee according to a traditional rite and it will meet the neighbor's knee. Boot to boot you will leave perhaps for an ardent ride.[31]

In short, the movies always promised an adventure: if they were bad, they aroused an erotic longing in the viewer which could lead to a real amorous escapade; if they were good, they launched him on an imaginary voyage.[32] "The modern traveller seeks the marvellous,"[33] stated Desnos, thus expressing one of the chief tenets of Surrealism.

The *Marvellous,* supreme goal of the human spirit ever since man has taken possession of the creative power granted him by poetry and imagination, appears too rarely in the cinema, which is still an admirable passport for reaching those regions where heart and thought liberate themselves from the critical and descriptive spirit which ties them to earth.[34]

Concerned with the erotic throughout his life, Desnos found the cinema particularly conducive to the evocation of amorous feelings. He saw the movies to be at the very source of modern love.

Let us speak if you like of the influence of the cinema on morals: that is
real. Modern love flows directly from the cinema and by that I do not mean
only the spectacle of the screen but also the hall, the artificial night.[35]

He described the sensual experience of being in the movie theater:

And it is in the cinema that the desire of love is most touching and poetic.
Pretty women of the screen, perfect heroes, modern succubi and incubi, you
preside over miraculous encounters. Under your protection, with the aid of
darkness, hands clasp and lips unite and that is perfectly moral.[36]

He even spoke of his own erotic encounters in the theater. It is not surprising
that he was particularly sensitive to the censorship imposed on the erotic in
movies. Again and again he spoke out against the proscriptions of the censors,
objecting to their refusal to show nudes, for example. He advocated total
license in the movies, proposing the filming of the Marquis de Sade's novels,
as Aragon also suggested. Yet he fundamentally believed that the erotic was
such an integral part of the movies that no amount of censorship could do
away with it. He issued the following warning to censors.

Watch out censor, look at that female hand quivering in the foreground,
that dark eye, that sensual mouth, your son will dream of it tonight, and
thanks to them, he will escape the life of a slave you intend for him. Look at
that sensitive actor, melancholic and audacious—what am I saying? that ac-
tor: no, that real creature gifted with an autonomous life—he will abduct
your daughter tonight in his celluloid embrace more surely than with arms
of flesh, and your daughter will be saved.
Why then are these men—who are the first to go see the spectacles of music
halls where girls display the voluptuousness of their nudity—why are they
so afraid of the world of cinematography? Their stupidity is logical. They
understand what magic key of the imagination is offered to the spectators.
They know what continuation external intrigue will have in honorable
souls. They don't misjudge the omnipotent liberating virtue of the dream,
of poetry, and of that flame which is on the watch in all hearts proud
enough not to be compared to a pigsty.
Despite their scissors, love will triumph.[37]

For Desnos, love and revolt had to be taken to their extremes in order for
true liberty to exist. Thus, he condemned the prohibition of films of revolt and
revolution in the same breath as the censorship of the potentially erotic in
movies. Love and revolution were part of the same impulse.

Vice exists only for the weak; sensuality, on the contrary, is a justification
of all forms of life and of expression. To the first belong literature, art, and
all the reactionary manifestations: tradition, classicism, the shackles of
love, hatred of liberty. To the sensuals, on the other hand, belong the pro-
found revolutionary thrills, the legitimate amorous and poetic perversions.
This is why we shall refuse to consider the spectacle of the screen in any way
except as the representation of the desired life in the same way as our
dreams; . . . this is why we want the cinema to be revolutionary.[38]

Desnos' commitment to revolutionary films is indicated by his articles on Eisenstein's *Battleship Potemkin, The General Line,* and Pudovkin's *Storm over Asia,* in addition to one entitled "Toujours la censure politque." In them he objected to the specific conditions of exploitation in the West and raised his voice against the films of propaganda coming from the Right which promoted Christianity or nationalism. But above all, he praised these movies for their sweeping spiritual power. He was especially enchanted with *Storm over Asia* since that film expressed revolution in its apocalyptic, Oriental form, the way he had conceived of it earlier. "*Storm over Asia* is the film of the destiny of the Occident, although its action takes place in the heart of Asia, on the plateaus of Tibet."[39] That destiny was purification through fire, brought by barbarian hordes. "Attila has done more for human evolution than Pasteur, Leonardo da Vinci, and Stephenson, the philanthropist, the artist, and the inventor."[40] And although two of the three films were banned in France, Desnos retained his faith that their revolutionary message would reach the public the way the erotic did.

Potemkin is not of those ships that they sink with torpedoes. It has weighed its anchors forever. It scuds along. Its wake encompasses the world. The elements, boundaries, and men can do nothing against it, and its immaterial prow is of a kind which breaks the sharpest reefs.[41]

Clearly for Desnos the cinema was an inspiration, a dreamlike transcendence, a mode of being. Yet he was also aware of it as a new medium and, accordingly, he set out to formulate judgements about its technical aspects and the nature of its aesthetic appeal. In his first article on movies, written in April of 1923, he named his preferences, which are almost exactly those of his fellow Surrealists: serials, American comedies and Griffith, German films such as *Doctor Caligari* and *Nosferatu,* the films of Louis Delluc. Over the years of writing about movies he carefully observed the paths of different national film industries. Already in 1923 he noted the tendency of American films toward sentimentality. A few years later he complained about their use of the same tricks, pretentious stage sets, and psychological scenarios. He faulted the Germans for sterile technical research placed in the service of an uninteresting realism. But he was most critical of the French cinema, which he considered to be wholly subservient to the theater. Only one French director received praise from him, René Clair, whom he regarded as continuing Delluc's poetic example. He praised him for his inventiveness, lyricism, metaphysical humor, and—although Desnos was not favorably disposed to the flamboyant use of cinematic technique—his use of stop motion, speed-up, and superimposition in adapting scenarios to the screen. And, with the advent of Russian revolutionary cinema, Desnos found the opportunity to champion a new national film production.

Such an overview of Desnos' likes and dislikes begins to reveal his aesthetics of film, which were not too dissimilar from those of his contemporaries. Like them, he too condemned all the theatrical trappings of film. That attitude was

a reaction to the overacted melodramas that were the staple of movie houses throughout the world. They were stories conceived as plays, performed by theatrical actors with stage sets in front of a camera, rather than in front of an audience. While some of the most successful elements of early film grew out of the theater—including the comic routines of the silent screen's great comedians, Chaplin, Keaton, Harold Lloyd—the French cinematic avant-garde and the Surrealists both denounced the vestiges of the theater in film. Although in retrospect their attacks seem excessive, they were necessary at the time for the liberation of film from its traditional constraints. Desnos disapproved of movies based on plays and novels, asserting that scenarios had to be written directly for films. He was naturally a great fan of Louis Delluc, whom he praised for creating for the first time in France "a film realized truly cinematographically on a real scenario."[42] He called the theatrical tendency in film art, while he labelled what was properly cinematographic poetry—not at all surprising coming from a poet's pen. But Desnos did not automatically approve of movies that made use of intrinsically cinematographic techniques. Above all, the movie had to have power, lyricism, humor, or mystery. The technique would then be of help in translating these elements effectively. Without an awareness of the medium movies were theatrical, but without content they were at best a series of cinematographic tricks. Desnos often praised the cinematic quality of his favorite movies. He credited René Clair with creative scenarios which put to use the movies' potential. In his films he saw the birth of lyricism. He called Mack Sennett the "liberator of the cinema," in part for creating burlesque, which he called "the most disconcerting form of lyricism."[43] Years after the release of *The Cabinet of Doctor Caligari* he attempted to establish why that film was so superior and why those which tried to imitate it failed so miserably. He observed that it had a remarkable scenario which demanded certain extraordinary decors, while the imitations presented flashy stage sets and unusual lighting for stories without any interest—essentially the same conclusions reached by René Crevel.

Desnos' interest in the cinema was so total that he discussed certain aspects of moviegoing which escaped the attention of most of his contemporaries. Since movies provided an aesthetic experience, no element of that experience could be ignored. On several occasions he discussed the role of captions in films. Not being a sterile purist, he argued that "all that can be projected onto the screen belongs to the cinema, words as well as faces. All the means that result in good films are valid."[44] He encouraged directors to pay attention to the text of the captions, citing their exemplary use in *Doctor Caligari* where "not only do they not slow down the action, but instead they precipitate it in a moving fashion, converging on the mystery of the action without any puerile artifice."[45] He was equally concerned with the music that was played to accompany the movies. He saw the need for music to drown out the noises in the theater and thus assist the spectator in slipping into the adventure unfolding on the screen. But he condemned the playing of classical pieces just as he de-

nounced the plays turned into movies. Both were essentially highbrow efforts to make art out of cinema and both detracted from the film itself. He even commented on the kinds of movie theaters that were being built. He faulted them with the same decadence that characterized most of the movies he saw. He despised their flamboyant architecture and plush seats, preferring a hall without any pretention. He liked only two theaters in Paris: one "because it has the air of a huge landing-stage for who knows where, the other because the women there are astonishing."[46] Furthermore, he realized the need for special theaters to show the films of innovators which may not appeal to the general public. He understood that such independent research required serious financial backing and mused if some millionaire would not devote his fortune to experimental filmmaking. In fact, wealthy backers, especially the Vicomte de Noailles, were to make possible a number of Surrealist film ventures.

Desnos discovered a genre that was generally ignored by the other Surrealists. Only Soupault and he affirmed their faith in the documentary film, but it was Desnos who first discussed the aesthetics of documentaries. He noted already in 1923 that the documentary was misunderstood by both the experts and the amateurs of the cinema. The former had a low opinion of it because it was not art, while the latter saw it only as a way of becoming acquainted with foreign countries and hitherto unexplainable mechanical processes. Desnos himself was not interested in the knowledge that documentaries could impart, but rather in the new mystery they created by simply revealing an aspect of everyday reality. His attitude was part of that more general fascination with the miraculous of modern life. As he wrote, "The cinema was one of the first modes of expression of mechanic poetry. . . . The monotonous and fantastic comings and goings of pistons, play of push rods, revolution of wheels and flywheels, from all that was born a new sensation of mystery."[47] He expressed his disdain for the discoverer of physical reality and claimed that true adventure was to be found in the workings of the imagination.

> To travel for the sake of leaving, be it! We shall leave. But I do not see ultimately any difference between the imbecile tourist who goes into raptures in museums and the explorer eager to rub out those white spots on the map which indicate that there is still a forgotten oasis whose simple existence is a consolation for living on a planet so heavily populated. But materialist travellers, your limited realm diminishes constantly. You shall soon know all the costumes and all the flora and fauna, while the supreme satisfaction of the heart and spirit will always remain for the pure souls. As long as a single imagination will remain capable of constructing its inaccessible universe, love will remain free of all stains, liberty will be saved, and the architecture of the barricades will not fall into oblivion.[48]

This viewpoint was only part of a more general understanding of reality. "In all the domains of the spirit, false pretense is opposed to superior reality and, very often, it is the former which takes the name of reality under guise of a contemptible materialism, and the latter that the vulgar call illusion."[49] As we have seen, for Desnos this higher reality was contained in very different kinds

of films. In fact, he praised them for doing opposite things. In 1924 he acclaimed the example of *Fantômas* and Mack Sennett for leading the cinema away from the real, while in 1930 his panegyric of Eisenstein's *General Line* opened with "To render concrete! this fundamental aim of all art, all expression, all human activity."[50] The truth is that in his view a higher reality could be reached through an absolute evasion of the real or a total confrontation with it. The films were only external stimuli to the imagination, which ultimately had to attain the higher state. Desnos' seemingly contradictory remarks reveal his conception of the imagination as at once autonomous and infinitely versatile, as well as indicating the growth of his political consciousness in the course of the 1920s.

The confusion vulgar taste made between the false and the true was vividly exemplified by the common lumping together of Surrealism with the avant-garde. Although they started in an avant-garde milieu after the war, the Surrealists came to despise "avant-gardism" as much as they disdained bourgeois society. Hence, Desnos vehemently argued to dissociate the films of the Surrealists and other valid films from the facile trickery of the contemporary avant-garde. He saw the whole idea of an avant-garde issue from Oscar Wilde's influence in the 1890s and saw it best exemplified by the work of Jean Cocteau.[51] He characterized the product of this mentality in the cinema in such a way:

> An exaggerated respect for art, a mystique of expression have led a whole group of producers, actors and spectators to the creation of a so-called avant-garde cinema, remarkable for the rapidity with which its productions become obsolete, its lack of human emotion, and the danger it has for all of cinema.[52]

These films were immediately contrasted with the Surrealists' efforts. "When René Clair and Picabia made *Entr'acte,* Man Ray *L'Étoile de Mer,* and Buñuel his admirable *Chien Andalou,* it was not a question of creating a work of art or a new aesthetic but of obeying profound and original movements, which consequently necessitated a new form."[53] He included most of the major "impressionistic" filmmakers in his list of the avant-garde, namely Marcel L'Herbier, Jean Epstein, Abel Gance, Claude Autant-Lara, as well as the lesser known André Sauvage, Alberto Cavalcanti, and Boris Kaufman. He faulted their movies for using cinematic techniques which were not demanded by the action, conventional acting, and a pretentiousness in dealing with emotional states. He finally dismissed the notion of the avant-garde altogether.

> In reality the avant-garde, whether in cinema, literature or theater, is a fiction. Whoever claims to count himself among the numbers of these timid revolutionaries plays the politics of "clothes make the man. . . ." Nothing is revolutionary except candor. The characteristic of all reaction is lie and insincerity. And it is this candor which permits us today to place on the same level the true revolutionary films: *Potemkin, The Gold Rush,* [Stroheim's] *The Wedding March,* and *Un Chien Andalou.*[54]

Desnos' judgment of films has certainly withstood the test of time.

In 1930 Desnos stopped writing film criticism. Like so many critics before him and since, he turned to writing for films instead of writing about them. He had written a single film scenario in 1925. Three years later Man Ray adapted one of his poems in making *L'Étoile de Mer.* (According to all accounts, Desnos' role in the production was minimal, consisting of a walk-on at the end of the film.) Then, beginning in 1930, he wrote three scenarios in addition to a script for a Dijon mustard commercial.

Desnos' completed film scenarios reveal an acute understanding of the medium. They are meticulously planned, with each shot numbered. Themes are handled in a visual way. Yet the stories themselves, whose importance Desnos emphasized so strongly in his criticism, are disappointing. They are of interest to us mainly because of what they reveal about Desnos and his view of the cinema, and because certain brilliant conceptions emerge despite the weaknesses of the story line.

His first scenario, *Minuit à quatorze heures,* opens with lovers whose affair is disturbed by the arrival of a young guest.[55] The man accidentally drowns as the young man becomes the new lover. A mysterious ball appears at night which eventually takes on gigantic proportions and finally swallows the couple. The scenario is not so simpleminded as all that, however. Its title is followed by the caption, "Essai de merveilleux moderne." Throughout the story Desnos tries to evoke this sense of the marvellous by various visual and conceptual means. He does this most persuasively by employing the circle as a pregnant leitmotif. Circles appear in the water for the first time after the former lover has fallen in. From then on we see circles everywhere: the circle of the sun, circles of light, hoops, doorknobs, etc. It appears as a mere suggestion of the destructive sexuality which brought death to the lover. It materializes as the ball only after the young man and woman have oppressive nightmares. The dreams themselves are conceptually moving, for the couple's separate dreams merge at one point so that they meet in their dreams. From that point on there is no difference between dream and reality. The ball begins to haunt the couple, eventually terrorizing them. The menacing presence of the ball is emphasized by such things as the repetition of its entrance into the house and the playing of *La Carmagnole* whenever it appears. Gradually the ball grows. The man kicks it out the window. The ball begins a journey over exotic lands. One night at full moon the ball returns many times its size. It swallows the couple and the house, without leaving a trace. Evidently the success of the scenario depends on the effective translation of ideas into images to create the requisite sense of mystery. Failing that, the story is shallow and the circle is but an excessively used symbol. The difference between such a possible haunting effect and a pointless story is precisely the difference between the immediacy of a vivid dream and the inane story it becomes when told to someone else. Knowing Desnos we can say that at least the kernel of the scenario came from one of his powerful dreams.[56] The circle's vaguely symbolic role calls to mind all those frightening images encountered in dreams which oppress the dreamer

without specifying anything concrete. It is just such an elusive symbol that appears as the starfish in Man Ray's *L'Étoile de Mer* and as the seashell in Artaud's *Seashell and the Clergyman.*

Perhaps in search of a producer, Desnos created an obviously more commercial effort in *Les Récifs de l'amour* of 1930. Divided into three parts plus prologue and epilogue, it is the story of a rich man who falls in love with a woman at first sight on the street. She is a woman of easy virtue who is part of a criminal band. By chance they burglarize the rich man's house, killing a servant in the process. The man returns home just as they are about to make their getaway and catches the woman. He hides her, and when one of the servants recognizes her, he kills him. They get married, but soon after she commits adultery. Driven mad with despair, he goes into the wilderness in an unsuccessful attempt to forget her. He hunts for diamonds, which, ironically, she ends up buying. The scenario closes as it opened, with a shot of her initials carved into the bark of a tree. This conventional story line is made even weaker by the forced coincidences which bring the couple together. The only saving grace of the story lies in Desnos' attempt to portray a passionate love for a woman who is modeled after Musidora, the criminal and bewitching heroine of *Vampires.*

Returning to a more imaginative topic, Desnos wrote *Les Mystères du métropolitain* in the same year. In it he explored one of the basic premises he shared with his Surrealist friends, namely, that the most common objects partook of mystery. This was especially true of the metro because it was at once a modern invention and part of the Parisian scape, both aspects having been idolized by the Surrealist imagination. The kind of mysteries Desnos attributes to the metro are quite different from what he attempted to evoke in his first scenario. Instead of creating a haunting atmosphere, he launches a crazy, fantastically humorous ride on the Parisian subway in the tradition of American comedies and recalling the chase in René Clair's *Entr'acte* whose total effect is comparable to Benjamin Péret's *Pulchérie veut une auto.* It starts with a huge crowd waiting to buy tickets at a subway station while the woman behind the window is writing a poem. Needless to say, the crowd becomes monstrous and a riot erupts, leading to public executions. Meanwhile the figures on the posters climb off the wall and start to fool around. Eventually the woman starts to sell tickets with incredible speed. The crowd gets on the train and a whole series of outlandishly funny incidents takes place. A fish jumps out the window, flies to the head of the train and guides it forward. The train emerges from underground and continues across the countryside. As it passes fishermen, the fish they catch join the lead fish. When the passengers get hungry, they start catching the flying fish and roast them over a fire built from benches in the cars. The train travels for days until it begins to be filled with skeletons. Finally it stops at a lake, where Indians attack the passengers. A few scenes of the metro and the streets of Paris at the end make it clear that what we have witnessed was a flight of the imagination.

Anxious to use the latest innovations of the cinema, Desnos conceived of

both his scenarios of 1930 as talking pictures. In the story of deceived love, he uses a terse but expressive dialogue. The fantasy about the metro contains sound effects to carry out his intention announced in the subtitle, "Scénario de film sonore et en couleurs." A few years later, he incorporates dialogue and songs into both the Dijon mustard commercial and *Y a des punaises dans le rôti de porc* of 1933.[57] This latter scenario is largely in the spirit of *Les mystères du métropolitain,* relying on well-tried comic effects of American comedy. It features an old tenant of a building named Cleopatra who sleeps with an assortment of junk, including a cat, a turtle, a broom, and a dictionary, and is involved in a number of comic episodes amidst bursts of silly song. The piece ends in a highly imaginative fashion. The action stops and we see only the blank screen. The director of the movie appears, only to find himself challenged by a spectator who calls the movie a swindle. Cleopatra arrives filthy as a pig, covered with feathers. She marries the proprietor and their marriage is blessed by a tenant dressed as Napoleon. All the actors appear and sing the serenade of the roast pork. When they finish, they leave the stage, leaving behind the corpse of a boxer as an organ plays a funeral march. This intrusion of the director onto the screen and the climactic ending with a mock-heroic twist is reminiscent of René Clair's *Entr'acte.*

None of these scenarios was ever realized. Yet Desnos never completely abandoned his dream of working directly with films. In 1937 and 1938 he wrote the narration for Jacques Brunius' films *Records 37* and *Sources noires.* With the coming of the war he had to give up his job at the radio and turned again to the cinema. He had about a dozen different projects for films, including plans for making an opera-film of the Arthurian legends and an adaptation of Musset's "Namouna." He left behind synopses of his own stories, some dealing with romantic triangles, but also a few highly original ideas. He planned to make a short documentary of the hypothesis that the universe is presently expanding and that it would one day begin to collapse. He planned to demonstrate the idea by showing everyday processes taking place in reverse. He intended to shoot another film about a bungling philanthropist who attempts to settle the quarrels of a town by sending pleasant notes to everyone. In so doing, he manages to stir up more ill will, until he confesses to his letters, at which point the people chase him out of town and happily return to their old feuds. Only one of Desnos' film projects materialized. In collaboration with Henri Jeanson he wrote the text and songs for Roland Tual's *Bonsoir Mesdames, Bonsoir Messieurs.* The movie was a happy mixture of American burlesque and the sentimental, song-filled style of René Clair, through which Desnos attempted to ease the pain of Nazi occupation. The movie was released on February 15, 1944. A week later Desnos was taken away by the Gestapo. Although he lived to see Allied troops liberate his concentration camp, his health had been permanently ruined. The man who had pleaded for liberty in his every utterance was to die only a month after escaping the most brutal form of slavery in this century.

Poet, dreamer, moralist, critic, Desnos served the cause of the cinema well.

His enormous faith in the new medium reverberated amongst his friends:

> What we ask of the cinema is the impossible, it is the unexpected, the dream, the surprise, the lyricism that erases the baseness in souls and hurls them enthusiastically onto the barricades and into adventure; what we ask of the cinema is what love and life have refused us, it is mystery, it is the miracle.[58]

NOTES

1. Soupault's involvement with movies was more erratic and his viewpoint less cohesive than Desnos'. He had been one of the prime instigators of the cinema in the postwar years. He maintained his early passion for it throughout his life and continued to write about it actively through the 1920s and early 1930s. In 1925 he wrote a number of *poèmes cinématographiques.* He started writing film criticism again in a random fashion in 1928. See his reviews in *Revue du cinéma,* February and December 1928, March, April, and November 1931, and in *La Revue des vivants,* October 1931. Between 1923 and 1926 he had reviewed books regularly for *La Revue Européenne.* At the end of 1929 he started a regular weekly column, mostly on movies but also on theater, in *L'Europe Nouvelle,* which he continued through 1932. In his introductory piece he announced his preference for documentaries because in them he saw a partial fulfillment of his early expectations of the cinema. This genre took vision one step further. When the audience saw a documentary on a factory, he explained, they "perhaps do not laugh like madmen, but they show no discontent. They came to the movies in order to see. They *see* and are satisfied. . . . The important thing in the cinema is to see, I insist. It is important to see and see better, more clearly and more profoundly than 'in life.'" Soupault, "Le Cinéma—Les paradoxes du cinéma," *L'Europe Nouvelle,* October 5, 1929. In his critcism he praised the purely visual and denounced what was literary or theatrical. Thus, he considered the accelerated blooming of a flower in a documentary on plants to be the triumph of the cinema. He called the emotion that certain scenes of *Un Chien Andalou* provoked cinematic. Yet he did not make a dogma of his ideas. He praised movies as diverse as Pudovkin's *Storm over Asia,* King Vidor's *Hallelujah!,* Joseph von Sternberg's *The Blue Angel,* René Clair's *Sous les Toits de Paris,* and Pabst's *Three-Penny Opera.* Or, in an insightful review of an American film, he summed up the achievements and limitations of American movies: "Outside of technical perfection, the Americans have discovered that one of the greatest attractions of the cinema, one of the masterly capacities of the movie camera is to capture the human face in all its mobility, to pierce the mystery of what we call expression. . . . There is no literature, no theater, nothing impure. The movement of eyes, of lips, the trembling of hands. . . . What is missing in this film, which is not a masterpiece but the culmination of a method, is the inspiration which we have praised in *Storm over Asia.*" Philippe Soupault, "Un Film Américain, *La Rafle,*" *L'Europe Nouvelle,* October 26, 1929.

After Soupault abandoned writing film criticism, he wrote a scenario for Jean Vigo. *Le Coeur volé,* like so many of the Surrealists' works, is set in the streets of Paris. It begins with the narrator walking all over the city, meeting different women on different bridges, noticing men walking around barefoot but with gloves on. A heart is stolen from an operating table and a massive search for it ensues. Perhaps the most frightening element of the scenario is the recurring sound of the beating heart, which keeps haunting the searchers. The effect was to be comparable to the pounding that drove Poe's hero mad in "The Tell-Tale Heart." In Surrealist fashion Soupault stops this noise by the intercession of a female—a little girl buries the heart in the sand and buries the sound with it. Only Vigo's untimely death in 1934 aborted this imaginative project.

2. While Desnos lived his mixture of dream and reality, for Breton this state was a goal to be reached in the future: "I believe in the future resolution of these two states of dream and reality, in appearance so contradictory, in a sort of absolute reality, surreali-

ty.'' Breton, ''Manifeste du surréalisme,'' *Surréalisme* (October 1924), pp. 23-24.

3. Desnos, ''Confession d'un enfant du siècle, I,'' *La Révolution Surréaliste,* no. 6 (March 1926), pp. 18-20.

4. Desnos, ''Journal d'une apparition,'' *La Révolution Surréaliste,* nos. 9-10 (October 1, 1927), pp. 9-11.

5. Desnos, ''Le Mystère d'Abraham juif, *Documents,* no. 5 (1929), p. 237.

6. Desnos, ''Pygmalion et le sphinx,'' *Documents* 2, no. 1 (1930): 33-38.

7. Desnos, ''Confession d'un enfant du siècle, I.''

8. Ibid.

9. Ibid.

10. Youki Desnos, *Les Confidences de Youki* Paris, 1957, p. 92.

11. For the account of Desnos' visit to Havana, see Alejo Carpentier, ''La Havane—Cuba—La Musique . . . et Robert Desnos,'' *Simoun* ''Robert Desnos'' no. 22-23 1956, pp. 42-46.

12. Desnos, ''Confession d'un enfant du siècle, II,'' *La Révolution Surréaliste,* no. 8 December 1, 1926, pp. 21-22.

13. For a study of the theme of shipwreck in Desnos' work, see Serge Gaubert, ''Desnos et le naufrage,'' *Europe* ''Desnos'' nos. 517-518 May-June 1972, pp. 15-34.

14. Desnos, ''Confession d'un enfant du siècle, I.''

15. Desnos, ''Description d'une révolte prochaine,'' *La Révolution Surréaliste,* no. 3 April 1925, pp. 25-27.

16. Desnos, ''Imagerie moderne,'' *Documents,* no. 7 1929, pp. 377-78.

17. Ibid.

18. Ibid. Breton had proclaimed the supreme significance of the marvelous: ''The marvellous is always beautiful, any kind of marvellous is beautiful, nothing but the marvellous is beautiful.'' André Breton, ''Manifeste de surréalisme,'' p. 24.

19. Desnos, ''Imagerie moderne.''

20. Desnos, *De l'érotisme, considéré dans ses manifestations écrites et du point de vue de l'esprit moderne* Paris, 1953 pp. 26-27.

21. Desnos, ''Imagerie moderne.''

22. Desnos, ''La Rédaction publicitaire radiophonique,'' *Publicité 1939* Paris, 1939 pp. 43-44.

23. Youki Desnos, ''Desnos poète populaire,'' *Simoun,* pp. 52-54.

24. The study of Desnos' work with movies has been greatly facilitated by a volume published by Gallimard: Robert Desnos, *Cinéma,* ed. André Tchernia Paris, 1968. The book is invaluable, for it contains all of Desnos' critical writing of films, his scenarios, and his projects for films.

25. Ibid., p. 151.

26. Ibid., p. 104.

27. Ibid., p. 178.

28. Ibid., p. 124.

29. Ibid., p. 169.

30. Ibid., p. 170.

31. Ibid., pp. 139-140.

32. Desnos' faith in the ability of any movie to transport the audience is like that of Breton's. The kind of distinction he makes between the effect of good movies and bad movies on the spectators is strikingly similar to Breton's distinction between deracination (*dépaysement*) and super-deracination (*sur-dépaysement*).

33. Desnos, *Cinéma,* p. 156.

34. Ibid., p. 137.

35. Ibid., p. 147.

36. Ibid., p. 159.

37. Ibid., p. 160.

38. Ibid., p. 155.

39. Ibid., p. 185.

40. Ibid., p. 186.

41. Ibid., pp. 162-63.

42. Ibid., p. 196.

43. Ibid., p. 166.

44. Ibid., p. 98.

45. Ibid., p. 125.
46. Ibid., p. 183.
47. Ibid., p. 143.
48. Ibid., p. 178.
49. Ibid., p. 177.
50. Ibid., p. 193.
51. Desnos's condemnation of the work of Jean Cocteau is significant because it appeared in 1929, a year before Cocteau made his film *Le Sang d'un poète*. If he is any indication of the mood of the Surrealists, then we can see how the group was already prejudiced against Cocteau's "avant-gardist" aims even before they saw his film.
52. Desnos, *Cinéma,* p. 189.
53. Ibid. When Soupault was asked many years later about the filmmakers who were closest to Surrealism, he came up with a comparable list. He cited René Clair and Picabia, Man Ray, Luis Buñuel, and Jean Vigo. He accused both Jean Cocteau and Salvador Dali of trickery—Cocteau for his *Sang d'un poète,* Dali for his role in Buñuel's films. Jean-Marie Mabire, "Entretien avec Philippe Soupault," *Études cinématographiques,* nos. 38-39 (Spring 1965), pp. 31-32.
54. Desnos, *Cinéma,* pp. 190-91.
55. The title is a play on words. *Chercher midi à quatorze heures* is an expression meaning looking for something in obviously the wrong place. The meaning of this phrase, however, seems to have no relationship to the content of Desnos' scenario.
56. If indeed Desnos based his scenario on one of his dreams, he would have been only following his own advice to directors. He had urged them in 1923 to write down a nightmare immediately after awakening so they could later reconstitute it. Desnos, *Cinéma,* p. 104.
57. Although the Dijon commercial, *Onésime à Dijon,* bears no date, it was written on paper used by the Surrealists and therefore, in André Tchernia's opinion, must be dated close to 1929, the year of the rupture between Breton and Desnos. Ibid., p. 10. It is probably closer to 1932, the year Desnos started writing commercials in an official capacity working in broadcasting.
58. Ibid., p. 165.

3
Dada Comes in at Intermission: Picabia and René Clair on *Entr'acte*

Entr'acte has been generally acclaimed as the single most important and most successful Dada film. It was realized in 1924, at a time when an increasing number of artists and writers as well as filmmakers were experimenting with the idea of non-narrative cinema. Two men of widely different backgrounds, ages, and temperaments were brought together to create this "classic of absurdity."[1] They were Francis Picabia, a forty-five-year-old accomplished painter, international Dada prophet, and bon vivant, and René Clair, a twenty-six-year-old Parisian film critic with some previous experience as actor and filmmaker.

Francis Picabia was one of those men to whom chroniclers will one day be able to point as a man whose life captured so much of the particular flavor of his epoch and whose presence left such an imprint on his age that he will be considered an embodiment of the first quarter of this century. He came from an international well-to-do family. He was the only child of a father of Spanish descent who was an industrialist and attaché to the Cuban legation in Paris, and of a mother who came from a prosperous Parisian bourgeois family. As a result, for the better part of his life he was a man of independent means, a fact which allowed him to live out the good life with characteristic Spanish gusto. Spoiled from the start, he was raised by maids after his mother died from tuberculosis when he was seven. He was left in a large house with his father, uncle, and the maternal grandfather who was greatly interested in the newly developing art of photography. Francis was drawn to the plastic arts at a very early age. By the time he was fourteen, he painted his first canvas, and it was submitted and accepted under a pseudonym by the Salon des Artistes

Picabia in one of his racing cars, 1922.

Français in 1894. The men got together and decided that it was in his best interest to send him to an art school.

If Picabia made such an early start as an artist, he did not lag far behind as a lover of the good life. At the age of eighteen he ran away to Switzerland with the wife of a prominent Parisian journalist, to return to Paris only when he ran out of money. In his lifetime he accumulated three wives and numerous mistresses. Given to excesses, he drank heavily, smoked opium, and loved the excitement of nightclubs, especially girlie shows, which he frequented throughout his life. Even after World War II, when he was touching seventy, he would go every Saturday night to the *Bal Nègre* in the company of Jacques Prévert, Simone de Beauvoir, Georges Auric, and a few Surrealist friends, staying out until 5:00 A.M., when the metros started running again. He loved racing cars, of which he owned nearly a hundred in his lifetime, and yachts, which he sailed near his home on the Côte d'Azure. He wrote once in a letter, "I need to live lying on scented rice powder, eating fruit paste and seeing buttocks carried by their owners in coats made of sable and mink. The women I see at the baccarat tables have eyes and nipples encircled by fatigue and pleasure. I love things which serve and are worn away rapidly."[2]

Picabia's artistic and literary efforts partook of the red-blooded, frenetic tempo of his life. Entranced by the work of Alfred Sisley in 1897, he started his artistic career by creating Impressionistic canvases for the next ten years. In 1905 he had his first one-man show, at the Galerie Haussman, of which one

Picabia's Orphic style: *I see in my memory my dear Udnie,* 1913.

critic wrote, "Picabia no longer needs to be presented to the public; the public goes to him alone by taste."[3] His success led him to exhibit in London and Berlin, and to receive a contract from Danthon, the owner of the Galerie Haussmann. Yet Picabia was not content with being "the spiritual son of Sisley," as the critics would have it. At the end of 1908 he made the first of many breaks with his previous artistic image by tearing up his agreement with Danthon. Soon after, he started to experiment with different styles, trying the techniques of Fauvism, Pointillism, and Cubism. Gradually he evolved his own complex Orphic abstractions which he recreated in so many successful canvases until about 1915. In the early teens he was a frequent participant at the meetings of the artists who were to be known as the Puteaux group. It was here that he developed his close friendship with Marcel Duchamp, the one other artist who actively displayed his kind of irreverence. Already around 1911-12 the two painters started to create canvases with a certain humor which

Picabia's "machinist" style: *Parade amoureuse,* 1917.

was to explode in the Dada movement a few years later. The year 1913 first took him to the United States, where he met Alfred Stieglitz and collaborated with him on his revue *Camera Work* the following year. Around this time his style underwent a radical transformation into his "machinist" phase. That change in style took place concurrently with the eruption of the Dada spirit in

La Nuit espagnole, 1922.

New York and the gradual emergence of his own Dada stance as pronounced in his journal, the well-known *391,* published first in January of 1917.

As was to happen throughout his life, Picabia's art reflected his physical and emotional condition. The writing of *391*—as well as his first attempts at writing, a volume of poems entitled *52 miroirs*—was largely brought on by the first major breakdown in his health. In 1916, as a result of his alcoholic and narcotic excesses, not to mention sheer overexhaustion, he was incapacitated to such an extent that even painting proved too much for him, and he turned to writing to pass the time. His continuing poor health necessitated his going to Switzerland for neurological treatment in February of 1918. When he publish-

ed his next book of poetry, *Poèmes et dessins de la fille née sans mère,* in April of that year, he dedicated it to the doctors who treated him. This was the volume which put him in touch with Tristan Tzara in August, the contact through which he became embroiled in the activities of the Zurich Dada group and, a little later, Paris Dada. Michel Sanouillet's observation concerning the therapeutic nature of this involvement seems accurate. "[I]n contact with the young Rumanian poet, he felt the rebirth of his taste for action, which was more effective than all the psychoanalysis to finally make him emerge from himself and from his prostration."[4] Picabia threw himself wholeheartedly into the demonstrations, manifestoes, publications, and personal squabbles of the Dadaists. During this period of intense Dada involvement, ending about 1924, he went so far as to break with the Dadaists on several occasions, a characteristic Dada move in itself. He did so in May of 1921, when in *Comoedia* he publicly broke with the group, and then again that July, in *Le Pilhaou-Thibaou.* He abandoned his "machinist" phase of the preceding years for an even more radical departure from traditional modes of representation. He began to introduce foreign objects into his canvases, such as buttons, matches, cigarettes, and feathers, and use Ripolin enamel paint instead of oils or watercolors. The change came as much in the subject matter as it did in the materials employed. Picabia created his first clear black-and-white depictions of human beings which he placed in unreal contexts to make them disconcerting, as in *La Nuit espagnole.* Or he explored subtle relationships as in the arrangement of ever-thinning vertical black stripes on a white field, with different colored human torsos strewn all over in *Conversation* of 1922.[6] Then again he created a large canvas in 1921 called *L'Oeil cacodylate,* which was for the most part a collection of signatures and dedications of his friends. His creative versatility during these years knew virtually no bounds. He published two volumes of poetry, *Pensées sans langage* of 1919 and *Unique eunuque* of 1920, and a novelette of sketches, poetry, aphorisms, and descriptions entitled *Jésus-Christ rastaquouère* in 1920. It was in the flurry of activity of these Dada years that Francis Picabia wrote the ballet *Relâche* and conceived the idea of the film *Entr'acte* to be shown along with it.

The five or so years after his meeting Tzara have a special significance in the life and works of Francis Picabia. After suffering a major physical and mental breakdown, he found in the Dada movement an opportunity to channel his energies, which had been previously diffused, into the creative activities of the painter, poet, polemicist, publisher, and major protagonist. His physical disorders seemed to have precipitated his own middle-age identity crisis. The relationship he began with his future second wife, Germaine Everling, in the fall of 1917 he affirmed by moving in with her in February of 1919, immediately following his first meeting and collaboration with the Zurich Dada group in January. But this search for rejuvenation was more than reaction to exaggerated frustrations of the past. Within Dada circles he appeared to have found a movement which reflected some of his innermost needs. Picabia was by temperament the participant best suited to the movement. He embodied the

Conversation, 1922.

very precepts of Dada in a way reminiscent of Lord Byron's personification of Romanticism. Inherent in Picabia were those personal contradictions which were to be articulated in the publications and demonstrations of the Dada circle. It was these conflicts which led him to break with his successful Impressionist career before 1910 and then radically to alter his style about every five years until his death.[6] His immediate alignment with the Zurich group, followed by squabbles with Tzara and Breton, and his ultimate acceptance of Breton in 1925, all testify to the fundamental way in which he lived out his inherent contradictions. Through the Dada movement he sought to sanctify his inner conflicts by creating a moral position founded on them: "The highest culture is that which supports contradictions."[7]

Picabia's radical reversals as an artist, polemicist, and husband stemmed from that most pronounced form of anarchy peculiar to the Spanish temperament.[8] Along with Tzara, he embodied those chaotic forces which Breton sought to counter in the creation of the disciplined movement of Surrealism. Picabia's anarchic temperament was based on his own visceral appetites and abandoning them in disgust to turn to creative action. He sought to submerge himself in food, alcohol, narcotics, sex, speed, and travel, for he felt that "an

intoxication is always moral.''[9] Painting and writing allowed him to escape
from his physical appetites, yet they continued to surface in both media. In his
first major period of writings, coinciding with his Dada involvement from
New York in the mid-teens to his leaving Paris for the Côte d'Azure in 1925,
Picabia frequently talks about consummation, tastes, and appetites, often ex-
pressing his views of life through them: *"We are in a digestive tube.* And this
digestive tube is larger and larger, it represents space whereas ours is only a
shooting star, perceived by this space for a fleeting moment.''[10] That he feels
ultimately trapped by his physical needs is suggested by his vision of the
universe. His Dada aphorism, *"The most beautiful discovery of man is bicar-
bonate of soda.''*[11] may elicit amusement, but it also testifies to his attempts to
overcome the discomforts of satiating his appetite. Elsewhere he elaborates his
vision of the world more completely in terms of taste:

> *Let us leave for the desert of taste.*
> Taste, something good, good wines, discourse, success, the immense gro-
> tesque of enthusiasm for one's nationality, for honor—I only give my word
> of honor that I will lie—are for me so many sensations of disgust, accom-
> panied by nausea. A suckling pig is more sympathetic for me than a member
> of the Institute, and I get a bitterness in my stomach while contemplating
> turkeys, peacocks, and geese that compose the top of the basket society.
> Celebrated sentiment of duty, boiled by good education! There are men
> who live in its perpetual indigestion and that makes their faces stink, for it
> can only be assimilated by some domestic corpses, made of bronze or mar-
> ble, in our public squares: Jesus-Christ-Stradivarius, Napoleon the trouble-
> maker [how can one translate *'l'emmerdeur'?*], Spinoza the opiate, Nietz-
> sche the masturbator, Lautréamont the sodomist.[12]

Here Picabia begins by grouping together things he likes with things he violent-
ly opposes as all evoking sensations of disgust in him. Once he is in his creative
realm, he renounces his physical appetites, seeing them as belonging to the
same materialism which society idolizes. Taste (*goût*) engenders its opposite
disgust (*dégoût*), therefore the poet must escape from both. The metaphor of
appetite continues to be applied to a society, whose elite is lower than a pig, the
very symbol of rapacious appetite. The passage ends with the debunking of the
heroes of society and a hero of the Dadaists themselves. In the spirit of con-
tradiction during 1920, a year of close cooperation with the Dada group,
Picabia entitles one of his publications *Cannibale* and one of his more impor-
tant polemic statements *Manifeste cannibale Dada*. Thus, in typical Dada
fashion he inverts his own position by associating it with the distastefulness of
satiation.

The dialectic of fulfillment and abstention characterizes whole periods of
Picabia's painting. After his break with traditional painting in 1909 he plunges
into his exuberant Orphic phase. At the high point of this period he creates
paintings such as *Danses à la source* of 1912, *Chanson nègre, Udnie, Culture
physique* of 1913, and *Animation* of 1914. Many of the subjects for his can-

vases participate in some exuberant physical activity, usually related to the night life of cabarets. He recreates the physical exhilaration with bright colors and violent movement of abstract forms. The result is an unprecedented complexity in the paintings, whose excesses are analogous to the satiation of physical appetite. What follows is the "machinist" period of 1915-20, in which complexity is eliminated by the reduction of the composition to a few clearly defined elements, most often mechanomorphic in nature, and the usual absence of color. Picabia's best works attain a degree of measure and an intimation of purity which is totally antithetical to his red-blooded Orphic creations. During his participation in the Dada movement his attempts reveal a desire to achieve a new kind of purity, whether it is through the creation of optical illusion, the use of new materials, or the clear delineation of human figures.

After the fulfillment of his Dada phase in *Relâche* and *Entr'acte,* Picabia continues to alternate between opposing styles of living and creativity. In May of 1924 he begins to build a villa at Mougins, in the hills behind Cannes, with part of the fortune he inherited from his uncle, Maurice Davanne, the year before. At the beginning of 1925 he installs himself there with Germaine Everling. For the next ten years he stays mostly on the seashore, first in his villa *Le Château de Mai,* then on his yacht once he starts to live with Olga Mohler. His departure from Paris also marks a break with Dada-turned-Surrealism: not a break in principle, but simply as a result of lack of participation. The continuous flow of ink of the Dada years dries up: Picabia writes nothing between 1924 and 1928, when his scenario-for-a-film *La Loi d'accommodation chez les borgnes* is published. Those creative years of the early 1920s are followed by a long period of escape from the intellectual activity of the capital. In the south Picabia immerses himself in the pleasures of resort life. Working in his garden, riding around in his cars, sailing his yacht, spending his time on the beaches and his money in the casinos and nightclubs, Picabia becomes a total hedonist. Amidst such conditions of complete physical fulfillment his paintings begin to display once more complexities which have been absent from his work since his Orphism. This is his "monster" phase, when he paints disturbing pictures of lovers and sibyls with several eyes or mouths, creating a totally jarring effect precisely because the subject lends itself to pleasing, harmonious treatment. As in his previous writing, so on the canvas Picabia makes physical pleasure seem repulsive. Thus, after the highly productive Dada years of 1920-24 Picabia retreats from Paris and gives up writing, while his paintings give evidence of inner tensions which appear as a result of his fruitless hedonistic life.[13]

Francis Picabia wrote, staged, and designed the costumes of the ballet *Relâche* for the Swedish Ballet and originated the idea and basic scenario for *Entr'acte* as the crowning achievement of his Dada years. His work with the Swedish ballet at the end of 1924 both in the production of *Relâche* and in that of *Cinésketch* were his last creative activities before leaving for the south, for what amounts to middle-aged retirement. It was a culmination of his years of

Picabia's "monster" phase: *Idylle*, 1923.

polemic activities and, appropriately enough, the final issue of his Dada
magazine *391* of November 1924 features on its last page an announcement of
the performance. It is this same issue, #19, which announces his "Instan-
taneism," Picabia's new version of Dada.

The phenomenon of "Instantaneism" was itself instantaneous. Only the last
issue of *391* bears that title and an article Picabia wrote for *Comoedia* on
November 21, 1924, in addition to his use of the term to describe his ballet
Relâche. He invented the term partly to spoof the movements which were issu-
ing from the decaying body of Dada and which were so much the vogue with
the avant-garde. His primary target was Breton, whose newly founded,
serious-minded Surrealism he could not accept.[14] The title of issue #19 of *391*
read "Journal of Instantaneism" followed by "for some time" in small print
to underline the fleeting nature of the "movement" in a humorous way. The
impulse was closely tied to Dada as the words, "Dadaism, Instantaneism" on
the same cover testify. Among its definitions listed on the first page were "In-
stantaneism: only believes in today," "Instantaneism: only believes in life,"
and "Instantaneism: only believes in perpetual movement." The impulse was
nothing but the final exaltation of the moment. As he wrote in Paul Dermée's
journal *Mouvement accéléré* that same month, "They will shout, 'To
anarchy,' and then what? I don't believe in the Fatherland, I don't believe in

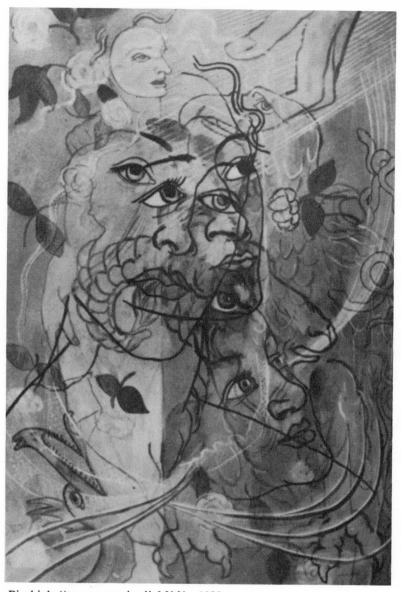

Picabia's "transparencies:" *Médéa*, 1929.

God, I believe neither in Good nor in Evil, and even less in Art; I only accept the present moment, besides it's more available."[15] The position was the natural outcome of a way of life which consisted of continuously giving oneself to the exigencies of the moment. As the short-lived promulgation of the "Instantaneist" movement was the perfect culmination of Picabia's Dada participation, so his move south was the next logical step in the fulfillment of his own credo.

Picabia's final phase: *Le Bonheur de l'aveuglement*, 1947.

Picabia's invention of "Instantaneism" seems to have been sparked by his working with ballet and film, art forms which were totally new to him, which unfolded through time. He called *Relâche* an "instantaneist ballet," and in his article entitled "Instantaneism" written for *Comoedia* he included a discus-

sion of the cinema. He was exhilarated to discover for himself art forms which were so close to life. Indeed he discussed *Relâche* in terms of life rather than art.

> The title *Relâche* [Closed down] expresses for me a truce put to all the pretentious absurdities of contemporary theater. I am not speaking of the music hall which alone has retained a lively aspect. But why do you want explanations once again? Why do you want to understand? That which I did, that which I will do, addresses itself more and more to truly physical pleasure. We were at the end of many cerebral possibilities. Now I only want to look for a joy comparable to the delight of lying in the sun, of doing 120 in a car, comparable to the pleasure of boxing or of being stretched out on the mat of an opium den.[16]

Films were likewise a means of liberation for him, as he elaborated in an interview he gave in his home.

> The actual cinema does not interest me: calendars, postcards, Henry Bordeaux, the antiquated psychology of André Gide, new year's greetings, sentimental speculations for sickly adolescents, or counterfeit virgins! Not interesting.
> What I like is the race across the desert, the prairies, horses, swimming. The cowboy who enters through the windows of the saloon, the explosion of window panes, the glass of whisky emptied at a right angle into a rough gullet and then two brownings leveled at the villain; all of that put to rhythm like a gallop accompanied by snaps of the whip, swears and gunshots.
> Or again the liberated picture, the picture with an intrinsic value, bouncing on the screen: this is what we have tried to do.[17]

This is what the ballet and the film meant for Picabia, an expression of his dynamic life through temporal artistic forms. But what was the production really like?

Relâche was supposed to open on November 27, 1924, at the Théâtre des Champs-Élysées. When opening night came, the elegant guests who drove up to the gates found that indeed the performance was "Relâche," that is "Closed down." As René Clair recalls, "There was a delightful outcry mingled with the comments of people in the know: 'We might have known. That's what the title meant. "Theatre Closed." It's the apotheosis of Dada. The best trick yet by that clown Picabia.'"[18] Yet, in truth, Jean Borlin, the lead dancer, had fallen ill so that the opening performance had to be postponed for a week. When the crowd of elite returned, they included some of the leading artists of the day as well as some of the most prominent members of the Parisian social circle. Pablo Picasso, Fernand Léger, the Japanese painter Foujita, the friend and backer of the Dada and later Surrealist circles Jacques Doucet, the Countess de la Rocca, Baroness Henri de Rothschild, and that patron of the theater Count Étienne de Beaumont were in the crowd. And then there was Mademoiselle Napierkowska, the dancer who had met Picabia on his first

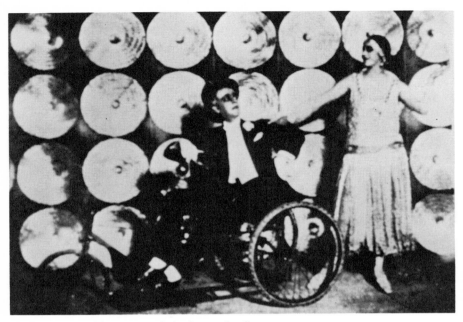

Relâche, Act I—Elegant couple in front of reflectors.

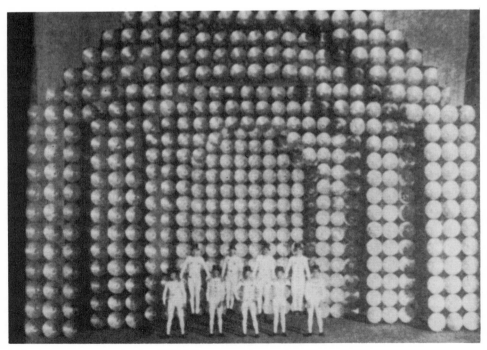

Relâche, Act II—Nine dancers with tophats, tights, and domino spots in front of 370 reflectors.

transatlantic cruise, who was arrested once the ship docked in New York for her lewd performances on board, and whose notoriety led her to stardom in the era of silent movies. While one of the critics saw the performance symbolize the degeneration of morals which was typical of all proletarian Dada art, Paul Achard might have been closer to the truth when he noted, after describing the glittering crowd, that "the avant-garde is above all a formula of the rich."[19]

The performance consisted of two acts. In the first, against a backdrop of 370 reflectors whose intensity varied according to the rhythm of the music, a fireman enters covered with medals and lights a cigarette. A woman in evening gown bedecked with jewels follows him, doing a few dance steps before sitting down and also lighting up. A well-dressed man drives on stage in a toy car with a red balloon trailing him. Then nine male dancers dressed in top hat and tails appear on the scene and begin to dance with the woman. At one point she strips halfway and walks on their arched backs as on a bridge. The act ends with one of them leading her away. The second act opens on a bizarre decor with mirrors, cabalistic formulas, phrases, and all sorts of odds and ends tacked on the curtain. Some of the signs read, "Do you prefer ballets at the Opera? Poor imbecile!," "At the door catcalls are for sale for two cents!," and "If you're not satisfied, go to hell!" The nine men reappear, as does the woman, who is wheelbarrowed in, accompanied by two cripples. The men take off their black frocks, remaining in white tights with domino spots on them and leaving on their top hats. Everyone begins to dance while the fireman keeps pouring water from one bucket to another. The woman's place is taken by a terra-cotta figurine, from which all turn away with disdain. One of the dancers jumps up and offers a wreath of orange flowers to Mlle. Marthe Chenal, seated in the dresscircle, Picabia's companion for the evening. At the end Picabia and Erik Satie drive on stage in a 5-h.p. Citroën.[20]

Picabia was not the first painter to work with the ballet companies which were acclaimed throughout Europe in the late teens and early 1920s. Pablo Picasso, for example, assisted in the creation of stage curtain, costumes, and scenery for five of Diaghilev's productions between 1917 and 1924.[21] In the productions of the Swedish Ballet between 1920 and 1924 Pierre Bonnard did the curtain and stage set for *Jeux*, Steinlen created the costumes and curtain for *Ibéria*, Foujita designed the costumes for *Le Tournoi singulier*, de Chirico was responsible for the stage set of *La Jarre*, and Fernand Léger designed the stage set for the two ballets that accompanied *Relâche* in its premier, *Skating-Rink* and *La Création du Monde*. It was with a similar commission in mind that Rolf de Maré, director of the company, turned to Picabia early in 1924. He was planning a ballet for the end of the year based on a libretto by Blaise Cendrars entitled *Après-dîner* with Erick Satie signed to do a musical score. The ballet was to be a cooperative effort of men who were among the leaders of the avant-garde in their fields. Such was the modus operandi of the company. In addition to the illustrious list of painters with whom they worked, their scenarios were created by Claudel, Pirandello, Cocteau, and Cendrars, their

music by Poulenc, Auric, Honegger, and Milhaud. Cendrars' unexpected trip to Brazil left a void, and so with characteristic aplomb Picabia took his place. His delight in working on a ballet led him to rewrite it completely and to propose a film to be shown in conjunction with it.

Picabia had had a brush with films once before. In August of 1923 he was introduced to Marcel L'Herbier, the film director, by his friend Jacques Hébertot, director of the Théâtre des Champs-Élysées. It was Hébertot's idea that the two should work together on a film. Picabia was all for the idea. He tried to interest his friends in the film, carried on a busy correspondence the whole winter to that end, but eventually the project was abandoned. Instead of this collaboration, Marcel L'Herbier shot another film, the famous *Inhumaine*, with Georgette Leblanc as the star, music composed by Darius Milhaud, and stage sets designed by Fernand Léger and Robert Mallet-Stevens, a group of illustrious collaborators who seem to have been transferred from one of the productions of the Swedish Ballet.

Having already missed such an opportunity, Picabia was all the more eager to include a film with *Relâche*. He saw the need for a film that could be shown during the intermission while the sets were being changed. Rolf de Maré was characteristically open to such an innovative idea, and it was again Jacques Hébertot who brought Picabia together with a filmmaker, this time the young René Clair, who headed the cinema supplement of Hébertot's publication on the theatre. Preparations for the play having begun in May of 1924, Picabia dashed off a short scenario which René Clair used in shooting the film during three weeks in June.

What is always referred to as a short scenario is really but an outline for a short film, written on a sheet of Maxim's stationery. Picabia prefaces these notes only with "ideas for the cinematic part of the ballet." These ideas are the following:

Curtain raiser:
Slow-motion loading of a cannon by Satie and Picabia; the shot must make as much noise as possible. Total length: 1 minute.
During the interval:
1. Boxing attack by white gloves, on a black screen. Length: 15 seconds. Written explanatory titles: 10 seconds.
2. Game of chess between Duchamp and Man Ray. Jet of water handled by Picabia sweeping away the game. Length: 30 seconds.
3. Juggler and father Lacolique. Length: 30 seconds.
4. Huntsman firing at an ostrich egg on a fountain; a dove comes out of the egg and lands on the huntsman's head; a second huntsman, firing at it, kills the first huntsman: he falls, the bird flies away. Length: 1 minute. Written titles: 20 seconds.
5. 21 people lying on their backs, showing the soles of their feet. 10 seconds. Handwritten titles: 15 seconds.
6. Dancer on a transparent mirror, filmed from beneath. Length: 1 minute. Written titles: 5 seconds.
7. Blowing-up of rubber balloons and screens, on which figures will be drawn, accompanied by inscriptions. Length: 35 seconds.

8. A funeral: hearse drawn by a camel, etc. Length: 6 minutes. Written titles: 1 minute.[22]

In using the film to distract the audience during the intermission, Picabia was following a prewar custom. As René Clair recalls, "When I met him he explained that he wanted to have a film projected between the two acts of the ballet, as was done before 1914, during the interval at café concerts."[23] In his notes he already has split the film into two parts, the shorter one to open the ballet, the substantial section to be shown during intermission. It is curious to note that in one of Picabia's better known volumes, *Jésus-Christ rastaquouère,* published four years before, he has two similarly placed sections entitled "Entr'acte." The first, announced by the caption "Entr'acte d'une minute," opens the novelette with a fanciful story of how the author was captured by natives of an island which was deserted during the day but which became the place of rendezvous at night of people from a sexually repressed city. It is while imprisoned on this island that the author wrote the book. His "Entr'acte de 5 minutes" is the complicated and rather pointless story of a Swiss friend in the mountains of Peru who falls in love with an Indian girl who refuses him. He goes insane and is cured only when an epidemic slays most of the tribe including his love, and when he throws her skull away three times, the third cracking it open to reveal the brains looking like a pair of buttocks. These "Entr'actes" stand apart from the chapters of the book not only by designation, but also in that they are the only narrative essays amidst aphorisms, moralizing, and polemicizing on the nature of life and art. They offer a conventional respite from an otherwise unconventional work. The first and shorter "Entr'acte" serves to introduce the volume, just as the "Curtain raiser" of the film introduces the ballet with a big cannon shot. The second and more substantial break comes about halfway through the work to offer further diversion.

The "Entr'acte" itself was not the only idea Picabia had used before. Most prominent in the notes is the appearance of guns: in addition to the cannon, there are two guns fired by two hunters which result in the killing of one of them.[24] Picabia had been obsessed by the idea of guns, as both his paintings and his writings bear witness. In all of the instances in which a gun or firing appears the context designates it as representing a violence whose source is sexual. In *Optophone I* of about 1922 he painted a target around a nude, so that her sexual organ is placed in the bull's eye.[25] In *La Nuit espagnole* of the same year the sexually related violence is made much more explicit.[26] The work is a large vertical canvas with the left half having a white background, the right half painted black. In the left half stands the black silhouette of a clothed male dancer, while in the right half is the white silhouette of a standing female nude. He is turned toward her with his silhouette invading her space. She has two targets painted on her body: one at her point of sex, the other at her heart. In the canvas is a number of bullet holes left by shots Picabia took at the canvas. From his "machinist" phase we have remaining an ink drawing named *Voilà elle* of 1915. It is "a pistol and a target with connecting mechanical linkage.

The nude as target in *Optophone I*, 1922.

The pistol and target, forms employed by Picabia as male and female sexual symbols, are aligned with the clear implication that a target hit would cause the pistol to be recocked and discharged again in a repetitive, mechanical action.''[27] Among his writings at least in one instance the gun becomes more menacing than usual by becoming organic, yet retaining its power to kill. In *Jésus-Christ rastaquouère* he recounts the fantastic story of the man who had to chew a revolver. He knew that as long as he chewed it he would stay alive, but if he stopped, it would go off and kill him. He also knew, however, that one day the gun would go off anyway. In a poem entitled ''Poison ou revolver'' of 1918 he seeks to end the physical love which has become too painful for him:

Odious caresses
Women or men on litters
Egoist homicide and unhappy victims
And they pretend to love.[28]

Michel Sanouillet comments, "The bitterness, agoraphobia, disgust of physical love expresed in this poem had been inconceivable in the Picabia of before the war, bon vivant and sensualist. These themes shall disappear from the few texts published by the painter in the happy years between the wars, only to surface again in the poems of his old age."[29] Indeed in his notes for the film the violence associated with the gun is largely absent. A hunter is killed, but only by accident. The shooting of the cannon as well as the guns is aggressive but playful. In creating his joyful ballet and film, Picabia's preoccupation with guns turned from one of ominous sexual violence to a trick attack on the audience in the "Curtain raiser" and playful target practice in the section of the intermission.

In his film Picabia aimed to fulfill the two chief requirements of a Dada performance: to attack the audience and to create absurdly funny situations, both through a spoofing of the conventional. The attack of the cannon shot right at the camera is followed by boxing gloves punching at the screen. Then he switches to the comic situation of a highly ordered game of chess being swept away by a hose to be handled by himself. The sharp contrast of an indoor mental game being disrupted by a strong jet of water produces the strong comic effect. It is the intrusion of nature into the ordered world of man, similar to the effect produced by the wind blowing off the hat of a serious businessman. It is also humorous because of the lack of proportion between the disruptive force and its object, similar to the cartoon character Jinx the cat using a bazooka to blast "those miserable meeces" out of their hideout. Certain other playful images appear in the outline, such as the lining up of twenty-one people lying on their backs with the soles of their feet showing or a shot of a dancer taken from straight below. Why that shot? Picabia answered, "I would always like to see dancers from below."[30]

Obviously the most important part of the film was to be the finish with a funeral procession, to which Picabia assigned more time than to all of the preceding sequences put together. Picabia's daredevil approach to life included a rebellious defiance of death. Opposed to society's conventions, he was especially irked by its rituals which denied human spontaneity. Of those rituals the burial seemed the most distasteful to him, for here was an institutionalized celebration of death. He tried to counter solemnity with irreverence, death with life. Thus, he entitled one of his volumes of poetry *L'Athlète des pompes funèbres*. He attempted to mock the burial process by infusing life into it, thus nullifying its significance. His remedy: "After our death we must be put inside a ball; this ball will be made of wood of different colors. They will roll it to the cemetery and the undertaker's assistants who will be in charge will wear transparent gloves in order to recall to the beloved the memory of our caresses."[31] It is exactly in this spirit that he thought of ending the film with a funeral procession in which the hearse is drawn by a camel. As he thought back on his film a few years later, he mused, "A burial is not a sad spectacle, it is the priests who have made death disagreeable. I wonder why they don't use hearses as a means of advertisement? Large placards could announce to us that

the deceased would not have died if every day he had drunk a glass of Dubonnet, for example!"[32]

Picabia's mocking disdain of death was characteristic of the whole Dada circle's attitude. One of the most famous Parisian Dada pranks consisted of the announcement of the death of the reactionary General Boulanger in one of their journals, accompanied by a sketch of him on his deathbed. Only General Boulanger's own declarations to the contrary convinced the Parisian public that, in fact, he was very much alive. Upon the actual death of Anatole France in 1924 the group gathered its forces to deal another morbid blow to social conventions. Anatole France, praised by the French literary establishment as one of the leading writers of his age, was to them the embodiment of all the false values of bourgeois society. Accordingly they published an issue of a magazine entitled *Cadavre* in which they vented their anger at the deceased writer. Their mock obituaries were called "The mistake," "An old man like the others," "Refusal to bury," and "Have you slapped a dead man yet?" This morbid humor was an important element of both Dada and Surrealism, from Philippe Soupault's "Épitaphes" of 1920, in which he drew character sketches of his friends, to André Breton's *Anthologie de l'humour noir* of 1940. Their indulgence in such black humor came from a very serious concern with death. In World War I they had witnessed the absurdity of massive killings in which they had lost a number of their friends. After such a chaotic upheaval they were forced to question the validity of life itself. In the very first issue of *La Révolution surréaliste* they began an inquiry concerning the question, "Is suicide a solution?" They had already made an idol out of twenty-three-year-old Jacques Vaché, who had committed suicide after surviving the war. Among others, Jacques Rigaud and René Crevel were to follow him. Being so close to death, members of the Dada-Surrealist circle had to indulge in black humor as a safety valve.

Ultimately Picabia's ideas for the film cannot be separated from his ballet. The film was originally conceived of in terms of *Relâche*, first simply to fill the intermission, later enlarged to include a simple prologue to announce the play itself. In fact, in advertisements in contemporary newapapers and in the program of the play one finds the following title: "Relâche, ballet instantanéiste en deux actes et un entr'acte cinématographique et la queue du chien de Francis Picabia." (Several critics correctly observed in their reviews of the play that they had seen no sign of the dog's tail.) It was not until after the opening that critics started to refer to the cinematic part of the ballet as *Entr'acte*, considering it as an integral work which had to be evaluated on its own terms. While reaction to the ballet ran the gamut of hearty praise to violent attacks, with every conceivable shade of opinion expressed in between, the film itself received generally favorable notice. One critic who dismissed *Relâche* ("It is not interesting. It had shown us nothing. It is only an imitation of something we have seen elsewhere.") acknowledged the power of the film with the comment, "We shall simply say that René Clair realized in it one of his most beautiful and most interesting productions. René Clair truly has a sense of cinema, and

of life."[33] When the ballet was long forgotten, the film still remained. Succeeding critics of film have naturally gone even further in considering *Entr'acte* in and of itself. Yet the truth is that Picabia created the film and the ballet in terms of each other, as parts of a total Dada production.

Indeed, in examining the ballet we are struck by the number of ideas and tricks which are exact counterparts of those in the film. The contradictions of the chess game being swept away by a jet of water or a camel drawing a hearse are echoes of the fireman smoking or a businessman driving a toy car—all of which are spoofs of social conventions. While in the film the audience is attacked by a cannon shot and boxing gloves, in the ballet they are confronted by the reflectors blinding them in the first act and by the signs taunting them in the second. The absurd idea of showing the soles of the feet of twenty-one people lying on their backs is matched by the equal absurdity of the fireman pouring water from one pail to another. As a true Dada, Picabia even mocked the traditional bow taken by the authors by driving on stage in a car with Erik Satie at the end of the performance. Picabia extended the taunting of his audience to the program, in which he wrote, "I would rather hear them shouting than applauding."[34] and played with them by promising a "dog's tail" in the ballet. Aside from being another innovative and colorful production of the Swedish Ballet which saw the creation of an excellent film, *Relâche* was the last in a long line of Dada manifestations which had started eight years before in Zurich's Cabaret Voltaire.

In evaluating Picabia's contribution to the film, we must remember that he was interested above all in the impact of his ideas rather than in their translation to the medium. Very simply, none of the ideas in his notes is especially cinematic. That is to say, in writing his outline he did not know very much about or was not much concerned with the strengths of the cinema in expressing certain kinds of actions or effects. Fortunately, René Clair, the director, was. We have seen that Picabia employed very similar ideas in the ballet and in the film, depending more often on the strengths of the ideas proposed than on their adaptability to the particular medium. That he saw film and ballet as easily interchangeable is further shown by his last scenario for a ballet written in 1950, in which we see him actually lifting some ideas he had proposed for the film.[35] In tableau 2 of *Réveil-Matin* the dancers wear luminous boxing gloves reminiscent of their attack on the screen; in tableau 8 he has costumes being inflated and deflated as he did with the balloons; and the ballet is supposed to end with male and female dancers lying next to each other, recalling the idea of the group of people showing the soles of their feet.

Through the production of *Entr'acte* Picabia seemed to gain an appreciation of the potential of cinema. His comments of November 1924 indicate the lesson he learned from that film. "The cinema, too, must give us a sense of vertigo, be a sort of artificial paradise, promoter of intense sensations going beyond the 'looping the loop' of the airplane and the pleasure of opium. It must orient itself toward the spontaneity of invention which will always be more alive than the foolishness of a beautiful photograph. . . "[36] Intrigued by

the particular power of film, he wrote another ballet during the month of December, immediately after the successful performance of *Relâche*, which was performed a single time on New Year's Eve. The ballet was entitled *Cinésketch* because, as Picabia said, "until the present the cinema was inspired by theater; [now] I tried to do the opposite, in bringing to the stage the method and live rhythm of the cinema."[37] Actually it was René Clair who staged the play and it was probably he who added the cinematic touch. That consisted of dividing the stage into three equal sections, each of which had its actors performing simultaneously. He worked the lights, alternately illuminating the three different sections to produce a rough equivalent of montage in films.[38]

Picabia applied his idea of the cinema to one more venture, a work published in 1928 and entitled *La Loi d'accommodation chez les borgnes*, which he called "a film in three parts." The work is essentially a fantastic scenario with a number of archetypes such as a painter, a cyclist, a priest, and their idol the manicurist, all going about their business while a cripple schemes to attain wealth and power at their expense. He kills the American, who is both patron and bon vivant, and succeeds in convincing the judge of the guilt of all the others, except for the manicurist, whom he wins for himself. Why Picabia called this work "a film in three parts" is explained in the preface. "I ask each of my readers to stage and to project for himself on the screen of his imagination, a veritably magic screen, incomparably superior to the poor black and white calico of the movies."[39] Four different-size types are used in the text to indicate the relative strengths of the images. Although this device is highly suggestive visually, it can scarcely be called cinematic. The most effective cinematic techniques, in the scenario, if not the only one, is the depiction of the thoughts and dreams of the characters, which readily lend themselves to the screen through a blurring or dissolve. The story itself ends in a highly visual manner. Three roads are shown. On the first, to Deauville, we see the cripple and the manicurist in their fancy car speeding past the judge and lawyers. On the second we see those condemned to hard labor walking and each in turn dreaming of the manicurist in his own way. On the third, the road to heaven, we see the two men condemned to death, the investigator and the painter, approach the end of the road, which is marked by a large standing crucifix. When they reach the cross Christ comes alive, bursts out laughing, unfastens his arms to start applauding heartily, and finally clasps the two of them to his bosom.

It cannot be denied that Picabia was interested in the cinema both before and after his participation in the making of *Entr'acte*. Yet for him the cinema was never more than another novel way of coming alive through self-expression. He was less concerned with cinematic form than with content. Once he became captivated with the power of the moving picture through René Clair's realization of his ideas, he sought to translate this "cinematic" effect to other media. But he was dealing not so much with the movies as with the power of the imagination. "The cinema must not be an imitation, but an evocative invention as rapid as the thought of our brain, which has the ability

The young René Clair. (courtesy Museum of Modern Art)

to transport us from Cuba to Bècon-les Bruyères, to make us jump on a spirited horse or from the top of the Eiffel Tower. . .while we eat radishes!''[40]

Few artistic collaborations have had partners as content with each other and the project as were Francis Picabia and René Clair in the creation of *Entr'acte*.

Picabia was especially pleased with the work of the young man. He recalled that "the realization of [the film] was complicated, my collaborator René Clair worked on it in admirable fashion and I experienced the most lively pleasure seeing the realization of what I conceived."[41] He was so much affected by the movie that he adopted his partner's attitudes toward films and went so far as to declare, "The cinema is going to begin. It will begin with men like René Clair, for example, who had understood everything new possible."[42] René Clair was equally enthusiastic about his partner, whom he called "one of the great 'inventors' of the day." After having played in a couple of movies, written film criticism, and made a movie which had not yet appeared, he was elated by the prospect of working with such an illustrious group as Picabia, Satie, and Rolf de Maré's Swedish Ballet. "[A]s I was the only person in the house concerned with the cinema, I was the one to be called on [to do the film]. What a piece of luck for a beginner!"[43] Indeed *Entr'acte* brought René Clair to the attention of the public and launched him on his successful career as filmmaker.

To begin to understand René Clair in the 1920s, one must first realize what a visionary young man he was. Excited by the political upheavals which had resulted in the October Revolution and Dada's assault on artistic conventions, he shared the Utopian fever of his brothers in politics and the arts. He looked to the cinema for its revolutionary potential: "In an epoch when for certain of us literature and theater seemed to belong to a worm-eaten age whose rubble was dispersed by the movers of Dada, at a moment when the word revolution seemed to be the key to all artistic problems, the cinema appeared as the newest means of expression, the least understood in its past, in a word the most revolutionary."[44] It was not only the novelty of the medium which caused René Clair to hold movies in such awe, but also its impact on the masses. "The cinema was made for the crowd, it could not live without it and certain films touched the most difficult of spectators as well as the most common public. Of what contemporary work of art or literature could one say as much between 1920 and 1930? And what revolution in means of expression already known had been as intoxicating as the discovery and the prospect of that which seemed miraculously destined for all men regardless of their social class, their language, or their country?"[45] Given a new medium of such revolutionary potential René Clair sought to prepare the public for understanding what it was witnessing. He postulated that they must start with a clean slate. "All that which dances in front of your eyes, according to taste and education, interferes with the focusing of your vision. Now what the cinema demands of you is that you learn to *see*."[46] Learning to see anew was not an easy task, but it was necessary for the new age that film was introducing.

If I could make you forget, I would make of you beautiful savages. Before the naked screen you would first marvel at elementary sights: a leaf, a hand, water, an ear; then: a tree, a body, a river, a face; then: wind in the leaves, a

man walking, the flow of a river, simple facial expressions. The second year you would answer visual riddles. You would be taught the coarse elements of provisional syntax. You would have to find the meaning of certain sequences of images the way a child or a foreigner must find out little by little the meaning of the sounds he hears. Some years later—or after the passage of a few generations (I am not a prophet)—one would respect the rules of convention of the visual as being as practical and no more tiresome than that of the verbal.[47]

In the novel of his youth entitled *Adams*, René Clair presented film as a medium powerful enough to enslave the mind.[48] The book is the exciting story of a superstar named Cecil Adams, modeled on Charlie Chaplin, to whom the book is dedicated. He is simply the greatest star of the screen, a man whose movies are seen throughout the world, who receives thousands of fan letters a day, and whose characters live on in the minds of millions. In the beginning, after he hears of the suicide of one of his fans, Adams hears a voice speaking to him of the dangerous powers of the screen:

"Watch out! William, Harold, Dorian, Charles, Eric, Antonio, Jack are stronger than you. These seven characters fly across the world and stick to the canvas screens which send back their image to the sensitive screen of the eye. Seven creatures, swallows multiplied by the play of a universal mirror, steal from the spectator the sense of space and time. Their adventures, dispatched by the aid of the orchestra, are not the total drama; they are only the prologue. The real drama is played on the screen of passive souls. A new film begins when the light of the theater blots out the shadowy enchantment. The canvas screen is as white as death. The Mother Goose drama of the screen engenders in each theater another drama, ten or twenty little dramas that the spectators carry away in their heart. Pursuit until the morrow. The aroused humans give themselves up to beautiful dreams. They bring back from their trip to the land of visions an experience which endangers them in a three-dimensional universe. The street is ready to receive their corpses and the vital statistics of the daily papers their undeserved epitaphs."[49]

The screen works its magic not only on the audience but on Adams himself. When he lapses into states of semiconsciousness, any one his seven characters may burst through the shell of his own identity. He is placed so much at the mercy of his characters that he sees the need of regulating them by alloting one day of the week to each. But the characters will not be controlled. The comedian Jack intrudes in the life of William the cowboy, the lover Antonio takes over the role of the shy Charles. In desperation, Adams carefully creates a film in which he attempts to regain his identity by doing his own life story. To no avail, because at the viewing he sees now one, now another character appear through himself. He is witness to his own gradual disintegration. At a loss for what to do, he takes a trip around the world, in the course of which he escapes from the crowds by letting his double continue the voyage. He comes back refreshed, ready to embark on the greatest project of his life, a film called *God*.

The preparations for the projection of *God* take on Olympian proportions. Samuel Aronson, Adams' shrewd manager, sees in it a chance to create not just the greatest film ever but also to stage an event to be remembered in the history of man. He sees it, above all, as a chance to make an inordinate amount of money and win for himself all the power he has ever imagined. Plans are made to show the movie right on the summer night sky with the aid of five thousand projectors so that the entire world can witness this miracle of miracles. In his press releases and interviews Aronson tells how he has sunk all his money into this enterprise and expects to get out of it only the satisfaction of knowing that he is contributing to the elevation of the spirituality of man. Accordingly the stocks of the company fall, and religious organizations all over the world take up collections for this greatest of all projects. The worldwide publicity and the appeal to man's religious guilt feelings works because the stocks start moving upward and eventually soar. For weeks in advance the single topic of conversation around the world is the upcoming movie.

The night of the projection finds Cecil Adams alone in his hotel room, anxious about the outcome of his greatest film. Three flashes of lightning start the show everyone has been waiting for. Music seems to come from everywhere, followed by luminous rains and angels flying about—all thanks to the expert staging of Aronson. Then the face of Adams as God appears on the sky, more infinite than the eye can behold. Slowly, imperceptibly, Adams is carried away into his dreams. The face of God approaches him, he feels a gentle shock, and suddenly he is the one who is surrounded by angels, he is floating above in the sky, he is god. He approaches the gates of heaven, which look remarkably like the doors of the Lyric-Cinema theater. His seven characters appear to him and he announces to them that he is in command now because he is God. At this, Jack sneaks around him and lands a giant kick in his pants. The signal given, the other characters join him in beating up their creator. The scene changes and Adams finds himself sitting between two angels watching an accusatory movie about his life. Whenever he protests the appropriate rebuke flashes on the screen. Adams is left alone when a young man appears on the screen, who turns out to be the incarnation of the Devil. The way he takes Adams into his power is one of the most moving passages of the novel. Until now René Clair played with what the screen could be: canvas, retina, night sky. It served as a metaphor for dreams, the personal subconscious, the collective unconscious, and God himself. Now the screen becomes an active force, opening up to swallow Adams. "On the screen, among the clouds, occurred a young man of marvelous beauty. He made a sign. The screen seemed to be displaced, it advanced, it grew, it engulfed the back of the room, the first rows of seats, and came to delicately absorb Cecil who found himself free of all ties among the clouds of the infinite canvas."[50] The young man tempts Adams to renounce the old God and declare himself the new God since the whole world believes in him now. Adams calls God haughtily, but there is no answer, only eerie silence. The prolonged silence instills in him tremendous fear as he realizes

where his pride has led him. His dream becomes a total nightmare when the young man returns to try to seduce him physically.

Greatly alarmed, Adams awakens to reports of the fantastic success of his film. Newspapers applaud the movie not just as a great work of art but as a work of divine inspiration. Adams runs to Aronson, telling him of his frightening vision, asking him to withdraw his film from circulation and destroy it. Aronson will hear of no such thing, now that his ambition is about to be realized. His greed leads him to establish a new religion which sees in the film *God* the latest manifestation of God on earth, a Second Coming as it were. Aronson becomes the high priest of this religion, which gains control of the entire world. Adams tries in vain to stop the snowballing of Aronson's power. He speaks to the press, but his message is not printed; he pays for posters to condemn the film, but they are quickly covered by others. He is stopped at every turn by the Aronson machine. Finally, when he speaks at a public rally, the crowd throws him off the stage, calling him an impostor. Adams flees to a monastery in Europe, one of the few remaining havens of the old religion, to atone for his sins. The years pass and he hears of revolutions all over the world directed against the Aronson trust. The big lie is finally exposed.

Adams is on his deathbed. "The film of your life unrolls its last meters, and your eyes follow the dispatch of its last visions."[51] He asks God to grant him his last wish: that his name be erased from the memory of man. As he expires, his wish is granted as his films are miraculously destroyed all over the world. The great star, the great monopoly, the great religious vision of humanity all vanish by that very simple process which appears in the final sentence of the novel, "The gelatine, alas, detaches from its celluloid support."[52]

In this novel, obviously film is the main character and its power over human imagination, the subject. Insofar as the cinema could exert a powerful control over the human mind, it was a medium of fantasy. For his very first films René Clair wrote scenarios in which the world of fantasy played an important part. His first film, *Paris qui dort* is the story of what happens when a mad scientist invents a time machine which can slow down to stopping or speed up the activities of human beings. His first major production after *Entr'acte, Le Fantôme du Moulin Rouge*, is about the escapades of a man who becomes invisible. His following production, *Le Voyage imaginaire*, shows the dreams of a young man in quest of his love. In all these works reality and imagination are intertwined as are the passages of hallucination and reality in his novel. In *Paris qui dort* a handful of people escape the effects of the magic ray so that they continue their activities while the life of Paris is brought to a halt. They are placed in a mental institution when they tell the authorities about their adventures. Who is right, the City of Paris or our small band of friends? In *Le Fantôme du Moulin Rouge* the nervous misanthrope who turns invisible casts off his inhibitions once he loses his physical presence and thus becomes a more liberated man. The fictitious premise of his invisibility is only the catalyst for the actual change of his personality. Is it fiction or fact? In *Le Voyage imaginaire* a shy young man dreams of winning a magical ring which is supposed

to give him powers to woo his love. When he wakes up he finds the ring in his hands, placed there by a friend. Believing in the dream, he has the confidence to approach his girl and win her. Only after his success does he find out that he was the object of a prank. But what does it matter, since the magic that he used came from within himself?

René Clair was profoundly influenced by Pirandello's theater as a young filmmaker. It was Pirandello who developed most emphatically the play of reality versus fantasy in the late teens and early 1920s. His best known work, *Six Characters in Search of an Author*, was shown for the first time in France at the Comédie des Champs-Élysées on April 10, 1923. In it he explores most vividly the problem of reality versus illusion. Who are more real, the characters who want to perform or the actors who are assigned to.play the characters? How "real" is the situation itself which he presents on the stage? The young director was intrigued by this juggling of reality in the cinematic medium. He applied his approach to the film: "Fiction? Reality? Pirandello in writing *Six Characters in Search of an Author,* that critical drama, brutally shook our actual conception of the art of the theater which was already sick. Fiction? Reality? Go ahead and try to separate fiction from reality, on the screen where the real, like the fictitious, is but a passing shadow."[53] The reason he combined the real and the fantastic was different from Pirandello's intent. While the playwright attempted to question the very premise of what is real, the filmmaker sought to reach a more fantastic reality, comparable to what he described in *Adams*. The new medium of film was perfectly suited for the rendering of this more exalted reality because of its inherent power of suggestion. Ultimately it was René Clair's revolutionary belief in the ability of the imagination to transform the world which led him to create the new fantastic reality of the movie screen.

René Clair translated his revolutionary fervor into a carefully defined aesthetic of the cinema which he articulated in his critism and which he followed in his films. Even before he became a director he developed his ideas on the nature of movies in his role as editor of *Films*, the supplement to Jacques Hébertot's *Théâtre et Comoedia illustré* between December 1922 and December 1924. In reading his columns we see to what a large extent his attitudes were shaped by the views of Louis Delluc, filmmaker and critic, who was the leading spokesman for the new French cinema after World War I. Delluc had written at the head of his magazine *Cinéa*, "Let French cinema be of the cinema, let French cinema be French." On the first count he attacked the "Film d'Art," which had featured famous actors in well-known plays, such as Sarah Bernhardt in *La Dame aux camélias*. He sought to remove the cinema from the realms of theater and literature by insisting on the visual impact of films based on scenarios especially written for the screen. As far as the creation of an indigenous school went, Delluc could look only to Louis Lumière and Max Linder for predecessors worthy of emulation. Among foreign creations, he applauded the works of Thomas Ince and Charles Chaplin in America, the Swedish school headed by Victor Sjöstrom, and German Expressionist film as

best exemplified by Robert Wiene's *The Cabinet of Doctor Caligari.* He perceived each nation's having its own cinematographic style, and so he sought to create the French school. In his writings he often used the term "impressionism" in a cinematographic sense and indeed the new flowering of the French film in the 1920s may be called the era of cinematic impressionism. Delluc led the way not only in his theorizing but in the making of films as well. In his best work, *Fièvre,* he emphasized the atmosphere of a Marseilles bar over and above any story line. He was not alone in his efforts, for Abel Gance, Germaine Dulac, and Marcel L'Herbier all worked on films which offered a powerful visual impact by means of impressionistic or mood-creating techniques.

Like Delluc, René Clair believed that the cinema of each nation was unique in capturing its own national character and that great cinema could evolve only if it were a national cinema. "The works most worthy of what we expect of the cinema. . .are all of a clearly national character, which does not prevent them from being understood outside their country of origin."[54] He shared Delluc's predilections, especially for the Swedish and American films, and sought to create French cinema along their example. In actual fact his films do not start to display a real French flavor until the late 1920s and early 1930s once his preoccupation with themes of fantasy ended. It is in movies such as *À nous la liberté, Sous les toits de Paris, Le Million,* and *14 juillet* that he develops a tender visual lyricism using the tableau.

In the early 1920s René Clair was much more concerned with making movies "cinematic." Since it was inherently a medium of motion, he considered its single most evocative feature to be the expression of movement.

[I]t is evident all the same that for me the cinema existed between 1900 and 1907. At the time when the Lumière brothers only wanted to register movement. . .they chose a *charge of soldiers, the arrival of a train, the gardener sprinkled.* At this moment they discovered the aesthetics of the cinema, if it must have an aesthetic. A notion in truth as primitive as that of an object in motion in front of a lens. But I still believe that after twenty years the cinema continues to be an *instrument entirely consecrated to the expression of movement.*[55]

Although talking about the first years of film, René Clair curiously makes no mention of Georges Méliès. The omission is significant because Méliès was the father of fiction film, a Frenchman, and the unquestioned pioneer of trick photography, of which René Clair made ample use in *Entr'acte.* To be exact, only once in his early writings does he mention his predecessor, recognizing correctly but without fanfare that Méliès "had created the fiction film and the film of poetic freedom."[56] The neglect by both René Clair and Louis Delluc of such a seminal figure points to the specific state of French cinema after World War I. Often having been reduced to static, stagelike presentations, the French film needed the transfusion of dynamic movement, rather than the occasional charm of visual magic. While Méliès' creative role was clearly recognized, his

example was not regarded as particularly relevant in the creation of a vital new cinema. The term "cinematic" was understood primarily as a temporal attribute: the way that a story unfolds. Sudden appearances and disappearances or transformation of locale and scale through superimposition were regarded as convenient and even necessary tools in the creation of a cinematic statement, but not the fundamental elements of cinematography. In fact, in many dramatic stories, they had no practical application.

While René Clair would use Méliès' tricks liberally in his early work, especially in *Entr'acte*, which was a "film of poetic freedom," he was much more concerned with the overall tempo of his films. He sought to achieve that tempo by the use of different kinds of movement.

> I distinguish three movements: (1) first, this pure or exterior movement which results from a displacement of persons or objects; (2) the movement of the action or interior movement which is perceptible in the cinema thanks to the simultaneism of the scenes; (3) the movement which is together function and factor of the preceding two and which is the proper element of that which one day perhaps will be called rhythm: the movement given by montage, that is to say, the successive order of images and *the duration of each view*.[57]

Clearly, his interest in movement and rhythm was realized in *Entr'acte*, most successfully in its celebrated chase sequence.

Picabia and Satie sniff the shell. (courtesy MOMA)

René Clair's successful collaboration with Picabia resulted in no small measure from his openness to the latter's adventurous spirit. Although *Entr'acte* proved to be the testing ground for René Clair's cinematic theories, it won Picabia's hearty approval because the young director captured the mood of Picabia's intentions in his film, so that much later he could recall: "Picabia knew only what he had written on a sheet of paper headed 'Maxim's,' and great was my satisfaction when, on presenting him with the completed film, I heard him laugh at what I had added."[58]

René Clair generally followed Picabia's scenario in shooting the movie, adding a few of his own ideas as he went along.[59] In the curtain-raiser, which shows Picabia and Satie loading the cannon, he captures the comic intent of the prescribed slow-motion scene by first having the cannon move around by itself willy-nilly and then having the two make faces after smelling the shell. He begins the main part of the movie by presenting four of Picabia's ideas in a generally lyrical manner. The inflation and deflation of dolls, the view of a ballet dancer from straight below, the attack of the boxing gloves on the screen, and the game of chess between Duchamp and Man Ray are interspersed with views of the city or are actually superimposed over them as in shots #51, #85, and #87. The city is the subject of shots whose succession helps to create a feeling of imagistic lyricism. That lyricism, however, is determined not by the subject but rather by the unusual shots taken and by their playful, rapid montage. The resulting flow of images produces a vertiginous sensation of impressions of Paris. The city also provides the night scenes from which René Clair creates those abstractions of plays of light which Man Ray had already achieved in his short *Retour à la raison* of 1923. In shots #28, #50, #54, #56, and #60 we observe variations of street lights blurring into abstractions. A similar evocation of abstract elements from a characteristic Parisian sight is accomplished mainly between shots #64 and #74. In this case different views of the columns of La Madeleine are presented until they lose their representative quality through dissolves and superimposition and become a play of geometric forms.

Of the several gags René Clair inserted amidst those prescribed by Picabia, his best is the one which starts with a close-up shot of the top of a man's head. A superimposed match spins around on his head and is joined by other matches. As they burst into flames a hand appears and scratches the head. The man lifts his head so that his eyes fill the screen as he raises his eyebrows in surprise. This gag is particularly effective because it is inherently a cinematic trick: only through superimposition can the simultaneity of scalp and burning matches be accomplished. Furthermore, it is a trick played in terms of the film as well, for while hitherto superimposition was a poetic device which tended to make the object seem more illusive, here the two different images are forcefully brought together by the very physical act of scratching. Its comic effect arises from illustrating a common irritation in an absurdly exaggerated fashion. (This is precisely what Buñuel does in *Un Chien Andalou* when he shows a hand caught in a door with ants crawling all over it—a metaphorical illustration of

Marcel Duchamp sticks out his tongue. (courtesy MOMA)

A paper boat floats over the rooftops of Paris. (courtesy MOMA)

Chess board superimposed on the Place de la Concorde. (courtesy MOMA)

the tingling sensation one has when the circulation of blood is cut off.) The impact on the audience is powerful because it shows such a basic tactile experience which we try to ignore. It also presents a confrontation with the audience in Picabia's Dadaist manner: just as the cannon aimed outward or the boxing gloves punching the screen engaged the audience, so too does the pair of large, surprised eyes looking straight out.

The transition from a gag to a lyrical sequence of images is perhaps best shown after the disruption of the chess game between Marcel Duchamp and Man Ray by a jet of water. The sequence of images is not strictly chronological. We see the chess board with a few pieces knocked over and images of streams of water preceding some of the shots of the two men playing. The attempt here is to create a mood of dissolution through the unordered sequence of images. Thus, the chess game is played outside, where the players are more at the mercy of the elements. We see them arguing over the game, Duchamp sticking out his tongue, the pieces knocked over, the streams of water. Finally we see the empty chess board lying on the ground with water cascading onto it, in a final image of destruction. But this concluding image of dissolution is only the beginning of a real deluge. It is as if the disruption of the ordered chess game unleashed the chaotic forces of the universe. A paper boat is sailing, superimposed over a shot of the roofs of Paris. The camera follows it, tilting from side to side, in order to translate into visual terms the sensation of a storm-tossed boat. The transition from chess game to deluge is subtly em-

phasized by a momentary image. Earlier, in the chess game sequence, we saw the chess board superimposed on the Place de la Concorde. Now, the Place serves as a background for the superimposed pouring water. The violent movement of the camera continues, tilting up and down as well to show alternately the sky and a high-angle shot of a roof. Among the succession of shots there are some in which the boat is absent, but the wave-like movement of the camera continues all the same.

Throughout this initial section of the main part of the movie we are presented tantalizing shots of a dancing ballerina taken through a glass from straight below. Our anticipation to see more of her seems to be satisfied after the storm-tossed boat sequence, when the camera finally focuses on her for a longer period. We see her leaping into the air, spreading her legs, and revealing her panties. Then we see her legs from the side as she is dancing and her arms gracefully moving above her head. Finally the camera pans slowly down her arms to reveal a bearded, mustachioed face.[60] The trick is completely in the spirit of Dada for it ridicules the sublime. It is particularly effective because the anticipation of the audience is built up through time. It is even a bit disturbing for the male audience because they were led on sexually, only to find their expectations frustrated. Their feeling is comparable to the experience of those watching a striptease in which one of the numbers turns out to be a female impersonator. They cannot help but applaud the successful deception, but they feel uneasy in being confronted with a male at the very moment when their arousal led them to expect the incarnation of their sexual fantasies in an unveiled voluptuous seductress.

The revelation of the dancer is followed by what is the last image of this initial section. A sheet of water appears which had appeared before momentarily among shots of the dancing ballerina. Then a pair of inverted eyes fade in and out, as does the ballerina's tutu. When the eyes finally disappear, a face emerges in profile. The same face shot from the other side appears next to the first to form a strange double profile. The water ripples behind them. This segment acts as a break between the trick of the dancer's identity and the loosely constructed narrative of the second part of the movie. It is the most powerful dreamlike image of the film, which suggests rather than announces, evokes rather than constructs. After the handful of gags in the first part of the movie, culminating in the jolting unmasking of the ballerina, the image of the vast expanse of water produces a soothing effect. Almost immediately, however, it becomes a screen for oneiric apparitions which continue to affect us deeply, if at a lower level of energy.

The remarkable extent to which René Clair combined visual gags and lyrical passages of movement makes one wonder how he could reconcile these two seemingly disparate modes. Yet for him the two went hand in hand because they were both inherently cinematic. In 1923 he noted that "the comic film is the one where the cinema has best succeeded in being itself."[61] In other words, the comic film best exploited the inherent movement of the cinema. In his terms, the comic situation was based by definition upon the "interior move-

Two faces superimposed over water. (courtesy MOMA)

ment'' supplied by a narrative and provided a great deal of the "exterior movement'' of characters and objects. The issue was clear-cut: "[I]n the comic, all weakness is visible, all error obvious. One laughs or one doesn't. And no critic's subtlety can fool the world on this point.''[62] It was only natural that in attempting to create a film of movement he would utilize what was to him the film industry's highest achievement to date, the comic film.

Entr'acte's famous chase scene is introduced by the least successful sequence in the movie.[63] It is based on one of Picabia's ideas, a rather complicated little fragment involving a hunter firing at an ostrich egg on a fountain, a dove flying out of the egg and landing on the hunter's head, while a second hunter fires at the bird but kills the first hunter by accident, as the bird flies away. This little fragment, characteristic of Picabia's mental contortions, is ill-suited for cinematic presentation. René Clair probably used it on Picabia's insistence, if not because it produced the corpse for the succeeding funeral procession. The sequence, however, lacks the possibilities of cinematic development which René Clair sought, for ultimately it is devoid of action, that is, all of the action is compressed into the firing of shots. This does not mean that he did not try to develop its humorous potential. We see a double-barreled shotgun pointing straight at the camera, one of its bores being larger than the other. An egg is balanced on top of the fountain's jet of water: the stream subsides but the egg stays in its position in midair. The hunter aims, but as he does so, he sees the fountain and egg multiply so that he is facing a row of superimposed foun-

Picabia takes aim from the rooftop. (courtesy MOMA)

The camel leading the hearse. (courtesy MOMA)

tains. Confused, he aims at all the eggs in turn, then lowers his gun. Despite these gags, the sequence falls short of the rest of the movie.

The succeeding funeral procession includes a whole slew of gimmicks which reflect Dada's mocking comtempt for death and ceremony. We see the mourners come out of a building dressed in their bereavement best. The men's apparel seems strange only in that a number of them wear wreaths around their neck. As the women approach the window to pay their respects, a strong gust of wind blows up their skirts. The hearse that is waiting at the bottom of the staircase seems at first glance to be properly funereal. Instead of being pulled by horses, however, a single camel is harnessed in front of the coach. The funereal coat of arms turns out to be a heart. The coach is decorated with paper chains, hocks of ham, and circular loaves of bread. In fact, once the mourners have lined up behind the coach and wait with serious expressions, one of the men standing close by breaks off a piece of the loaf and starts munching on it as the others look on with disapproval. Just before the procession begins, we see behind the well-dressed mourners a whole group of people in ordinary street clothes.

The hearse starts off. The crowd follows it, running in slow motion. Their slowness is emphasized by shots of longer duration. A number of people run by the camera taking large steps as a short old lady in street clothes strides by them with enormous leaps. Everything has been slowed down, including the traffic they pass at an intersection and the interjected shot of the dancing ballerina. The procession reaches a circus ring in the Luna Park of Paris. They circle round the ring at normal speed. The ropes which attach the harness to the hearse drop off without anyone's noticing. The driver continues to lead the camel away as the coach starts slowly rolling by. The carriage gradually picks up speed as the crowd follows, still unaware of what happened. The driver turns around to see why his camel stopped, sees that he has lost the coach and looks around panic-stricken. He lets go of the camel and rushes off after the crowd. Meanwhile the runaway carriage continues accelerating, and the crowd runs faster and faster to try to keep up with it. The movement of the coach and followers begins to be speeded up cinematically. The crowd gradually thins out as some run out of breath while others have shed their jackets to be able to run faster. Now the chase takes on the appearance of a race. Traffic passes the carriage going in the opposite direction. A runner in jersey and shorts is running after the hearse. The race is joined by a group of cyclists, then by a group of cars. We even see an airplane and a boat join the race at exaggerated speed. The pace of the film is so furious at this moment that a cripple who has been pushing himself along jumps up, abandons his cart, and joins the race. Traffic is disrupted so that cars coming the other way narrowly miss a collision. The acceleration of the movement continues as we are sitting in a roller coaster, the camera aimed directly in front of us. We plunge down, climb up, and take sharp turns. The images of passing countryside, moving vehicles, and runners become shorter and shorter, often being superimposed on each other to give us a maximum sensation of speed. Toward the end we only catch blurs of move-

The mourner gets hungry. (courtesy MOMA)

ment on the screen. This entire process of acceleration is pounded into the audience by the staccato rhythms of Satie's accompanying music. Finally, the carriage throws out its cargo, the coffin, onto the ground, bringing the chase to an end.

The chase scene of *Entr'acte* has always been its most acclaimed feature. René Clair intended it to be the single most important element in his film. It is an extremely long sequence taking up about half of the entire movie. It further reveals the basic difference between Picabia and René Clair, for while the Dadaist intended the final half of the movie to be a spoof of society's funeral ceremonies, the film director adapted his suggestion to create a highly cinematic chase scene.

It was in the chase scene more than anywhere else that René Clair put his film ideas to the test. For him the cinema was a medium of movement, so it was movement that he pushed to its furthest limits in the chase. In his first film, *Paris qui dort*, he was preoccupied with the same thing. Basing his film on a story about a time machine, he was able to include slow-motion and fast-motion shots of people going about their business under the guise of having the machine go out of control. Since film reproduced motion, it was only natural to play with its speed. But while in his first film René Clair only played with the possibilities of altering the normal speed of movement, in *Entr'acte* he orchestrated his distortions to create what he called rhythm. He built his chase episode so that it started with slowmotion, progressed to showing people walking at the regular speed of the camera, went on to show them running at normal camera speed, and finally showed them running with the film speeded up. He supported the acceleration of the physical movement with the gradual reduction of the duration of each image. He further supported the increasing of

speed by selecting subjects for the screen which are linked in the minds of the audience with a certain pace, such as the camel at the beginning, the cars and roller coaster toward the end.

But René Clair was interested in more than the simple evocation of speed on the screen. Remembering what revolutionary dreams he had for the possibilities of the cinema, we can begin to understand his real motivation for the creation of this chase scene. He saw movement as the single most important element of the motion picture. Used properly, it could transport the audience to another reality. That could only happen through a movie which appealed to feelings rather than the intellect: "We hadn't come in order to think. To see and to feel is sufficient for us."[64] The process by which this immediacy between film and viewer was established was carefully explained by René Clair in an article entitled "Rhythm." "The thought rivals in speed the parade of images. But it slows down and, conquered, submits to surprise. It gives itself up. The screen, a new look, imposes itself on our passive gaze. It is at this moment that rhythm can be born."[65] By starting slowly and gradually accelerating the chase he grabbed hold of his audience and took them on a wild ride, dropping them only when the pace had reached its most frantic point. Through the proper use of movement he could achieve rhythm which evoked feeling in the spectator and allowed him temporarily to transcend himself.

By the time René Clair developed the chase in *Entr'acte* it had been used in different contexts by a number of directors. The first known chase films were

The roller coaster as metaphor of the chase. (courtesy MOMA)

produced in England, but they were quickly copied by Pathé Studios. It was in France that they were really perfected by Ferdinand Zecca, Emile Cohl, Jean Durand, and Louis Feuillade. These directors created dozens of films which were based on chase scenes and trick photography, which Georges Méliès had pioneered only a few years before. They started with practically anything, a runaway horse, a pretty girl, a pumpkin rolling off a wagon, and then built up the chase through the addition of incidents. In films such as Zecca's *Slippery Jim* (1905), *The Runaway Horse* (c. 1907), or Cohl's *The Pumpkin Race* (1907), they used the chase as an excuse for their camera tricks such as slow motion, fast motion, stopmotion, reverse shots, and superimposition. At the end everything was restored to order as if nothing extraordinary had happened at all.

The movement of those chases was so compelling that they became a staple of early movies. They could increase either the comic element of the story or the dramatic as Edwin Porter and D.W. Griffith were to do. In some of his earliest movies at Biograph, Griffith already included chase scenes. In the coming years he perfected their potential for suspense through parallel editing until he arrived at their most spectacular version in *The Birth of a Nation* and *Intolerance*. Yet neither the French directors nor Griffith had a monopoly on chases. They were so cinematic, so popular, so essential to the construction of a variety of stories that the first two decades of movies witnessed their universal proliferation. The surfeit of chases was noted by a commentator in 1916: "Perhaps to a certain extent the 'chase' is no longer stylish: nevertheless, a good chase is still amusing, as it was at the time of the old films of Biograph (*The Curtain Pole*), of Pathé (*The Runaway Mother-in-Law*) or of Gaumont (*The Drunken Coachman*)."[66]

Yet precisely when some viewers began to tire of chases, Mack Sennett revitalized them in his Keystone Comedies. Sennett had been inspired by both his friend Griffith and the French in the creation and construction of the chase. He had acted in some of Griffith's Biograph films, including *The Curtain Pole*. He freely acknowledged his debt to the master: "So far as any knowledge of motion-picture technique goes, I learned all I ever learned by standing around, watching people who knew how, by pumping Griffith, and thinking it over."[67] But while Griffith was the main influence on his filmmaking, the early French directors offered him models for his comedies.

> I thought about the funny pictures the brothers Pathé made. Now, I have been posing for many years as the inventor of slapstick motion-picture comedy and it is about time I confessed the truth. It was those Frenchmen who invented slapstick and I imitated them. I never went as *far* as they did, because give a Frenchman a chance and he will go the limit—you know what I mean. But I stole my first ideas from the Pathés.[68]

Sennett does not refer specifically to the chases, because he sees them as but one ingredient of his comedies, though an important ingredient at that.

Mack Sennett did not simply copy the early French comedies. He originated

those funny little symbols of authority who came to be known as the Keystone Cops. In creating stories for them, he revised the form of the French chases, making them somewhat more ordered. The Keystone Cops would typically set off in hot pursuit after some villain. Once it dawned on them that the culprit got away, they all jumped on their wagon in hot pursuit. From the very beginning the chase was shown at a fast speed. Since the chase was inherently fast, the few straggling cops had to run after their own wagon once it got started. In the course of the chase all who got in the way lived to regret it. Cars crashed into each other or ran off the road, bystanders lost their pants, peddlers got their carts overturned as the paddy wagon brushed by them in its careening course through streets and fields. The speed demanded to catch the culprit also meant that the cops had to go at uncontrollable speeds.

In his early films René Clair was strongly influenced by both the pioneer French directors and Mack Sennett. Zecca, Cohl, and Durand had created the first great epoch of the French cinema, in opposition to the artificial theatrical adaptations of the *Films d'Art*. His first film, *Paris Qui Dort,* was essentially based on a well-known Jean Durand movie called *Onésime horloger* of 1910, in which an impatient man takes liberties with time. But René Clair's greatest idol was the American King of Comedy.

> Mack Sennett is one of the great personalities of the cinema. It is he who created the genre of "Mack Sennett comedies," those fantastic poems where clowns, bathers, an automobile, a little dog, a jar of milk, the sky, the sea and some explosives are interchangeable elements each of whose combinations provoke laughter and astonishment. The fresh and rapid lyricism of Mack Sennett reveals to us a light world where the law of gravity seems to be replaced by the joy of movement. His short comedies announce to us the reign of lyrical fantasy which will no doubt be the triumph of the cinema.[69]

One of his films provided the actual model for the chase in *Entr'acte*. In *Heinze's Resurrection* of 1913 he weaves a little story around Heinze, his wife, and his friend, Pat, who has his eyes on her. Pat foments trouble between them by convincing her to force the lazy Heinze to do his share of housework. When confronted, Heinze naturally refuses and is doused by a bucket of water. He storms out of the house, only to run into Pat, who advises him to play dead in order to test his wife's love for him. When Pat informs her of his death, she begins to cry, but his kisses console her. Pat quickly seals Heinze's coffin and makes arrangements for the funeral. Heinze realizes that the joke has gone too far and unsuccessfully tries to get out of the coffin. The funeral procession takes off with the casket in the front carriage. Pat whips the horses so that they start to gallop, leaving the procession behind. Coming to a bend, the carriage hurtles over a cliff. The casket breaks open and the infuriated Heinze steps out, grabs an axle, and hurls himself at the mourners, all of whom run away, including the conniving Pat. His wife calms him down and the couple is happily reunited. The motif of the hearse which runs away from

the crowd, eventually overturns, and spews forth a casket from which the dead man emerges very much alive is taken over intact in *Entr'acte*.[70]

The influence of the early French comedies and the films of Mack Sennett is not confined to René Clair's adaptations of particular stories. His conception of the chase scene in *Entr'acte* is an amalgam of the two sources. He followed his French predecessors in basing the chase on a ridiculous premise and using various camera tricks in its unfolding. What appealed to him in Mack Sennett's work was the simplicity of the chase, as opposed to the accumulation of complications in the French movies. He was also attracted by the unrelenting speed of the pursuit and, to a lesser extent, by the havoc it created as it passed. But René Clair aimed at more than the creation of a comic film strip. He sought to make the cinematic illusion as convincing as possible. Thus, he kept the incident itself simple and focused on the development of the sensation of speed. He showed the chase from every angle to try to recreate the total experience of movement. We see the mourners running from the side, from behind with a stationary camera, from the runaway carriage. We see them running in a group with the camera showing only their legs moving like pistons. The hearse appears in a similar way, from all positions, close-ups of the wheels showing them spinning rapidly. We are shown tracking shots of the countryside quickly passing by. But he did not have to stick to a realistic representation of the race. He threw in a boat, a plane, a track star, speeding cars, racing bicycles, all of them partaking of the rapid movement he is trying to convey. The speed is so compelling that even a cripple joins the race. Since his purpose was to convey a sensation he edited the film to bombard the audience with a "torrent of images."[71] He superimposed images, switched quickly from one fastmotion shot to another, and turned his shots sideways and upside down at the most heated part of the chase. The final *coup de théâtre* is the sequence which shows a roller-coaster ride from the point of view of the passengers. A generation before Lowell Thomas's *This is Cinerama*, René Clair gave his audience a thrill they never forgot. Like Mack Sennett almost a decade before him, he had successfully revitalized the chase. In so doing, he must have particularly pleased Picabia by conveying the exhilarating speed of his racing cars in his newly discovered artistic medium.

The chase is resolved in a fun-loving, unconventional manner. The coffin rolls out of the carriage and lands in the middle of a field. The pursuers finally catch up with it and examine it carefully. Suddenly the lid begins to move, flies off, and the hunter is revealed sitting up in the coffin, dressed as a magician and covered with medals. To the surprise of the entire group, he jumps out, waves his magic wand, and makes the coffin disappear. Then, he turns to each of them in succession and with the tap of his stick makes them vanish. Finally, with a great flourish, he turns the wand on himself and causes himself to disappear. In this final movement René Clair shows us his love of the magical, which he had first seen in Méliès' films and which he explored especially at the beginning of his career.

Breaking with the conventional ending. (courtesy MOMA)

But because *Entr'acte* is a Dada film it does not end with anything so neat as a magician making his friends and himself disappear. Dada does not believe in conventional illusions; it prefers to engage the audience by a break with the medium. After the final disappearing act, the word "End" appears on a large sheet of white paper. Suddenly a man jumps through it in slow motion and lands on the ground. A pedestrian walks by and gives him a strong kick which sends him back through the sheet by running the film backwards. The word "End" is pieced together once again. Thus the conventional ending is invalidated by the continuing action of the film. There is too much life in the characters for them to vanish by a simple wave of the wand, just as the hunter could not be killed by a gunshot earlier in the film. At the end the dynamic movement of the film attempts to break through its own limitations.

The collaboration of Picabia and Clair resulted in the creation of the single most outstanding Dada film. Picabia's scenario provided Clair with exactly what he needed for the making of the film. He followed his own advice that "the principal task of the director consists of introducing, by a sort of ruse, the greatest number of purely visual themes into a scenario."[72] The cinematization of Dada was a grand success. Perhaps Picabia summed up the effort best: "*Relâche* promenades in life with a great burst of laughter: Erik Satie, Rolf de Maré, René Clair, Prieur and I created *Relâche* a little bit the

way God created life. *Relâche* is the happiness of moments without reflection: why reflect, why have a convention of beauty and joy?''[73]

Entr'acte remains as a curious product of postwar France, in which a number of different artistic tendencies find expression. Although commonly regarded as a Dada film, it is a special brand of Dada. Coming as it does after the demise of the movement, it is somewhat an anachronism. As a result, it was no longer intended to outrage but rather entertain. Before, Dada had broken artistic conventions in order to attack bourgeois conceptions of beauty and art; now, its assaults on the audience were visual surprises which were greeted with unanimous approval and delight. For Picabia's aim was the affirmation of life, rather than the negation of art. And the Parisian audience had become partially inured to the affronts made upon it.

Lacking the vitriolic force of Dada in its heyday, the film partook of the then current celebration of the avant-garde in the theater. The Russian and Swedish Ballets introduced some of the most significant painters, writers, composers, and designers to avid theatergoers. While those artists infused the performances with their exuberant creativity, the style of the ballets required a toning down of the revolutionary impulses which had brought them to the attention of the public in the first place. Because of his propensity for the sensual pleasures of life, Picabia was particularly drawn to an art form that was essentially a celebration. Having participated in the Dada movement from its inception, he had exhausted his own interest in it by 1924. His subsequent withdrawal from Paris to the Riviera offered an outlet for his hedonistic nature. His involvement with the Swedish Ballet marks the point at which his Dada defiance turns into the lifelike affirmation of the stage.

Yet Picabia'a acerbic character was not totally submerged by his collaboration with the Swedish Ballet. Significantly, the film received a better response than did the play. Indeed, the play aimed as much to aggravate the audience with a number of insipid incidents as it did to please them by creating a spectacle. In fact, Picabia aimed to do in the film what he did in the play, as the number of common elements between them indicate. The enthusiastic reaction to the film testifies to the way in which Picabia's ideas were altered by the medium. Generally speaking, their cinematization made them less immediate and therefore less frustrating, while at the same time more novel because until then very little experimentation with film had been tried.

René Clair was the one who made *Entr'acte* into the entertaining film it is, not by directly attempting to capture the joyful spirit of the ballet, but by aiming to make the film work on its own terms. His sense of the cinematic allowed him to create a rhythm for it. Through that rhythm he attempted to catapult the viewer into a more fantastic reality, as Adams had been in his novel. While he was never a member of the Surrealist group, René Clair believed in the transcendent power of film as many Surrealist poets had. That communality of fascination is indicative of the rapture so many early enthusiasts of the cinema felt. While for the Surrealists the cinema was merely one possibility of

liberation, for René Clair and other early filmmakers it was *the* vehicle for creating a new reality.

Despite René Clair's inspired cinematization of Picabia'a ideas, *Entr'acte* has a number of weak spots. It is best in its creation of moods, in its simulation of sensations, as in the flood caused by the jet of water disrupting the chess game or in the chase scene. It also works well in specific incidents, such as the opening firing of the cannon, the sudden revival of the corpse, or the unexpected breaking of the end title. Other elements in the film, however, are tedious, disjointed, and unnecessarily complicated. The inflating and deflating dolls are at best cute; the appearance of profiles in the water is confusing; the sequence with the hunters is hopelessly elaborate. These elements are weak because they fail both as entertainment and as provocation. They are for the most part Picabia's ideas put to film. They are no better than many of his ideas in the ballet, such as the fireman pouring water from one bucket to another. If they are meant to irritate, they do so by their simplicity.

The few weak moments, however, are more than balanced by the energy and wit of the film as a whole. It appealed to a large audience, including the Surrealists, but rather as a film like so many of Chaplin's, to be appreciated rather than imitated. For one thing, there were as many points of similarity as of divergence between Dada and Surrealism. For another, *Entr'acte* was a hybrid between Dada and the fashionable avant-garde, whose aims conflicted directly with those of the Surrealists. Then too, Breton, extremely sensitive to personal criticism, was not favorably disposed to Picabia's mockery of the newly formed Surrealist movement just at the time of the premiere of *Entr'acte*. What he wanted was a committed member of the Surrealist movement who would create a film in line with Surrealist goals, not a one-time fortuitous collaboration. Besides, in 1924 one of their members was already experimenting with film who would fuel their hopes for the creation of a Surrealist cinema for a number of years. That was another former Dada luminary, the American Man Ray.

NOTES

1. Maurice Bardèche and Robert Brasillach, *Histoire du cinéma* (Paris, 1935), pp. 218-22.
2. Michel Sanouillet, *Picabia* (Paris, 1964), p. 19.
3. Ibid., p. 21.
4. Ibid., p. 36.
5. Such optical ventures came at the time when Marcel Duchamp was turning his energies to the creation of three-dimensional illusion in his roto-reliefs. According to Duchamp himself, Picabia "was searching for optical illusion with means that were almost 'black and white'; the spiral and circles which play on the retina." Ibid., p. 40. Picabia's work, in fact, may have been triggered by Duchamp's experiments. Intriguing parallels exist between the work of the two artists in the previous decade as well. Com-

pare, for example, Duchamp's *Passage of the Virgin to the Bride* of 1912 with Picabia's *I See in My Memory My Dear Udnie* of the following year for their similar sexual subject whose tone is made intense by the use of highly suggestive forms at once mechanical and humanoid. Or consider the possible influence of the mechanical parts of the *Large Glass* upon the very premise of Picabia's "mechanistic" phase.

6. Michel Sanouillet has distinguished phases of four to seven years in the following way: traditional between 1897 and 1904, Impressionist until 1909, Orphic between 1910 and 1915, machinist until 1920, Dadaist until 1925, "monsters" between 1923 and 1929, "transparencies" until 1935, a complex period until 1940, figurative paintings during the war, and the years before his death different forms of abstractions. Ibid., p. 13.

7. Ibid., p. 9.

8. Gertrude Stein in her biography of Picasso attempts to reveal the nature of his Spanishness: "Spaniards did not mistrust science, they only never have recognized the existence of progress. While other Europeans were still in the nineteenth century, Spain because of its lack of organization and America by its excess of organization were the natural founders of the twentieth century." Gertrude Stein, *Picasso* (London, 1938). The history of Spain at the end of the nineteenth and beginning of the twentieth century bears witness to these literary generalizations. After the 1871 dispute between Marx and Bakunin, only in Spain did the mass of the movement follow Bakunin. The Anarchists numbered 50,000 in 1873 and a million and a half in the ranks of the anarchist Confederación Nacional de Trabajo in 1931. See Hugh Thomas, *The Spanish Civil War* (London, 1961), pp. 40-41. It is also not by chance that the filmmaker who created the most anarchistic films of the Surrealist epoch was the Spaniard Luis Buñuel.

9. Sanouillet, p. 9.

10. Francis Picabia, *Jésus-Christ rastaquouère*, (Paris, 1920), p. 35. The passage in italics is head of a small section in the book.

11. Ibid., p. 34. All italics in quotations are taken from the original texts.

12. Ibid., pp. 15-16.

13. Further changes take place in Picabia's style in the next few years which are consistent with the previous discussion of his stylistic metamorphoses. A period of purifications follows his "monsters" beginning in 1927-28 which lasts into the mid-1930s. In this phase of "transparencies" figures are clearly drawn and placed over each other. While in certain works the result is one of extraordinary clarity and simplicity, in others tremendous visual complexities are created. The style which he evolved to cleanse his work thus engendered new complications. The dialectic continues to the very end of his life, when he creates paintings which consist of simple elements, but whose effect is more disturbing than anything he had ever done before. Few works in the history of art can compare in sheer horror with his *Kalinga* of 1946, *Niagara* and *Le Bonheur de l'Aveuglement* of 1947.

14. "The works of Messrs. Breton and, how do you say? Philippe Coupeaux [pun on Soupault], I believe, are a poor imitation of Dada and their surrealism is exactly of the same order." Francis Picabia, *391*, no. 19 (November 1924), p. 2.

15. Francis Picabia, "Première heure," *Mouvement Accelérée*, November 1924.

16. Rolf de Maré, "Á propos de *Relâche*," *Comoedia*, November 27, 1924.

17. André-L. Daven, *"Entr'acte," Comoedia*, October 31, 1924.

18. René Clair, "Picabia, Satie, and the First Night of *Entr'acte*," *Á NOUS LA LIBERTÉ and ENTR'ACTE, films by René Clair* in *Classic Film Scripts* (New York, 1970), p. 110. This is the translation of the article which appeared in *Figaro Littéraire*, June 1967.

19. For the critic who saw in the play a Communist plot, see Camille Aymard, "Picabia est un symbole," *Liberté*, December 10, 1924. The other view was presented in Paul Achard, "Soirs de Paris," *Siècle*, December 3, 1924. Both of these articles and many other relevant clippings can be found together in the Picabia Dossiers of the Jacques Doucet surrealist library in Paris.

20. This account was compiled from reviews of the play, most notably from Camille Aymard, "Picabia est un symbole," Maurice Bouisson, *"Relâche-Entr'acte," Événement*, December 15(?) 1924, and Jane Catulle-Mendes, *"Relâche," Presse*, December 6, 1924.

21. Between 1917 and 1921 Picasso worked on Diaghilev's ballets *Parade, Pulcinella,*

Le Tricorne, Cuadro Flamenco, Le Train Bleu, and Étienne de Beaumont's *Mercure.* For his role in each of these, see Alfred R. Barr, Jr., *Picasso, Forty Years of His Art* (New York, 1939), p. 192. The list compiled here does not include some of his work in plays, such as Jean Cocteau's free adaptation of Sophocles' *Antigone,* for which he created the decors.
22. "Francis Picabia's Original Notes for *Entr'acte,*" *Classic Film Scripts,* p. 113. Translated from the French which appeared in *L'avant-Scène du Cinéma,* no. 86 (November 1968).
23. René Clair, ". . .First Night of *Entr'acte,*" Ibid., p. 109.
24. Significantly, in the movie Picabia plays the role of the killer.
25. Mr. William Camfield offers a more ingenious explanation of the meaning of this picture. "An optophone is an instrument which converts light variations into sound variations so that a blind person may estimate varying degrees of light through the ear and actually 'read' printed matter. Picabia's *Optophone* seems to be a comparable instrument that 'converts' electrical energy into sexual energy. The circular patterns here resemble a diagram of a static magnetic field around a current-bearing conductor, and by placing a female nude with her point of sex at the center of the field, Picabia makes her a 'charged body' or the 'conductor of the charge.' " See the excellent exhibition catalog of William A. Camfield, *Francis Picabia,* Catalog of the Solomon R. Guggenheim Museum (New York, 1970), p. 119.
26. The canvas was first known as *L'Amour Espagnole* and *Nuit d'Amour.* At the bottom left it sports the ominous inscription *Sangre Andaluza.*
27. Camfield, p. 24.
28. Picabia, "Poison ou Revolver," *Poèmes et dessins de la fille née sans mère* (Lausanne, 1918).
29. Michel Sanouillet, *Francis Picabia et "391"* (Paris), 2:50.
30. Francis Picabia, *"Entr'acte," This Quarter* (Monaco) 1, no. 3 (1927):301-2.
31. Michel Sanouillet, *Picabia,* p. 10.
32. Francis Picabia, *"Entr'acte," Orbes,* no. 3 (Spring 1932), pp. 131-32.
33. R. de Givrey, *"Relâche," Bonsoir,* December 7, 1924.
34. René Clair, "First Night of *Entr'acte,*" *Classic Film Scripts,* p. 110.
35. Picabia, *Réveil-Matin* (Paris, 1954).
36. Picabia, "Instantanéisme," *Comoedia,* November 21, 1924, p. 4.
37. Paul Achard, "Picabia m'a dit," *L'Action,* January 1, 1925, p. 4.
38. Interview with René Clair, November 15, 1972. Picabia described the contents of the play to Paul Achard in the following way:

ACHARD: Will it have a subject?
PICABIA: Yes, a little story but decorated with a bunch of colored details. Thus I reconstitute a painting by Cranach, the only painter I actually find tolerable: one will see in a kitchen this evocation of Adam and Eve come into view. I would like to tell you right away, so that there won't be any misunderstanding, the characters will be totally nude. Marcel Duchamp and Francine Picabia, one of my psychic children, will revive this charming canvas.
You will see a burglar. . .a very elegant lover. . .a baroness. . .There is even a husband. . .
ACHARD: There has to be. . . .
PICABIA: Yes. That's M. Fournier. . . .Jean Borlin will be a policeman and Mlle. Bronsdorff a nude lady. . . .All will be accompanied by the first jazz-band of New York, Georgiew's. . . .With that a flood of light. . . .The people disappearing under showers of green, pink, and yellow light. . . .As decor? A kitchen, a corridor, a bedroom, whose walls will be covered with chalk. There you have now a very precise idea of what *Cinésketch* will be. [Ibid.]

39. Francis Picabia, *La Loi d'Accommodation chez les Borgnes* (Paris, 1928), p. 8.
40. Francis Picabia, "Instantanéisme."
41. Francis Picabia, *"Entr'acte," This Quarter.*
42. Francis Picabia, "Instantanéisme,"
43. René Clair, "First Night of *Entr'acte,*" *Classic Film Scripts,* p. 109.
44. René Clair has assembled much of his early writings on the cinema in an invaluable

book, René Clair, *Cinéma d'hier, cinéma d'aujourd'hui* (Paris, 1970), which has appeared in English, René Clair, *Cinema Yesterday and Today*, ed. R. G. Dale (New York, 1972). The book is an updated version of his *Réflexion faite* of 1951 in which he presented extracts of his early writings with commentary written in 1950. In the latest book he adds current observations to his earlier writings. The book is thus a record of his fifty years as movie critic and filmmaker. The passage quoted from pages 46-47 was written in 1970. From now on the year will be indicated in parentheses.

45. Ibid., p. 49 (1950).
46. Ibid., p. 34 (1923).
47. Ibid., p. 35 (1923).
48. Jean Mitry, noted film historian and assistant to René Clair in 1924, has noted that Clair wrote *Adams* in 1924. Jean Mitry, *René Clair* (Paris, 1960), p. 10.
49. René Clair, *Adams* (Paris, 1926), pp. 49-50.
50. Ibid., p. 193.
51. Ibid., p. 247.
52. Ibid., p. 252.
53. René Clair, *Cinéma d'hier. . .*, p. 152 (1923).
54. Ibid., p. 73 (1923).
55. Pierre de Massot, "Avec René Clair," Dossier Picabia XI, p. 95.
56. René Clair, *Cinéma d'hier. . .*, p. 183 (1927).
57. Pierre de Massot, "Avec René Clair."
58. René Clair, ". . .First Night of *Entr'acte*," *Classic Film Scripts*, p. 109.
59. In 1968 René Clair released a definitive version of *Entr'acte* put to the original music of Erik Satie under the direction of Henri Sauguet. In so doing, Clair also restored the film to its original state. It is the scenario of this corrected print which appears in *L'Avant-Scène du Cinéma*, no. 86 (November 1968). The English shot-by-shot analysis published by *Classic Film Scripts* is based on an uncorrected silent version. Two major differences exist between the copies. The old print begins with shots of a monkey interspersed with shots of Paris before the cannon sequence of the curtain-raiser. Clair told me in an interview of November 15, 1972, that the monkey sequence must have been added to the film by technicians from footage he shot but which he did not include in the original copy. Accordingly this sequence has been eliminated from the sound version. The older version also features a different ending. After the man flies through the sheet with "End" printed on it, the conjuror appears in order to scold him. An argument follows between the two. This ending must have also come from experimental footage which was discarded in favor of the more striking conclusion of the sound version. While I have worked from the corrected copy of the film, shots cited by number refer to the numbering in *Classic Film Scripts*.
60. This is not the first time in Dada experience that a female grows a beard. In Apollinaire's *Les Mamelles de Tirésias*—the play which was such a hit with the Dada circle in 1917 and in whose preface the word "surrealism" is used for the first time—the rebellious heroine Thérèse becomes the male Tirésias in Act I, Scene I, by having her breasts inflate as balloons which fly away and simultaneously growing a moustache and a beard.
61. René Clair, *Cinéma d'hier. . .*, p. 100 (1923).
62. Ibid., p. 102 (1970).
63. Bardèche and Brasillach also see the film as being divided at this point into two sections: "[A]ll that passes in the spirit of a sleeper still benumbed after an evening passed at a fair. Towards the middle of the film a break occurs or rather a definite orientation of the dream. The egg on the jet of water makes one think of shooting, shooting of death, death of burial which becomes the principal theme of the end." Maurice Bardèche and Robert Brasillach, *Histoire du Cinéma*, p. 219.
64. René Clair, *Cinéma d'hier. . .*, p. 88 (1923).
65. René Clair, "Rhythme," *Les Cahiers du Mois*, nos. 16-17, (1925), pp. 13-16.
66. W. Stephen Bush, "The Mystery of Laughter," *Moving Picture World* 27, no. 10 (March 11, 1916).
67. Mack Sennett, *King of Comedy* (Garden City, 1954), p. 55.
68. Ibid., pp. 64-65.
69. René Clair, *Cinéma d'hier. . .*, p. 123 (1923).
70. I am indebted to Professor Standish Lawder of the University of California at San

Diego for bringing to my attention Mack Sennett's *Heinze's Resurrection*.

71. René Clair, *Cinéma d'hier. . .*, p. 36 (1923).

72. Ibid., p. 150, taken from "Cinéma pur et cinéma commercial," *Les Cahiers du mois*, pp. 89-90.

73. Francis Picabia, "*Relâche,*" *La Revue Hebdomadaire*, December 27, 1924.

4

An American in Paris: Man Ray as Filmmaker

Of the whole group of painters and poets who were members of the Dada and later Surrealist circles, the one who contributed the most to the development of the cinema as a Surrealist medium was Man Ray.[1] Arriving in Paris on Bastille Day of 1921, he sought to continue his activities as a painter in the art capital of the world. It just so happened that his paintings received relatively little attention despite the fact that he had been one of the leaders of New York Dada and despite recognition of his works by the Paris Dada circle. His initial one-man shows were total failures, with no sales and the sole spiritual consolation being a few laudatory comments from a bearded visitor by the name of Erik Satie. Like all people out of a job, he had to look for another. He became a photographer as a temporary solution to his financial problems.

While he made commercial photographs for his livelihood, he explored the medium for its aesthetic possibilities.[2] The favorite subject of his camera was the female nude, which he approached with a totally fresh vision.[3] He observed the fullness of flesh, the flexible bending of limbs, and the face and hands close up.[4] His penetrating eye transformed the most familiar angles of the body into supernatural terrain: his pictures vacillate between close-ups and expansive, tactile fields almost conforming to geometric patterns. But while he was enamored with his nude photos, he also made fun of them. In a picture of an apple taken close up he replaced the stem with a screw. The effect is very close to that of his nudes—the fullness of form, the geometric shape, and the texture of the object—and that is precisely why the visual pun is so successful.

The creation of these close-ups was determined by an attitude that was at least as conceptual as it was aesthetic. Man Ray has described how in his

114

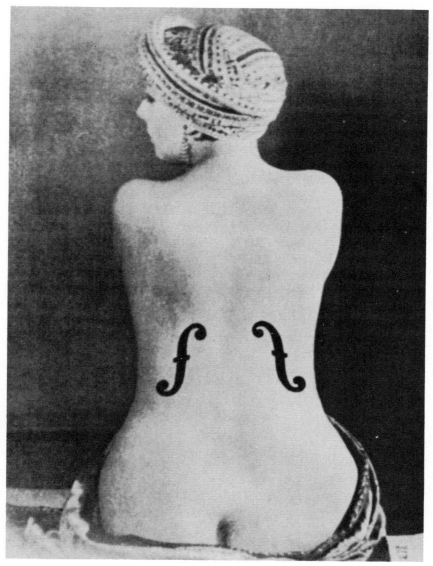

One of Man Ray's visual puns with the nude: Kiki in *Violon d'Ingres*, 1924.

photography he attemped to duplicate the mental process. Since the range of the human eye is quite large, the objects in its field of vision do not stand out by themselves. It is the mind which enlarges them in the thinking process. Thus, in order to approximate that conceptual end product, Man Ray took pictures of a small area which he later enlarged.[5] As may be expected, the effect is not one of Cézannian distillation of the everyday to elemental abstraction. Rather, it is a sharpened vision which we still find jarring. The photos at-

tempt to break through the veil which we have placed in front of us to shield us from the painfully exciting confrontation with a total reality. As André Breton wrote in his essay for a book of Man Ray's photographs, "It needed nothing less than the admirable experience which, in the vastest plastic domain, is that of Man Ray, to dare, beyond the immediate likeness—which is often only that of a day or of certain days—to aim for the profound likeness which, physically, mortally engages the entire future."[6]

Man Ray pursued the expression of his own surrealistic vision in certain other kinds of photographs. He manipulated his material in the darkroom freely to achieve the desired end product. Thus, he superimposed two pictures of a nude while distorting both to arrive at a humanoid female in *Demain*; he took the negative of a picture of two people and, allowing light to reach it at regular intervals, he gave the effect of white shadows featuring zebra stripes in *Projet pour une tapisserie*; he superimposed a self-portrait on a collection of objects so that his face seems to consist of a patterned maze. The supernatural quality of his photography emerges even in his portraits. The face is usually seen up close, and the photo is often solarized to make the features appear extraordinarily pale and to silhouette the head sharply against the background.[7] In other pictures the features are blurred to give another kind of haunting vision.

Man Ray was to follow a rather different kind of vision in his rayographs. He discovered the process by accident, a circumstance which endeared the new medium all the more to its Dada discoverer.[8] Working in his studio, Man Ray had accidentally mixed in an unexposed sheet of photosensitive paper with exposed sheets in the developing tray. Waiting in vain for an image to appear, he placed a couple of objects on the paper and as he turned the light on, he saw the image take form right in front of his eyes. The following day Tristan Tzara, the wizard of Dada, showed up and immediately took notice of the rayographs. It was only poetic justice that the Dada leader took part in the birth of a new art form. Immediately they set to work making rayographs together, each proceeding in his own manner. Tzara took a matchbox, placed the matches on the sheet, tore up the matchbox, and even burned a hole in the paper. Thus, he proceeded systematically to utilize and violate the newly found medium simultaneously in true Dada fashion. Man Ray, on the other hand, formed cones, triangles, and wire spirals, thus exploring the possibilities of the new process in geometric terms. The results, in his words, were "startlingly new and mysterious."[9] He continued making rayographs, achieving a three-dimensional effect in creating abstract patterns with light values reversed in the manner of negatives and with the shadowy grays forming receding transitional zones. In December of 1922 he published twelve rayographs with a preface by Tzara in a small volume called *Les Champs délicieux*. The title was a takeoff on the first Surrealist work published the preceding year by André Breton and Philippe Soupault and entitled *Les Champs magnétiques*.

As a result of his experimentation with photography, Man Ray became sufficiently interested in moving pictures to buy a small automatic camera.[10] His

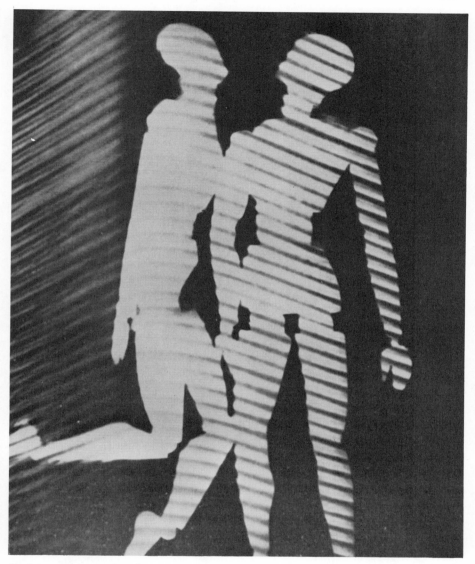

Projet pour une tapisserie.

initial idea was to shoot enough footage for a 10 to 15-minute film, insert some meaningless captions, and then show it to his Dada friends. He had shot only a few scenes when Tzara, the only person who knew of these plans, dropped in one morning with an announcement of the Dada program *Le Coeur à Barbe* which listed Man Ray as presenting a Dada film. He protested that he would not have enough for a showing, but Tzara prevailed by suggesting the addition of rayographs to the shots he already had. And so was born the first Dada film!

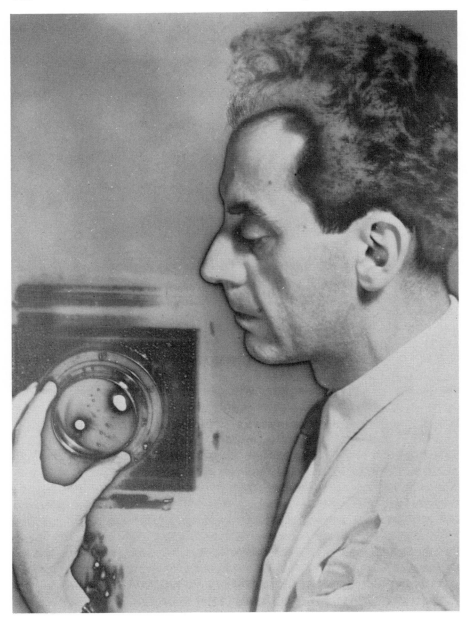

A solarized self-portrait by Man Ray.

Man Ray's first film is a real melange of artistic camerawork, animated rayographs, shots of some of his created objects, and Dada pranks. Its title, *Le Retour à la Raison*, is as ironic as the titles given to many of his objects. Although the filmstrip was really just the result of a night's work, so are many

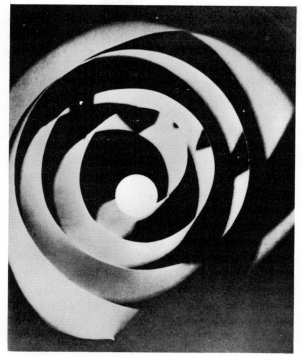

Rayograph, 1923-26.

other creative human achievements worthy of discussion. Man Ray remembers that "my curiosity was aroused by the idea of putting into motion some of the results I had obtained in still photography."[1] Accordingly, even before he was approached by Tzara, he had shot sequences of rotating objects. But even the rayographs saw their cinematization, for by exposing whole strips of film to particular kinds of objects he could realize their animation on the screen.

While Man Ray admits that he had no idea of how the rayograph sections would appear on the screen, we can credit him with the same conceptual vision he exhibited in his previous work. With the initial shot of salt scattered on the strip appearing as a shimmering field, he began his film by a negation of the representative nature of movies. His switching to a field of daisies is already an indication of his interest in juxtaposing abstract effects with familiar elements. The camera is aimed down so that the flowers occupy the entire screen as did the salt particles and thus make the connection between the two shots evident. He went on to the exploration of the behavior of various objects randomly placed on the celluloid. The placement of a single thumbtack in each frame results in a mad but recognizable jumping of a particular object. A transitional strip of both thumbtack and nails is inserted before we see a shot of the flickering nails. Then, a number of geometric form and ground effects are tried, among them a black and white field, a spiral, strips, and circles. Certain tricks

Two of Man Ray's objects shown in *Le Retour à la Raison: Dancer*, 1920, shot #13 and *Lampshade*, 1919, Shot #22.

are lost completely in viewing, for example, a phrase written across five frames. It is out of the question that Man Ray actually expected to recognize that on the screen. Perhaps he just wanted to see what would happen if one did do something as uncinematic as reserving a particular image for a single frame. Or it was an inside joke, a Dada prank for one.

In the shots taken with the camera certain other concerns emerge. His interest in the rotation of objects is exemplified by the rotating paper spiral, the

egg crate, and the nude human torso. With the fields of daisies it is the camera which describes a circle among the flowers. In the rotating shots the camera comes so close to the object that the object fills the screen. Thus, Man Ray used the same close-up method in his photography as he did in his first film. The result of such a close study is that the abstract nature of a particular object is highlighted, rather than the object itself. But insofar as it takes up much of the screen, the abstract form constantly wavers between acting as a form and a

cinematic ground. In the process of rotation the abstract "ground-form" becomes a dynamic visual experience.

That Man Ray was interested in creating just that effect is obvious from the way the shots are executed. First, the egg crate is shown rotating from a string, accompanied by its strong shadow on the wall. Together they increase the sense of rotation. Evolving from the everyday object to a more abstract dynamic, Man Ray continues by superimposing one strip of film upon another to produce two crates with two shadows all hopelessly enmeshed with each other. He even inserts the sequence upside down in order further to impede identification and break through to the abstraction which is hidden in the form of the vulgar object. With the turning human torso Man Ray attempts to focus on its movement by the repetition of the turn, the apparent fluidity with which the turn is accomplished, and, above all, by switching from the shot itself to its negative.[12] The consecutive placement of the crate and torso rotations establishes a disturbing association between the two, so much so that the audience at the first Dada showing erupted into catcalls when the crate followed the torso. Thus, Man Ray plays everyday objects against the abstraction which he can evoke from them to create a film in which Dada intentions intermingle with aesthetic effects in a highly experimental first try.

The Dada evening at which *Le Retour à la Raison* was shown was broken up after the filmstrip broke for the second time. Cries went up and a scuffle erupted until the police who had been stationed outside waiting for just such a disturbance intervened and emptied the theatre. The event therefore counted as a complete Dada successes: the first Dada film had been shown and had succeeded in ending the evening in utter chaos. Word went out that Man Ray had started to make movies despite his own disclaimers.

In the next couple of years a number of different people approached him with film projects. Dudley Murphy showed up in his studio and offered to make a movie with Man Ray's ideas and his equipment. The project fell through when neither was willing to bear the costs of the film. Murphy went to Fernand Léger and with him produced *Ballet Mécanique*. At the same time, Man Ray appeared in Francis Picabia's and René Clair's joint effort, *Entr'acte* in the true-to-life shot showing him playing chess with Marcel Duchamp on the roof of the Paris Opera. He helped Duchamp make his *Anemic Cinéma*, a film that was a study of revolving discs producing a three-dimensional effect and carrying various phrases laden with alliterative puns.[13] But he did not have the opportunity to make a film himself until a client named Arthur Wheeler, who had come to have a portrait of his wife made, suggested to him that he make a film which he would finance. Such an offer Man Ray could not resist and so he bought the finest camera available and went to work on *Emak Bakia*.

The movie Man Ray produced was quite different from his first, overnight Dada effort. Equipped with his professional camera, having all the time he needed plus an invitation to stay with the Wheelers at their home near Biarritz, Man Ray had the ideal conditions for making a movie. He acquired a number

of accessories, including special lamps, an assortment of crystals, an electric turntable, and some deforming mirrors, yet he remembers that he "was thrilled, more with the idea of doing what I pleased than with any technical and optical effects I planned to introduce."[14] Thus he placed at least as much emphasis on the film as a free entity as on the cinematization of certain photographic effects. He called his work a "cinépoème" as an indication that the film would be a medium of poetic expression closely linked with the latest concerns of the Surrealist movement.

The Dada circle of 1923 had become the Surrealist group of 1926. Man Ray evolved with them toward a new artistic and philosophical direction. His summary of the transformation reveals his own position: "What Dada had accomplished was purely negative; its poems and paintings were illogical, irreverent, and irrelevant. To continue its propaganda a more constructive program was needed, at least as an adjunct to its criticism of society. And Breton came up with Surrealism. . . . Dada did not die; it was simply transformed, since the new movement was composed of all the original members of the Dada group."[15] He had become a regular; his paintings, drawings, photos, and rayographs illustrating every issue of *La Révolution Surréaliste*. He participated in the first Surrealist exhibition at the Galerie Pierre in 1925 in the company of Arp, Masson, Ernst, De Chirico, Mirò, and Picasso, and the following year he had a one-man show at the Galerie Surréaliste. That Man Ray thought of his film as being a Surrealist work is further evidenced by his revealing account of the reaction of the Surrealist group after the showing.

> My Surrealist friends whom I had invited to the showing were not very enthusiastic, although I thought I had complied with all the principles of Surrealism: irrationality, automatism, psychological and dreamlike sequences without apparent logic, and complete disregard of conventional storytelling. At first I thought this coolness was due to my not having discussed the project with them beforehand, as we did in the publication of magazines and in the arrangement of exhibitions. It was not sufficient to call a work Surrealist, as some outsiders had done to gain attention—one had to collaborate closely and obtain a stamp of approval—present the work under the auspices of the movement to be recognized as Surrealist. I had neglected this, been somewhat too individualistic.[16]

Thus, while *Emak Bakia* was in no way an official presentation of Surrealist principles, it was conceived as a Surrealist work by a person closely associated with the group.

Even the way Man Ray went about making *Emak Bakia* is revealing of the tension between chance and purpose that was characteristic of the Surrealist movement as a whole. On the one hand, they sought chance encounters such as Breton's inexplicable meetings with Nadja, they practiced automatic writing, they created *corps exquis*, composite drawings whose totality would be revealed only when the four artists had independently finished their sections of it. On the other hand, they saw these apparently random activities as revealing

a more fundamental reality, that of the subconscious as Freud had described it. Unlike Freud, they were not interested in analyzing that other reality, merely in attaining it and depicting it. Yet as their experiments progressed, they found themselves in an epistemological trap. Their novels, for example, while subverting the traditional narrative in their choice of seemingly unrelated events, were tied together by themes and motifs of their chief preoccupations. Thus, while their methods stressed the seizing of chance elements, they could not help but weave these elements into a meaningful work, meaningful not in the traditional sense, but meaningful nonetheless. Dada had given them the example of an irrational object, the found object, *l'objet trouvé*. But they were not satisfied with the defiant stand of Dada: they pushed beyond it to create new works of art which integrated chance elements into a totality of greater complexity and greater design.

Emak Bakia is a vivid example of the way in which chance was harnessed by a Surrealist filmmaker to create a purposeful film. Man Ray's method of shooting was random not by the careful design of other Surrealist poets who strove to achieve randomness, but simply because of his own Dada temperament. The method was simple: "All the films I have made have been improvisations. I did not write scenarios. It was automatic cinema."[17] When he was in Biarritz he shot whatever interested him. A near crash in an automobile suggested to him the collision sequence with the herd of sheep and the camera thrown into the air. There were certain other sequences which he planned more carefully. Ultimately, however, when he returned to Paris, he still only had a "hodge-podge of realistic shots and of sparkling crystals and abstract forms."[18] In the final ordering of the sequence these various elements were brought together, sometimes with a fluid transition between them, sometimes in stark contrast. It was in their juxtaposition that Man Ray's sense of direction emerged. Like many products of the Surrealists, the film does not convey one meaning nor does it develop a narrative in the traditional sense. Rather, it is composed of a number of tendencies, themes, and motifs of the Surrealists.

The film begins with a shot of Man Ray as cameraman rolling film as he is reflected in a mirror. This opening shot is at once a personal affirmation of Man Ray as filmmaker, a cinematic trick showing the mechanics of the filming process, and perhaps the first presentation of the human eye as an element of Surrealist iconography. It is an ingenious opening, simultaneously a Dada and Surrealist device which also happens to introduce the author as creator. The film continues with several abstract sequences taken from the first film before launching into its own abstract imagery. These latter differ from those of the former in one significant respect: while in the first film the rotations were those of concrete objects, here the rotations are of lights or objects reflecting lights. We observe indistinct lights revolving in the distance, the recognizable lights of a merry-go-round seen close up, traveling news lights, and the rotation of a prism among mirrors in which a whole pattern of complex light reflections is set up. It seems that between the making of his first film and the second Man Ray discovered that film was more than just moving pictures, that

Emak Bakia, #16—The driver of the car. (courtesy MOMA)

although it was able to animate an object, it was above all a medium of light. Thus, he moved from animated photography to the film of light.[19]

The play with light comes to an end for the time being with shot #14, which commences a series of objective shots forming a narrative fragment. The motif of the eye reappears superimposed on the headlights of a car. The coupling of human and mechanical elements is similar to his previous juxtaposition of rotating egg crate and human torso in stressing the relationship of elements functionally different but in appearance similar. From here the episode unfolds quickly towards its climax showing the collision in shots #20-#25. The movement of the car is established by a series of shots of approaching headlights, the driver, the rear tire, a low-angle shot of the car moving, and finally a shot from the speeding car itself of the road ahead. With similar brevity and suggestive symbolism the collision is conveyed. First, the obstacle, a close-up of sheep crossing the road. Then a shot of the approaching car taken from the ground, which emphasizes the size and destructive potential of the car. Three consecutive shots symbolize the actual collision: first a sleeping pig, then a landscape, then the pig again, this time suddenly starting from sleep. And finally the havoc of the collision itself expressed by violently moving trees and blurs taken by a camera thrown up into the air and caught. In the collision this particular episode is brought to its climax, but the objective shots continue. The running board of the car is shown in a low-angle shot as one pair of feet get out, then the same pair once again and again and again and again. Finally, they are superimposed upon each other to create a multiple image of

feet descending. It is a dénouement to the collision sequence—is it the ghost of the passenger?—or merely a thematic transition from the motion-packed scenes involving the car to the following series of objective shots.

Shot #27 of the girl doing the Charleston alternating with the man strumming a banjo sets the rhythmic, musical dimension of the film. Man Ray had made this film with the express idea of having it accompanied by music. As he recalls, "I was not a purist concerning black and white photography. I liked the idea of a sound accompaniment."[20] For the first screening of the film at the Vieux Colombier he provided jazz records by the Django Reinhardt guitarists which alternated with the live theatre ensemble playing some tango and popular sentimental French tunes.[21] It is at this point therefore that an exact visual equivalent is created for the music which had already set the tempo and mood in the preceding segments. The close-up of the banjo and the focusing on the legs of the dancer enforces the connection between image and musical accompaniment. The usual length of the sequence stresses its importance in resolving the contradictions between the play of abstractions at the beginning of the film and the representative fragment immediately preceding the sequence. It acts as a unifying, tempo-setting interlude a third of the way through the film. It is further woven into the fabric of the film by the visual relationship of the dancing legs to the multiple pairs of legs stepping out of the car preceding it, and the continuation of the action on the stairs in the background in the following shot..

Another episodic fragment, somewhat looser in structure than the collision segment, follows the pivotal music interlude. A woman walks up a flight of stairs and prepares herself in front of the mirror, before walking out to a terrace to pause and look out between two columns. The camera scans the landscape, first the cliff, then the surf. In four shots, therefore, a transition is established between the Charleston scene and the view of the ocean. A certain feeling of expectancy has been created by closely following the woman's movements and especially by observing her get ready in front of a mirror. The shots of her walking up the stairs and out to the porch are taken from the back, a device which always creates a sense of the unknown by its purposeful concealment of her face. The columns are shown first in shot #30 and we wait for her to walk onto the screen. The sense of expectancy thus created by both the technique and the content of the shots seeks an emotional release in what follows. Shot #31 is only a narrative explanation of the preceding build-up: it is the view the woman has from the porch. The following five shots, however, channel away the emotional expectations of the viewer. The close-up shots of the waves can no longer be part of the woman's scope of vision. It is already an improvisation on the waves. By the breaking of the straight narrative line the sense of expectancy is dispelled. The following shot of the bather refers us back to the woman yet continues the exploration of the beach. The placement of the camera focuses attention on the bright sunlight which emerges from behind her silhouetted legs as she moves them back and forth. The play with sunlight is continued in the following shot, which focuses on the glare on the

Emak Bakia, #36—The double exposure of fish. (courtesy MOMA)

water from a position high up, perhaps the woman's vantage point again. The rotation of the camera, inverting sky and sea, is intended to give us a sense of underwater motion which is actually shown in the following shot of swimming fish. This sensation is further explored through a double exposure of the fish. By ending the fragment with shots of plays of sunlight, rotating seascape, and submarine views, the built-up sense of expectancy is resolved in a cinematic play of shots of nature. The double exposure of fish results in a playful moving image similar to shot #26 of the multiple image of legs getting out of the car. In fact, both of these trick shots are the only trick shots in their respective narrative fragments. They both come at the end of the fragments so that they may reassert the visual playfulness of the film and thus link the fragments to that visual rhythm.

What follows this second narrative fragment is a set of four shots, #37–#40, of sculptures, objects, and geometric shapes observed in various arrangements and movements. What sets them apart from the shots where Man Ray plays with light is the clarity with which their materiality is depicted. The way they differ from the two previous fragments is that they are all nonhuman geometric forms whose movement is for the most part jerky and mechanical. Together, they act to stop the fluid continuity of what has gone before and thus serve as a temporal lull in the middle of the film. Their role is the polar opposite of that of the Charleston sequence, for while the dancing legs and banjo highlighted the musical tempo of the film, the jerky movement of sharp-

Emak Bakia, #38—Geometric objects form a castle. (courtesy MOMA)

Emak Bakia, #39—The shadow of a man arrested in the midst of a jump. (courtesy MOMA)

Emak Bakia—Strips of different scenes. (courtesy MOMA)

ly defined geometric objects breaks up the musical tempo by an insistence on a staccato rhythm.

Nevertheless, from the spasmodic movement of these objects a transition is made to the following recapitulation of abstract light forms. The still life of geometric objects comes to life in a virtual dance in shot #40, one of the most delightful animations of the entire film. They describe circular patterns, flow to the center, and scatter from the table until a trick is played with the dice, which, after being cut in half, unite to form one die. That is followed by traveling news lights which announce cryptically, "Every night at Magic City." But aside from the message the news lights serve to link the previous dance of objects to the following rotation of lights. For while it partakes of the former through its ordered movement, it is really but a play of light. The consecutive placement of shots #40, #41, and #42-#43 question our most basic prejudices which surface in the process of viewing. For the traveling news lights are nothing but movements of light particles which are organized in the form of moving letters. Is such an organization of lights any more sensible than the dance of objects on the table? Aesthetically is it less appealing than the in-

distinct light rotations which follow it? Aside from the provocative nature of
these shots, they mark a return to the abstract light play which began the film.
As such, they recapitulate a fundamental imagistic theme.

Man Ray now brings together the two dominant themes of the film by
coupling suggestive shots of human presence with abstract light rotations. A
sense of imminence is evoked by the slow removal of a fan to reveal a woman's
face with eyes closed. Her eyes open and gaze directly into the camera. The im-
age fades out as revolving merry-go-round lights reappear. Through the fade-
out of a rotating glass cube the woman's face appears again with eyes closed.
Again she opens her eyes and this time smiles. A shot of a coral flower is
followed by a shot of another woman sitting up with closed eyes. Once more
the eyes open and her mouth starts to move. She is again followed by light
rotations. Such terse cutting of elements of the two major themes results in a
very special effect. With the build-up of the two previous narrative fragments
eliminated, we are left with three different shots closely resembling one
another, each creating a feeling of wonder and expectancy by itself. That sense
of wonder is created by the specific content of these shots: all three are of the
awakening of a woman whose eyes mysteriously look into the eyes of the
viewer. The mystery with which the Surrealists enshrouded woman and ac-
claimed feminine love is well known. Here we observe Man Ray evoking a
sense of mystery from a pair of awakening feminine eyes. Earlier in the film
the presence of the woman in the second narrative fragment was greatly
responsible for the sense of mystery and expectation of that sequence. That is
why Man Ray had observed her engaged in feminine preoccupations such as
putting on makeup and jewelry in front of the mirror. In this sequence a coral
flower is inserted between two shots of women, the flower being a metaphor
for feminine beauty as it is in L'Étoile de Mer. The eyes themselves are signifi-
cant elements. A single eye seen through the lens had opened the film, and a
pair of eyes superimposed on the headlights of a car opened the first narrative
fragment. Thus, the eyes in these three separate shots are especially mean-
ingful because they are associated with the beginning of a sequence. Yet there
is no narrative elaboration here as there was before. The knowing eyes
themselves are the subjects of the shots. That an awakening or revelation is in-
deed the implied aim of this segment is emphasized by the behavior which ac-
companies the opening of the eyes. First, a fan is withdrawn; then the woman
breaks into a smile; finally she seems to say something. All these gestures have
the effect of making her come alive. But she reveals herself in a specifically
feminine way, so that again it is her femininity which is the source of the
mystery. Yet the dissolves which remove or bring back her face to the screen
create a dreamlike mood. Is she slipping into a dream or awakening from one?
That we can no more determine in this sequence than we could in the narrative
fragment about the seashore. In both cases, however, the placement of
lightplays and abstractions after shots which suggest contemplation or realiza-
tion make those abstractions functions of the imagination.

Man Ray was now ready to finish the film "with some sort of climax, so that

the spectators would not think I was being too arty. This was to be a satire on the movies.''[22] He started a sequence which he entitled "La raison de cette extravagance." "This was to reassure the spectator, like the title of my first Dada film: to let him think there would be an explanation of the previous disconnected images.''[23] Accordingly Man Ray leads the audience on a wild-goose chase. He unfolds a conventional plot which begins with a car driving up to a door, a man with a briefcase getting out, going inside and opening a suitcase full of collars. The sequence ends in typical Dada fashion with the collars torn up and thrown into a circle, then all jumping back, and finally starting a revolving dance.

It is in this sequence that Man Ray creates the one truly Dadaist progression of the film, partly to show that he is still very much Dada in spirit (as he would be for the rest of his life) and partly to insert a truly discordant sequence which would bring the rhythmic flow of the film to an abrupt halt. The insertion of the caption itself stops the flow of images, but Man Ray made sure that there would be no mistaking his intentions: accordingly he had the musicians stop the music at that moment and not resume playing until the collars started rotating. The sequence resembles, at least superficially, the two previous narrative fragments in the brief build-up of anticipation followed by some sort of outcome or resolution. Yet the differences between them are those which separate Dada from Surrealism, at least as far as Man Ray is concerned.

Insofar as Dada came into existence through its violent denials of reality, that stable reality first had to be posited in a work of art before it could be destroyed. The better established and more convincing that reality, the more provoking is its violation and the more successful it is in Dada terms. That is why the audience is made to expect a rational progression by the introductory caption, so that the deliberate departure from reason will be so much more striking. The build-up lacks all symbolic or mystery-evoking shots in an attempt to present a setting as conventional as possible. Nothing could be more conventional than a businessman arriving at a building with a briefcase ready to do business. The revealing of the contents of the suitcase and his ripping the collars provoke the audience by a mocking which turns into a violation of the everyday. Significantly the protagonist is a man, for man is the worker, therefore man must be the destroyer to create the characteristic Dada contradiction. In the Surrealist sequences, on the other hand, reality in its everyday sense was not posited because the Surrealists had arrived at a transcendent understanding of reality. The cinematic progression therefore evolved as a mixture of "realistic," symbolic, trick, and mystery-evoking shots. The element of surprise that accompanied the provoking Dada endings was incorporated into the Surrealist experience, so that we find surprises in a number of shots. And while the Dada sequence featured a man for his role as actor-violator, the Surrealist segments present woman, who was celebrated by the Surrealist poets for her evocative presence.

The final moment of the Dada sequence shows the businessman throwing down his straw hat and ripping off his own collar, a gesture which is the

ultimate Dada act for Man Ray because it is the removal of a disguise, a viola-
tion which sets one free. Once the disguise is gone, the free dance of objects is
resumed to the joyful accompaniment of "The Merry Widow Waltz" as at the
first showing. After the Dada joke is perpetrated, the play of imagination can
recommence. It is important to note, however, that the Dada sequence is not
an isolated segment in the film. It is immediately preceded by the three
awakenings which prepare the viewer for a revelation, and it is followed by the
fluid rotation of a collar whose violent ripping was the very point of the se-
quence. The strong inpact of this segment is in large part due to its thorough
integration into the thematic and imagistic flow of the film.

The captioned sequence is the first climax of the film which evaporates once
the dance of abstractions resumes. These abstractions grow increasingly com-
plex from shot #60 on as they evolve from a rotating collar to plays of light. In
shot #67 we once again see a woman's face with eyes painted on her eyelids.
She sits up, opens her eyes, and smiles. Then she closes her eyes and lies down
again, while the same shot of her is superimposed upside down. The final shot
is of the superimposed face rotating on the screen.

We observe here the kind of double ending which brought René Clair's *En-
tr'acte* to a close. Once "Fin" appeared on a large sheet of paper, a character
jumped through it only to be kicked back by someone else. Here the first end-
ing, which purports to give reason to the whole film, ironically leads to a
resumption of those rotations which it had claimed to explain. Finally one of
the recurring objective images, that of the mystery-evoking woman, reappears
for the last time. The previous shots of suggestive female awakenings is now
completely mocked by her double awakening. A Dada trick is perpetrated on a
Surrealistic motif. Yet when she closes her eyes to return to sleep and and her
face is duplicated and rotated on the screen, an element of wonder returns.
The double ending, which features provocative elements and which in itself is a
provocative device, is so well woven into the cinematic fabric that we witness
the inextricable fusion of Dada and Surrealist intentions.

In *Emak Bakia* we observe Man Ray's fullest cinematic statement. His very
first essay with film, *Le Retour à la Raison*, exhibited but a few of his con-
cerns. His following film, *L'Étoile de Mer*, although a free rendering of a
Desnos poem, was still the adaptation of someone else's work from one
medium to another. As such, it was a cinematic version of a Surrealist poem.
Le Mystère du Château de Dés, his last completed work until the 1940s, is
again too much tied to the commission from which it sprang—a movie of a
party at the chateau of the Vicomte de Noailles. That these other films are also
highly successful artistic efforts is to Man Ray's credit, but in no other work
does he come close to the freshness, versatility, and pure visual poetry of
Emak Bakia. That film is the one which stands at the juncture of Dada and
Surrealism. It brings together both movements on top of the underlying
abstract current in a fresh, harmonious film.

What are Man Ray's singular accomplishments in *Emak Bakia*? For one
thing, the establishment of a visual rhythm which creates a smooth transition

from one shot to another. Consecutive shots are linked either imagistically or thematically to create the flow. Visual rhythm is accompanied by an audial rhythm which Man Ray sought to create by accompanying music and which finds its visual correspondent most specifically in the Charleston-banjo shot. The rhythmic tempo is further echoed by the segments into which the movie is indistinctly divided. Furthermore, the exploration of rotating light forms in itself is a study of rhythmic movement.

Despite the existence of these traditional elements, the film lacks traditional meaning, openly defying cinematic conventions in true Dada fashion. Narrative conventions are deliberately violated as are the aesthetic aims of the contemporary avant-garde in the cinema. Years before Luis Buñuel explicitly rejected the artistic shots of avant-garde film, Man Ray instinctively veered away from studied composition in the frame, and was rather drawn to movement in the shot and through rapid cutting. Undoubtedly the film owes its conceptual novelty and visual energy to Dada.

But the germs of Surrealistic cinema can already be detected in this film. The short narrative fragments in which a sense of anticipation is built up to an unexpected resolution are already examples of the new primacy of emotion-evoking over the forging of the narrative. That is why they are short fragments, for they aim only to evoke a response without a clear-cut story. In order to elicit such emotions various techniques are used to shock the viewer into a new awareness. The opening shot of the camera filming itself, is such a device, as is the collision in which the moving car, herd of sheep, starting pig, and thrown camera give a multidimensional sense of a collision. The comparison of two functionally different but apparently similar objects, such as the eyes and the headlights, also offers a new way of perceiving these objects in terms of each other. In a sense, too, the rotating light forms create a new visual reality for the viewer. We find certain specific Surrealistic themes and images in the film, such as the haunting eye and the mysterious woman. The process of awakening is treated between the dreaming and waking states. And in a wider sense, the entire film is a function of a liberated imagination which plays with the intermingling of objective and nonobjective shots and sequences. Man Ray summarized his film in the following way:

A series of fragments, a cinepoem with a certain optical sequence make up a whole that still remains a fragment. Just as one can much better appreciate the abstract beauty in a fragment of a classic work than in its entirety, so this film tries to indicate the essentials in contemporary cinematography. It is not an "abstract" film or a storyteller; its reasons for being are its inventions of light-forms and movements, while the more objective parts interrupt the monotony of abstract inventions or serve as punctuation. Anyone who can sit through an hour's projection of a film in which sixty percent of the action passes in and out of doorways and in inaudible conversations, is asked to give twenty minutes of attention to a more or less logical sequence of ideas without any pretention of revolutionizing the film industry.[24]

If Man Ray was prompted in 1926 by one of his clients to produce *Emak*

Bakia it was his own idea to make a film two years later. The idea was born at a farewell dinner for his friend, Robert Desnos, as he was about to be sent to the West Indies for a reporting assignment. As usual, Desnos recited a number of poems at the end of the meal, including one he had written that day entitled *L'Étoile de Mer,* which had a great impact on Man Ray: "My imagination may have been stimulated by the wine during our dinner, but the poem moved me very much, I saw it clearly as a film—a Surrealist film, and told Desnos that when he returned I'd have made a film with his poem. That night, in bed, I regretted my impetuous gesture—I was letting myself in for another wild-goose chase, but I had given my word, and would go through with my promise.[25]

There were three characters in the film, which were easily assigned to Man Ray's mistress, Kiki, a young man who lived in Desnos' house, and Desnos himself. He specifically did not want actors for his film, but rather people who would follow his directions closely. The shooting took but a few weeks and yielded enough material for a half-hour's running time. Man Ray "cut and rejected ruthlessly"[26] until he was left with a film half its length. The movie was first shown in a small local cinema with the accompaniment of French popular music.

The movie is a narrative essay capturing that quality of the poem which Man Ray summed up as having "no dramatic action, yet all the elements for a possible action."[27] As such, there are no shots of form and light abstractions as there were in the previous two films. The only technical distortion in the film is the use of a gelatin filter over the lens to create a mottled effect in selected shots. That effect, however, is tied to the narrative intent of the film rather than to any attempt to explore surface qualities. Because of its close ties to Desnos' poem and its pointed lack of surface shots, *L'Étoile de Mer* is more purely Surrealist than any other of Man Ray's films. As such, it must above all be examined in literary terms.

The film is organized into a number of segments which defy a rational explanation not only because of their placement (if that were the case, it would be merely a case of rearranging fragments as one is wont to do with flashbacks) but also by virtue of their content. The film presents not a story, but rather various actions, themes, and motifs which together create certain impressions in the eyes of the viewer regarding the inner motives which propel the characters. The film is not about the characters, for they are but the human vessels containing psychic forces. That is why Man Ray had no need of real actors: the characters were puppets who went through certain movements and performed certain actions. Psychic forces were represented through symbols and the context of the characters' actions rather than through personal dramatization.

Man Ray opens his film with a shot of a rotating starfish, whose meaning is as significant as the opening image of the cameraman shooting *Emak Bakia.* The starfish, of course, illustrates the title of the film, but its hazy rotation already suggests its symbolic use and recalls the rotations of geometric forms

L'Étoile de Mer, #4—Man and woman on a path shot through gelatin. (courtesy MOMA)

'Étoile de Mer, #32—They examine the starfish. (courtesy MOMA)

of the previous two films. The narrative is placed between the hazy shot of an oval glass in a door opening and the same shot showing the closing of the door at the end. In such a way Man Ray ascribes to the entire film a quasi-imaginary quality.

The first segment is perhaps the most complete of the film. It shows the man and the woman walking down a path, stopping, and the woman bending down to fix her stockings. The secretive sexual significance of the gesture is underlined by her turning to him and looking behind her before bending down. His arousal is suggested by the superimposition of his concentrated face over the shot of her fixing her stockings. The caption, "Women's teeth are such charming objects . . . that they should only be seen in a dream or at the moment of love," makes the sexual meaning of the gesture explicit. The caption is followed by the couple going into a house, climbing stairs, and going into a room with a bed in it. She strips right away, while he sits down and gazes at her with a blank look. She climbs into bed and wiggles around expectantly. He stands up, kisses her outstretched hand, and walks out of the room, down the stairs to the door, where he disappears as the door closes. Thus the progression of shots—especially the climbing of the stairs, which stand as an obstacle to be surmounted—builds up a sense of expectation of sexual union which is not fulfilled. It is the man who cannot consummate the union perhaps because "we are forever lost in the desert of eternal shadows [*éternèbre*]" as the caption following the segment reads. What is more important than the actual union are the inner forces which lead the couple toward each other. The focus is upon those forces rather than on the actualization of the union. At the same time there is something preposterously funny about the man walking out at a moment of great anticipation for the woman. The totally anticlimactic nature of his action channels the viewer's built-up anticipation of voyeuristic gratification into the release mechanism of laughter. It is a Dadaist boycotting of the real, that is the inevitable, whose comical intent is emphasized by the punning caption "Si belle! Cybèle?" at the moment of departure.

While the first sequence builds up sexual anticipation only to frustrate it at the last moment, what follow are vignettes presenting the reactions of the man and the woman toward the mysterious involvement that they share. She is shown as a newspaper vendor on the street when the man comes up to her and together they go to examine the glass jar containing the starfish. Thus, the starfish, symbol of erotic force, is introduced as an object of wonder for both the man and the woman. It is chiefly the male who is puzzled by the mystery of the starfish. Sexual union proved a problem to him. The close-up view of the woman in shot #26 as she is selling newspapers is really his view. The caption following it, "How beautiful she is," likewise comes from him. That is why we see him sitting in his room examining the jar in shot #33, which follows the entire street scene.

The shot of the man in his room contemplating the starfish is repeated in shots #66 and #95 not because Man Ray is interested in the man's attempt to understand the unexplainable, but because, by showing him trying to solve a

mystery, he posits the "problem" of the film as being a certain inexplicable mystery. Man Ray had already attempted to create a sense of the mysterious in *Emak Bakia*, most noticeably around his awakening women. In *L'Étoile de Mer* the evoking of a sense of mystery becomes as essential building block of the film as a whole. That sense of the unreal is created in a number of ways. The abrogation of the clear narrative line is a violation of reason which leaves the viewer with the mystery of the irrational. The use of the gelatin filter with certain shots creates a hazy effect which tends to give those scenes an air of unreality. But even the gelatin is not used in a clear, ordered manner. Straight shots appear amidst gelatin sequences and vice versa so that the initial impulse to group dream sequences and real-life segments on the basis of the use of the filter is hopelessly frustrated. That, of course, should come as no surprise, for the Surrealists explicitly aimed to fuse our dreaming and waking experiences into a unified reality of the imagination. The filter shots thus lend the film an air of mystery without imposing an order of their own. Man Ray evokes the mysterious in specific sequences as well. The street segment begins with the camera panning down a tall chimney until it shows a narrow, quiet, empty street. Only after such a portentous introduction do we see the woman with the papers, which are whipped by a wind which arises out of nowhere.

The man examining the mysterious starfish in his own room opens a wide series of segments which revolve around his search for the mysterious in terms of his relationship to the woman. His imagination is triggered by the starfish so that we can observe the ponderous movement of a live starfish close-up. Then we see newspapers scattered by the wind as the man runs after them. The chase is symbolic of his quest for the mystery of the woman, especially since the association of wind-blown newspapers with her was made explicit in the preceding street scene. Once he catches a paper and looks inside, the article on Eastern European diplomatic affairs appears as a kind of answer or at least a clue to his search. Yet clearly it is not: it makes as little sense as does the insertion of the traveling news lights in *Emak Bakia*. The news they both bring is part of everyday reality, but once lifted out of that environment they are divested of their matter-of-fact actuality and take on instead the mystery of the written word as magic text. The quest is continued in the series of shots where the mental search is represented by the movement of a train and the activity of a harbor. That this is still a part of his attempt to understand her is emphasized by the preceding shot of him with his head in her lap.

With shot #50 a transitional section begins whose intention is to break up any psychological continuity which may have developed so far. The phrase "If flowers were made of glass" is interspersed with shots of a flower in a flowerpot. While these are still related to the man's conception of the woman, shot #52, in which the screen is divided into twelve different sections with twelve different actions going on, is a break with the preceding psychic flow. So is still-life shot #56 of newspaper, wine bottle, starfish, and banana. While they contain the imagistic leitmotifs of the starfish and newspaper (indeed the other objects might also be seen as symbolic), the fragmentation of the screen and

the unusual length of the still life break the continuity of the film. Man Ray introduces this break in order to keep his film free of the determinism of a narrative or even psychological continuum. The section is analogous to shots #37-#40 of *Emak Bakia*, which also broke the rhythmic flow which preceded them and cleared the way for the ending of the film. This conscious interruption comes around the halfway mark of *L'Étoile de Mer* as well. It breaks the previous psychological flow because here the woman's reaction to the affair is introduced for the first time. In one shot we see her lying on the sand examining an object while in another we see her stepping out of bed onto a book with a starfish lying next to it. Both are views of her involvement with the problem of the affair. From this point we find a close intermingling of the man's and the woman's inpressions of the relationship until the very end.

The second half of the film emphasizes the latent violence of the relationship. That violence is suggested in part by the captions, which compare the woman successively to a flower "of glass" "of flesh," then "of fire." That last comparison is made more poignant by its appearance right after a shot of her face seen through flames. Another caption, unconnected to the flow of images, tells us that "one must beat the dead while they are cold." The increasing violence of the second half takes place largely in connection with the associative use of the starfish. In the first half the starfish remained an object of wonder, free of specific suggestive associations. Now it becomes closely linked to a violence whose origins are sexual. The first explicit connection between the woman and the starfish is made in the shot in which she steps out of bed and her foot lands right next to the starfish. A more disturbing symbolism is developed when a view of the starfish is followed by shots of the man's hands with blood accentuating the main lines. When we see the woman climb the stairs brandishing a knife, the starfish appears at the foot of the stairs, and it is further superimposed on the final close-up of her clutching the knife. The starfish reappears at the very end, when the man is trying to understand why the woman left him. Yet even in this second half the starfish remains a multivalent symbol. For while it is an organic underwater creature whose ponderous movements suggested a primitive sexual force before, it is also a cold attractive object like a glass flower and in fact follows the caption which refers to the woman as being "beautiful, beautiful as a flower of glass." Starfish—flower—woman—sexual violence form a circle of overlapping associations. The woman as embodiment of violent force is stressed with a certain ironic note when we see her sheathed in a tunic and topped by a Phrygian cap as she holds a spear, a haughty expression appearing on her face.

Yet the violent motifs appear amidst the flow of poetic and mystery-evoking images. Man and woman stand together as she removes the mask she is wearing, followed by the shot of the mask itself. Another sequence shows an empty street, a massive wall, then the full sky, which turns into a starlit sky with a shooting star. "And if you find a woman on this earth with a love that is sincere . . ." is followed by shots of flowing water reflecting the sun. "The sun, one foot in the stirrups, nestles a nightingale in one [a stirrup] of crape,"

L'Étoile de Mer, #74—The blade reflects the light as she climbs the stairs. (courtesy MOMA)

L'Étoile de Mer, #84—She stands defiantly. (courtesy MOMA)

L'Étoile de Mer, #89—Kiki asleep. (courtesy MOMA)

is followed by her lying nude on a bed. Thus, the introduction of motifs, statement of problem, and search that triggers in the first part of the film is transformed into a concern that is at once more poetic and violent.

The resolution of the film is in some ways as provocative as the multiple endings of *Emak Bakia.* The shot of the woman stretched out nude on the bed is followed by a reminder to the man, "You are not dreaming." What follows is the "cruel reality" of a stranger coming up to the two of them and leading the woman away. The action is performed in much the same manner as was his walking out of the room when she was stretched out on the bed. All the characters act in a matter-of-fact way without the least sign of emotion, and only a stern look of incomprehension shows on the man's face. The scene offers a comic release which is as powerful after the build-up of violent and poetic images as was the comic release of frustrated union in the first sequence. As before, he turns to the starfish in his search for an explanation. "How beautiful she was" turns to a realization of "How beautiful she is" still. The last scene is hard-hitting and ironic at the same time. She looks into the camera with her haughty stare. A glass bearing the word "beautiful" stands between her and the camera. The glass shatters, she turns away, only to turn back and look into the camera once more. The scene is the man's final and absolute vision of the woman: she is a femme fatale whose hard-luster appeal will live on. The violence of the breaking glass is the final manifestation of the violence which has been accumulating in the film. In its final eruption it is expressive of

L'Étoile de Mer, #99—The penultimate violent shot. (courtesy MOMA)

the violence inherent in female sexuality. It is also a final view of the woman, the last gesture of the theme of unmasking toward which the film was progressing. Thus, we have come all the way from the gentle evoking of feminine mystery of *Emak Bakia* to a total revelation of the violent force inherent in the mysterious female. Typical of Man Ray's creativeness, the breaking of the glass reveals yet other levels of meaning: it is a negation of the concept "beautiful" as applied to the woman through the symbolic breaking of the glass bearing that word or a final psychic consummation of the affair through a symbolic violation. Man Ray ends his film at the highest level of conceptual playfulness, which is the hallmark of his created objects.

The film *L'Étoile de Mer,* like the poem, had "no dramatic action, yet all the elements for a possible action."[28] It presents acts, symbols, descriptions, and gestures which all create certain moods but which do not add up to a narrative. While in a sense the movie examines aspects of a sexual and emotional love relationship, it does not narrate a love story in any sense. We do not witness the moment when man and woman meet for the first time, for example, because they are archetypal figures who have always known each other. They react to certain things which characterize a love relationship in a number of expected and unusual ways. The flow of often disparate images and mean-

ingful and meaningless captions combine to convey a simultaneity of emotions which are present in every moment of a love relationship. Some of the most basic human psychic forces are expressed in a convincing way, yet they are appropriated into the realm of the ironic by the use of farce, comic release, multiple entendre, and the popular French music which Man Ray assigned as accompaniment to the film and which further underlined what the film was not.[29] The total artful mixing of the real and unreal, the actual and fabricated, resulted in a totally Surrealistic film.

Man Ray's final cinematic effort in the twenties was *Le Mystère du Château de Dés*, a film commissioned by his friend and patron of modern art, the Vicomte de Noailles. So far the movie has been gravely misunderstood. It has been dismissed as "a sophisticated home movie made for the amusement of the idle rich,"[30] yet it has also been discussed in close connection with Philippe Soupault's contemporary novel, *Dernières Nuits de Paris*.[31] While one point of view underestimates the film, the other attributes to it complexities which do not properly belong to it. The film is not a Surrealist work as such, but it remains a work of some interest because it provides an example of some of Man Ray's advanced cinematic concerns.

The movie arose specifically out of an invitation of the Vicomte de Noailles to Man Ray to spend a vacation at his home in the South of France along with

Le Mystère du Château de Dés, #5—The chateau. (courtesy MOMA)

other guests. The Vicomte merely asked Man Ray to "shoot some sequences showing the installations and art collections in his chateau . . . as well as make some shots of his guests disporting themselves in the gymnasium and swimming pool."[32] Man Ray recalls that he was not especially enthusiastic about the prospect, but the kind assurances of Noailles convinced him that he would be as much of a guest as the others and would receive a fee in addition. He accepted the offer and began to consider it as a chance for a vacation. As for the movie, it "would be purely documentary, requiring no inventiveness on my part, it would be an easy, mechanical job and not change my resolution to do no more films. The thought of not showing it in public reassured me."[33] A photograph of the chateau with its cubic forms next to the ruins of a monastery started Man Ray thinking about the potential of the movie: "In spite of myself, my mind began to work, imagining various approaches to the subject; after all, it would be best to make some sort of plan if only not to waste effort."[34] He collected accessories such as dice and stockings "to help create mystery and anonymity."[35] He drew up a general plan, which he started filming while still in Paris. The movie is thus an imaginative creation which is ultimately based on Noailles' order.

Man Ray writes that "the cubic forms of the chateau brought to mind the title of a poem by Mallarmé: 'A Throw of the Dice Can Never Do Away with Chance.' "[36] His real reason for recalling that title, rechristening the chateau with it, and using the phrase as the purported theme of the movie goes much deeper. The poem was one of the Surrealists' favorites,[37] for they saw in it the culmination of Mallarmé's poetry. It was his last major work, in which the poet who had attempted most to create a tight poetical structure acknowledged chance as the force which even the poet could not dominate. It was also the poem with the freest structure and the only one in which the visual impact of the words on the page (their placement as well as the type) was utilized to support the total poetic effect.[38] Man Ray's interest in the poem was no doubt sparked by his Surrealist friends. His belief in chance as a ubiquitous force in the creative process has been demonstrated again and again in his artistic efforts. He had used dice once before in *Emak Bakia*, when they are made to dance amidst other geometric objects before being split in two and the two halves joined together. But the single greatest drawing force of the poem must have been the title, for it expressed the kind of paradoxical double entendre which had become a hallmark of Man Ray, especially in his objects.[39]

The action of the characters takes place in the context of the role of chance. The two passengers roll the dice in the beginning to decide whether they will leave, the man and the woman at the end roll the dice to decide if they will stay, and the four figures whom we first see in the chateau are also introduced rolling dice presumably to decide what they will do (although it is once again declared that chance will reign even when the dice are cast). The guests' activities seem to be subordinated to the laws of chance. But that explanation is as insufficient as the section entitled "La raison de cette extravagance" in the context of *Emak Bakia*. For while Mallarmé's poem treats chance as a univer-

Le Mystère du Château de Dés, #88—The inhabitants roll the dice. (courtesy MOMA)

Le Mystère du Château de Dés, #119—Shadows by the pool seem to be animated. (courtesy MOMA)

sal force which manifests itself everywhere, Man Ray's film uses chance in a seemingly meaningful, yet ultimately playful way.

In a work that has less of a narrative or psychological structure than his two previous films, Man Ray has followed his own inclination to play with ideas, images, and camera tricks in a random fashion. He observes the guests playing in a playful manner. He mixes straight shots of swimming with the reverse shot of a dive or a woman seeming to juggle balls in the water. Shots of the reflection of the water on the wall intermingle with barbells rolling toward the camera apparently of their own force and with playful captions such as "Piscinéma." If any atmosphere is created, it is that of a mythological reality, but even that is done only in an offhand manner. It is mainly the captions which strike the mythical note: "Do phantoms of our actions exist?," "The deities of the living waters let their hair flow," "Helmeted Minerva." A few scenes carry out the mythological intent, such as the four bathers who stand on stools in front of piers imitating caryatids in shot #124 or what appears to be a ritual dance in shot #133 with three bathers turning around holding up a medicine ball. The mythical ambience is underlined by setting the activity of the guests between the first night and the second. Our expectation of the appearance of people is built up through the lengthy examination of the house in which we encounter no one. The captions stress the emptiness of the house and with "When morning breaks" introduce the people, who seem to have been

Le Mystère du Château de Dés, #135—A guest as "Helmeted Minerva." (courtesy MOMA)

Le Mystère du Château de Dés, #157—The final shot of the spectral inhabitants in negative. (courtesy MOMA)

created from the dark and the void. That the guests are portrayed as gods amusing themselves should come as no surprise. The movie was created for the Vicomte personally. His distinguished guests could easily take to being featured as gods and goddesses, even if that were done playfully. It was not the first time that the artist had depicted his patron in mythological terms.

The other part of the commission called for the filming of the chateau and its furnishings. Man Ray fulfilled that order in the first half on an exciting search through the mansion right after the introductory traveling scenes. The ride in the car imparts the sense of movement which we have witnessed in the traveling scenes of *L'Étoile de Mer.*[40] We view the road ahead with its occasional traffic, we look at the trees we are passing by the side of the road,[41] we pass through towns until we catch a glimpse of the mountains where the castle is perched. We are shown a number of different views from the car which are often bouncy, thus giving us an actual visual sensation of the ride. We are led all the way up to the chateau and, once we are there, the camera continues to pan quickly so that the movement of the car is imparted to the camera. The speed of panning continues until we catch a glimpse of an abstract statue. We are led immediately into a slowly rotating examination of the statue. It is only after these transitional shots that we are finally presented a 360° view of the mansion and its surroundings. An examination of the outside of the house and the gardens turns into an exploration of the inside through another transitional

device. The first two shots taken from inside are aimed at a paper star and the sculpture outside in the garden. Once inside, the camera discovers the house through a number of varied shots, including tracking close to the floor, down a corridor, panning rooms, and moving up and down the stairs as would a human visitor.

Man Ray transformed the energy of movement of the traveling section into a sense of expectation and wonder in the section which exhibits the mansion. The movement slows down, becoming more deliberate in the exploration of the house. Captions call attention to the emptiness. A number of unusual sculptures are shown. Some rooms are darkened, with strong sunlight filtering through blinds. The sense of anticipation is thus created with the aid of superb transitional shots. They help to maintain the continuity of imagistic flow which is necessary for creating expectation, an emotion which is a function of time.

Despite the freshness of *Le Mystère du Château de Dés*, as well as certain brilliant techniques and ideas realized in it, the movie did not possess the artistic integrity of Man Ray's previous two films. Is the movie weaker because it was restricted to Noailles' specific commission or because Man Ray increasingly came to resent being regarded as a cineast? The latter seems to hit closer to the mark. The private showing of the film was a great success, so much so that Noailles immediately offered to finance a full-length film by Man Ray with no strings attached. He refused, so that the Vicomte's offer was taken up by Luis Buñuel and Jean Cocteau in creating *L'Âge d'Or* and *Le Sang d'un Poète*.

A number of moviemaking opportunities continued to be presented to Man Ray. He was asked to take documentary footage of both Kerensky and Trotsky, but, unlike other Surrealists who were becoming more and more involved in politics, he wanted nothing to do with them and passed both assignments on to others. Then, he got together with Jacques Prévert to make a film about the more sordid aspects of Parisian life, since the city, especially the city street, had become a favorite setting for the daily activities and fantasy life of the Surrealists. They took some pictures in a dance hall, of prostitutes accosting pedestrians in Pigalle, and they even had some of the locals act out a scene on a deserted lot. Once the person who had put up the money backed out of the venture, the project was shelved.

The one project which had a great deal of promise was a joint venture started by Man Ray, André Breton, and Paul Éluard during the summer of 1935 while they were vacationing at Lise Dehorme's house in the South of France. Man Ray was excited about the enterprise, especially since "here was a chance to do something in close cooperation with the Surrealists, whom I had not consulted in my previous efforts."[42] The effort was to be called *Essai de simulation de délire cinématographique*, whose scenario was written by Breton and Éluard in one day. A number of fascinating sequences were shot, including a young girl in a one-piece bathing suit riding bareback on a white horse,[43] women wandering through the house and gardens in strange attire with one of them attached to the wheel of a well, a bowling game where the

Stills from the unrealized *Essai de simulation du délire cinématographique*, including a shot of André Breton with a dragonfly on his forehead

balls were replaced by women, and a shot of Breton reading by the window with a dragonfly perched on his forehead. Breton lost his patience in posing and flew into a rage, which Man Ray recorded and was especially intent on using since it was something real, unlike the make-believe of acting. The project was abandoned, to everyone's regret, because the small hand camera Man Ray

was using jammed too often. Chance, so dear to the Surrealists, had created the right circumstances for the making of an ultimate Surrealist movie only to frustrate it once the film was actually being shot.[44]

Man Ray's contribution to the Surrealist film may be best characterized as haphazard. His initial effort grew out of his interest in photography. Of the successive film projects that came his way he realized a few, only to let others slip through his fingers. Even those he undertook display a wide variety of intention and results, all testifying to the inconstancy of his interest in cinema. If an evolution were charted in his films, it would be a graph of his own changing attitudes, rather than the forward movement of a mind attempting to discover the essentials of Surrealism in the new medium. Unlike the poets, who saw film as a perfect vehicle of Surrealism, Man Ray was rather interested in its plastic possibilities. Fundamentally a Dadaist painter, Man Ray never became more than a fellow traveler to Surrealism. Characteristically, the abandonment of his last film project with Breton and Éluard meant more to them than it did to him.[45] The ephemeral quality of film that had endeared it to them made Man Ray feel uncomfortable with it. As he summarized the reasons for giving up filmmaking:

> A book, a painting, a sculpture, a drawing, a photograph, and any concrete object are always at one's disposition, to be appreciated or ignored, whereas a spectacle before an assemblage insists on the general attention, limited to the period of the presentation. . . . I prefer the permanent inmobility of a static work which allows me to make my deductions at my leisure, without being distracted by attending circumstances.[46]

Yet Man Ray played a significant role in the realization of the Surrealists' dreams for the cinema. More than any other individual, he sparked their interest in the creation of Surrealist films, through his own several essays. Antonin Artaud's eight-year involvement with film and Luis Buñuel's lifetime devoted to Surrealist cinema both followed his pioneering example.

NOTES

1. For the details concerning Man Ray's work with film I have relied most on his autobiography, Man Ray, *Self-Portrait*, (Boston/London, 1963), especially the chapter entitled "Dada Films and Surrealism."

2. Man Ray was not a total stranger to photography when he came to Paris. In his Dada days in New York he had come into contact with the photographers Steichen and Stieglitz. It was then that he bought his first camera, a 4 X 6, to reproduce his works and experiment with photography. In 1916 he developed the "cliché-verre" process on his own, although it had been known to the Barbizon artists. The process consisted of drawing on a blackened plate of glass, which was placed on top of photosensitive paper and then exposed to light, resulting in black lines where the whites of the plate had been. Man Ray's varied photographic experiments in Paris, however, did not include "clichés-verre."

3. Man Ray's approach to erotic subject matter was always one of defiant directness. He is fond of recalling that as a student in New York he went from studio to studio until he found one where the model was a female nude. Once there, he spent only the

minimum of time drawing and the rest simply watching. See Pierre Bourgeade, *Bonsoir Man Ray* (Paris, 1972), pp. 10, 19. He has said, "Speaking of nudes, I have always been partial to this subject, at once in my painting and in my photography, and I must admit that this was not always for purely artistic reasons." Jean Adhemar and Julien Cain, *Man Ray, L'Exposition de l'oeuvre photographique à la Bibliothèque Nationale* (Paris, 1962), p. 11.

4. Man Ray himself recognized the value of these photographs: "Some of the most effective photographs in black and white I had made were magnifications of a detail of the face and body." Ray, *Self-Portrait*, p. 254.

5. "I think that the truth lies in likening the lens to the human eye. Now . . . the eye, lens and dark room, sees little, and it is the brain which enlarges the image, which is transmitted by the retina. Therefore I think that I must always photograph very small and then enlarge, expecting that way to draw near to the vision of the human eye." Adhemar, *Man Ray*, p. 14.

6. André Breton, "Les Visages de la femme," in James Thrall Soby, ed., *Man Ray/Photographies/1920-1934* (Paris/New York, 1934).

7. That Man Ray was interested in achieving a particular kind of effect through his solarized photographs rather than in playing with a new kind of technique is made clear in his autobiography: "[Solarization] is a developing process thanks to which the contours of the face are accentuated by black lines, as in a sketch. This process is purely photographic, although I have been accused of having retouched and altered the negatives. . . . Every time that I deviated from conventional methods, it was simply because the subject demanded a new treatment. I applied or invented techniques in order to underline certain characteristics which seemed important to me. Only superficial critics could accuse me of trickery." Ray, *Self-Portrait*, p. 203.

8. Man Ray's close friend and fellow artist, Hans Richter, has illuminated Man Ray's discovery of the rayograph in the following way: "That he discovered it seemed accidental. But then everything is. It is accidental that Man Ray is an inventor. He just cannot help to discover and reveal things because his whole person is involved in a process of continuous probing, of a natural distrust in things 'being so.' " Hans Richter, "Private notes for and on Man Ray," *Man Ray Retrospective of the Los Angeles County Museum of Art* (Los Angeles, 1966), p. 40.

9. Ray, *Self-Portrait*, p. 129.

10. Just as Man Ray had had some experience with photography before coming to Paris, so too he was not a total stranger to films. While assisting Duchamp in New York in the creation of a film that was to reproduce a three-dimensional effect through stereoscopic filming and viewing, he shot a sequence of himself shaving the pubic hairs of a nude model. All of the film was ruined in the developing process due to the makeshift facilities the two had fabricated. Ibid., p. 263.

11. Ibid., p. 259.

12. If the tack sequence was a cinematization of the rayographs, the turning nude torso is in a real sense the cinematization of his photographs of nudes.

13. The phrase that was a real tour de force was "Rrose Sélavy et moi esquivons les ecchymoses des esquimaux aux mots exquis."

14. Ibid., p. 269.

15. Ibid., p. 263.

16. Ibid., p. 274.

17. "Surréalisme et cinéma," *Études cinématographiques,* nos. 38-39, (Paris, 1965), p. 43.

18. Ray, *Self-Portrait*, p. 270.

19. Man Ray's concern with light in film recalls Philippe Soupault's comment on the role of light in Man Ray's pictures, "Light resembles Man Ray's painting like a hat resembles a swallow, a coffee-cup a lace merchant, a letter the post." *Man Ray à la Librairie Six* (Paris, 1921).

20. Ray, *Self-Portrait*, p. 272.

21. If he had had his way, Man Ray might have eliminated the tangos and popular tunes altogether. In his autobiography he notes that the jazz pieces "were beyond the house musicians' repertory." Ibid., p. 273. Most likely their performance was included merely for the sake of having live accompaniment at some point. Man Ray has specified elsewhere that for *Emak Bakia* "any collection of old jazz will do." See P. Velguth,

"Notes on the musical accompaniment to the silent films," in Frank Stauffacher, ed., *Art in Cinema* (San Francisco, 1947), pp. 91-95. Evidently the desired musical accompaniment was jazz, all the way until the collar sequence when the silence followed by the "Merry Widow Waltz" played a crucial role.

22. Ray, *Self-Portrait*, p. 270.

23. Ibid., p. 272.

24. Man Ray, *Close-Up*, August 1927, as quoted in Stauffacher, *Art in Cinema*, p. 53.

25. Ray, *Self-Portrait*, p. 276.

26. Ibid., p. 277.

27. Ibid., p. 275.

28. Ibid.

29. Stauffacher, *Art in Cinema.*

30. Barbara Rose, "Kinetic Solutions to Pictorial Problems," *Artforum*, September 1971, p. 71. Miss Rose manages to destroy the movie in a single paragraph of the critic's glib vernacular, calling it "preposterous," "pretentious," and "full of heavy references."

31. Carl Belz, "The Film Poetry of Man Ray," *Criticism*, Spring 1965, pp. 117-30. Mr. Belz's attempt to find comparable works in Surrealist literature is to be applauded; however, his results are not wholly satisfactory. In his attempt to find affinities between Philippe Soupault's *Dernières Nuits de Paris* and *Le Mystère* . . . he neglects the very specific conditions of the commission to which Man Ray was tied. He overemphasizes the narrative aspect of the film to make the comparison tighter.

32. Ray, *Self-Portrait*, p. 279.

33. Ibid., p. 280.

34. Ibid.

35. Ibid.

36. Ibid.

37. Breton praises the poem in his statement "Situation surréaliste de l'objet," which he delivered in Prague in 1935. What interests him is the use of words and their simultaneous visual arrangement and thus he mentions it in the same breath with Apollinaire's *Calligrammes*. These works help to "dépayser la sensation." André Breton, "Situation surréaliste de l'objet," *Position politique du surréalisme* (Paris, 1971), p. 137.

38. For an insightful treatment of the poem, see the chapter on "Un Coup de Dés" in Wallace Fowlie, *Mallarmé* (London, 1953). The most ambitious work devoted entirely to the poem is Robert Greer Cohn, *Mallarmé's "Un Coup de Dés"* (New Haven, 1949).

39. In all other ways the film is independent of the poem, except maybe for shots #88-#93. Here the title is split up into three parts amidst shots of the four bathers rolling dice. In the poem the title is divided into four sections, printed in large type to stand out, yet placed so that each segment bears some relationship to the text around it. Man Ray had transposed only the most obvious visual impact of the divided phrase.

40. In all three of Man Ray's mature films we find sequences of landscape shot from a quickly moving vehicle. He recalls that "for twenty-five years I drove cars, in Paris, in America. Like a madman, always. I should have been killed ten times, but I always escaped, not even an accident! No, never an accident, and yet I always had sports cars, and I loved speed, at that time!" Bourgeade, *Bonsoir Man Ray*, p. 113. His love of speed extends to his working method as well: "When I was filming I was always in a hurry. I had no patience. I have never used more than double the amount of film necessary for my shots." *Études cinématographiques*, p. 43. The combination of his love of speed and fast work resulted in the many rough shots of the trip from Paris to Hyères which succeed remarkably well in translating physical movement to a visual sensation. That is precisely what Man Ray sought to achieve, for as he notes, "I finally realized that speed was purely an optical phenomenon." Bourgeade, *Bon Soir Man Ray*, p. 113.

41. Man Ray saw this shot as a way of rendering three-dimensionality on the screen. "But there is something else which can produce relief, and that is movement. Sometimes in a film a landscape is shown, and trees are shown passing in the first plane which are much closer than the landscape. That creates a three-dimensional effect. It's the movement which produces that." Bourgeade, *Bon Soir Man Ray*, p. 58. In this film

he was especially intent upon translating a sense of the three-dimensional onto the screen. At one point he presents a 360° view of the mansion and its surroundings. At another point he examines an abstract sculpture from all sides, gradually moving the camera in a vertical and revolving motion. His exploration of the inside of the house also shows an acute awareness of the total environment that the house offers.

42. Ray, *Self-Portrait*, p. 286.

43. Man Ray wanted to have her ride naked bareback, but since she was a local girl that was out of the question. He thus had her wear a one-piece bathing suit and hoped that at a distance she would appear to be naked.

44. Man Ray made no films after this last effort. *Ruth, Roses, and Revolvers*, in Hans Richter's color film of 1944-46, *Dreams That Money Can Buy*, was based on a scenario he wrote, but he was not present at the actual shooting. Interview with Man Ray, June 19, 1972.

45. ''I was urged to continue, but my heart wasn't in it. . . . Too bad, they said. Yes, too bad, I replied, with the afterthought: perhaps for the others. My curiosity had been satisfied—surfeited.'' Ray, *Self-Portrait*, p. 286.

46. Ibid., pp. 286-87.

5

What the Surrealist Film Might Have Been: Artaud and the Cinema

During the premiere of *The Seashell and the Clergyman* on the night of February 9, 1928, the hushed silence of the audience at the Studio des Ursulines was broken by the following loud exchange:

—Who made this film?
—Madame Germaine Dulac.
—What is Mme. Dulac?
—She is a cow.

Armand Tallier, director of the theater, had the house lights turned on and pinpointed the disrupters, Antonin Artaud, Robert Desnos and a couple of Surrealist buddies. He asked them to apologize, but instead of excuses he received a stream of obscenities. Friends of the establishment quickly joined forces to evict the troublemakers, but they succeeded only after an exchange of kicks and blows. The undesirables broke some of the mirrors of the lobby and shouted more obscenities before they abandoned the premises.[1]

The fury of this outburst was indicative of the great concern with which Artaud approached film. He had certain ideas about the demands of Surrealism on the screen which he was determined to put into practice. During the period of his most serious involvement with the cinema, between the years 1926 and 1930, he attacked the medium with the uncompromising fervor that characterized all of his artistic ventures. He wrote film reviews, articles on the theory of film, answered questionnaires and interviews, but above all he devoted himself to writing film scenarios which he hoped to see made into movies. No wonder that he reacted so violently when he saw his first

film—which was to be his only film—misinterpreted and his ideas distorted.

The violent attack was not merely the result of Artaud's dissatisfaction with the way the film was made. A man who had a history of mental disorders from the time of his childhood, Artaud was an easily excitable personality. His feelings always crystallized in extremes. A number of points of disagreement with Mme. Dulac were enough to propel him to the state of anger which eventually burst forth at the movie premiere. Indeed, Artaud's nervous disorders were so intensive that they determined the very course of his life. He attempted to deal with his infirmities in large part by projecting them into his very creative activity. And since his greatest contribution was in the realm of the theater, a discussion of his cinematic work must ultimately be related to both his nervous state and his stage activities.

As a child Artaud was struck by serious head pains which developed into meningitis. The aftereffects of the disease were to emerge in his teens, when he suffered from headaches so acute that he had to be sent to doctors and rest homes on several occasions. It was after a beneficial two-year treatment in Switzerland that the chief doctor recommended that he go to Paris, where he could pursue his artistic bent. From the time he arrived in 1920 Artaud participated in the theater. He became a student under Charles Dullin, founder and head of the Théâtre de l'Atelier who starred in his first film *The Three Musketeers* that same year. Artaud was entranced by the wondrous world that was opening up for him: "One has the impression while listening to the teachings of Dullin that one is rediscovering old secrets and a whole forgotten mystique of the *mise en scène*."[2] No sooner had Artaud started learning than he began to develop his own mode of acting. His nervous disorders were now projected into his roles. His interpretations were too tense and personal, his movements were often a complicated series of exaggerations. Little wonder that he received few theatrical roles.

Unable to make much headway on the stage, Artaud turned to other artistic outlets. He resumed writing poetry, after having toyed with it in his teens, and thus formed literary contacts which eventually put him in touch with the Surrealist circle in 1924. Artaud's affiliation with the Surrealist movement produced a different result in him than in the other newcomers. While most of them were struck by the splendid opportunity for irrationality as members of the group, affiliation for Artaud meant a chance to project his own infirmities in a more coherent form. The confidence and lucidity of his Surrealist texts testify to the salubrious effect his membership in the group had on his mental health. By publishing his articles in *La Révolution Surréaliste* his ideas received for the first time the sanction of the printed word. By being an active member of the group he gained the self-assurance he needed to strike out on his own once he was expelled from the circle two years later.

While Artaud had acted in a film as early as 1922, it was not until the mid-1920s that he began to appear in movies with any regularity. Meeting with failure on the stage largely because of his intense interpretations, he gravitated toward the more defined, cooler roles of the cinema, at least as a temporary

Artaud as Marat in Abel Gance's *Napoléon*, 1927. (courtesy MOMA)

solution. It was at this time that he first turned his thoughts to film as an artistic medium. That he should have done so is only to be expected. His increasing appearances in movies, of course, brought him in close contact with the medium. Since his efforts on the stage were placed in check, he needed other artistic outlets of a comparable order. But perhaps the most important factor was his contact with the Surrealists, who had made the movies a part of their life and who went so far as to incorporate particular features of the cinema in their own artistic creations.

In Artaud's first Surrealist works we already find evidence of his interest in the cinema. In the third issue of *La Révolution Surréaliste* which appeared under his direction, he published a number of his most famous Surrealist texts, including "Address to the Pope" and "Address to the Dalai Lama," as well as a "Dream" in three parts.[3] This dream greatly resembles the cinematographic poems of Philippe Soupault which appeared in the special cinema issue of *Les Cahiers du Mois*. While Soupault in his action-packed paragraphs wanted "to give an impression neither clear nor precise, but similar to a dream,"[4] Artaud's dream passage began with an aerial cinematographer who recorded the fantastic adventures of a group of men on an airplane.

How closely associated were films and Surrealism in Artaud's mind is best borne out by his first film scenario, *Two Nations on the Confines of Mongolia*.[5] While his other scenarios are plans for movies he has in mind, this one has an independent literary value. It is written in the form of a prose

poem. While many of its lines are descriptive of the action, personal observations, poetic images, and a certain narrative verbal flow endow it with a literary integrity. In fact, this scenario exemplifies the influence of the cinema on literature in a way comparable to Soupault's cinematographic poems. It is the story of an explosive political situation between two countries of the Far East. The one solution to the dispute is a Surrealist poem. The poem is wired to the belligerents but, because of its elusive nature, it is misunderstood, thus precipitating an even graver crisis. It appears that the real cause of the conflict is not political at all, but verbal. On the other hand, poems become people, which begin to multiply and which thus have the power to counterbalance the force of China. The scenario wanders further and further away from its descriptive function and takes on a personal, meditative, sometimes imagistic character. The build-up of chaotic images is resolved suddenly by the final sentence, which explains that a real airplane brings gold to the opponents of the Soviets' allies and "all is settled for fear of complications."[6]

Because of its "literary" nature, there is little reason to believe that Artaud intended *Two Nations . . .* to be made into a movie. Yet at some point during his involvement with the Surrealist movement he began to think seriously of creating films. An interview from that period bears witness to this newly formed interest. In it he talked for the first time about the possibilities of the cinema and what the movies meant to him. "I like the cinema. I like any kind of film. But all types of films are still to be made. I think that the cinema can only accept a certain type of film: only that in which all the means of sensual stimulation of the film will have been utilized. The cinema involves a total reversal of values, a complete overthrow of sight, perspective, and logic."[7] Therefore, motion pictures were not merely another artistic medium worthy of exploration, but a medium of such power that it could induce a transcendental mental state all by itself. "The cinema above all has the virtue of a harmless and direct poison like a subcutaneous injection of morphine."[8] Drugs and the cinema both induced states of mind where the norms of everyday life were swept away. Such revolution in perception could best occur when the screen engaged the senses as fully as possible. When asked what kinds of films he would want to make, Artaud replied that "a film's subject matter must not be inferior to the film's active potential—and must partake of the marvellous."[9] As for the actual unfolding of the movie, "The cinema calls for exaggerated subjects and detailed psychology. It demands rapidity, but above all repetition, emphasis, and afterthoughts."[10]

Perhaps the most interesting comments of the interview relate to Artaud's previous concern with the theater. "When the flavor of this art [the cinema] will be joined in sufficient proportion to the psychic ingredient which it contains, it will leave the theater so far behind that we shall relegate it to the lockers of our memories. Because the theater is already a betrayal. We frequent it much more to see the actors than the works."[11] Such disparaging remarks about the theater should come as no surprise, not if we remember Artaud's lack of success on the stage in the years immediately preceding. Con-

versely, his revolutionary work with the theater of cruelty will not commence until his initial attempts with cinema meet with failure. But in 1925 the particular magic of the screen still held out a special promise to the young man who wanted to engage the public in a profound way. Indeed, Artaud bases his first actual scenario for a film on a concept which readily lends itself to cinematic adaptation.

Eighteen Seconds is the unfolding of a man's thoughts during that short period of time as he is standing on a street corner.[12] As Artaud himself comments, "The whole interest of the scenario lies in the fact that the time during which the described events take place is really eighteen seconds while these events will require an hour or two to be projected on the screen."[13] Artaud emphasizes this duality of interior and exterior time by showing the close-up of a watch on which the seconds pass with infinite slowness. True to his precepts about the role of films, he chooses a subject of direct psychological import, namely, the individual's optical thought process. Sharing the Surrealists' attitude that the cinema is the medium which best approximates dreams, he assigns the screen the role of transmitting the daydreams of a man. His reflections are shown on the screen precisely because Artaud believes the psychological process to be of paramount importance. Not only is interior time longer than exterior but it is also infinitely more powerful: the man's daydreaming finally leads him to commit suicide.

Because Artaud saw the cinema as being especially apt for showing the internal state of man, he chose an appropriately psychological topic for his first film plan. Because of his belief in the potential of the cinema, he projected his own inner turmoils into that scenario more directly than into any other piece of fiction he produced. The story is of an actor. He is close to winning glory and just as close to winning the woman he has loved. He is struck by a strange malady, however, which disrupts all his plans. He becomes unable to reach his own thoughts. Although he is completely lucid, he cannot give his thoughts an exterior form, to translate them into the appropriate words. He is reduced to seeing a parade of images unfold in his mind. As a result he becomes incapable of sharing the lives of others and of giving himself to any activity.

The situation thus described in the opening scenes of the scenario fits Artaud's own situation exactly. He was a young actor in love with the actress Génica Athanasiou. He surely felt that his theatrical career never blossomed because his nervous disorders compelled him to act with an intensity which was unacceptable on the stage. His inability to win her total love stemmed from this same malady. In his famous correspondence with Jacques Rivière in 1923 Artaud talked about the problem he had in expressing his thoughts: "I suffer from a frightful disease of the mind. My thought abandons me at all stages. From the simple act of thinking to the external act of its materialization into words. Words, forms of phrases, interior directions of thought, simple reactions of the spirit, I am in constant pursuit of my intellectual being. When, therefore, *I can seize a form*, imperfect that it may be, I fix it, for fear of losing all my thoughts."[14] According to his own testimony, therefore, simply

writing about his affliction, both in his letters and in the scenario, was an achievement, the seizing of a form for the expression of his thoughts, a cure for his illness through a literary form.

Confronted with his mental infirmity, the actor curses his fate. In his desperation he swears that he is ready to change places with anyone, even the hunchback selling newspapers on the street, in order to exercise control over his faculties. The mental disorder is much more serious than any physical defect could be. The hunchback is shown thinking while images of power and success flash by. At some point the actor becomes the hunchback as he hopes that his hump will also be removed when he finds the central problem. He begins his quest for sanity. We see him at meetings, on the road, in front of books trying to find the answer. He is arrested and placed in an insane asylum, where he becomes truly mad but remains intent on finding the cause of his problem. A revolution frees him, the crowds acclaim him as their king. Now it seems that he has everything, yet he is still not in possession of his mind. He finds himself in a theater watching an act when he realizes that the hunchback on the stage with his mistress is only an effigy of himself, a traitor who stole his love and his mind. Once this moment of recognition comes, the two characters merge into one on the screen. The suicide of the actor that follows is an indication that the problem cannot be resolved. The hunchback who stole his mind is indeed only an effigy of himself, yet it was he who thought of himself as the hunchback, so that the problem is circular and resides within his own head. As in this scenario, so in real life Artaud was forever in quest of a seminal truth without ever being able to resolve the mental problems that were tormenting him.

Artaud's first film scenario is of special interest in a consideration of cinema because of its relationship to Man Ray's *L'Étoile de mer* based on a poem by Robert Desnos. In *Eighteen Seconds* as in *L'Étoile de mer* a man is shown haunted by a woman. Artaud's scenario specifies visions of a very beautiful woman as she exists in the imagination of the man. The hero begins a quest which takes him first on a physical journey, then on a mental search. While Artaud has his man turn to the Kabbala, Man Ray has his hero explore the meaningless text of a newspaper article. Both men are impeded in the attainment of their idealized women by an inner force: unspecified but symbolized by the starfish in Man Ray's film, while in Artaud's it is his mental infirmity, represented by the hump of the hunchback. One might trace these similarities to the close friendship that existed between Artaud and Desnos, the author of the poem which is the source of *L'Étoile de mer*. Although *Eighteen Seconds* was not published, Desnos may very well have seen it by 1927, when he wrote his poem. Yet is is not necessary to go to such lengths to try to prove a relationship between two works produced by men working in the same milieu at the same time. It will suffice to observe that these themes and images expressed some of the basic interests of the Surrealist circle. Interestingly, Artaud's projection of his inner conflicts into a film scenario are remarkably similar to Man

The military officer smashes the clergyman's shell. (courtesy MOMA)

The officer and the woman in the confessional. (courtesy MOMA)

The face of the officer is distorted as he turns into a priest. (courtesy MOMA)

Servants clean the glass bowl containing the clergyman's head. (courtesy MOMA)

The clergyman's visions during the wedding ceremony. (courtesy MOMA)

Ray's conscious effort to create a Surrealist film on the basis of a Surrealist poem.

Artaud's best-known film scenario is, of course, the one which was realized by Germaine Dulac, *The Seashell and the Clergyman*, and which provoked the ruckus at the Studio des Ursulines.[15] The story is as complicated as that of *Eighteen Seconds*. It opens with a clergyman in a laboratory pouring liquid from a huge shell into various beakers, each of which he proceeds to smash on the floor. A military man appears and breaks the shell with his sword. The clergyman appears following a carriage on all fours. Inside the carriage is the officer and a beautiful woman, who eventually enter the confessional of a church. The clergyman attacks the officer, but as he does so the officer turns into a priest. He throws this double away on top of a mountain. We then see the clergyman and the woman in the confessional. He hurls himself at her and rips off the bodice of her dress. Underneath is a shell protecting her breasts which he tears away and waves in the air. We then see him in a crowded ballroom where the officer and woman appear on a dais. He continues to chase the woman in various places as we see images of her float by. He goes down a corridor opening doors with a large key, until he finds the officer and the woman in the last room. A chase begins. We see his fingers searching for a neck as various landscapes appear between his hands. The clergyman is asleep. He dreams that servants enter a room with a glass bowl in it and start to do some cleaning. A governess dressed in black enters who turns out to be the same beautiful woman. Two young people enter from the garden: they are the

woman and the clergyman and they are to be married by a priest. Visions from
the clergyman's dream interrupt the process. Now the headless clergyman ap-
pears carrying a package. It is a glass bowl, which he breaks in order to take
his own head out of it. The head melts into a blackish liquid as it rests on an
oyster shell: the clergyman drinks it with closed eyes. The British Board of
Censors banned the film with an illogic of a different sort: "The film is so
cryptic as to be almost meaningless. If there is a meaning, it is doubtless objec-
tionable."[16]

Although this scenario is not so clearly autobiographical as *Eighteen
Seconds*, it still presents as the main problem themes which haunted Artaud
throughout his life. In this scenario as in the previous one he presents a quest
for a woman as well as a quest for self-knowledge. As Bettina Knapp has right-
ly pointed out, "Such a quest begins in a scientific manner, usually in a
laboratory of some sort, as it had with the alchemists of old."[17] In fact Ar-
taud's quest, as it was projected into his theories of theater, at least parallels
the processes of alchemy if it does not directly issue from them.[18] At least in
one other of Artaud's works the scientific laboratory plays an important sym-
bolic role in the discovery of Self. In a play written in 1931 called *The
Philosopher's Stone* a Dr. Pale carries out experiments to find the
philosopher's stone, the object of all alchemical processes. His experiments
consist mostly of chopping away at the body of his double, Harlequin, who in-
corporates in himself the sexual appetites noticeably absent from the doctor.
Mrs. Knapp observes that "mythologically speaking, it is through the *cleans-
ing, burning,* or *dismemberment process*, that transformation and rebirth can
occur."[19] Comparable to this destructive act in the laboratory is the
clergyman's titration of liquids which ends with his breaking of beakers as well
as the officer's smashing of the shell with his sword.

Just as in *Eighteen Seconds* the actor's quest for the woman was related to
his attempt to gain control of his own mind, so in *The Seashell . . .* the
beautiful woman is but a focal point of the clergyman's attempt to break
through the divisive forces of his character. The officer represents the other
side of the clergyman's nature. He is the obstacle to the clergyman attaining
wholeness through union with the woman. He appears in the laboratory as a
disruptive force. He seems to usurp the clergyman's role even in the church
when he seats himself in the confessional. The clergyman attains the power to
destroy his double only once they are in the church, in his own domain. It is
while the officer is being choked by the clergyman that his true identity
emerges: his face changes to that of a priest. Once he is destroyed, the
clergyman thinks he has removed the chief obstacle to his union with the
woman, yet she keeps on eluding him. His triumph over his officer double was
only temporary. The officer keeps reappearing by the side of the woman in the
involved chase scenes. The clergyman even dreams of being united with his
love, but that is only a dream. Since it is his psyche which is split in two, he
cannot reach a state of inner unity by the external act of union with a woman.
He must alter the very chemistry of his being by drinking the mysterious li-

quid. Is the liquid totally life-restoring or is it deadly? Whichever it may be, the act of drinking is as final a step as the suicide of the actor in *Eighteen Seconds*.

After reading Artaud's scenario, a viewing of the film will confirm that Germaine Dulac closely followed the script in shooting the movie.[20] Yet when Artaud first saw the film he was so greatly dissatisfied with it that he caused the great uproar at its premiere. As a result of his immediate disclaimer, observers have tended to side with Artaud in judging the film to be a distortion of Surrealism on the screen. Lately, Alain Virmaux has come along to clarify the nature of the relationship between Artaud and Mme. Dulac in their participation on the film.[21] Virmaux has documented the change from Artaud's respectful attitude toward Mme. Dulac in the first few months of the venture to his total disillusionment by the time of the opening. Briefly, Artaud emphatically denied newspaper rumors that he wanted to interfere in the making of the film, writing to Mme. Dulac, "I do not have the slightest pretention to collaborate with you. It would be a stupid pretention."[22] Yet as time went on he started giving suggestions to her on the "conception" if not the "realization" of the film.[23] What her reaction was we do not know, but there is a gap of two and a half months between Artaud's first batch of letters and his last of September 25 in which he complains to Mme. Dulac of not knowing anything about the progress of the film. In a letter of August 29 to Jean Paulhan he says that he would like to write an article for *La Nouvelle Revue Française* "to defend my film without attacking anyone, but to determine my position with respect to this film."[24] Thus, Artaud was already suspect of the way the film would turn out long before he actually saw it.

Why was Artaud so totally dissatisfied with the finished film? He had certainly decided in advance to make his own attitude on it public. That decision was made after he had had time to think about how he wanted his film to be made. Although at first he wanted no part of the production, he gradually began to envision certain scenes shot in certain ways. As he realized in his own mind the possibilities of the cinema, he was more and more eager to have a hand in the actual production. Of course, there were a few specific misinterpretations in the movie, but by and large the movie was faithful to the script.[25] What made Artaud disclaim the movie was not so much that his intentions were distorted, but rather that he could not participate in their cinematization. Having entrusted his scenario to Mme. Dulac, Artaud then wanted to assist in the execution of the film. "[T]here are a series of nuances, of detail, of subtleties, even of sleight-of-hand turns which I see exactly how to do, but which can only be indicated when shooting. I also had a rather precise conception of the way in which the actors should play, of a certain rhythm to ask of them, to communicate to them."[26] For Artaud the smallest details of the movie became significant. He began to imagine a certain tempo which he wanted to create in the film through the perfomance of the actors. His ideas, in fact, combine certain theatrical suggestions with purely cinematic considerations.

In the scene of the ball I see after one or two very distant shots taken from high up, exactly as you had in mind, other shots where the camera would be placed on the ground and aimed vertically towards the sky, so as to show the bottom of the chin and the cavity of the actors' eyebrows. And I believe that this would be possible. About these same dancers, I see them now dancing in regular fashion and without expression like ordinary dancers, now dancing in a paroxysm of anger with their faces in convulsions and their bodies swinging normally, now an expression of voluptuousness, of amorous delirium but completely stereotyped.[27]

Certain other suggestions in the letters further clarify for us the way in which Artaud imagined his film. He sought to create a powerful psychological undercurrent through a number of devices. He proposed, for example, an actor for the role of the officer whom he had picked in order to emphasize "a great contrast in expression between the head of the officer and that of the clergyman."[28] In order to create a particular mood, he suggested a total simplicity of decor and went so far as to envision the ballroom filmed without any walls.[29]

What emerges from these scanty letters is the germ of a particular kind of vision that Artaud had for the cinema. That vision was rooted in his experience with the theater and was to be more precisely articulated in his essays of the 1930s, *The Theater and Its Double*. He is already demanding highly exaggerated performances from his actors which border on a nervous fit. He wishes to accentuate these extreme states of mind through the assistance of the camera, which can show a somber close-up of human faces taken from an unusual angle. He wants to make the decor absolutely simple precisely in order to emphasize the actors. Yet their performances are to be ruled by a certain rhythm which he will try to recreate again in imitating the rhythmic patterns of Oriental theater.

His opposition to the film prompted Artaud to elaborate his attitude to the cinema in more general terms in the years 1927 and 1928. In an article entitled "Witchcraft and the Cinema" of the summer of 1927 he stressed the sense of mystery unique to movies. "I have always noticed in films a special quality in the hidden movement and in the very substance of the images. There is in the cinema something unforeseen and mysterious which is not to be found in the other arts."[30] Artaud then compared movies to dreams: "If the cinema is not made for translating dreams or all that which in the waking life is connected to the domain of dreams, then the cinema does not exist. Then nothing differentiates it from the theater."[31] Movies were not just related to dreams, but to all imaginary experience. "The cinema is essentially a revealer of the occult life with which it puts us directly in contact. . . . Raw film, taken as it is, in the abstract emits a little of this atmosphere of a trance eminently favorable to certain revelations."[32] Artaud explained why the film was so closely related to these forms of the imagination: "The smallest detail, the most insignificant object take on a meaning and a life which belongs to them exclusively. This, over and above the value of the meaning of the pictures themselves, beyond the thoughts they translate or the symbols they form. By the fact that it isolates

the objects, the cinema endows them with a separate life which tends to become more and more independent and detached from the ordinary meaning of the objects."[33] He would have surely emphasized this independent life of the object as image in his film, as is indicated by his suggestion to focus on the eyebrows of the dancers, for example. Because of its extraordinary powers over the mind, motion picture was for Artaud the medium which could best express the contemporary liberation of the spirit. "There will not be on the one hand the cinema which represents life, and on the other that which represents the functioning of thought. Because more and more life, that which we call life, will become inseparable from the spirit. A certain hidden realm tends to surface. The cinema, better than any other art, is capable of translating the representation of this realm since stupid order and habitual clarity are its enemies."[34]

Artaud became especially concerned about the way his movie would be received when he was convinced that Mme. Dulac would greatly distort his scenario. In having his scenario published in *La Nouvelle Revue Française*, he added an explanatory preface about his artistic intent. In it he returned to a discussion of the role of dreams in response to Mme. Dulac's advertising the film as a "dream by Antonin Artaud."

> This scenario is not the reproduction of a dream and must not be considered as such. I will not try to excuse its apparent incoherence by the simple loop-hole of calling it a dream. Dreams have more than their logic. They have their life, where only a dark and intelligent truth appears. This scenario searches for the somber truth of the mind, in images issuing only from themselves, and which do not draw their meaning from the situation where they develop but from a sort of powerful and interior necessity which illuminates them with merciless clarity.[35]

Contrary to what most critics have deduced, this passage is not an attempt by Artaud to dismiss dreams. He is merely saying that he did not write his scenario on the basis of a dream he had, but wrote it to expose certain deeply felt inner psychic images. A careful reading of the passage will confirm that Artaud thinks of dreams as powerful manifestations of the spirit ("Dreams have more than their logic. They have their life."). If anything, he is attempting to recreate the impact of a dream as it is being dreamed rather than to jot down a waking man's memories of a dream. His aim is to capture its power rather than its irrationality. Thus, there is nothing inconsistent about Artaud's previous attitude toward the cinema as a medium which best explores the realm of dreams.

In the preface to his scenario Artaud situated his cinematic efforts within the context of contemporary movie production. He saw two main types of film being produced: "pure cinema," which attempted to present visual abstractions, and commercial cinema, which was based on "psychological situations which would be perfectly in place on a stage or in the pages of a book, but not on the screen."[36] The problem with the former was that "one can only remain insen-

sible to purely geometric lines, without a value of signification by themselves."[37] For Artaud abstraction meant nothing. As far as he was concerned, "As one delves deep into the mind, one finds at the source of all emotion, even the intellect, a physical sensation which comes from the nervous system. This sensation is nothing but the recognition. . . of something substantial, of a certain vibration which recalls states either known or imagined. . . ."[38] Abstract cinema simply could not reach this nervous base of all emotions. Commercial movies, on the other hand, by attempting to translate a text exactly into pictures, did not exploit the potential of the image, and hence failed to attain the possibilities of motion pictures. Artaud, therefore, sought to create a solution which would correct the faults of both types of films. He wanted to make movies which worked directly through the unfolding of images (as did abstract movies) and which would engage the audience psychologically (as commercial movies tried to do). In regard to *The Seashell* . . . he wrote, "In the following scenario I sought to realize this idea of visual cinema where even psychology is devoured by acts. . . . Not that the cinema must dispense with all human psychology: this is not its principle, quite the contrary, to give to this psychology a much more alive and active form."[39] "*The Seashell and the Clergyman* does not tell a story but develops a series of states of mind which are deduced from each other as thought issues from thought, without this thought having reproduced a rational chain of events. True psychic situations are produced from the clash of objects and gestures."[40]

Now we know what kind of film Artaud sought to create, but in what kinds of films did he see his ideas best realized? In the favorite genre of the silent era, the comic film. It is instructive to see exactly what the appeal of comic film was for him.

> [The cinema] does not separate itself from life but rather it rediscovers the primitive state of things. The most successful films in this sense are those where a certain humor reigns, as in the early Buster Keatons, and in the least human Charlie Chaplins. Motion pictures studded with dreams, which give you the physical sensation of pure life, attain perfection in the most excessive humor. A certain movement of objects, of forms, of expressions can only be appropriately expressed through the convulsions and somersaults of a reality which seems to destroy itself with an irony in which one hears the extremes of the spirit crying out.[41]

In fact, Artaud considered the comic film to be the first example of a successful use of subjective images. He saw *The Seashell*. . . as a further step in an evolution which began with the comic film.

> *The Seashell and the Clergyman* is the first film ever written which makes use of subjective images untainted by humor. There were other films before it which introduced a similar break in logical thought patterns, but humor always provided the clearest explanation for breaking the *links* between patterns.
> The mechanics of this type of film, even when applied to serious subjects, is

modeled on something rather similar to the mechanics of laughter. Humor is the common factor, known to all, by which the mind communicates its secrets to us.

The Seashell and the Clergyman is the first film of a subjective type where an attempt was made to deal with something other than laughter, and which even in its comic segments, does not rely exclusively on humor.[42]

The year 1927 was eventful for Artaud not only in terms of the cinema. In that year he officially broke with the Surrealist movement. He was denounced by a pamphlet published in the beginning of the year entitled "Au grand jour." The pamphlet was primarily a political statement signed by Breton, Aragon, Eluard, Péret, and Unik which announced the affiliation of the Surrealist group with the Communist party. It denounced both Artaud and Soupault for, among other things, "their isolated pursuit of stupid literary adventure."[43] Artaud responded with a pamphlet called "À la grande nuit ou le Bluff surréaliste," published in June 1927. In it he attacked the Surrealists' taking a political position as a betrayal of their own quest for the liberation of the spirit, and saw in it the death of Surrealism as such. He declared that for him "surrealism had always been only a new sort of magic."[44] He would continue to pursue his aim of "a metamorphosis of the interior conditions of the soul"[45] regardless of the Surrealists' change of direction. Thus, his break with the Surrealist group in no way changed Artaud's views on the role or content of his own creative work. If it had any effect at all on him, it was to push the young poet to seek new outlets for his creativity.

The same month that Artaud published his answer to the Surrealists' attack saw the launching of another artistic venture. Artaud had founded the Alfred Jarry Theater the year before in collaboration with Roger Vitrac, the playwright, and Robert Aron, the essayist. June 1 was opening night at the Théâtre de Grenelle of the company which was to present three different plays. Artaud's concern with the difference between theater and cinema was made apparent in the first of these, his own one-act play, *Scorched Belly or the Mad Mother*, "which denounced humoristically the conflict between the movies and the theater."[46] For the next three years Artaud was to work actively in both media, writing film scenarios while staging plays for the Alfred Jarry Theater.

The film scenarios that followed were generally inferior to the first he had written, lacking their power and originality. Their weakness may be due in large part to Artaud's recognition of the fact that movies were above all a commercial venture. If he wanted his scenarios to be produced, he had to cater to commercial tastes. As he wrote in a letter to Yvonne Allendy in connection with his scenario *Flights*, "Evidently this is for me *only* a matter of money."[47] He was aware of the lower quality of these scenarios, agreeing in a letter with the judgment of a man named Kruger who put *The Seashell* . . . much above *The 32*.[48] The scenarios are inferior in a number of respects. They include fewer scenes of truly cinematic potential. Images do not arise from previous

images as he had planned before and as they did in his earlier scenarios. A rather straight narrative style dominates. Only the subject matter continues Artaud's preoccupation with the magic created by the screen.

These later scenarios show Artaud returning to an idea which had haunted him ever since he became involved with movies. In his first Surrealist text, which resembled Soupault's cinematographic poems, he placed a cameraman on an airplane. In *Two Nations* . . . hostilities can only be avoided by sending a mail plane to deliver the surrealist poem intact. Throughout the scenario-poem the plane makes its appearance as a flying machine as well as a sensory concept: "Vertiginous speed, sound;/how the plane swims over time;/mist of occultism for aviation," or "the vibrating propellor imitates the radiation of poetry;/airstreams clash and ebb." The conflict is settled when a "real plane" brings needed gold.

One of Artaud's later scenarios is actually built around the theme of flying. *Flights* is a simple detective story of a young lawyer who pursues his pretty client's father-in-law for stealing a document which names her as the beneficiary of a great fortune.[49] The interest of the scenario lies in its rich visual exploration of the theme of flights.[50] When the young lawyer first daydreams of his attractive client, we see a flight of seagulls, then a view of the ocean taken from an airplane. Later, among the girl's daydreams appear the flight of a sparrow and again the flight of seagulls. When we see the thief running, he is shown from high up, as from an airplane. The father-in-law's escape to Constantinople takes place on the Orient Express, but the progress of the train is again shown from a flying plane. Once the young lawyer retrieves the precious document from the thief, he rushes with it to the nearest post office, where he posts it airmail. The story closes with a shot of a mail plane flying in a clear sky.

We have remaining a two-page fragment of an eight-page scenario entitled *The Solar Airplane*.[51] The scene is set in the Far East and in the extant pages we are given a detailed description of the experiences of a pilot flying in unusual weather. He attempts to clear clouds, a whirlwind shakes the fuselage, the plane is surrounded by flames and sparks. The propeller of the plane seems to make even the ground tremble. We have also remaining the first and last lines of the scenario: "For a few days a strange terror weighs . . . and it is the wait for news about him which created this nightmare."[52] The whole scenario is therefore concerned with a kind of nightmarish terror which is somehow connected to the flight of an airplane. The flight itself is a total sensory experience, approaching certain hallucinatory states.

Artaud's interest in flight is related exclusively to his cinematic works. While the theme frequently occurs in his film scenarios, it is absent from all of his other writings. Artaud seems to have evoked this subject repeatedly in his scenarios because of a certain relationship he felt between airplane flight and the cinema. The airplane was a time machine ("how the plane swims over time"); it was a vehicle which could enter the realm of the occult ("mist of occultism for aviation"); it was also the vehicle for entering extraordinary sen-

sory states in *The Solar Airplane*. In many ways it symbolized the effects of the cinema as Artaud perceived them. Of course, the airplane symbolized for him the flight of thought as it did for many other poets, but it also created a sensation equivalent to that of a deeply stirring poem ("the vibrating propeller imitates the radiation of poetry"), and at one point he even described it in terms that apply directly to the cinema ("being transported in an uncontrollable, vibrationless machine, representing a direct line of action").[53] For Artaud the airplane proved to be the most appropriate cinematic symbol: in his scenarios he invested it with the transcendental qualities he found in the movies, perhaps because only the exhilaration of flying could approach the enchantment of the movies.[54]

Although Artaud dealt with flight only in film scenarios, not all of his scenarios are concerned with air travel. All those that do not, share another theme, that of a split or dual personality. While obviously the airplane was specifically linked to Artaud's conception of the cinema, his concern with a dual identity was such a fundamental, lifelong preoccupation that it surfaced in all of his writings That a number of his film scenarios revolve around this latter theme testifies not only to the existence of this psychological state in him but also to his inclination to use the media first and foremost as so many vehicles for self-purification through the outward projection of his own emotional instability.

The early film scenarios give ample evidence of Artaud's interest in the problem of dual identity. *Eighteen Seconds* presents a double duality, as it were. First, we have the man on the street corner and his vision of himself as the actor who goes through the adventures of his daydreams. Second, the actor is both the king and the hunchback, the former having a mental deficiency, while the latter is marked by physical deformity. The hunchback is the darker aspect of Artaud's personality who stole the king's mistress and mind. The conflict is resolved with the merging of the two characters into one. In *The Seashell* . . . the officer acts as a psychological double of the clergyman. The officer stands as an embodiment of the clergyman's desires. Yet he also stands in the way of the realization of those desires. There is actual conflict between the two. The officer symbolically intrudes into the clergyman's laboratory and smashes his shell. The clergyman in turn attacks the officer inside the church and temporarily succeeds in casting him off. Obviously the two characters represent the two opposite sides of a single personality. This is why the officer is not eliminated permanently: his presence is a symbol of the divisive forces which prevent the clergyman from exercising his will. It was with the difference of these two characters in mind that Artaud wrote to Mme. Dulac, "I had wanted a great opposition of expression between the head of the officer and that of the clergyman."[55]

Artaud's interest in a dual personality kept surfacing in his scenarios. *The 32* is the story of a handsome young professor whose aid is requested by one of his pretty students who was abandoned when she became pregnant.[56] She asks the young man for occult intervention. In the course of her visit to him he is

suddenly overtaken by a fit. He is placed under medical care. The girl keeps visiting him. During one visit the young man conjures up a ghost that looks a lot like him. Another time the girl begins to dream once a glass bowl is put into motion. She dreams of an aquatic world, of bestial faces, of masks, of animals' paws. Suddenly the vision disappears and in its place in the mirror we see the head of the young man, but completely transformed into something hideous. He takes out a black noose, at which the girl cries out and turns around. The young man is suddenly calmed down, but we do not know if all this was a dream or not. A war comes and the young man leaves. The house stays abandoned for a long time. The mayor and the commissioner of the town decide to search the premises. In the cellar they find the bodies of thirty-two women with a black noose around their necks. Investigation of the murders leads to a vampire in Turkey. The girl enters a hospital with the mayor and the commissioner. When they ask to see the young professor, they are led to the bed of a man with a terribly distorted, pockmarked face who looks nothing like the young man.

In this work once again a character is presented with dual personality. He is a handsome professor ready to help a young girl in trouble, but he is also a hideous vampire who had murdered thirty-two women. It is significant that these two aspects do not exist peacefully side by side, but are the source of continuous conflict. The split is like a disease which erupts in strange fits when the character passes from one identity to another. Artaud created this scenario partly out of *Bluebeard* and partly from *Dr. Jekyll and Mr. Hyde*, because he found in them a way to express his ambivalent attitude toward women and his preoccupation with split personality.

Artaud writes in a letter to Mme. Allendy that he feels greatly encouraged by the interest some Americans have shown in *The 32* and suggests that, if they are truly interested in having him produce a scenario, "they have but one thing to do and that is to *order* of me without waiting any further a new scenario less *demoralizing* than the old one but in the same vein."[57] He has in mind for this scenario three different ideas, the second one of which is the following: "The parallelism of the power of crime and of good in a man under the spell of his ancestral past. Therefore, another moral point of view: the fragility of ideas of good and evil, all of which is expressed by events and by signs from which the public will draw the conclusion it wants. For that Stevenson's *Master of Ballantrae* will suit me."[58] Having worked on an idea by Stevenson in *The 32*, he now chose to do an adaptation of one of his novels.

The general sense of the adaptation is worth recounting to see exactly what Artaud saw in the story.[59] Two brothers of Scottish nobility live in their father's castle. They are of completely opposite temperaments: the older, the Master, is bad, proud, careful, ready to defend his birthright. Henry, the younger, is good, retiring, more lucid, suffering in silence. The Master must go off to war, and is supposedly killed. Henry marries his brother's widow, but in time the elder brother comes back to claim his rightful place. He must avenge himself on Henry, who is but a usurper. A fight breaks out between them in

which the Master is left for dead. The servants come for his body but he has disappeared, left on a ship. Henry becomes ill at the same time. Once again the Master returns. This time Henry allows him to stay, but that is all. Yet Henry himself decides to leave the castle just to be rid of his brother. Once the Master discovers Henry's flight, he takes off after him in order to torment him. To free himself of his brother once and for all Henry outfits an expedition for a treasure hunt which the Master is interested in undertaking. He gives the captain orders to kill his brother so that he will never see him again. In the course of the expedition the Master falls ill and dies. Slowly the members of the expedition also die off. Having no news of the group for a long time, Henry becomes concerned and sets out after them. He finds his brother's servant, who says he put the Master asleep to save him from the murderous hands of the members of the expedition. They try to resuscitate the Master and do so successfully. Seeing his brother alive once more after thinking that he was finally really dead, Henry dies of despair, and in his turn, the Master dies as well. These two contradictory spirits are laid to rest under the same tombstone.

Artaud's scenario presents the two brothers as siblings of opposite temperaments who struggle against each other throughout their lives. Their mutual existence predicates conflict. They share the same ancestry; they even have the same wife. Their personalities are opposite, yet they are so close that the evil brother sometimes does good deeds, while the good brother eventually turns murderous. The Master is like an apparition that haunts Henry. Three times he is supposedly dead, only to come back to life each time. The Master reappears as easily as does the officer in *The Seashell* . . . after the clergyman strangles him. The theme of doubles is even manifest in the servant each brother has, a servant who takes the interest of his master to heart. The conflict between the two halves of this ancestry ends only with their simultaneous deaths.[60]

Artaud's tenacity in pursuing the idea of dual personality resulted in works presenting this theme which lie outside his cinematic oeuvre. In his play *The Philosopher's Stone* a doctor keeps cutting away at a Harlequin who seduces his wife and whose child looks like the doctor. Harlequin possesses sexual appetites noticeably lacking in the doctor. They are two conflicting aspects of a single personality. In *The Conquest of Mexico*, the play which he saw as best fulfilling his ideas of the theater, Artaud presented, among other things, the inner struggles of Montezuma. "It seems that one can make out in him two personnages: (1) He who obeys almost in a holy fashion the orders of destiny, who fulfills, passively and armed with all his conscience, the fate which ties him to the stars. . . . (2) The torn man who, having performed the outward movements of a rite, having fulfilled the rites of submission, asks on the inner level if, by chance, he wasn't mistaken, rebels in a sort of superior tête-à-tête where the phantoms of being hover."[61] For Artaud the concept of duality was so important that he entitled his most crucial essay on the theater, *The Theater and Its Double*. The way he defined the "double" in terms of the theater was "the great agent of which the theater, in its forms is only the figuration until it

becomes its transfiguration.''[62] In fact, Artaud returned again and again to the idea of a dual personality precisely because he felt that he contained within himself two conflicting facets, as he had written in his letters to Jacques Rivière. As he projected his personality into his works, so he generalized this idea to apply to the world, and thus observed that ''the origin of things is double when one thought them to be simple; and that the world, far from descending from a single principle, is the product of a combined duality.''[63]

In his efforts to get his scenarios produced Artaud became increasingly aware of the commercial side of filmmaking. His letters are a record of his efforts to interest producers in his work. In a letter to Mme. Allendy in the spring of 1929 he makes detailed calculations to arrive at a sum he would need to make a film of *Master of Ballantrae* by himself.[64] A few months later Artaud talked about the difficulties of moviemaking in an interview: ''The cinema is a frightful profession. Too many obstacles prevent you from expressing yourself or from realizing the movie. Too many commercial or financial contingencies constrict the directors I know.''[65] He did everything possible to see another of his films realized when he traveled to Berlin in the summer and fall of 1930. It is not known if there was a single main reason for his going to Berlin since his letters talk about his attempts to land roles in films, to stage a play, as well as to interest filmmakers in his scenarios. In this last domain he succeeded in engaging Walter Ruttmann, creator of *Berlin, Symphony of a Great City*, to shoot *The 32*. Unable to obtain the necessary funds, however, Artaud had to abandon this project.

Faced with the difficulties of raising the required sums for a full-length feature, Artaud came up with an alternate solution. Why not create a firm for the production of short features? In a rather lengthy proposal he outlined the needs and aims of such a company.[66] He stated his belief that there was a market for short features to be shown in specialized theaters. He took the initial financial success of *Un Chien andalou* to be ample proof of the viability of such a venture. Thus, he proposed to create films between 500 and 1,000 meters in length at a cost of 50,000 to 150,000 francs, roughly ten percent the cost of even modest contemporary productions. His general proposal was aimed specifically at obtaining the necessary funds for the filming of his last scenario *The Revolt of the Butcher*. Supposedly the Brillancourt studios had already put up 60,000 francs toward the shooting so that he needed only 40,000 more, but those funds were not available.

It is unfortunate that Artaud could not film this last scenario, because in it he created a work comparable in strength and originality to *Eighteen Seconds* and *The Seashell*. . . . In fact, Artaud saw the scenario as picking up where *The Seashell* . . . had left off. In a prefatory note he wrote, ''*The Revolt of the Butcher* originates in a similar intellectual impulse, but the elements which were latent in *The Seashell* . . . —eroticism, cruelty, blood-lust, thirst for violence, obsession with horror, dissolution of moral values, social hypocrisy, lies, perjury, sadism, perversity, etc.—have been made as explicit as possible.''[67] The

scenario is even less coherent than the early ones. It presents symbolic images and acts which have actually very little to do with each other. Each situation, however, creates a certain sensation, evokes certain associations of a violent nature. Much of the power of the scenario lies in its presenting certain highly charged emotional states from which there is no adequate psychological release, thus building anxiety in the audience.

The scenario opens with a man in anguish pacing around a deserted square, having the compulsion to bite. A butcher's van drives by, swerves to avoid the man, and drops a beef carcass. The man walks into a bar, arousing the curiousity of the clientele. A prostitute enters with a gigolo and smiles at him. We see the madman inspecting the customers who are lined up at the bar standing absolutely still. Then we see a mad race, each customer rolling down a steep slope on a particular object. The madman is on the running board of a taxi with the whore and the gigolo inside and a heavy butcher sitting on top. Meanwhile, a little woman enters the bar and is taken to the police as soon as she admits that she is waiting for the madman. She escapes and the whole police force races after her. They scatter, and when we see them again, they are marching together entranced, playing bagpipes. We see seminarists and soldiers running in slow motion. The madman sees the butcher unload the stiff body of the woman. When he approaches he sees only a side of beef. He finds the woman under wood shavings. Butcher and madman sit down amidst the cutting of carcasses, with the woman laughing between them. We have a view of the woman in a basket, with her arms spread out and bloody. The butcher gets ready to cut her up but cannot do it. There is a big festivity for the butcher and the little woman, who are getting married. In front of the slaughterhouse the whore and the gigolo are consoling the madman. He closes the gates and goes off driving a herd of cattle in front of him. In his final plan for a film Artaud produced a work of unprecedented violence and great cinematic potential.

The Revolt of the Butcher is an important work for yet another reason. In it Artaud wanted to use sound in a highly suggestive manner. Actually, he had included sound effects for the *Master of Ballantrae* as well. It was while he was writing that scenario that he decided to make notations in the margins to indicate the appropriate sound accompaniment. He was prompted to do so by commercial considerations. "I decided to introduce sections of sound and even speech into all my scenarios, because there is such a push toward *talking* pictures that in a year or two *no one* will want any more silent films. . . . Everyone is starting talkies. We must follow the crowd in order to direct it."[68] But Artaud was not simply abandoning his ideas of the role of cinema for commercial considerations. "[I]t is imperative that people like us who have maintained the meaning of true and pure cinema demonstrate precisely by example the absurdity and fruitlessness of silent or non-silent cinema and that in giving to the fools their feeding of words we maintain the *identity* of the other cinema of which we are perhaps the only trustees."[69] He incorporated sound effects into *Master of Ballantrae* in such a way as to heighten the effect of cer-

tain scenes. He made sound notations sparingly, using them in a few scenes to accentuate the particular emotional state of his characters as they fight their personal struggles in natural settings. When the Master realizes that all the members of the expedition are out to kill him he bemoans his fate in the desert, his voice echoing in the solitude. Once he dies, the members of the expedition lose their way. Here Artaud's directions called for the mixing of the cries of the men with the howling of wolves and the sound of the wind. Thus Artaud utilized sound to support the particular psychological mood he was trying to create with images. It was specifically used to emphasize the way in which nature reflected the struggles of the human spirit.

By the time Artaud turned to the writing of *The Revolt of the Butcher* his ideas on the role of sound were more sophisticated. As he wrote in the prefatory note, "One will find in this film an organization of voice and of sounds, taken in themselves and not as the *physical consequence* of a movement or of an act, that is to say, without agreement with the facts. Sounds, voices, images, breaks in images, are all part of the same objective world in which movement counts above all else."[70] No longer, therefore, does sound merely support a scene, giving it greater depth or emphasis, but it contributes to the movement of the film itself. As in *Master of Ballantrae*, so here, too, sound is used sparingly. In the bar the gigolo approaches the madman in order to provoke him. The madman hits him in the face, saying calmly, "Watch out, your head will go to the butcher." The waiter then drops his tray. There is a resounding crash which makes an already tense man into someone terrifying. He begins to beat the gigolo with inhuman rage. Just as the people come to the rescue, his mind goes blank and we hear the rumble of the butcher's van on the empty square where he was standing at the beginning of the movie. These sound effects make the action of the film progress which until now has been accomplished purely by visual means. Furthermore, they are particularly effective in capturing the psychological tension of the madman. They interrupt the silent progression of images as the madman's pent-up emotions burst forth. In another scene, when the butcher is supposed to cut up the woman and hesitates, he opens his mouth, then there is a break in the film and an amplified voice announces, "I have had enough cutting up meat without eating it." Such dissociation between the source of the spoken word and the word creates the independent existence of sound as Artaud intended it. Ultimately, however, all these elements are joined together by the visual process. "The voices are there *in space* like objects. And, if I may say so, it is on the visual level that they should be accepted. . . . And it is the eye which finally gathers up and underlines the remainder of all the movements."[71] In the end, it may be Artaud's highly sophisticated use of sound that accounts for the singular impact of *The Revolt of the Butcher*.

While Artaud's concern with the cinema as a commercial product led him to experiment with the use of sound in a startlingly original way, it also brought him up against the hard realities of the movie industry. Despite his repeated efforts to raise funds, Artaud failed to realize any more of his scenarios. In 1930

he wrote his last scenario and returned from his trip to Berlin without any success. After that, his interest in the movies rapidly declined. True, he wrote about an idea he had for a documentary on sorcery and the occult sciences in May 1931, but it never became more than a letter that he planned to send.[72] He could still become excited about the latest movies of the Marx brothers at the end of 1931. Yet he praised them not so much for being exemplary films, but for partaking of a particular magic. "It is difficult to define the nature of this magic. It is in any case something which is not specifically cinematographic, but which does not belong to the theater either, and of which only certain surrealist poems have succeeded, *if they have*, in giving us an idea."[73] He became increasingly contemptuous of movies, especially of those which he saw as following the example he had set in *The Seashell.* . . . He had remarked at the time of the release of *Un Chien andalou* how much that movie owed to *The Seashell.* . . . [74] Now he vehemently attacked Jean Cocteau's *Le Sang d'un poète* and Luis Buñuel's *L'Âge d'or.* "[I] think that *The Seashell and the Clergyman* engendered little movies in all these films, and that they all belong to the same spiritual vein but that which was of interest in 1927—because *The Seashell . . .* was easily the first of the genre and a precursor film—has no more interest in 1932, five years later."[75] He accused his followers of failing to organize the dreamed images, an act which was absolutely imperative if the movie was to have an impact on the mind. Thus, they lacked an intellectual music. Or, as he put it in terms of psychology, "The aim is not show that we are unusually intelligent and that we know today how to approach these things, but to finally give exemplary works of this poetry of the unconscious . . . which is the only poetry possible, the poetry possible and true, with metaphysical tendencies to which films like *Le Sang d'un poète* resolutely turn their backs."[76] Artaud's criticism of these later movies might indeed be valid. Perhaps they do fail to create a psychological, cinematic progression in their zeal simply to exhibit their psychological content. But Artaud's comments must be taken with a grain of salt. Not only was he forever jealous of his ideas and innovations, which he guarded compulsively, but at this period he was becoming increasingly critical of the cinema.

His final break with the cinema came shortly. In an essay written in 1933, entitled "The Premature Senility of Film," he launched into a full-scale attack of movies. Writing as an outsider, he divides films into two types, dramatic movies and documentaries. He makes no mention of himself and of his efforts since they are a thing of the past. He condemns the dramatic film for suppressing poetry in principle. The documentary, on the other hand, presents a fragmentary vision of the external world. It attempts to discover the real nature of things by its arbitrary manner of recording. Through the very process of filming the camera imposes its own order on the spectacle, an order which the eye recognizes as being valid insofar as it corresponds to certain memories of external events. Yet such a film is unable to discover a deeper reality. For Artaud, "The world of the cinema is a dead world, illusory and truncated."[77] It is largely talking pictures which brought about such state of

affairs, for, in being too explicit, they arrested "the unconscious and spontaneous poetry of images."[78] They excluded chance from playing a part in films. For Artaud chance had been a crucial factor in movies before he actually started writing scenarios. In 1925 he had written, "The cinema is the actualization of chance."[79] Now, once again a spectator, he complained about the elimination of chance from movies. "We knew that the most characteristic and most striking virtues of the cinema were always, or almost, the effect of chance, that is to say, a sort of mystery whose fatality we could not explain."[80] Yet whatever reasons Artaud brought forth to prove that movies were reaching an early death, it was in the end his own frustration and disappointment with the cinema over a period of eight years that was responsible for his total disenchantment. Artaud concluded his indictment of movies with the judgment that "we must not expect of the cinema to restore to us the Myths of the man and the life of today."[81]

By 1933 it was in the theater that Artaud expected to find the myths of the present revealed. He was in the midst of writing the essays which were to form the core of his ideas on the theater, *The Theater and Its Double*. It was in this year that he wrote his play *The Conquest of Mexico*, which best exemplified the theater of cruelty. He was to stage his sensational *Cenci* only two years later. He became the apostle of the theater of cruelty, for which he is best remembered today. Yet for a long time he sought his personal answer in the cinema. Perhaps it was only because of his inability to realize his scenarios as films that he totally abandoned the medium.

The line between Artaud's cinematic and theatrical work is not at all clear. He worked in both media at the same time. What he attempted to achieve on the stage was often remarkably similar to the effects he sought to attain on the screen. He wrote of the theater in terms which he applied to the cinema as well: "We conceive of the theater as a veritable magic operation. We do not address ourselves to the eyes, nor to the direct emotion of the soul; that which we seek to create is a certain *psychological* emotion where the most secret energies of the heart are laid bare."[82] He often presented the same motifs in both plays and film scenarios, such as the idea of dual personality, which haunted him throughout his life. Ultimately both the theater and the cinema served as artistic projections of Artaud's search for his own identity.

NOTES

1. This incident was recounted in *Le Charivari*, February 18, 1928, and is reprinted in *Oeuvres complètes d'Antonin Artaud*, (Paris, 1970), 3:368. This volume, which brings together all of Artaud's film scenarios, articles, and interviews on the cinema, as well as many letters from the period of his involvement with films, is the single most important work for the study of Artaud's cinema. A number of scenarios and texts have been translated into English and published as "Scenarios and Arguments: Antonin Artaud," *Tulane Drama Review* 2 no. 1 (Fall 1966):166-85.

2. Letter from Antonin Artaud to Max Jacob, c. October 1921, in Artaud, *Oeuvres complètes* 3:116.

3. *La Révolution Surréaliste*, no. 3 (April 15, 1925).

4. Philippe Soupault, "Enquête," *Les Cahiers du Mois*, nos. 16-17 (1925), pp. 179-82.

5. No exact dates exist for Artaud's first two film scripts, *Deux nations sur les confins de la Mongolie . . .* and *Les Dix-huit secondes.* The only suggestions as to their dates was made in the notes accompanying volume 3 of Artaud's *Oeuvres complètes.* The suggestion is that *Deux nations . . .* must be dated around 1926 because of the specific political events mentioned in it, such as the revolt in China and its allusions to Surrealism. *Les Dix-huit secondes* is assigned 1924-25 because the single typed copy belonged to Génica Athanasiou. These dates should be understood as attempts to locate the works in general chronological framework. The information available to us does not allow specific dating. The two scenarios clearly precede Artaud's other film scenarios, all of which he deposited with the Association des Auteurs de Films and which therefore bear the exact dates of their deposition. I agree with the opinion in Gallimard in assigning 1925-26 to these initial scenarios, but I believe that the order should be reversed. *Deux nations . . .* is a specifically Surrealist piece, designed more as a literary work than as a scenario to be realized as a film. Artaud's most fervent involvement with Surrealism came at the very beginning of his association with the group, as No. 3 of *La Révolution Surréaliste*, an issue which he edited in April of 1925, would indicate. It was only later that he wrote scenarios which he sought to realize on the screen. Therefore, I see *Les Dix-huit secondes* as a work which followed *Deux nations . . .* and which preceded his other scenarios of 1927 and later.

6. *Deux nations sur les confins de la Mongolie . . .* in Artaud, *Oeuvres complètes* 3:23.

7. "Réponse à une enquête," Ibid., p. 79.

8. Ibid., p. 81.

9. Ibid.

10. Ibid., p. 80.

11. Ibid.

12. *Les Dix-huit secondes* in ibid., pp. 11-16.

13. Ibid., p. 11.

14. Letter from Artaud to Jacques Rivière, June 5, 1923, as reprinted in Antonin Artaud, *L'Ombilic des limbes* (Paris, 1968), p. 20.

15. *La Coquille et le clergyman* in Artaud, *Ceuvres complètes* 3:22-31. The scenario was deposited with the Association des Auteurs de Films on April 16, 1927.

16. Quoted in *Film: The Museum of Modern Art Department of Film Circulating Programs* (New York, 1969), p. 29.

17. Bettina L. Knapp, *Antonin Artaud, Man of Vision* (New York, 1969), p. 123.

18. The connection between Artaud's theater and alchemy has been illuminated in a fascinating article by Ann Demaitre, "The Theatre of Cruelty and Alchemy," *Journal of the History of Ideas* 33, no. 2 (April-June 1972):237-50. What emerges most clearly is that the key step of the alchemical process, the *Mortificatio*, is also Artaud's central preoccupation. This is the step which consists of the annihilation of matter as a necessary preamble to resurrection. The act of cleansing destruction haunts Artaud throughout his life and often surfaces in his works.

19. Knapp, *Antonin Artaud, Man of Vision*, p. 124 .

20. For a close comparison of the text and the film I have relied on the unpublished, shot-by-shot analysis of the film as established by Señor Román Gubern of Barcelona and which he kindly made available to me. Such comparison of text and film plan shows just how closely Mme. Dulac followed Artaud's instructions.

21. Alain Virmaux, "Artaud and Film," trans. Simone Sanzenbach, *Tulane Drama Review* 2, no. 1 (Fall 1966):154-65.

22. Letter from Artaud to Germaine Dulac, c. May 19, 1927, as reprinted in Artaud, *Oeuvres complètes* 3:131.

23. Letter from Artaud to Dulac, June 17, 1927, in ibid., p. 133.

24. Letter from Artaud to Jean Paulhan, August 29, 1927, in ibid., p. 141.

25. In an article prepared by Mme. Yvonne Allendy after the Ursulines Club scandal, she calls the instances of Germaine Dulac's deviations from the script, "heavy errors such as: the skirt which becomes a night shirt (instead of a road at night), the tongue which becomes a rope, the repetition of the story of the key in the passageway, etc., im-

ages whose meaning is disfigured and which only have a technical value without any interest." Published in ibid., Notes, p. 369. Only a person intent on disagreeing would consider these substitutions as constituting a major distortion of the spirit of an entire movie. Indeed, a few years later Artaud changes his opinion and looks back at *The Seashell* . . . as an exemplary film. See below, footnotes 73-74.

26. Letter from Artaud to Dulac, June 17, 1927, in ibid., p. 133.
27. Ibid.
28. Ibid., p. 134.
29. Letter from Artaud to Dulac, July 13, 1927, in ibid., pp. 138-39.
30. "Sorcellerie et cinéma," ibid., p. 82.
31. Ibid., p. 84.
32. Ibid., p. 83.
33. Ibid., pp. 82-83.
34. Ibid., p. 85.
35. "Cinéma et réalité," *La Nouvelle Revue Française*, no. 170 (November 1, 1927), as reprinted in ibid., p. 24.
36. Ibid., p. 22.
37. Ibid.
38. Ibid., pp. 22-23.
39. Ibid., pp. 23-24.
40. "Le cinéma et l'abstraction," *Le Monde illustré*, No. 3645 (October 29, 1927), as reprinted in ibid., p. 89.
41. "Cinéma et réalité," ibid., pp. 24-25.
42. *La Révolte du Boucher* in *La Nouvelle Revue Française*, No. 201 (June 1, 1930), as reprinted in ibid., p. 70.
43. "Au grand jour" in Maurice Nadeau, *Histoire du surréalisme* (Paris, 1945), 2:96.
44. "À La Grande Nuit ou le Bluff surréaliste" in Antonin Artaud, *L'Ombilic des limbes*, p. 229.
45. Ibid., p. 226.
46. "Ventre brûlé ou la mère folle," Artaud, *Oeuvres complètes* 2:37-38.
47. Letter from Artaud to Yvonne Allendy, February 19, 1929, in Artaud, *Oeuvres complètes* 3:157.
48. Letter from Artaud to Yvonne Allendy, March 21, 1929, in ibid., p. 161.
49. *Vols* in ibid., pp. 32-38. The scenario was deposited at the Association des Auteurs de Films on November 19, 1928.
50. The French title *Vols* means both "flights" and "thefts." While here we are simply interested in the exploration of the theme of flights, the title is also a pun on the two thefts in the story, the original theft and the lawyer stealing back the document.
51. *L'Avion solaire* in ibid., pp. 56-58. The scenario was deposited at the Association des Auteurs de Films on January 17, 1929.
52. Ibid. Notes, p. 372.
53. Quotes taken from *Deux nations* . . . in ibid., pp. 17-21.
54. The connection between flight and movies goes deeper than the similarity of sensations experienced in an airplane and in the movie theater. Sigmund Freud observed that flying was a universal symbol of sexuality in dreams. See *The Interpretation of Dreams* in *The Basic Writings of Sigmund Freud*, ed. and trans. Dr. A.A. Brill (New York, 1938), pp. 315, 387. His psychoanalytic work on Leonardo da Vinci probably offers his most complete discussion of this relationship. He notes the numerous instances in which sexuality was expressed in terms of flight: the story of the stork bringing the baby, the winged phallus of the ancients, the German slang expression for sexual intercourse, *vögeln* (to bird), and the Italian slang for the male member, *l 'uccello* (the bird). (Similar expressions may be found in current American slang as well.) Freud demonstrates in his work that Leonardo's sexuality was sublimated to a remarkable extent into his creative activity, thus making him an almost asexual person. His sexuality surfaced in the very powerful infantile dream he recalled of a vulture swooping down on him, opening his mouth with its tail, and slapping it. Leonardo's later interest in the dynamics of flight is seen as a further emergence of his sublimated sexuality. Freud concludes that "the wish to be able to fly signifies in the dream nothing more or less than the longing for the ability of sexual accomplishment." See Sigmund Freud, *Leonardo*

da Vinci, trans. A.A. Brill, (London, 1922), p. 108. Freud's observation might just as well have been made about Artaud, whose love for Génica Athanasiou remained unfulfilled. Artaud's inability to attain his love is such a dominant concern that it surfaces in his scenarios, *Eighteen Seconds, The Seashell and the Clergyman*, and *The Revolt of the Butcher*. What is noteworthy about the theme of flight is that it appears only in his film scenarios. It was the cinema which aroused an awareness of his sexuality, just as it did in André Breton, Robert Desnos, and the other Surrealists. But while these others wrote openly about their sexual fantasies which were launched in the movie theater, Artaud's imagination transformed these erotic impulses into the images of flight which we have noted.

55. Letter from Artaud to Dulac, June 17, 1927, in Artaud, *Oeuvres complètes* 3:134.
56. *Les 32* in ibid., pp. 39-55. The scenario was deposited at the Association des Auteurs de Films on January 17, 1929.
57. Letter from Artaud to Yvonne Allendy, March 10, 1929, in ibid., p. 158.
58. Ibid., p. 159.
59. *Le Maître de Ballantrae de Stevenson* in ibid., pp. 59-69. The scenario was deposited at the Association des Auteurs de Films on April 26, 1929.
60. Artaud undertook the writing of a film scenario soon after *The Master of Ballantrae*, an adaptation of *Le Dibbouk* by An-ski (Solomon Rappoport). In a letter to Yvonne Allendy of April 19, 1929, he writes that this scenario is already finished and that he only has to type it. Ibid., p. 170. Unfortunately the scenario has not come down to us. It is significant that Artaud chose this story, for it concerns a "dibbouk," a restless soul which occupies the body of another in order to purify itself. Once again Artaud was drawn to a story about a dual personality.
61. *La Conquête du Mexique* in Artaud, *Oeuvres complètes* 5:23.
62. Letter from Artaud to Jean Paulhan, January 25, 1936, in ibid., pp. 272-73. I have used Ann Demaitre's translation of this phrase as it appeared in her article "The Theatre of Cruelty and Alchemy."
63. *Héliogabale* in Artaud, *Oeuvres complètes* 7:140. For a thorough examination of Artaud's split personality, see Dr. J.-L. Armand-LaRoche, *Antonin Artaud et son double* (Paris, 1964).
64. Letter from Artaud to Yvonne Allendy, April 21, 1929, in Artaud, *Oeuvres complètes* 3:172-75. Artaud arrives at a figure of 700,000 francs that he would need to make a full-length feature of *The Master of Ballantrae*. He writes that this compares well with the usual 2,000,000 spent on a film. Indeed, the figure seems reasonable, since Luis Buñuel and Jean Cocteau made their *L'Âge d'or* and *Le Sang d'un poète* respectively with a million francs each.
65. "Antonin Artaud," *Cinémonde*, August 1, 1929, as reprinted in ibid., p. 347.
66. "Projet de constitution d'une firme destinée à produire des films de court métrage d'un amortissement rapide et sûr," in ibid., pp. 92-98.
67. *La Révolte du Boucher* in *La Nouvelle Revue Française*, No. 201 (June 1, 1930), as reprinted in ibid., pp. 70-76.
68. Letter from Artaud to Yvonne Allendy, April 19, 1929, in ibid., p. 171.
69. Ibid.
70. *La Révolte du Boucher* in ibid., p. 71.
71. Ibid.
72. Project of a letter from Artaud to Maurice Garçon, May 3, 1931, in ibid., pp. 235-36.
73. "Les Frères Marx," *La Nouvelle Revue Française*, No. 220 (January 1, 1932), as reprinted in Artaud, *Oeuvres complètes* 4:165.
74. "All these people, I feel are upset, especially because they *all recognize* (I knew it) the connection *Coquille-Chien Andalou*, and this connection WEIGHS ON THEM." Letter from Artaud to Yvonne Allendy, November 1929, in Artaud, *Oeuvres complètes*3:189.
75. Letter from Artaud to Jean Paulhan, January 22, 1932, in ibid., p. 300.
76. Ibid., p. 302.
77. "La vieillesse précoce du cinéma," *Les Cahiers jaunes*, No. 4 (1933), as reprinted in ibid., p. 104.
78. Ibid., p. 105.
79. *La Révolution Surréaliste*, No. 3 (April 15, 1925).

80. Artaud, *Oeuvres complètes* 3:106.
81. Ibid., p. 107.
82. "Manifeste pour un théâtre avorté," November 13, 1926, in Artaud, *Oeuvres complètes* 2:23.

6

The Fulfillment of Surrealist Hopes: Dalí and Buñuel Appear

The Collaboration

The Surrealist experiment with movies culminated in the efforts of Luis Buñuel and Salvator Dalí in the two films they produced together in 1929 and 1930. *Un Chien Andalou* and *L'Âge d'Or* were immediately hailed by the Surrealist circle as films which faithfully represented the aspirations of the group. André Breton, the dean of the movement, was so impressed with them that even twenty years later he continued "to regard them as the two most accomplished Surrealist films."[1] With the passage of time they have come to stand for Surrealist cinema as such.

The numerous ingenious attempts that have been made to explain these films have neglected to deal with the basic problem of authorship. If any comment is made at all about the respective roles of the two men, it is invariably that Dalí's role was greatly subordinated to Buñuel's and that Dalí was responsible only for the slick effects that appear in the two films. The reasons for such favorable opinion toward Buñuel can be understood but cannot be condoned. Those who have written about surrealist film are either partial to Surrealism or to the cinema. The Surrealists, with their strong pro-communist sympathies, never forgave Dalí deserting them for Catholicism, Franco's Spain, and rich Americans. Biographers of Buñuel have not forgotten that Dalí was at least indirectly responsible for Buñuel's dismissal from his job as chief editor of film adaptations at the Museum of Modern Art during the early 1940s. Furthermore, faced with the vast body of Buñuel's excellent cinematic work, they all too readily attribute the shortcomings of the movies to Dalí. It is time for a serious examination of the two men's cooperation if we are to understand the dynamics of the two films.

It is no easy task to separate the Dalí and Buñuel components of the films under discussion. While in the case of the production of *Entr'acte* we are faced with two radically different personalities in Francis Picabia and René Clair, the co-authors of these two films appear embarrassingly similar at the time of their adhesion to the Surrealist circle. The two young Spaniards met in the early 1920s at the Residencia of the University of Madrid where the Generation of '27 was forged, that group of talented writers and artists who were to shape the artistic and intellectual profile of Spain in the coming years. Their common intellectual formation offered only the basis for the close friendship that was to grow between them. By the time of their collaboration on the films, they both had gravitated toward Paris. They joined the Surrealist group after the showing of *Un Chien Andalou* in 1929 and contributed to the Surrealists' periodicals for the next few years. Only in the mid-1930s did Dalí begin to express rightist opinions which led him away from both Buñuel and the Surrealist group. Since then, not only have the two men not talked to one another, but also their lives and work have gone completely different ways.

Dalí's contribution was especially significant in the first film, as the two men's accounts indicate. In his autobiography Dalí writes of their work on *Un Chien Andalou* in the following way:

> It was at about this period that Luis Buñuel one day outlined to me an idea he had for a motion picture that he wanted to make, for which his mother was going to lend him the money. His idea for a film struck me as extremely mediocre. It was avant-garde in an incredibly naive sort of way, and the scenario consisted of the editing of a newspaper which became animated, with the visualization of its news-items, comic strips, etc. At the end one saw the newspaper in question tossed on the sidewalk and swept out into the gutter by a waiter. This ending, so banal and cheap in its sentimentality, revolted me, and I told him that this film story of his did not have the slightest interest, but that I, on the other hand, had just written a very short scenario which had the touch of genius, and which went completely counter to the contemporary cinema.
> This was true. The scenario was written. I received a telegram from Buñuel announcing that he was coming to Figueras. He was immediately enthusiastic about my scenario, and we decided to work in collaboration to put it into shape. Together we worked out several secondary ideas, and also the title—it was going to be called *Le Chien Andalou*. Buñuel left, taking with him all the necessary material. He undertook, moreover, to take charge of the directing, the casting, the staging, etc. . . . But some time later I went to Paris myself and was able to keep in close touch with the progress of the film and take part in the directing through conversations we held every evening. Buñuel automatically and without question accepted the slightest of my suggestions: he knew by experience that I was never wrong in such matters.[2]

This passage cannot be totally dismissed merely because of its conceited, pompous tone. According to Buñuel himself, it was he who had come to the Dalí home in Figueras to work on the scenario.[3] It seems that he had indeed first mentioned his idea to Dalí for a film dealing with a newspaper which he gladly

abandoned in favor of Dalí's proposal.[4] Moreover, Buñuel was extremely
satisfied with their cooperation. In a letter written at the time he says that
"with Dalí, more united than ever, we have worked in intimate collaboration
to create a stupendous scenario, without antecedents in the history of the
cinema."[5] Even years later he freely admitted that "as far as the scenario of
Chien is concerned, you can say that it is the work of both of us. In some
things we worked greatly united. In fact, Dalí and I were flesh and blood dur-
ing that period."[6] Thus, in the writing of the scenario one can be certain that
Dalí's part was considerable, and, in fact, he may have acted as the initiator of
ideas.

Dalí's role in the actual shooting was much more limited. According to his
own testimony, he left the direction of the filming to Buñuel, who, after all,
had been Jean Epstein's assistant for the past three years. Buñuel recalled that
Dalí showed up only on the last day of shooting.[7] Even if we pit this against
Dalí's boastful account of his role, he still emerges only as a bystander whose
opinions were taken into consideration during the production.

Even from these two accounts, it becomes apparent that Dalí's contribution
was considerable. In order to determine his exact role, we must sketch his pro-
file, which will also reveal the nature of his creative impulse. First of all,
Salvador Dalí's highly original imagination and remarkable virtuosity in paint-
ing are established facts. He has created some of the most powerful canvases
of the Surrealist painters. Both in his paintings and in his writings he has
displayed an obsessive interest in psychological matters which go beyond those
of a disinterested observer. As one who knew him well, André Breton re-
marked that "on the physiological level, he is satisfied to have stayed partially
at the level of his first teething; he flatters himself that he knew no woman un-
til the age of twenty-five; on the mental level, no one is smitten more by
psychoanalysis than he, but if he makes use of it, it is in order to maintain
fiercely his complexes, to carry them to exuberance."[8]

Indeed, Dalí has remained somewhat of a child throughout his adult life.
His autobiography bears testimony to how his acts of childhood exhibitionism
were carried on into maturity. This exhibitionism was the outward projection
of a narcissism with which his works are stamped so clearly. For example, he
relates a story from his childhood when on a hot summer day, while watching
the women work in the orchard, he hid in a storeroom, stripped bare, and let
the juice from an overripe pumpkin run over his body. He describes with great
relish many other sensual impulses to which he gave in, such as touching the
breasts of a matronly blossompicker. "All my life has been made up of
caprices of this kind, and I am constantly ready to abandon the most luxurious
voyage to the Indies for a little pantomime as childish and innocent as [this]
one."[9]

The young man could pursue his narcissistic whims without much detriment
to himself until he left the stability of the parental home and came to confront
his own sexuality in the outside world. It was soon after his first exhibitions in
Paris and just before his collaboration on the two films under discussion that

he went through a rather severe psychological crisis. On one of his first trips to Paris he was living by himself in a single room. While taking a bath, he noticed a tick on his back, which he tried to remove by slashing at it with a razor. He cut himself so severely that he began to bleed profusely. When a doctor arrived, he found out that he had been cutting a mole which had always been there. In such a period of emotional crisis, his deeply rooted narcissism was turned against himself to become a self-destructive force. He mentions that during this time he experienced an increasing number of hallucinations, such as this one. In the summer of 1929 his friends Luis Buñuel, René Magritte, and Paul Eluard came down to Cadaqués to visit him, and it was in their company that he frequently broke down into uncontrollable fits of laughter.[10] He recalls with glee how he fled from his friends, cut himself with a razor, and rubbed a paste of goat manure all over his body in preparing to exhibit himself in front of them. It was only at the last moment that he decided to wash off the smelly concoction. When Eluard's wife, Gala, sought to understand his strange behavior, he reached out to her for the kind of emotional stability he needed. Meeting Gala provided Dalí with the chance to resolve his narcissistic conflict. "Gala thus weaned me from my crime, and cured my madness. . . . My hysterical symptoms disappeared one by one, as by enchantment. I became master again of my laughter, of my smile, and of my gestures. A new health, fresh as a rose, began to grow in the center of my spirit."[11]

Living with Gala, Dalí found a new strength and peace of mind which allowed him to project into his work the violent narcissistic drives which had threatened to destroy him. Gala became a mother who accepted his whims and complexes. He found in her the security of the maternal womb. Dalí's fixation on the womb is a rather pronounced one. He begins his autobiography with a fantastic description of his intrauterine memories. He has posed as a grown man for a photograph in which he curls up nude in the prenatal position within the form of an egg. No wonder that he strove to make the house he brought with Gala in Port Lligat "very small—the smaller, the more intrauterine."[12] The fulfillment of his longing for the womblike security of a woman led him to confront the world with greater self-assurance. He developed his "paranoiac critical activity," which in itself was a curious echo of his newly found, peculiar emotional stability. Defined as a "spontaneous method of irrational knowledge based upon the interpretive-critical association of delirious phenomena,"[13] it was essentially an attempt to create a certain order out of impressions of fantasy which could be applied to works of art or everyday experience. Dalí himself associated "paranoiac" with soft, i.e. elusive, and "critical" with hard, i.e. tangible.[14] This method, with its fleeting impact on Surrealism, reflected Dalí's new state, for amidst spasms of emotional turmoil which threatened to remove him altogether from the sphere of reality he found in Gala the ordering stability that could balance his wild imaginary spirit.

Meeting Gala gradually brought out other aspects of his character. In a poem written soon after the beginning of their affair he writes, "Gala . . . gives me degrading notions of egoism, of the absolute lack of pity, of desirable

cruelty, . . . Nothing outside of her suffering which is my suffering . . . can touch me vitally, for even if I had to observe the most atrocious torture of the most admired friend I would rather feel my stick ready for erection than my mind troubled by a lowly moral sadness."[15] It was the extreme security he found in Gala after his dangerous confrontation with the outside world that made him withdraw and renounce the political and social struggle that his Surrealist friends were waging. For his egocentric temperament it was sufficient that his own crises be resolved. Once they were, he easily came to identify with the patrons of art whose way of life he all too readily adopted, earning him the derisory nickname devised by Breton "Avida Dollares."[16]

Such thumbnail psychological sketch of Dali would be of little help in trying to understand the nature and extent of his contribution to the movies if there were nothing else. Fortunately he wrote a film scenario in 1932 called *Babaouo*, in which his cinematic ideas find full expression. This scenario and his psychology should provide the two points of reference from which our own observations may be made. In *Babaouo* Dali demonstrates that he had a more than casual involvement with the cinema. In the short preface entitled, "Summary of a critical history of the cinema," he attempts to make a few general comments about the nature of the medium itself. Like much of his writing which treats conceptual problems, this prologue too tends to be muddled. What does emerge is that Dali considers the cinema to be a medium poorer than all others. Its fault lies in its very nature which easily lends itself to the creation of harmony.[17] Since harmony is the exact opposite of true poetry, the filmmaker must break through that innate harmony. "The poetry of the cinema demands more than any other [medium] a traumatic dislocation, violent towards concrete irrationality, in order to attain a true lyrical state."[18] The scenario that follows bears out Dali's attempts to bring about such a traumatic dislocation.

Babaouo is more than the actualization of a theory of film. In it Dali proves that the strength of his imagination is not confined to the creation of extraordinary canvases. That he has a remarkable sense of the theatrical is borne out by the opening scene. A bellboy rushes down the corridor of a hotel. He stops at a door and is about to knock when he hears the hysterical laughter of dozens of people coming from inside mixed with the violent noise of heavy objects striking the walls. He waits to knock until the noise subsides, but the uproar simply continues with added vigor. He starts to beat on the door impatiently. A woman's voice calls out, "Just a second. You can't enter now," and the tumult resumes. After a short interval the door opens with great ease, but just enough to reveal half of a woman in a transparent wrap. The soft focus of the lens is supposed to reveal a beautiful young creature with disheveled hair. The bellboy tells her he has an express letter for Mr. Babaouo. When she withdraws, the noise reaches a new crescendo and the door budges under the blows. It opens again only to let out a decapitated hen. We see it going through its last convulsions outside in its pool of blood. Finally Mr. Babaouo makes his appearance.

After such a suspense-building opening, Dali's scenario proceeds unevenly, but he does include several surprisingly effective images. He introduces a number of visions which are intended to have an oneiric quality. Thus, Babaouo sees a completely naked woman at the end of the metro car he takes. Then, while waiting at the platform to change trains, he notices seals playing in the tunnel. Dali also builds events which create shock effects. He has a piano come crashing down the stairwell onto a marble floor as Babaouo leaves his hotel room. Or, while he talks to a friend on the street, a flood descends ankle deep, bearing the carcasses of cows, donkeys, and horses. Interspersed in the narrative are wonderful tableaux which remind us of the author's ability to create on the canvas extraordinary combinations of objects. On the way to the Chateau du Portugal, where his beloved Mathilde has called him, Babaouo comes across a theater where he sees a violinist enraptured by the piece he plays, with a chest of drawers balanced on his head, standing on one leg while the other is placed on a plate of milk, his trousers carefully rolled up. Then, when our hero is driving away with his love, he sees off the main road a bus five times regular size. It contains a little boat, floating on water. Inside the boat are three crippled Japanese singing a rhumba with great sensuality. When Babaouo stops to look at them, they burst out laughing and, try as they might, they cannot go back to the song.

Dali is not limited to presenting highly effective isolated gags. He is equally capable of creating entire scenes of gripping suspense or outrageous humor, as we have seen him do it in the opening of the scenario. At the point when Babaouo starts walking toward the chateau of his mistress, he begins to hear the rhythmic noise of monstrous breathing. As he approaches his destination, the pounding rhythm increases until it becomes deafening. Babaouo is absolutely terror-stricken. We notice that his path has led him closer and closer to a long, high wall. The raising of the camera at this point high above his head should reveal the entire panorama of the terrain, especially the beach on the other side of the wall where the noise is created by the pounding surf. Dali is just as skillful in building scenes of mass chaos. When Babaouo goes into the metro station to begin his journey to the castle, he sees a couple doing a tango on a landing. At the platform he finds a hugh orchestra starting to play. The crowd waiting for the train pays absolutely no attention to them. They walk among the musicians, talking loudly. Despite disturbances, the players show remarkable self-restraint. Often music stands are knocked over, but the players pick up their soiled music sheets with bitter smiles. When the metro arrives, the crowd rushes on the trains like stampeding animals. The music virtually stops: some players grab their instruments to themselves for protection; the less fortunate try to find them amidst the feet of the crowd; still others huddle against the walls for cover as they try to continue the piece. All the while, the conductor is rapping his baton impatiently against his stand. Once the chaos reaches intolerable proportions, all he can do is nervously bite his lips. The train finally leaves and the battered musicians slowly reassemble. No sooner do they start playing, however, than a train comes from the other direc-

tion to disgorge its passengers as violently as the previous one sucked them up. Confusion reigns once again.

While *Babaouo* proves the unusual creativity of Dali, it compares in no way with the scenarios, let alone the finished films, of the Dali-Buñuel collaboration. Most conspicuous is the absence of a forceful, unifying argument which lies at the core of both *Un Chien Andalou* and *L'Âge d'Or*. The masterful touches of *Babaouo* do not add up to anything more. A vision is tacked on to an episode with little craft and less reason. But those brilliant vignettes lead us to believe that Dali's role in the films was much greater than previously assumed.

Unlike the exhibitionistic Dali, Buñuel was always more introverted and self-controlled. The oldest of seven children, Luis assumed the responsibility of being the oldest brother from early childhood. In the Jesuit college he attended he was a serious student, envied by many of his classmates for his unusual maturity. Yet the outward propriety masked deep emotions in the young Luis. He recalled his childhood as having been guided by two basic sentiments, eroticism and an awareness of death. These concerns naturally led him to Surrealism as a young man and they were to emerge with unabated strength in most of his creative work long after he lost contact with the Surrealist group.

Like so many students of the Jesuits, Luis, too, rejected their teachings to become a revolutionary. He turned against the sexual and political restraints of Catholicism without being able to divest himself completely of its trappings. While in his films he has repeatedly explored a whole gamut of perversities in order to show the force of total, irrational, mad love, in his personal life he has been at once discreet and monogamous. He has always lived the asceticism of his Jesuit teachers. Even today he lives a monkish life in a simple, impersonal house in a Mexico City suburb. He goes to bed at 9:00 P.M. and gets up at 5:00 A.M., sleeping on hard wooden boards, covered by a rough blanket. He walks two miles every day and exercises regularly. Politically, Buñuel has been consistently at odds with the forces of oppression and injustice throughout his life. His joining the Surrealists, his working for Republican Spain, his dubbing of anti-Nazi films in the U.S., his permanent exile from Franco's Spain, not to mention the sum total of his films all testify to his unwavering radicalism.

Thus, the two men differ greatly in temperament, lifestyle, and world view. Buñuel's personal austerity contrasts sharply with Dali's hedonism. Unlike Buñuel, who has sought to lead a private life, Dali has always been in search of publicity. Dali's mercurial change in political loyalty is the antithesis of Buñuel's steadfast radical position. Essentially, Dali's is an amoral stance, at odds with Buñuel's morality, which he has defined in opposition to conventional bourgeois morality. While lack of a moral position can result in a number of divergent, contradictory forms, any moral stance necessitates a consistent world vision. It posits a purpose and works toward it by means of an argument. Thus, what separates the work of the two men is structure—its absence in Dali, its presence in the very first of Buñuel's creations, which he

confirmed and elaborated in his later films.

Although the nature of their work is so different, the specific contributions of the two collaborators are difficult to pinpoint. Their similar backgrounds and experiences, as well as their close friendship at the time of their working on the films makes a clear-cut separation of their roles impossible. They were so close, in fact, that a number of images appearing in the two films can be said to belong to both men's artistic repertoires. A vivid example of such a motif is the putrefying carcass of a donkey. Already in 1927 Dalí had depicted the carcass in his painting *Le Sang est plus doux que le miel.*[19] In *Un Chien Andalou*, of course, two dead donkeys appear on the piano. Then in Buñuel's documentary film about the life of a very poor people in a remote corner of Spain, *Las Hurdes*, we see again a donkey which has fallen in its tracks, never to stand up again. Such an image obviously sprang from their recollections of experiences in the Spanish countryside. It was an image equally powerful and equally valid for both of them. Another theme which had common appeal was that of a hand crawling with ants. Buñuel recalls that Dalí had obsessively dreamed that image before they sat down to pool their ideas.[20] Ants appear in a number of contemporary Dalí canvases, such as *Le Grand Masturbateur*. But that image struck deep chords in Buñuel as well, since he was an avid student of entomology, using scorpions, bees, and cockroaches in his later movies for their intrinsic appeal and as symbols of the human condition.

Yet another similar common image is that of the orchestra which plays in *L'Âge d'Or* while the lovers are in each other's arms nearby. It is an image which probably sprang from Buñuel's mind, since he was very fond of the violin as an adolescent, going as far as forming his own orchestra, which performed in church. He had the intention of putting an orchestra in the background of the scene of *Los Olvidados* when Jaibo is ready to kill another boy in a vacant lot. He wanted to place the musicians on the skeleton of the building shown in the background and was prevented from doing so by his producer. The appearance of the musicians would have had a highly comical impact because of the ludicrous place they occupied.[21] It is significant to note not merely that Dalí used the image of the orchestra in *Babaouo*, but that he used it in a similarly striking and comic way.

In the making of *Un Chien Andalou* Buñuel seems to have followed Dalí. Coming to ask his for his cooperation in writing the scenario, he quickly abandoned his initial idea of a film on newspapers and accepted Dalí's suggestion which became the movie. Dalí's boasts of his leading role may not be great exaggerations, expecially when we consider Buñuel's own account of the way decisions were made. Buñuel remembers the choosing of the title in the following way: "Dalí then found out the title of one of my forgotten books of poems: *El perro andaluz*. 'This is the title!,' exclaimed Dalí and so it was."[22] Apart from the general idea of the movie, certain vignettes can be traced directly to Dalí, such as the one in which the hero pulls a load comprising two corks, a melon, two priests, and two grand pianos, each with the carcass of a donkey on top. The conglomeration of such disparate objects is a veritable

motif of *Babaouo*. This was the scene which Dalí helped prepare and in which he appeared as one of the priests. His account of the preparations of the accessories reveals his violent and perverted bent:

> The shooting of the scene of the rotten donkeys and the pianos was a rather fine sight, I must say. I "made up" the putrefaction of the donkeys with great pots of sticky glue which I poured over them. Also I emptied their eyesockets and made them larger by hacking them out with scissors. In the same way I furiously cut their mouths open to make the white rows of teeth show to better advantage, and I added several jaws to each mouth so that it would appear that although the donkeys were already rotting they were still vomiting up a little more of their own death, above those other rows of teeth formed by the keys of the black pianos. The whole effect was as lugubrious as fifty coffins piled into a single room.[23]

We may safely attribute certain other ideas and images to Dalí, such as the book read by the woman which opens on an illustration of Vermeer's *Lacemaker*, or the sequence in which the man's mouth disappears and takes on the hair of the woman's underarms. Dalí's admiration for Vermeer is a well-known fact. His concern with Vermeer's works appears, for example, in a canvas such as *The Ghost of Vermeer of Delft*.[24] The disappearance of the man's mouth is related to Dalí's preoccupations with his intrauterine experience. The wish to return to the womb also implies a return to an unformed state. In fact, such undefined embryonic figures populate Dalí's paintings. *Le Rêve* of 1931 exemplifies this interest, for neither the eyes nor the mouth is articulated in the image of a woman's face.[25] Dalí's psychological preoccupations may be seen in other scenes as well. The appearance of the hero's double might be regarded as a slight alteration of Dalí's obsession with being the exact counterpart of his parents' first child, after whom he was named and who died from meningitis three years before Salvador's birth.[26] Or, the view of the hero dying in the fields, reaching out to a woman whose naked back is turned toward him may be seen to reflect Dalí's essentially helpless attitude toward women.[27]

The complexity of the problem of attribution of specific motifs is highlighted by the most memorable and jarring scene in all of Surrealist cinema, the slashing of the eyeball, which opens *Un Chien Andalou*. In a recent interview Buñuel recalled that he had dreamed of the slit eyeball.[28] In the film, he is the actor who performs that cut. Yet a contemporary account by Georges Bataille, a friend of Buñuel's, attributes that scene to Dalí.[29] Buñuel reportedly felt physically ill after slashing the eye, while Dalí clearly relished the similar cutting of the donkeys' eyesockets.[30] Even if the confusion is merely a function of the passage of time, that only confirms the similarity of the two men's imagination which has caused Buñuel alternately to claim and to reject that most striking of images.

Rather than attempt to solve such insoluble problems, it might be best to recall the general approach of the two men in making the film. By this time both Buñuel and Dalí were thoroughly acquainted with the writings of Freud.[31] They had set out specifically to make a psychological film. Thus, it is

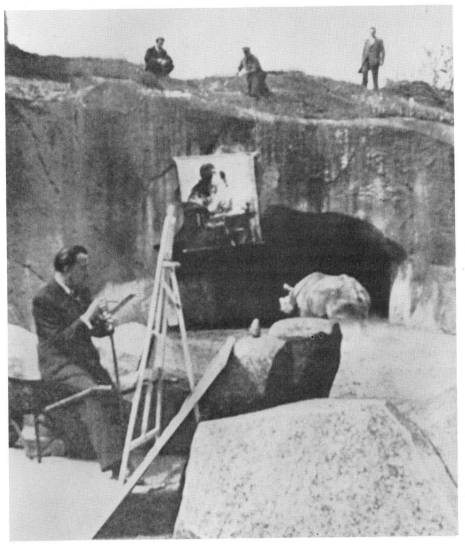

Salvador Dali posing with two of his favorite objects, Vermeer's *Lacemaker* and a rhinoceros, 1955.

no wonder that the movie abounds in scenes and images which refer to so many extreme psychological states.

Un Chien Andalou immediately propelled the two young Spaniards into the limelight of the Parisian moviegoing public. Their film was well received by the apostle of Surrealism, André Breton, who exclaimed as he came out of the theater, "This, yes, this is a surrealist film."[32] From that point on they were full-fledged members of the Surrealist group. Yet the two young men reacted very differently to the immediate success of the film. Dali was perfectly pleased:

Salvador Dalí, *Le rêve*, 1931.

"The film produced the effect that I wanted, and it plunged like a dagger into the heart of Paris as I had foretold. Our film ruined in a single evening ten years of pseudo-intellectual postwar avant-gardeism."[33] Buñuel, on the other hand, had expected to excite the audience to angry disapproval and had thus come to the opening night with stones in his pockets prepared for a brawl. Since the audience was generally composed of artists and aristocrats, the film was received enthusiastically. Buñuel commented, "What can I do against those fervent admirers of novelty, even if a novelty outrages their deepest convictions, against a venal or hypocritical press, against the idiotic multitude which has pronounced as 'beautiful' or 'poetic' what in essence is only a desperate and passionate appeal to murder?"[34] It was with the lesson of *Un Chien Andalou* deeply embedded in him that Buñuel proceeded to make his second movie, *L'Âge d'Or*, and it was the articulation of his moral position that was to turn Dalí against the film.

Buñuel asked for Dalí's cooperation on the scenario for his second film just as he had for his first.[35] But this time Dalí was totally absent from the filming.[36] While he had been perfectly satisfied with the finished product of *Un Chien Andalou*, claiming all the credit for himself, he was dismayed by the completed *L'Âge d'Or*: "I was terribly disappointed, for it was but a caricature of my ideas. The 'Catholic' side of it had become crudely an-

ticlerical, and without the biological poetry that I had desired."[37] His account of his ideas for the film and the way in which Buñuel subverted his intentions reveals the enormous aesthetic and moral differences that had arisen between them since the making of *Un Chien Andalou*:

> My mind was already set on doing something that would translate all the violence of love, impregnated with the splendor of the creations of Catholic myths. Even at this period I was wonderstruck and dazzled and obsessed by the grandeur and the sumptuousness of Catholicism. I said to Buñuel, "For this film I want a lot of archbishops with their embroidered tiaras bathing amid the rocky cataclysms of Cape Creus." Buñuel, with his naïveté and his Aragonese stubbornness, deflected all this toward an elementary anticlericalism. I had always to stop him and say, "No, no! No comedy. I like all this business of the archbishops; in fact, I like it enormously. Let's have a few blasphematory scenes, if you will, but it must be done with the utmost fanaticism to achieve the grandeur of a true and authentic sacrilege!"[38]

While *L'Âge d'Or* is almost totally Buñuel's creation, Dali's hand can be detected from time to time. As his account of their collaboration indicates, it was his idea to present the archbishops and perhaps even the landing of the official party of Majorcans. Certainly the setting of Cape Creus was Dali's suggestion, for he has always spoken with great admiration of these spectacular rock formations close to his native Cadaqués. He intended to create with these

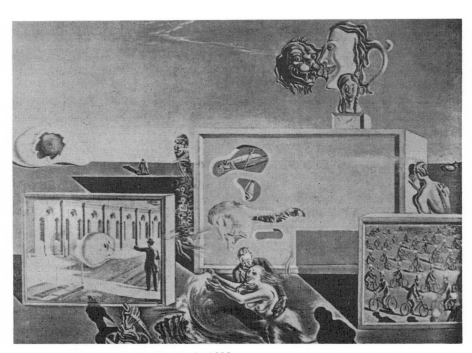

Salvador Dali, *Les plaisirs illuminés*, 1929.

elements something like one of his later canvases where the full pomp of the Church is suggested amidst fantastic surroundings. Or perhaps what he envisioned was something in the nature of a scene which he evoked while discussing his views of films. He described a liturgical bullfight in which brave priests would dance in front of bulls which would be lifted to heaven by a helicopter.[39] According to his testimony, he was willing to allow a few blasphematory scenes, but only as a conciliatory gesture to Buñuel. Yet Dalí realized "that in spite of everything the film possessed an undeniable evocative strength."[40] After all, at the time the two men still shared certain aesthetic attitudes. The final scene, from de Sade, might very well have appealed to him,[41] as did the scene in which the heroine sucks the toes of a statue in sheer desperation.[42] Also, at least one other of Dalí's favorite images appears in the movie, a shot of a well-dressed man walking in a park with a large flat stone on top of his hat. He passes a statue which is similarly crowned by a stone. Dalí had painted a group of bearded, bespectacled men on bicycles with rocks on their heads in a section of a painting entitled *Les Plaisirs Illuminés* of 1929.[43]

Dalí's contribution to *L'Âge d'Or* is minimal. What Buñuel aimed to create in it will be seen in the discussion of the movie. For the moment it will suffice to determine the nature of the two men's contributions to the two films. Dalí's personality considered along with his film scenario *Babaouo* and his own comments about the making of the films reveal his flair for creating dazzling images and theatrically effective sequences. In both these elements Dalí stresses the spectacular, the strange, and the luxurious. Buñuel attempted to supply Dalí's disparate vignettes with a unifying argument which was a function of his moral stance. He was concerned with the nature of man as he is governed by his instincts, while Dalí was drawn toward the psychological excesses and aberrations themselves. At the time of their working on *Un Chien Andalou* they were joined not only by their friendship and common intellectual pursuits, but also by the opportunity they had for creating a totally different kind of movie, in which Freudianism and Surrealism would find full expression. Buñuel seems to have been impressed by Dalí's fantastic imagination, for he returned to ask for his cooperation in writing *L'Âge d'Or*. At the latest by the time he came around to shooting, he had decided to take greater control of this second film. He sought to give it a direction which had been lacking in *Un Chien Andalou*. Disturbed by the easy success of that first film, he set out to outrage his viewers by attacking the very foundations of their morality through a surrealistic representation of man's contemporary situation. In his efforts he was very much in keeping with the Surrealist spirit, as articulated by André Breton: "The most admirable thing about the fantastic is that the fantastic does not exist. All is real."[44] While Dalí's fantastic mental constructions led him further and further from reality, eventually ending in an irreparable break with the Surrealist circle, Buñuel endeavored to discover new levels of reality with the aid of Surrealism. His personal vision embodied the tenets of Surrealism so totally and faithfully that he was able to satisfy fully the aspirations and expectations that the Surrealist group had of the cinema.

The Films

A good number of attempts have been made to unravel the meaning of *Un Chien Andalou*.[45] The interpretations have been ingenious, the explanations enlightening. Perhaps their greatest common fault has been to stray too far from the actual film. The problem of interpretation lies only in the bewildering content of the film, for the dual authorship of the movie presents no problems. First, Buñuel and Dalí were close friends with very similar intellectual backgrounds and aims, as we have seen, so that their film was the result of a true collaboration. Second, the film was directed and edited largely by Buñuel, so that it is primarily his vision that emerges in the final product.

The way the film was conceived is essential to understanding it. As Buñuel later recalled, "Dalí and I chose gags, objects which came to mind, and we rejected mercilessly all that could have signified something."[46] They quite consciously adapted the Surrealists' modus operandi to the cinematic medium. In the early years of Surrealism the participating poets had practiced automatic writing, putting down on paper whatever came to mind. They did so because they wholeheartedly accepted Freud's psychological observations and thus sought to break through their ego to their id. Their recital of dreams to each other (many of which appeared in their journals) was but another way of allowing their unconscious to surface. In effect Buñuel and Dalí were performing a similar experiment. They also worked with dreams, whose exact role Buñuel defined in the following way: "The plot is the result of a CONSCIOUS *psychic automatism* and, to that extent, it does not attempt to recount a dream, although it profits by a mechanism analogous to that of dreams."[48] That they removed all those elements which they thought had meaning was in keeping with their belief that the realm of the unconscious was irrational and therefore inaccessible to the reasoning mind. Buñuel knew, however, that the realm they were exploring in the film could be understood if the psychoanalytical process were applied: "NOTHING in the film SYMBOLIZES ANYTHING. The only method of investigation of the symbols would be, perhaps, psychoanalysis."[49] It makes only sense to follow Buñuel's advice in coming to terms with his film. Yet it would be a distortion of the film to seek a rational explanation for the most minute elements as a number of critics have done, since its authors deliberately sought to frustrate a coherent reading of the work. Significance is to be found in the themes of the film, rather than in a particular interpretation of its multivalent scenes and images.

Un Chien Andalou is not simply the collection of gags that Dalí and Buñuel dreamed up. In eliminating those which had a too obvious content and in linking what was left, they created a progression which was dictated at least by their instincts, if not by rational choice. As such, the finished movie presents some apparent and other more veiled psychological preoccupations which, taken together, form a conceptual whole. The initial scene, of the slashing of the woman's eye, presents the theme of the most extreme form of physical violence directed by a man against a woman. The act is of the most heinous

Un Chien Andalou—Buñuel looks up at the moon for inspiration before slashing the woman's eye. (courtesy MOMA)

sort, as it is premeditated and executed at night. It is set in mythical time, as the introductory caption "Once upon a time . . . " announces. The next caption, according to a characteristically Surrealist usage, sets the events that are about to follow "Eight years after." In this section, which comprises the largest part of the film, the theme of sexual interaction between a man and a woman is elaborated. More specifically, it explores the man's sexuality in terms of the woman. First, we see him riding a bicycle down the street, dressed in frilly clothes. When he reaches the apartment where she lives, he simply collapses against the curb. The veiled meaning of sexual impotence or exhaustion of this sequence is made more explicit by her actions. Even before he falls, she becomes nervous, sensing the imminent accident. She goes to the window and sees him fall. She runs down to assist him, bringing back to the room his frilly outfit and striped box that he wears. On her bed she arranges these belongings as if he were lying there. This trick seems to work, for the man soon appears in the room intact. Thus, the woman is the agent who restores the man to his own. When we see him, he is engrossed in watching ants crawl over the palm of his hand. The woman joins him. The object of their wonder is transformed into the head of an asexual woman whom they are watching from the window. Her lact of femininity is emphasized by her holding a stick with which she pokes an amputated hand. But the effect of the scene is not to reverse sex

Un Chien Andalou—The cutting of the eyeball. (courtesy MOMA)

Un Chien Andalou—Bicycle rider collapses against the curb. (courtesy MOMA)

Un Chien Andalou—The proper arrangement of the man's clothes on the bed makes him reappear. (courtesy MOMA)

Un Chien Andalou—The man eagerly awaits the androgyne's death from the window. (courtesy MOMA)

Un Chien Andalou—A comic chase in the room between moments of extreme passion. (courtesy MOMA)

Un Chien Andalou—She barricades herself into a corner holding a tennis racket for defense. (courtesy MOMA)

Un Chien Andalou—Two priests pulled by the man behind the piano. (courtesy MOMA)

roles, rather to indicate impotence through an androgyne aimlessly performing an act with onanistic overtones. A policeman picks up the hand for her, places it in a box, and hands it to her. She clutches it to herself as she stands in the middle of the street while cars pass by. One car goes straight toward her and runs her over. During this time the camera switches back a number of times to show the couple in the window. The man's face changes from one of joy when the androgyne is playing with the hand to one of lustful, sadistic anticipation when the cars come whizzing by. Once she is hit, the man attacks the woman next to him, incited by his voyeurism when he beheld a scene of symbolic masturbation culminating in physical violence. The woman escapes his clutches and barricades herself in a corner of the room to defend herself from his anticipated assault. But he picks up two ropes in front of him which he starts pulling. The camera reveals to us his burden, the well-known shot of priests followed by putrefying carcasses of donkeys on top of two pianos. He is prevented from attacking by the inhibitions which his burden implies. When the woman runs to the door, he lets go of the rope and follows her. She slams the door in his face, catching only his hand. We then see that the woman is really standing in the same room, with the man lying peacefully on the bed where his costume had been laid out.

The next section is introduced by the caption "At three o'clock in the morning," the time most people are asleep, and thus suggests it is a dream sequence. A stranger enters the room and commands the man to rise. He pulls him up and strips him of the frilly outfit and striped box, throwing them all out the window. He then orders him to stand in the corner as punishment. The following caption reveals the full meaning of this episode, for "Sixteen years before" obviously refers to the man's childhood. We see the stranger turn around and show his face, the same one as the man's, but younger. He is the man's conscience come to rebuke him for his behavior. The younger man walks to a school desk, picks up two books, and gives them to the man in the corner. In his hands, they change into revolvers, with which he shoots and kills his younger counterpart, his conscience.[50] He is shown dying in the fields, clawing at the bared back of a woman. Even at the moment of death the sexual instinct emerges.

With the younger half of the man, his conscience, dead, the conflict between the man and the woman resumes. They are both standing in the same room. He loses his mouth; she affirms hers by wielding a lipstick. Hair grows over the place where his mouth was, while she discovers that her armpit has lost all its hair. She seeks escape from the perversions of the man as represented by these unnatural physical transformations. In disgust, she sticks out her tongue at him, throws a shawl over herself, and opens the door. A strong wind is blowing from outside. It is a force of nature which promises to sweep away the welter of psychological problems which had been played out between them. She suddenly finds herself outside and runs to join another man on the beach. They walk together arm in arm. There is no trace of the sexual problems which interfered with the union of the woman and the previous man. We seem to

Un Chien Andalou—Dying, the young man clutches at the woman. (courtesy MOMA)

Un Chien Andalou—The hair of her armpit is transferred to his mouth. (courtesy MOMA)

Un Chien Andalou—She responds with disgust and defiance. (courtesy MOMA)

have arrived at fulfillment through escape, a happy ending. But the final image of the movie dispels any such expectations. Man and woman are half-buried in the sand, blinded and in rags, consumed by the burning sun and swarms of insects. Their union is only that of mortals: they are ultimately at the mercy of the violent elements. The caption "In the spring" underlines the cruel irony of their common death.

The movie is built around the psychosexual framework described above. Yet this framework provides a no more complete explanation of the film than does the human skeleton for demonstrating what the human body is. Such a psychosexual interest was certainly shared by Buñuel, Dali, and the Surrealist group, but there is nothing inherently Surrealist about these preoccupations. Buñuel himself saw *Un Chien Andalou* as containing two main components: "In the film the aesthetics of surrealism are blended with the discoveries of Freud."[51] Now, the Surrealist aspect of the film remains to be investigated, which is to be found as much in the organization of the material as in the subject itself.

The movie presents psychosexual themes without the strict confinement of an ordinary narrative. While it is true that the beginning and the end are not randomly picked (that is, the beginning is chosen for its shock value and the end offers a bitter resolution to the relationship of the couple), the large body of the film does not follow a conventional narrative pattern. The unfolding of the film occurs through associations made between particular ideas or images.

Thus, it is the sight of the androgyne being killed which triggers the violent erotic forces in the man to erupt and to impel him to attack the woman. Or again, the man losing his mouth makes the woman outline hers; when in its place hair grows, she looks at her hairless armpit.

An analogous association is made between different images. A cloud intersects the full moon just before the woman's eye is slashed. Or, the image of the hand crawling with ants dissolves to show the armpit of a woman, which then fades out to reveal the spines of a sea urchin, which in turn dissolves to show the head of the androgyne as seen from the window. We cannot even say that these two sets of associations of images produce similar effects. In the former, the shock of the eye splitting is accentuated through the differences between the peaceful first image and the violence of the second. In the latter, the fixation on the palm crawling with ants gives way to other organic, more sexual images which end in the view of the head of the woman, whose fixation on a hand is similar to the man's. In the former, the association is made on the basis of the superficial resemblance of the image, while in the latter the images partake of a certain organic sexual sensation. In both instances the association is determined by the characters' impulses, which lie outside the world of reason.

The movie tries to confound rational understanding in still other ways. The indications of time that appear in the captions fit a rational explanation only in part. Why does the movie begin "Once upon a time" and why does it continue "Eight years later"? The role of these captions is to seem to offer explanations which do not work. They are similar to Man Ray's conclusion of *Emak Bakia* with a portion entitled "The reason for this extravaganza" which did everything but give a reason for the film. Similar liberties are taken with space. Although the young man is shot in the room, he falls and dies in the park. Or, when the woman slams the door behind her, she finds herself immediately on the beach. Further irregularities happen to people, such as the alternate disappearance and appearance of the man inside the room. Thus, the accepted properties of space, time, and mass are altered in the course of the movie.

The point of dispensing with a traditional narrative and the most accepted properties of the everyday world is to assist the audience in obtaining the liberty of irrationality. Yet that liberation cannot come about by systematically breaking down the walls of reason. It cannot be created in the spectator by subtle transformations of reality or a simple juggling of time and space. It must come as a blow that will send the spectator reeling. It was with just such an intent that Dalí and Buñuel opened the film with the cutting of the eyeball, one of the most devastating shots in the entire history of the cinema.[52] Once this cathartic shock was administered, the previously mentioned devices would help to enforce the dislocating effect demanded by the authors. The violence of the opening scene is not an isolated case. It recurs throughout the movie, always as a function of sexuality. The onanistic instincts of the androgyne are directed toward a truncated hand. Her violent death unleashes the sexual desires of the man toward the woman. As he is caressing her, his eyeballs roll

Un Chien Andalou—His ecstatic expression and bloody saliva indicate the man's violent sexuality. (courtesy MOMA)

up in ecstasy and bloody saliva trickles from his mouth. Among the things that prevent him from possessing the woman are the decomposing carcasses of two donkeys. When his conscience, in the form of his double, reproaches him for his adult behavior, he shoots him.

The way Buñuel portrays violence in this movie will be characteristic of his later films. He attempts to reveal the deep contradictions of human personality. He wants to demonstrate that the highest human emotion of love is activated by the lowest instincts of violence. His position is, of course, predicated upon and inspired by the work of Freud. Yet his work uses the psychoanalytical only as a point of departure, for his vision is much more extreme than the case histories of the psychoanalyst. While Freud set out to explore the unknown terrain of human nature and concluded by positing the existence of the unconscious on the basis of aberrant and peripheral human activitity, Buñuel takes the realm of the unconscious as the true realm of the spirit. Thus, he engages the audience at a new, instinctual level. And if Freud is right about this part of the psyche being more vital in determining human behavior, then we have found the psychological basis for the success of the film.

Buñuel presents such extreme emotions in his work that the film threatens to become melodramatic. The reason it does not is that Buñuel spreads the tension to another aspect of the subconscious, namely, humor.[53] Freud had

Un Chien Andalou—The end of a comic dance of advance and withdrawal. (courtesy MOMA)

Un Chien Andalou—The visual equivalent of a physical sensation. (courtesy MOMA)

shown that the subconscious surfaces regularly in one form or another to break the rational progress of human activity. Both violence and humor are particular manifestations of that subconscious. Humor thus belonged to Buñuel's subconscious world as much as did violence. His humor is as jarring as his violence and, in fact, the two are often found together. When the man at the window is aroused by the sight of the killing of the androgyne, he lunges at the woman. Since she tries to evade him, they virtually execute a dance without one touching the other. The tango played during this sequence underlines the comic intent of the scene. The sight of the man straining against his inhibitions presents another scene which is violent and ludicrous at the same time. The man's load is intended to represent the forces which hold him back from demonstrating his violent sexuality, and are therefore intended to be violent themselves, as is the case with the rotting carcasses of the donkeys. Yet the objects which are brought together in that room are so incongruous that they cannot fail to elicit laughter. What an idea to put priests on the floor joined to grand pianos with dead donkeys on top! Or again, when the woman escapes from the room, she finds herself in the same room as her pursuer, but now he is quietly looking up at her from the bed instead of dragging his load across the floor. The disorienting nature of humor is once again demonstrated.

Yet another way in which Buñuel appeals to the instinctual is through his emphasis of tactile sensations. The bloody saliva trickling down the man's chin is a tactile suggestion of the violence inherent in his desire for the woman. The succesion of images proceeding from ants on hand to hair in armpit to sea urchin to head of hair is created as a free association of objects along the line of a certain organic and sexual preoccupation. That meaning emerges in large part from the similar titillation of the sense of touch which these different objects are capable of producing. The image of ants crawling on the palm of the man appears again, when the woman slams the door on his hand. The meaning of the image changes in this new context. In the first instance, it was an object of fixation for the man which started the chain of associations ending in a similar preoccupation with the androgyne on the street. As such, it was a strongly sexual image, perhaps standing for itching desire.[54] In the second instance, the crawling ants are there for a more simple and immediate reason, namely, to illustrate at the level of a metaphor the tingling sensation arising from interference with the circulation of blood.[55] Such a different use of the same image is, in fact, characteristic of the absolute freedom with which Buñuel approached the cinema. A similar appeal to the senses is made at the point when the stranger is at the door in the middle of the night. Immediately after he is shown pressing the buzzer, we see two arms struck through holes in the door shaking a silver cocktail shaker. The agitated motion evokes more readily the sound of the buzzer than the simple pushing of the doorbell. The ingenuity of this image is similar to that of ants crawling over a trapped hand. Both are perfect visual metaphors for two nonvisual sensations. The appeal to tactile sensation is perhaps most poetically expressed in the sequence showing the man caressing the woman. Once he has cornered her, he begins to stroke her

breasts through her dress. His desire is so highly aroused by feeling the motion of rolling breasts under his fingertips that his imagination eliminates the obstacle of the dress, so we see him in the following shot fondling the naked breasts. Then suddenly the breasts turn into naked buttocks which the man is kneading. The sequence is so very successful because it recreates a feeling of sensuality through a representation of tactile stimulation. Desire is stirred by the act of caressing breasts. The replacement of breasts by buttocks develops the sensual nature of the passage. Furthermore, it offers the kind of linking of similar images which we have already seen at other points in the film. These associations of similar forms are the most successful cinematic elements per se in *Un Chien Andalou.*

Buñuel's evocation of men's instincts and his attempts to appeal to the instincts of the audience are part of a view which posits man primarily as a function of his instincts and therefore of his unconscious. As Buñuel remarked about the uniqueness of *Un Chien Andalou*, "Its fundamental difference from other movies resides in the fact that the protagonists are motivated by impulses, whose primordial sources are mixed with the irrational, which in turn are the sources of poetry."[56] Buñuel's poetry emanates from a jarring irrationality which is based on his use of instinctive reactions.

Buñuel arouses the audience by touching upon a number of their deeply seated psychosexual impulses. Since these instincts are evoked without being fitted into a rational framework, they unleash the disorder of the unconscious. In this psychic turbulence a few straws are cast to the viewer as key elements which should explain the movie in some way but do not. Such is the role of indications of time. Even more significant is the Surrealist object which appears as a kind of motif in the film, the striped box. This box is worn by the bicyclist who collapses in front of the woman's window. It appears to be vital to the life forces of the man, and the woman considers it as such in her ritual placement of his belongings on the bed to bring him back to life. Later, the policeman places the truncated hand in the same striped box to give it to the androgyne. When the man's double appears at night, his first action consists of stripping the man of his outfit and throwing it all out the window along with the box. The box appears once more, at the end, when the couple walks along the beach and finds it broken along with the clothes washed ashore. Therefore, the striped box becomes associated with the man only loosely. Its meaning is diffused through the appearance of the stripes on his tie or the alternation of black and white keys of the piano and its repetition on the teeth of the donkeys which hang over the piano. In fact, it could be even argued that the very notion of stripes is linked to the violent slash of the eyeball that opens the movie. The striped box serves as an irrational focus of attention, without acquiring any specific meaning. As such, it resembles very closely the function of the starfish in Man Ray's *L'Étoile de mer* and the seashell in Artaud's *The Seashell and the Clergyman.* In Man Ray's film the starfish was associated with the central problem of the union of the man and the woman, but its unexpected appearances as well as its depiction as both a symbol and an ordinary object reflected Man

Ray's refusal to give it a more precise definition. In Artaud's film the seashell has a similar role. It appears in the opening of the film as the clergyman is pouring a liquid from a large seashell. The shell is broken by the intruding officer. Later, shells reappear as protective plates over the breasts of the woman the clergyman is trying to attack. In the final scene the head of the clergyman melts into a black liquid on a seashell, which he proceeds to drink. The seashell is thus linked to the alchemy of the clergyman, but no more explicitly than is the striped box to the life force of the man in *Un Chien Andalou*. In all three films the elusive Surrealist object appears in the opening and closing scenes to affirm its nonexistent importance.

Buñuel was shattered that a film which he considered to be "a passionate call for murder" was applauded for its poetic novelty. His anger was only slightly assuaged by the fact that the Surrealists had also responded to his film and admitted him to their ranks. He had sought not to please, but to outrage his audience. For him Freud's investigations proved that society strangled the natural desires of the subconscious through the development of the superego. Only in passion could the subconscious emerge. But precisely because the subconscious was imprisoned, it developed a violence which occasionally erupted through the veneer of civilized behavior. In *Un Chien Andalou* he treated the ideal state of revolt of the suppressed part of the human psyche and showed individuals motivated totally by submerged, irrational forces. That violence was manifested best in amorous desire, which was not only the most elemental force of human nature, but the one most constrained by the socially determined superego. Its violent eruption in so many destructive ways was a recognition of its irrepressible vitality. In *Un Chien Andalou* Buñuel was concerned with demonstrating its supreme power in the individual. He sought to intensify the impression of the strength of libidinal drives by organizing its various manifestations into a complex nonlinear structure. Yet the message was so novel, the form so unusual, that the audiences cheered the film for being yet another product of the avant-garde.

Infuriated by such a complete misreading of his first film, Buñuel attempted to clarify his position. When *Revue du cinéma* published his scenario in its November 15 issue, he wrote an open letter of indignation to fifteen different newspapers. It was in order to set the record straight that he had the scenario published a month later in the final issue of *La Révolution Surréaliste* with the preface which condemned an aesthetic appreciation of his film. Buñuel went so far as to refuse to show the film with Jean Vigo's À propos de Nice because, as he reminisced years later, "that was the time when we surrealists practiced 'the extremism of anti-progananda.' I even thought of destroying the negative of *Chien Andalou*."[57] So when Buñuel received a million francs the following year from the Vicomte de Noailles to make another film, he prepared to shoot a movie in which aesthetic considerations could not obscure the revolutionary content.

In *L'Âge d'Or* Buñuel takes complete control of the movie. While Dali's

touches can be recognized here and there, they exist according to Buñuel's demands. The movie is the first to reflect the vision of Buñuel which forty years later can be easily identified by any moviegoer. It is not a break with but an evolution from his first film. While he continues the Surrealist approach of his previous film, he is not afraid to create the more solid structure which his moral statement requires. He takes the theme of psychosexual drives from *Un Chien Andalou* and locates them in a social context, thus articulating for the first time one of his most basic, lifelong concerns, the need to study man "not isolated, as an individual case, but in relationship with his fellow beings."[58] Indeed *L'Âge d'Or* is in some ways the resolution of Buñuel's investigations in *Un Chien Andalou*. The inhibitions which are the obstacles to the union of the man and woman in the first film are shown to be functions of bourgeois morality in the second. While the presentation of psychosexual themes is the main concern of the first film, the second develops a movement through these instincts which leads to an outcome. The assortment of objects pulled by Pierre Batcheff in *Un Chien Andalou*, which included donkey carcasses on top of pianos, is significantly jettisoned by Gaston Modot at the end of *L'Âge d'Or*. It is *L'Âge d'Or* that gives full expression and direction to Buñuel's initial Surrealistic impulse.

Instead of jolting his audience as in his first film, Buñuel begins *L'Âge d'Or* with a short documentary segment on the nature of the scorpion.[59] In this very first sequence he presents a subject which will become a characteristic theme of his later films. His strong interest in insects dates at least from 1920, when he spent a year studying entomology under the direction of Dr. Bolivar, Director of the Museum of Natural History in Madrid. His interest has continued throughout his life as his later movies bear witness. In *La Mort en ce jardin* he shows us a snake devoured by ants, in *The Young One* he presents beehives, in *Discreet Charm of the Bourgeoisie* cockroaches fall on the keys of the electrified piano used to torture a young prisoner. But insects are more than a simple fixation for Buñuel. They are personifications of human beings. As he said of a character of one of his movies, "The hero of *El* is a type that interests me as does a beetle or a mosquito,"[60] or when describing a movie of which he always dreamed, "I would invent characters as realistic as those who appear in *Chien Andalou* and *L'Âge d'Or*, but who would possess the characteristics of certain insects: the heroine would behave like a bee, the hero like a beetle, etc."[61]

In the opening sequence of *L'Âge d'Or* Buñuel sets the tone for his film by choosing the scorpion as a symbol of man. The movie opens with a shot of two scorpions fighting. Succeeding captions explain the functions of the scorpion's various parts as the camera focuses on them in close-up. The claws receive special emphasis as organs of battle and information as does the end of the tail, which holds the poisonous sting. Amidst these expository shots the camera returns to showing two and three scorpions battling each other. A caption explains that, since he is a friend of darkness, the scorpion burrows beneath rocks. One of them does just that as another attacks him from behind.

The explanation comments on the antisocial nature of the animal as we see the intruder ejected. Finally we see a scorpion battle a large rat, which it wounds mortally. Buñuel sought to make the connection explicit between the scorpions and the bandits in the following sequence. He wanted to explain in the last caption that the scorpion lives in a barren region, then show a scorpion in close-up climbing vertically up a rock. The camera was to track back rapidly to show an arid landscape in which we were to see a bandit perched on the rocks looking out toward the sea. Buñuel abandoned this transition along with his simpler version of the scorpion sequence because the unforeseen violence of the scorpions in front of the camera suited his general aims perfectly.[62] A connection between scorpions and mankind is made nonetheless. The introductory caption places the scorpions "in the hot regions of the ancient world," thus striking the theme of antiquity which will be elaborated with the foundation of Rome. The actual link between the death of the rat and the introduction of the bandits is the simple caption "Some hours afterwards."

The scorpion sequence sets the tone of the entire movie. It presents the insect that is most dangerous to man as a creature which is ferociously belligerent even to its own kind. Man's inhumanity to man is sufficiently exhibited in a scene of a father shooting his son for a simple mischief. The scorpion as an instinctive, antisocial creature will find its parallel in the exploration of the isolated bandits or the hero and heroine whose concern for the fulfillment of their sexual drive makes them willing outcasts of society. Yet the scorpion sequence must not be mistaken for a parable. It does not present a moral lesson, which is to be borne out by the movie itself. It exists as a highly objective examination of a natural phenomenon.[63] Insofar as man is also a part of this same world, certain relationships should surface betwen the two species. The scientific exposé of the opening suggests that a similar objective process will be followed in examining the mechanisms of the human world. But in the very act of placing the two side by side for comparison Buñuel reveals his fundamentally cynical view of humanity.

The second sequence begins as a bedraggled sentry stares intently at something in the distance. He is watching four archbishops in their ceremonial robes standing amidst rocks near the shore, making ritual gestures. They chant in a monotone, holding a breviary in their hands.[64] The exhausted guard rushes off to warn his companions. He hurries as much as his condition will permit him. When he attempts to jump over a narrow ditch, he collapses pitifully. He is hurrying to a hut where his companions are staying. They are as filthy, listless, and wretched as he is. Their hut looks as miserable as they do, with gaping holes in the ceiling, broken chairs, and piles of straw for bedding. One of the men has a crutch, another is dying. Two others are painfully pulling a rope through the prongs of a pitchfork. Their meaningless activity accentuates the futility of their state. The sentry appears at the door, lost in thought. He is so exhausted that he is unconscious even of his actions. The captain has to prod him for news of the Majorcans' arrival. He now takes control, ordering his men to pick up their arms and follow him. Only a dying man stays

The four bishops as vanguard of the new civilization.

behind, gasping, "I'm done for." When the captain answers that he is too, the dying man utters his last words; "Yes, yes, but you've got accordions, hippopotami, keys, climbers . . . and . . . paintbrushes." The ragged group starts its march a little faster than they should in their condition. As they climb over the rough terrain, they drop from sheer exhaustion one by one. The captain, as exhausted as his men, musters his forces to keep going. He turns around to see if his men are still following. When he sees that they have all collapsed, he looks back at them for the last time with infinite sadness and exhaustion.

As powerful as is the sequence of scorpions, so poignant is that of the bandits. These wretched of the earth exist at a level not very different from that of insects. They inhabit the same barren landscape where they must carry on a similar struggle for survival. Unlike the ferocious scorpions, the men only have the fighting instinct left in them without the ability to carry on the fight. Buñuel does everything to communicate the pathos of the band, so that even the avowedly surrealistic task of pulling a rope through the prongs of a pitchfork is used to emphasize the utter futility of their existence.

Buñuel's grand scheme for the movie begins to emerge in the episode of the bandits. It is nothing less than an application of the principle of "the survival

L'Âge d'Or—The skeletons of the bishops on the rocks.

of the fittest" to the human world. It is a Marxist application of Darwinistic concepts.[65] At first we witness the deadly struggle in the animal kingdom between members of the same species as well as between different species. The course of natural evolution is long only in terms of a human lifespan. On the grand scale of things it is but "some hours afterwards" that the first stage of human civilization has already come to its end. The group of bandits represents the generic exhaustion of that first wave. They have outlived their usefulness: they are no longer capable of carrying on the struggle for survival. A more vital civilization is ready to take over where the primitives left off. Ironically the vanguard of that civilization consists of the four archbishops on the rocks who are as ineffectual as the bandits have become. That they represent the expanding civilization which will settle the land of the bandits is Buñuel's introductory comment on modern society, which will be developed in the course of the film. Yet the presence of the archbishops also evokes the colonizing role of the Church and by implication defines the bandits as barbarians. Indeed, they can be seen as a number of groups—bandits, barbarians, or even artists who make a futile attempt to confront society with their paintbrushes, as the dying man's pointedly surrealistic last words would suggest.[66] They are members of an exhausted social order who still accept the leader as the person in whom the power of the group is vested but no longer have the energy to fulfill his commands. They are also those millions who have been left behind by civilization, such as the imbeciles of *Las Hurdes* or the wretched of

L'Âge d'Or—The official party lands on the beach.

Los Olvidados. Their expiration suggests the eventual decay of the new social order as well. In fact, no sooner do we see the men collapse than we behold a view of the archbishops' skeletons strewn all over the rocks.

The new civilization is founded on the spot where the archbishops' dried bones were left. A sizable official party lands on the beach to consecrate the historic site. It includes priests, military, and decorated public officials as the elite of the new society. The whole group clambers over rocks to be able to pay homage to the skeletons, then gather around an inaugural stone where the groundbreaking ceremony is to commence. Just as the governor is about to start his speech, screams interrupt the proceedings. They are the screams of a man and a woman rolling around in the mud in paroxysms of passion. The crowd gathers around to kick the man and separate the woman from him. She keeps looking after him anxiously as she is being led away, while he goes almost mad with desire as he is held down. He continues to roll around feverishly until he gives himself to a soothing vision. He imagines her in evening dress sitting on a toilet. We see a shot of the empty lavatory with an unwound roll of toilet paper bursting into flames. A shot of streams of lava from a volcano looking very much like excrement ends the vision.

Already in the first two sequences of the film Buñuel created the dialectic of nature between the world of insects and that of men. The dialectics of civilizations and classes were set up in the opening of the bandit sequence when the

shot of the bedraggled sentry was followed by a shot of the four archbishops reciting their prayers. Then, in the sequence of the foundation of the new state, the problem was narrowed to the confrontation between individuals guided by their natural instincts and a rigid social system. He could not have shown their opposition more clearly. To the large crowd of restrained and dignified people he opposes the couple who give free rein to their passions. It is precisely at the moment when the group is about to witness a solemn public rite that the shrieks of delight announce the commencement of the couple's love ritual. While the ceremony has been planned long in advance, the couple begins to make love on a sudden impulse. Nothing symbolizes the lovers' actions better than the mud in which they roll around. They take their passion back to the moist dirt where life began. Their passion consists of those elemental forces which bourgeois society has attempted to cover up. They have thus plunged clothes and all into the mud puddle, the slightest spot of which used to be meticulously scraped off by their attentive mothers. Returning to the theme of the highest emotions being activated by the lowest instincts, Buñuel places his archetypal lovers in the slimy mud, which stands in contrast to the starched shirts and ironed suits of the officials at the ceremony. Thus their action is an affirmation of their passion as well as a rebellion against social mores which do not allow such open and violent expressions of love. In such a way Buñuel has introduced the rebellious lovers in the very first sequence which shows contemporary bourgeois society. Already at its foundations the new civilization displays irreconcilable contradictions between its citizens and the social order which will condemn it to rapid extinction. Buñuel has posited at the start the conflict that will be the theme of the major part of the movie.

It is also with this section that Buñuel begins to assault the audience's bourgeois tastes and thus allies himself with the lovers he is presenting. Certainly the image of the couple in the mud is overwhelming. But Buñuel wants to make sure that he has insulted proper sensibilities while creating a new image of sublime beauty. The man's vision of his love in the toilet carries on his intention as does the shot of the bubbling excrement.[67] Yet these images are not included gratuitously to shock the viewer but are wholly integrated into the movie. They further elaborate the theme of love as a product of base instincts. They introduce the element of social restrictions on adolescents which have made the lovers associate their sexuality with the toilet. These are images which are at once symbolically evocative and scatologically humorous. The vision of the toilet paper bursting into flames is a case in point. It is an extraordinary symbol of the passion of the man for the woman. Yet it is just toilet paper catching on fire after the woman has used the facilities.

Once the conflict between lovers and society has been introduced, Buñuel develops it by alternating sequences of the lovers reacting to their plight with others which elaborate the nature of this civilization. The man is being led away from the founding ceremony by two policemen when he hears a dog bark at him from the crowd. The dog awakens his rage toward the group which tore him away from his love. Overcome by fury, he breaks the cops' hold on him to

give the animal a violent kick. Subdued once again, he is led away, but he notices an insect crawling on the rocks. He drags his guardians to it and viciously stamps on it. Clearly the violence of his love is now directed against any and all living beings since his most basic desire has been frustrated. The camera returns to the proceedings of the group. The governor, after having given his speech, takes a towel and deposits a little pat of cement on the foundation stone. A close-up of this slimy chunk emphasizes the ridiculousness of the pomp and ceremony, for the piece looks suspiciously like excrement. Buñuel wants us to make no mistake about the aim of his scatological comment. A close-up of the inscription on the stone identifies the city being founded as Imperial Rome in the year 1930. Another caption makes it clear that the city is also the secular seat of the Church. In fact, he has picked Rome to stand for the contemporary bourgeois world since it is identified both with pagan splendor and a spiritual leadership which means moral corruption to Buñuel. He demonstrates the characteristics of modern city life with its apartment buildings, its car traffic, its cafes, but also more unusual sights, such as a gentleman walking in a park with a rock on his head or another kicking a violin down the street. He presents more explicit signs of chaos in the city, such as an accident or the caption "Sometimes on Sunday . . . " followed by whole houses collapsing amidst explosions.

It is in this modern bourgeois Rome full of its contradictions that Buñuel begins to develop the theme of insane love for which his movie has been acclaimed. The love is situated in particular social conditions which are themselves located in terms of the struggle of cultures, which in turn is but a special application of the laws of nature. The title of the film emphasized Buñuel's intent. The Golden Age has always referred to the high point of a civilization where all of its members have shared in a commonweal and generally benefited from the flowering of the arts. The modern bourgeois believes this high level has been reached because his material needs have been fulfilled. Buñuel agrees but has serious reservations about its desirability. His next film, *Las Hurdes*, was to display the incredibly primitive living conditions of a people in a remote corner of Spain, the backwater of European civilization. What extreme differences exist even in the most highly developed social system! But in *L'Âge d'Or* Buñuel was still examining the contradictions of society as they affected individuals. While modern society has reached an apex in materialistic terms, it has restrained its members from fulfilling their most vital physical and emotional needs. In *L'Âge d'Or* we see that at the acme of civilization the disruptive forces are already at work. They cannot be suppressed because they involve the most basic instincts of individuals.

Flanked on either side by policemen, our handcuffed hero makes his way down one of the streets of the metropolis. He is distracted time and again by advertisements which reveal different parts of the female body. First, he stops by a poster of a feminine hand next to a jar of cream. He imagines a real hand in its place with its ring finger rubbing against a tuft of hair. He stops again when he sees a sandwich-board man appear with a stocking ad showing

outspread legs. His desire is aroused noticeably more by a large photo of a woman looking like his mistress with her head thrown back voluptuously. The photo is replaced by a shot of the mistress, who is then revealed by the backtracking of the camera lying on a sofa, shuddering with desire. The vision is not merely fantasy, for we see her get up with a sleepy, sensual expression on her face and collect herself before going into the drawingroom, where her mother is reading. The sensual communication between her and her lover across the barrier of space suggested by the transformation of the photo is further carried out by her bandaged ring finger. When she is asked about it and says it has been sore for several days, we recall the strongly sexual image that occurred to the man as he was looking at the handcream poster. Yet no sooner is such a specific symbolic association made between the ring finger and the dynamic attraction of the man and the woman than the finger is shown in a totally different, humorous context: the woman's father uses his ring finger to plug a bottle he is shaking energetically.

The communicability of desire between the separated lovers is most poignantly revealed by the sequence that follows. When the woman returns to her room from the drawingroom, she finds a huge cow lying on her bed.[68] Although she chases the cow from the room the tinkle of the cowbell remains. She sits down in front of her mirror lost in thought. Her eyes fill with tears and

A symbolic obstacle to the union of the couple.

she presses her hands to her heart as she thinks of her lover. Suddenly she hears dogs barking, and in the next shot we see two dogs barking at her lover from behind a railing. He stops in front of them with an expression of great tenderness on his face, his eyes rolling in tears. The two are fixed dreaming about each other while the tinkling of the cowbell mixes with the barks. Their desire is so strong that a burst of wind begins to blow at the woman from the mirror, truly a gust of desire. The emotional union of the couple is strengthened by the accompanying sounds, for we hear simultaneously the barks of the dogs at the man, the tinkling of the cowbell by the woman, and the sound of the wind which unites them.

While the man was able to dream about and commune with his mistress, he was completely oblivious to what was happening to him. After that high pitch of emotional communion is reached, he starts reacting to the outside world again. He insults a passerby, then hails a taxi. When policemen tell him to behave, he realizes that he has had enough and pulls out his official papers to put an end to his harrassment. The policemen are suspicious, but they take a look at the important-looking document anyway. A dissolve reveals the official ceremony at which the paper was presented and we hear the laudatory speech of the minister who entrusted the man with his special assignment. We realize that this rebel against society is one of its leaders: his personal revolt appears much more significant since he was one of society's pampered few. The disclosure of the true identity of the hero when he is in trouble in a common occurrence in literature. Going incognito in search of adventure, the hero can always resort to identifying himself if he faces real danger. Yet here he mocks his own position at the moment when he discloses his identity. The speech of the minister still resounds in his ears when the camera returns to the man who is bored so greatly by the whole business that he finishes the bombastic speech in the recitative, singsong manner of school children. Knowing the power of his identity, he walks away before the policemen have had a chance to react. He hails another taxi, but before getting in, he goes over to a blind man and deliberately kicks him.[69] Having suddenly become aware of the people who are preventing him from being with his mistress, he is ready to take vengeance on everybody.

The forced separation of the lovers is but a prelude to the evening party where the film reaches a crescendo. Having observed the yearning of the lovers for each other when separated, we eagerly await their reunion. But there is even greater inherent logic in bringing the film to its climax at an elegant soirée. The film opened with a detailed elaboration of the nature of social conflict before it situated the lovers in society in a very general way. In one powerful vignette at the founding ceremony it illuminated the central problem through the juxtaposition of the social ritual par excellence and the ultimate personal ritual. But for the most part the themes of society and individuals have been treated separately. Now the lovers are brought together at a gathering of aristocrats and upper bourgeoisie, a sampling of high society. It is at this point that we find a confrontation between individuals and society.

The aristocratic party has often served as the metaphor for a decadent social order. It is an appropriate symbol because it features the most successful members of society meeting simply in order to amuse themselves, but who do so in a highly formal, rigid manner. It illustrates the absurd extreme of the socialization process, a structuring of behavior in a situation set up precisely in order to allow personal relaxation. Jean Renoir chose just such an aristocratic gathering to illustrate a decaying society in *Rules of the Game* of 1939. In Pudovkin's *Storm over Asia* of 1928 Genghis Khan's descendant is stirred to revolt during a party of foreign notables. Buñuel himself returned to the subject of a fashionable party many years later in *The Exterminating Angel* to show how easily social rules break down when individuals are placed under stress.

Buñuel's critique of the ruling classes begins with a ridiculing of the individuals. The short, self-important governor appears with his wife, who is a full head taller than he is. The Marquis who is giving the party appears with his face covered with flies. Occasionally he takes the trouble to wave them off, but with no greater concern than a cow moving its tail to wave flies off its rump. The guests carry the trappings of the Church everywhere with them, so that when the footman opens the door of an arriving car, he takes out a reliquary, which remains on the ground until the guests have alighted. From caricaturing the individuals Buñuel moves to attack the group as a whole. No sooner does the camera reveal the entire ballroom with the party in full swing than a farm cart appears in the room. In it are two drunken workers; a third guides the horse pulling the cart. The guests pay no heed to the group except to step aside politely to let it pass. The image of this procession is indeed a powerful one. It presents the lowliest workers right in the midst of polite society. The farm cart in which they are riding is a tumbril, the vehicle which carried the enemies of the French Revolution to the guillotine. Yet despite the sinister connotations of the cart, the crudeness of the men, and the anarchic nature of the whole ensemble, the guests refuse to see them for what they are. They give proof of the blindness to the real nature of their circumstances that have always characterized weakening ruling classes.

Buñuel holds no one who is associated with the rulers above criticism. The servants have taken on the attitudes and moral outlook of their masters. The general sense of order seems to be threatened once again when a fire breaks out in an adjoining room. The image is even more chaotic and violent than that of the drunken workers in their cart rolling through the ballroom, yet once again the event is ignored. A maid escapes from the fumes shrieking with terror and collapses right in front of the door, but two servants who are standing nearby only cast a glance at her before they start offering punch to the guests. Meanwhile, in the garden the gamekeeper of the estate affectionately plays with his son. For the first time we see people act with genuine human emotion. As the man begins to roll a cigarette, the boy playfully knocks it out of his hand. The father flies into a rage and takes a swing at his son, but he runs off happily into the fields, expecting his father to continue the game.

Overcome with fury, the gamekeeper grabs his gun and bags the boy in two shots. The guests give a start when they hear the shots and go out on the balcony to investigate. Yet their reaction is only that of mild disapproval, and when they return to the room, their curiosity satisfied, we see that many of the guests had not even left their seats when they heard the shots.

Perhaps these incidents could be explained away as merely surrealistic elements which bear no relationship to bourgeois morality if it were not for a subsequent incident which sets them off in such a way that no doubt is left as to their intended meaning. Our hero arrives at the party right after the shooting has occurred. When he notices his mistress, he signals to her to be careful. They are exchanging passionate glances when her mother comes to greet him. Unable to escape from her, he sits down and lets her talk, but cannot concentrate on what she is saying. When she hands him a drink and accidentally spills some on him, he is suddenly overcome with rage as he had been when he heard the dog bark in the crowd. The bark and the spilled drink were both the last straw which unleashed his pent-up fury. Both the woman and the dog appeared as obstacles to reaching his love, and so they both became the subject of his attack. The terrific slap he gives her is one of the most surprising and hilarious scenes in the movie. Its effect is that of a bombshell on the assembly. Men rush to her side, the Marquis has to be restrained from correcting the insult his wife received, and our hero is seized to prevent him from further violence. How totally different is the reaction to the slap from that to the murder! It matter precious little when the child of a worker is killed outside, but when social decorum is violated in the ballroom, it calls for moral outrage on the part of everyone.

The man must leave the party after his improper behavior, but since he is drawn too strongly to his mistress, he comes sneaking back. He catches her eye and signals her to meet him outside. At a moment when no one is looking he dashes out into the garden after her. No sooner are they in each other's arms than we see the guests also filing out into the garden to hear a concert. The two parallel themes of lovers and society connected and clashed in a minor conflict at the party in order to expose the nature of society. Afterwards, the film shows the two themes separating again to continue along parallel tracks. While the official party moves outside to listen to a concert, the couple hides in a dark corner of the garden to make love unimpeded by the gathering. Ultimately they cannot separate themselves from society, which keeps on interfering with their love. The parallel editing in this section emphasizes the differences between the couple and the group, while setting the action in the garden allows for the interaction of the two. The parallel track is emphasized by views of the lovers struggling on the gravel. then pulling up chairs to facilitate making love, interspersed with shots of the audience calmly seating themselves. In fact, no matter what they may try, the lovers cannot consummate their passions. They seem to be held apart by inexplicable forces, similar to those which prevent people from leaving a room in *The Exterminating Angel* and which prevent friends from coming together in *Discreet Charm of the Bourgeoisie*. Later it

will become clear that society is responsible for all of the interference. After further attempted caresses, the man prepares to kiss the woman passionately when a shot reveals the conductor beginning the opening bars of the death scene from Wagner's *Tristan and Isolde*.[70] When they hear the music, they give a start and look in the direction of the orchestra. (This same music will keep playing throughout their lovemaking until the conductor leaves his podium.) The lovers try to go back to making love, but obstacle after obstacle prevents them from continuing. When they both turn, they hit their heads together painfully; when he pulls her over to him, she falls out of her chair; trying to break her fall, he falls too. Then they are trying to get back in their chairs without letting go of each other, which results in more awkward fumblings. Or again the man becomes distracted by the toe of a marble statue standing next to them which evokes a vision of four priests crossing a bridge, the fourth of whom stops halfway, stares at the camera, and runs back in fright.[71]

When the couple return to their caresses once more, a servant arrives with the message that the man is wanted on the telephone by the Minister of the Interior. Resentfully he pulls himself together and goes off to answer the phone. The woman has had her passion aroused and left unfulfilled too often. She is no longer conscious of what she is doing when she instinctively starts to suck the big toe of the statue. The shots now alternate from the woman sucking the marble toe to the orchestra playing and the audience listening. Thus, a dual relationship is set up among the three subjects by this editing. On the one hand, the passionate conducting of the orchestra expresses the passion of the woman, which is finally being satisfied, even if in a perverted, fetishistic way. On the other hand, the juxtaposition of the properly seated audience with the woman carried away by her desire makes her action seem especially humorous. The audience and the orchestra serve to accentuate the ridiculous and sublime aspects of the woman's self-gratification.

Meanwhile, the man answers the phone call. The minister on the other end is furious. He blames the man for a catastrophe in which children as well as old men and women died. Excerpts from newsreels show large crowds teeming in a square and women and children fleeing through smoke and flame. The minister's words recall the mission he entrusted to the man, in which he was made responsible for the lives of women and children. That ceremonial speech was clearly a series of shibboleths, and we have a suspicion that so is the minister's reprobation by phone. Those suspicions are confirmed when the minister accuses the man of implicating him in the affair. What infuriates him is not the deaths but that he himself has been dishonored. But the man is really not concerned with the veracity or falsehood of the accusations. He has given himself to his passions so totally that everything outside his love has ceased to matter to him, especially society, which has obstructed him at every turn. Enraged by the inanities of officialdom, our hero hurls the receiver against the wall. The minister shoots himself: his body lies on the ceiling as an ironic comment on the virtues which he has embodied and which have propelled him toward the heavens.

L'Âge d'Or—Sexual desire too great to be left unfulfilled.

The dishonored minister commits suicide and falls to the ceiling.

Our hero runs back to his mistress in the garden now that he has finally severed all ties with society. He is now able to make love to her because he has rid himself of all the inhibitions which society has nurtured in him. Their love scene is one of extraordinary poignancy. After he throws himself in her arms and kisses her body, he slides down until his head is by her knees. She throws her head back in a frenzy as her lover takes her by the knees and spreads her legs. They consummate their love with a burning stare. Then their expressions change from mad desire to tenderness, signaling a new phase of their love. The woman's face suddenly ages for a moment now that they have attained permanent union. As they hold each other, a dialogue is carried on between them without their opening their mouths. This "interior dialogue" underlines their absolute union, since they are exchanging not words, but thoughts and emotions. Their exchange consists of the trivialities of after-love, asking about each other's comfort as they are about to go to sleep.

As they hold each other tenderly, the sounds of the accompanying music grow stronger.[72] Again we see shots of the orchestra, the conductor leading the music more passionately than before. The passion of the music seems to be transferred to the woman, who suddenly comes alive with ecstasy and cries out: "What joy to have murdered our children." The hero's face is now covered with blood as he groans, "My love! My love!" We are reminded of the ecstatic face of the man in *Un Chien Andalou* with blood seeping from his mouth as he was about to attack the woman. It is at this most passionate moment that the violence of love erupts. The conductor reaches an emotional climax at the same time. Unable to control his passion, he hurls away his baton, bursts into tears, and walks away from the orchestra with his hands holding his head. The long sequence of *Tristan and Isolde* finally comes to an end. The only sound we hear is the loud crunching of the conductor's footsteps on the gravel as he walks toward the spot where the lovers are. As he stops by the couple, continuing to sob, the woman becomes fascinated with him until she throws herself in his arms and starts to kiss him passionately. The lover is enraged and clenches his teeth as he prepares to avenge himself on the conductor. As he jumps up, he hits his head very hard on an overhanging branch. A drum starts beating at this point and continues until the very last scene of the film. It conveys the excruciating pain he feels. He puts his hands up to his head and staggers away on the path, very much the way the conductor came toward them. Here the man's fury at seeing his mistress stolen is transformed into the physical pain of being knocked on the head, which is expressed by the loud, rhythmic beating of a drum.

The man escapes into the woman's room and throws himself on her bed, sobbing. He starts to paw at the pillow, which he tears apart, pulling out handfuls of feathers. He breaks a bust, then picks up a large wooden plow and stands in the middle of the room with it. Finally he notices a window, which he yanks open and throws out a burning pine tree, an archbishop, who gets up and runs away, the plow, the archbishop's crook, and a stuffed giraffe which falls into the sea. This final scene of the man enraged is more desperate than

Blood stains the face of the man after they consummate their passion.

anything before, since here he is no longer battling against the outside world, which stood in his way, but against himself. Once his mistress gave herself to the conductor, he was powerless to intervene. The frenetic scene of violence in her room directed against objects rather than people is the sign of a sexuality turned inward. His throwing himself on the bed, his wielding a huge plow, then a burning tree, and the falling of white feathers out the window, all suggest masturbation. Yet in being deprived of his love and consequently directing his rage against himself, he goes through a final purging whose result is shown in the last sequence. This cleansing is demonstrated by his throwing a medley of objects out the window, an assortment which calls to mind the load pulled by the man toward the woman in *Un Chien Andalou*. If those donkeys, pianos, and priests were inhibitions which held him back in the first movie, then the giraffe, plow, and archbishops are inner obstacles that are being cleared away in the second film. As in *Un Chien Andalou*, so in *L'Âge d'Or* the end opens up (through a door in the first, a window in the second) to reveal the edge of the ocean with its intimations of a soothing eternity. But *L'Âge d'Or*, with its openly moral intent, includes one more significant sequence before the last, brutal image.

The final section is as divorced from the main body of the film as was the introductory scorpion sequence. Like that sequence, it is an entity unto itself which was lifted from the works of the Marquis de Sade just as the scorpion footage comes from the annals of entomology. Yet both sections carry the

L'Âge d'Or—The boundless fury of the thwarted man.

L'Âge d'Or—The scoundrels leave the castle after 120 days of debauchery.

mark of Buñuel in the way they are related to the core of the film. In this final section Buñuel shows four sexually depraved men emerge from a castle where they had sequestered themselves for 120 days to engage in the vilest forms of debauchery. The idea is faithfully borrowed from de Sade's *120 Days of Sodom* down to the detail of the scoundrels' names, the isolated castle they choose in the mountains, and quotes from the book appearing as captions. The only substantive alteration of de Sade consists of depicting the leader, the Duke of Blangis, as Jesus Christ. To emphasize the wickedness of these men, Buñuel shows them walking out across the drawbridge completely exhausted, squinting their eyes unaccustomed to bright daylight. They are led by the apparently pious Duke of Blangis, who makes a gesture of blessing and clasps his hands in prayer. When they reach the other end of the bridge, a young girl appears at the gate in a white dress clutching her breast with a bloodstained hand. The Duke of Blangis walks back slowly when she collapses, picks her up gently, and walks her inside the castle. Suddenly a terrible shriek rends the air and we realize that the girl has become one more victim of the men's perversions. The Duke reappears completely impassive.[73] We see him for the last time with tragic piety on his face. The last shot is of a snow-covered cross with human scalps hanging from it and blowing in the wind.

Although seemingly unrelated to what went before, the de Sade passage marks the final development of the central theme of the film. In the preceding sequence the man went through a violent cleansing process in which he liberated himself from all the vestiges of society's morality still encumbering him. De Sade offers the final step: a total recognition that sexuality and violence are two aspects of the same drive, resulting in complete liberation through sexual violence. The link between the main narrative and this epilogue is the forceful pounding of the drums, which suggests the powerful drives which are incarnated by the man and the four orgiasts. The inclusion of the de Sade passage testifies to the way in which Buñuel intended his film to reach the public. He had been disappointed that *Un Chien Andalou* did not outrage the audience. Here he was determined to shake them. What better way was there than to include a passage of de Sade, whose works were and still are censored in France. To intensify the attack, he made Christ be the leader of the sodomists.[74] Surely there was no better way to cap the ridicule and criticism he leveled at the Church throughout the film. In this final passage he drives home his point that the values of bourgeois society are completely reversed.

Such an exegesis has attempted to provide the rationale of *L'Âge d'Or* precisely because it appears to be so labyrinthine. Yet such an explanation inevitably distorts the true nature of the film by robbing it of its flavor. Part of its appeal is its ambivalence, the coexistence of the rational and the irrational. For example, while the scorpion sequence is related to the bandit segment, which is continued in the central narrative and concludes in the de Sade portion, each also stands as a separate section which apparently has nothing to do with any other. A similar ambiguity is created around certain preoccupations which appear as straightforward symbols but are not. Thus, the ring finger

Jesus Christ, leader of the orgiasts.

assumes a sexual significance after the man sees it twitching against a lock of hair and the woman appears with her finger bandaged. But this sexual implication has been barely confirmed when the Marquis enters the room and starts to shake a bottle with that same finger used as a stopper. One could still make a sexual explanation, but the sense of the gesture is very different. It is as humorous as the other two instances were foreboding. Instead of the moving finger standing for sexual activity, it becomes a multifaceted motif in the film. In a similar way, ecclesiastics have more than a symbolic function in the film. The bishops on the rocks, the number of clergymen among the landing party, and the bishop who is defenestrated at the end all symbolize a corrupt faith allied with a decadent bourgeois social order. Yet the little Marist monk who stops in the middle of the bridge, gets a frightened look, and scurries back like a rat, has nothing to do with symbolizing society. His presence is a bit of fantasy, irrational and humorous at the same time. Such expansion of the symbol to the motif is not a Buñuel invention. Desnos' circle in *Minuit à quatorze heures*, Man Ray's starfish in *L'Étoile de Mer*, and Artaud's seashell in *La Coquille et le Clergyman* all assume symbolic functions without being confined to

a one-to-one relationship between subject and symbol. But Buñuel uses his motifs in more varied ways than any of his colleagues. Mainly he imparts to them an unexpected comic function which is totally absent from the motifs of the other Surrealists, which tend to create an ominous sensation by their mysterious recurrences. Thus, his motifs are richer, more ambivalent, less defined. They strike the spectator more profoundly because they are at once rational and irrational; they appeal both to the conscious and to the unconscious.[75]

Having examined Buñuel's second film, one should also judge it according to his own criteria. In his unpublished autobiography he writes:

> The story is also an account of surrealistic morals and aesthetics concerning two principal figures, a man and a woman. The exciting conflict unfolds in every human society between the feeling of love and any other feeling of a religious, patriotic, or humanitarian nature; here also the characters and landscapes are real, but the hero is motivated by egoism which renders all attitudes pliant, lacks control, and is outside the realm of sentiment. The sexual instinct and the consciousness of death form the substance of the film. It is a romantic film, realized with all the frenzy of surrealism.[73]

Buñuel sees *L'Âge d'Or*, then, as a movie which romantically pits love against society in a surrealistic framework. An aspect of that surrealism is the juxtaposition of an objective world through documentary footage and of a subjective world as perceived and lived by the man. Buñuel points out that the love he presents is a form of egoism. The man is egoistic insofar as he obeys his immediate impulses. Because they go uncontrolled, they appear in their most extreme state. These impulses were also the focus of *Un Chien Andalou*, specifically the sex drive and the death wish. The car killing the androgyne, the man being shot by his double, and the corpses of the couple sunk into the sand, all are presented as the direct result of the exercise of the individuals' libidinal drives. In *L'Âge d'Or* death is defined in contradistinction to the sexual drive. Death surrounds the couple but does not touch them. In Buñuel's version of the doctrine of "the survival of the fittest," the most vital creatures are animated by an irrepressible libido. Those who lack that sexual drive become easy preys of death. The bandits have lost that drive; the archbishops never had it. Lacking such a fundamental life force, the Minister of Interior easily succumbs to suicide when he learn he has been dishonored. At the end this law of the wild abruptly confronts our basic moral sense. It is the evil Duke of Blangis who lives on after killing his innocent victim. His twisted sexual appetite is a life force which can triumph in a world where innocence is a useless attribute. Buñuel's preoccupation with sexuality and death originated in his childhood. As he recalled, "The two basic sentiments of my childhood, which remained inside me until adolescence, were that of a profound eroticism, at the beginning sublimated into a great religious faith, and then the perfect consciousness of death.'"[77] His entire cinematic work testifies to the fact that these two main concerns stayed with him for the rest of his life. His

confession further confirms what we have suspected so far—that religion stood in the way of his sexual drive. The full blossoming of this sexuality in his first two movies (and in later ones as well) results in a correlative attack on the Catholic church through incidents too numerous to mention.

A subtle but significant transformation of the subject takes place between *Un Chien Andalou* and *L'Âge d'Or*. While in the first film emphasis is placed on the psychic *forces* which drive man, in the second the focus is shifted to the *man* who is driven by inner needs. *Un Chien Andalou* carries more the mark of Salvador Dalí, whose narcissistic preoccupations led to an interest in psychoanalysis and an interest in the sexual forces that motivate man. *L'Âge d'Or*, on the other hand, reflects Buñuel's concern with the man whose position vis-à-vis the world is dictated by his inner needs. We shall find such characters throughout his later movies: in *Simon of the Desert* the anchorite who withdraws from the world, in *Nazarin* the priest who decides to live by his own moral code, or in *Belle de Jour* the wife who transfers her dreams to reality in response to her sexual needs.

The man who lives out his impulses, even though they be of the highest inspiration, is acting only in his own interest. The hero of *L'Âge d'Or* is motivated by egoism, for he subordinates everything to the attainment of his love. Thus, while Buñuel clearly takes the side of love in its struggle against social restrictions, he does not idealize the lovers. They are as selfish as the bourgeois against whom they rebel. Their revolt issues from the personal setbacks they received at the hands of society. Their aim is to satisfy their sexual drive, nothing else. Barely have they been united than the woman throws herself into the arms of the conductor. Buñuel will continue to express this highly realistic, even pessimistic vision of man in all his movies. The poor and crippled, for example, are not good as Christian teaching would have us believe. They are as avaricious and crooked as the rest, if not more so.[78] Thus, the blind man in *Los Olvidados*, who is a victim of the gang of boys, is also a bully in his own domain who survives while the two boys are killed. Buñuel even demonstrates the fault of Christian idealism in *Nazarin* through the story of the young priest of great religious faith who learns only through his own misfortunes that his belief is inadequate for dealing with the outside world. For Buñuel such realistic attitude toward the nature of man is a prerequisitie for the formulation of a political attitude. The power of social classes lies in their willingness to struggle for their own selfish rights, just as the power of the hero's revolt in *L'Âge d'Or* springs from the defense of his own personal interest.

A vital element of these two films is the accompanying music and sound effects Buñuel selected. The significance of the music lies not only in terms of the films, but in terms of Buñuel himself. In both movies he relied most heavily on the music of Richard Wagner, especially his *Tristan and Isolde*. Wagner had a very special meaning for him. He had been his favorite composer from the time he was a child.[79] Now he had all but a few brief passages of *Un Chien Andalou* accompanied by *Tristan and Isolde*. In *L'Âge d'Or* the "Death of

Tristan'' is played by the orchestra during the long scene of the couple making love in the garden. In *Cumbres Borrascosas*, his adaptation of Bronte's *Wuthering Heights*, he included about an hour of Wagner, since here, too, the main theme was the all-encompassing love of a man for a woman.[80] It was Wagner who had first aroused the overpowering sentiments of youth and later evoked the violent emotions of love. The predominance of Wagner's music in these early films testifies to Buñuel's romantic faith in love.

Buñuel's use of Wagner to evoke the sublime aspect of love points to his reliance on sound to give his films an added dimension. Because he invested sound with too great an import, years later he expressed his disgust with the facile use of music in films: "I detest music in movies. I tend to suppress it because it is too easy. How many movies would 'hold up' if the music were eliminated?"[81] Music and sound in his films take on a number of different roles. The "Death of Tristan" played during the love scene in the garden does more than underline the couple's passion. It is the actual piece of music being played by the orchestra.[82] As such, it is associated with the gathering and thus exists as the incarnation of bourgeois consciousness. The first note struck by the orchestra stops the lovers from kissing. When the impassioned conductor throws his baton away, he becomes the agent of the couple's separation. Thus, the music takes on simultaneously a supportive and an ironic role. Music was used in a humorous or ironic way in other instances as well. In *Un Chien Andalou*, when the man is attempting to corner the woman, they virtually execute a dance as one is trying to escape, the other to attack. To make sure the audience does not mistake his intent, Buñuel has a tango come in just for the sequence. The final shot of both films shows the remains of people exposed to the elements. Both are accompanied by a jubilant *paso doble*, which accentuates by ironic contrast the brutality of the image.

Un Chien Andalou was a silent film which Buñuel accompanied with music; *L'Âge d'Or* was a talkie in which he played with sound effects in addition to using music as accompaniment. He used sound sparingly, often letting captions explain the unfolding of the action. When he did use sound, it was done in ingenious and novel ways. He created the first "interior dialogue," during the scene of the lovers in the garden, by having the two converse without showing their lips move. He translated the head pain and fury of the man into the sound of rolling drums, which stand for his driving desire and which link the central part of the movie to the de Sade sequence. He expressed the communing of the separated lovers in the mixing of the sounds of cowbells, barks, and the blowing of the wind as the camera alternated between the woman seated in front of the mirror and the man staring at the dogs. Buñuel used both sound effects and music to stand for particular emotions or drives which motivate his characters, and he did so in a highly original way.

While Buñuel's *L'Âge d'Or* has been amply praised, critics continue to find fault with his conservative camera style. Aranda has pointed out that "Surrealism in Buñuel is above all a philosophical and moral position. It is important to remember this, because ignorance of it has misled many critics to a

disappointment with Buñuel, who is aesthetically conservative and almost nonexistent."[83] While Aranda correctly points to Buñuel's main concerns, he fails to see how his philosophical position is related to the way in which he expresses himself on the screen.

That absence of technical virtuosity must be understood in the context of the position of Surrealists vis-à-vis the contemporary avant-garde cinema. In a discussion of *Un Chien Andalou* Buñuel fixed his opposition to those films in the following way: "In reality, this is a revolt against the avant-garde film, against the artistic film, where you have only the impressionistic and camera effects."[84] Thus, a definition of his Surrealist position excluded a dazzling use of the camera. Even years later he confessed that "technique does not pose problems for me. I hate films of 'framing,' I detest unusual angles."[85] He was led to such a vehement stance against camera tricks because he felt that camera work was often used as a substitute for content. He made his point in talking about the American movie *Detective Story*, where he considered everything to be great, actors, camera work, dialogue, except for the story, which he thought ridiculous. To him it was "a gigantic machine, made of the best steel, of a thousand complicated gears, tubes, of hand-levers, of dials, exact as a watch, of the size of a transatlantic steamer, whose only function is to affix postage stamps."[86] In his zeal to create a purposeful movie Buñuel eliminated all of the more spectacular camera tricks which were then in current usage.

Buñuel was not unaware of the possibilities of the camera: he only used them when they could help express his ideas. To accentuate the fatigue of the sentry as he is making his way back to the bandits' hut, he makes the sequence rather long and shows him walking from different angles to emphasize the difficulty of his efforts. To make the impact of some scenes stronger, he filmed certain shots head on. When the assembled dignitaries at the founding ceremony hear screams coming from behind them, the camera (placed where the lovers are supposed to be) catches the group turning around to stare at the couple and therefore right into the camera. Or, when the woman is dreaming of her lover in front of the mirror, we see her alternately from the back with a view of the sky in the glass and straight on with a sensual expression on her face.

Buñuel's real cinematic technique has nothing to do with what we know as camera work, which is conspicuously ordinary in both movies. He expresses his understanding of the medium in his editing: the construction of *L'Âge d'Or* carries out the ideological content of the film. The film develops through juxtapositions of contrasting elements, scenes, and concepts. Bugs are compared to men, bandits to archbishops, composed society to inflamed individuals, unbounded passion to specific obstacles, documentary footage to acted parts. Buñuel constructs his film in support of the dialectic inherent in his moral position. Every image and every sequence obtains its strength from the juxtaposition of opposites, whether it be a well-dressed couple rolling in the mud, the slapping of a woman at an elegant party, the killing of a child for a silly prank, or the contrasting of classical music with rolling drums. Certain-

ly this dialectical process best expresses the conflict between individuals and bourgeois society. Often, however, what strikes us is not the logic of the dialectic but the absurdity of the juxtaposed elements. In other words, the contrasts tend to emphasize not just the opposition of elements but also their unusual and shocking relationship. The aesthetic impact of such disparate terms is very much like that prescribed by Lautréamont and adopted as a motto by the Surrealists, "Beautiful as the meeting of an umbrella and a sewing machine on an operating table." Clearly *L'Âge d'Or* takes its place at the confluence of Marxism and Surrealism.

The Issues

L'Âge d'Or was immediately hailed by the Surrealists as the most perfect Surrealist movie. Its success was greater than that of any other movie discussed before, including Buñuel's own first essay, *Un Chien Andalou*. Neither the presence of surrealistic elements within the film nor its excellent execution can account for such excitement among the Surrealists. What ignited their enthusiasm was that the movie integrated their two favorite themes of love and revolt.

To understand the Surrealists' near obsession with these two human concerns, one need only recall the extremely romantic inspiration of the movement. Despite their resolution to carry out objective investigations of the real nature of human thought as proclaimed by Breton in his *Surrealist Manifesto* of 1924, the movement always inspired highly subjective creations. The reason for this paradox may be located in the aims of the movement itself. Trying to arrive at the true nature of thought, the Surrealists set out to produce works of "pure psychic automatism." Being poets first and foremost, they became interested in the practice of their own psychic automatism as a new means of self-expression and consequently abandoned any scientific interest they may have had in determining the true functions of thought. In a similar way, Freud's findings interested them insofar as they demonstrated the existence of extreme psychological states in the guise of the unconscious. In short, the Surrealist poets were primarily interested in the role of human emotions which they felt guiding their own poetic quest. Like the Romantics of a hundred years earlier, they projected their inner aspirations to the outside world. The highly subjective world they created thus offered external equivalents to their inner, psychological states. To the Romantics the storm-tossed boat was the reflection of the rage of the poet's soul; to the Surrealists their quest for love through a new Eve turned all of Paris into a feminized world.[87] And since both movements were highly emotional in inspiration, they both counted among their chief concerns those two volatile experiences of the soul, love and revolt.

That Surrealist literature is marked by the quest for the ideal woman, that it

is highly erotic besides, and that it ultimately seeks transcendance through love are all common knowledge. All of Surrealist literature bears witness to its overwhelming hold on the group. André Breton writes of the special preeminence of the idea of love between the years 1927 and 1932:

> Apart from the profound desire for revolutionary action which possessed us, all the subjects of exaltation proper to surrealism converged at this moment upon love. "Hands off Love," that is the title of a surrealist tract aiming to do justice to the accusations of "immorality" brought against Charlie Chaplin, in whom we honored above all "the protector of love." The most beautiful poems of Éluard, Desnos, Baron, published at this period are love poems. This conception of love, exalted by us to the highest point possible, was capable of leveling all barriers.[88]

No matter what their individual vision was, the Surrealists agreed that the highest form of love could exist only in absolute freedom. When they led an inquiry on love in the final issue of *La Révolution Surréaliste* two of the four questions had to do with the possible limitations placed on love by actual social conditions.[89] That love and freedom were indeed linked in the minds of the Surrealists is further borne out by Robert Desnos' novel *La Liberté ou l'amour!* The title applies to the absolute freedom with which love erupts throughout the book, not just between the hero and the heroine, Corsaire Sanglot and Louis Lame, but also among the many other characters who appear and disappear like specters throughout the novel. In Desnos' work the total liberty of love leads to highly erotic and even perverse engagements, a characteristic result of the Surrealists' attempts to attain completely unfettered love.

Sexual freedom was an integral part of the Surrealists' efforts to liberate love. Benjamin Péret pointed out the fundamental way in which they are related and kept apart by contemporary society:

> Sublime love implies the most complete sexual liberty. Without it, the possibilities of choice remain ludicrous. Thus, it finds its justification in the goal which it can attain. Such is not the case today, with sexual liberty remaining dissociated from love. Instead of multiplying the possibilities of choice, it leads to the formation of a ground of non-choice which presents a new obstacle to the triumph of sublime love.[90]

The Marquis de Sade's appeal to the Surrealists now becomes especially clear. In his works they saw the complete liberation of love carried to its furthest excesses, and in him the man who confronted society with a new morality which threatened to undermine the very foundations of the existing social order.

That Luis Buñuel expressed in *L'Âge d'Or* the vision of love that the Surrealists held for their own is quite clear. He portrayed an all-consuming love demanding absolute freedom which led it both to violent excesses and to

clashes with representatives of the existing order. A few years after the showing of the movie, André Breton wrote a book entitled *L'Amour fou*, "mad love," the name that came to be adopted by the Surrealists for their all-pervasive passion. In in Breton praised Buñuel's film in the following way:

> This film remains to this day the only undertaking of the exaltation of total love the way that I envisage it. . . . Love, in all that it can have for two beings absolutely limited to themselves, isolated from the rest of the world, was never manifested in as free a manner, with as much quiet audacity. . . . In such a love exists in full power a veritable "golden age" as a complete break with the age of mud that Europe is passing through.[91]

Buñuel for his part felt that he held the same ideas about "mad love" as did the Surrealists. In discussing *Cumbres Borrascosas*, a movie version of *Wuthering Heights* filmed in the 1950s, he remarked, "It is a film that I wanted to shoot at the time of *L'Âge d'Or*. For the surrealists it was a tremendous book. . . . They liked its mad love aspect, a love above all, and naturally since I was part of the group I had the same ideas about love and I thought the book was great."[92] Clearly then, *L'Âge d'Or* remains as faithful a presentation of the Surrealist "mad love" as anything we may find in Surrealist literature.

Even more basic than the emotion of love was a sense of fury that motivated the Surrealists. Barely had the group been formed than they issued a resolution whose purpose was to determine whether Surrealist or revolutionary principles motivated the movement. Their first point was "that before all surrealist or revolutionary preoccupation, that which dominates their spirit is a certain state of rage."[93] Indeed, it was a poisonous inner flame that made them band together, taunt the public through manifestos and other means, while creating the refuge of a magical world of dreams, beauty, and desire in their own literary creations. Many years later Breton posited the nature of this rage that burned within them: "It is revolt itself, only revolt which is the creator of light. And this light can only be known in three ways: poetry, liberty and love which must inspire the same zeal."[94] Thus he revealed what was to be the very crux of the Surrealists' problem of political and ideological definition with respect to the Communist party, which was to haunt them from 1925 on. Motivated by their own sense of personal revolt, they were to remain faithful to themselves and to their movement, and in the end were unable to give themselves wholly to Communist ideas. As Albert Camus wrote, "In reality, revolution for André Breton was only a particular case of revolt, while for Marxists, and, in general, for all political persuasions, only the contrary is true."[95]

The Surrealists' flirtation with Communism is a matter worth investigating because it was the most important issue confronting the group during its most vital years, because it reveals the political and moral aspects of the movement, and because *L'Âge d'Or* reflects both a sense of revolt and revolution that were held dear by the Surrealists. In his *Surrealist Manifesto* of 1924 Breton

had written, "The sole word of liberty is all that still exalts me." What he meant was a liberty of the imagination which the Surrealist movement was setting out to capture for itself. The following year began to witness a ferment in ideas, but only ideas. The second issue of *La Révolution Surréaliste*, which inaugurated the year 1925, included a manifesto entitled "Ouvrez les prisons, licenciez l'armée." It was the first Surrealist attack on the constraints of society. How foreign was the idea of political alignment at that time was demonstrated by a letter Aragon wrote to *Clarté*, a magazine with Communist leanings. The poet who in a few years was expelled from the Surrealist group because of his staunch support of the policies of the Communist party then rejected the Communists in the following way: "I place the spirit of revolt well beyond politics."[96] It was at this time that the Surrealists placed their personal sense of rage above all other considerations. Antonin Artaud and Robert Desnos both turned to the Orient for inspiration because, as Nadeau pointed out, "The orient is not only the home of the Sages, it is also a reservoir of savage forces for the surrealists."[97]

The Surrealists' vague ideas of personal revolt and revolution in expression were quickly transformed into a coherent political revolutionary outlook once the issue of the Moroccan War polarized French public opinion. They formed a kind of united front with the Marxist and Communist magazine *Clarté*, *Philosophies,* and *Correspondance* in issuing the manifesto "La Révolution d'abord et toujours," which was in itself a turning point for the movement. For the first time, the Surrealists published a declaration of position on specific political issues. They censured the financial slavery exercised by the haves over the have-nots; they condemned the Moroccan War; they called for immediate disarmament. And above all, they subsumed their political views under a more general practical political stance: "We are not Utopians; we only conceive of this Revolution in its social aspect."[98] A few years later Breton looked back to the significance of this change in the attitude of the Surrealists:

> "La Révolution d'abord et toujours". . . . no doubt ideologically rather confused. . . . marks no less than a distinctive precedent which will decide all of the later conduct of the movement. Surrealist activity, in the presence of this brutal, revolting, unthinkable act [the Moroccan War] will be led to examine its own resources, to determine its limits; it will force us to adopt an exact attitude, exterior to itself, in order to confront issues which go beyond its limits. This activity entered at this moment its rational phase. It suddenly experienced the need to clear the ditch that separates absolute idealism from dialectical materialism.[99]

The most important step had been taken toward adopting a specific Marxist revolutionary attitude.

The Surrealists' efforts to define their relationship with both the Communist party and Communist principles proved to be a major problem in the years to come. At stake was the very definition, or rather redefinition, of the movement at a time when the enterprise had already shifted from its basic premises. One such significant change in the character of the movement was the decreas-

ing role of objective experiences, exemplified by the recording of dreams and automatic writing, and a corresponding growth of emphasis on literary activity. In this search for a new identity a number of Surrealist stalwarts were expelled, to be replaced by new adherents, while the very aims of the movement were being reassessed. The major disruptive force of the Surrealist movement was the temptation posed by Communist ideology. Precisely because the Communist program was so appealing and the party's demands for orthodoxy so strict, the Surrealist group adopted more and more of their beliefs while retaining their independent identity. The major ideological hurdle was the Communists' single-minded concern with improving the economic bases of life for the proletariat, an attitude which led them to suspect all intellectual effort not directed toward the exaltation of their struggle for the masses. Breton emphatically refused to subordinate the aims of Surrealism to a program of artistic propaganda, even though it was for an ideology which he supported: "There is no one amongst us who does not wish the passage of power from the hands of the bourgeois to the hands of the proletariat. In the meantime, it is no less necessary, according to us, that the experiences of interior life be carried on, and that, of course, without exterior control, even Marxist."[100]

Despite such fundamental disagreement with the Communist party, the Surrealists increasingly came to identify with the premise and political aims of Communism. Breton became a member of the party in 1927 and remained a member until he was expelled at the end of 1933. He indicated the new direction of the enterprise in the opening words of the *Second Surrealist Manifesto*, which appeared in the final issue of *La Révolution Surréaliste:* "Surrealism offers only to provoke, from an intellectual and moral point of view, a *crisis of conscience* of the most general and most profound order."[101] This was a 180° change of direction from the principles of Surrealism as they were proclaimed six years before in the first manifesto, in which Breton's definition of Surrealism included the following qualifier: "Dictate of thought, in absence of all control exercised by reason, outside of all aesthetic or moral preoccupations."[102] The newly proclaimed morality of Surrealism was to be based on Marxist principles and it was to utilize them in the promulgation of its goals:

> How is one to admit that the dialectical method can only be applied to the resolution of social problems? All of the ambition of surrealism is to provide it with possibilities of application which in no way oppose the most immediate conscious domain. I do not really see, with all due deference to certain revolutionaries of a limited mind, why we refrain from raising (provided that we envisage them under the same angle as that under which they envisage—and we do too—the Revolution) the problems of love, of dream, of madness, of art, and of religion.[103]

The change in direction of the movement is best indicated by the change in the name of the official Surrealist periodical after the publication of the *Second Surrealist Manifesto*. Appearing under the name of *La Révolution Surréaliste* from its foundation through the end of 1929, it reappeared in 1930 as *Le*

Surréalisme au Service de la Révolution. To make this new political direction clear, the first issue of the new journal opened with the telegram sent to Moscow pledging support for the Soviet government in case of open conflict between capitalism and communism: "Comrades, if imperialism declares war on the Soviets our position will conform to the directives of the Third International position of the members of the French Communist Party." Then they continued by offering their immediate support for the cause of revolution: "In the present situation of unarmed conflict we believe it useless to wait in order to put in the service of the revolution the means which are more particularly ours."[104] It is at this high point of political ferment among the Surrealists and their solidarity with the Communist party that Buñuel filmed *L'Âge d'Or.*

Luis Buñuel's political and moral views were very similar to those held by the Surrealist group. He was disposed by temperament to oppose the values of bourgeois society. Like so many men who were educated by strict religious orders, he too saw in them the most reactionary forces of that society, and accordingly became an atheist. Once at the University of Madrid, he became aware of the political dimension of his natural sentiments. Even before he came into contact with the Surrealists, he had reached a certain political awareness. In a review he had written of Fritz Lang's *Metropolis* in 1927 he disapproved of the depiction of the masses for the following reason:

> In our opinion the main fault of the movie lies in the fact that the author did not follow the idea illustrated by Eisenstein in *Battleship Potemkin*, in that he forgot a single actor, although full of novelty and of possibilities: the masses. . . . That does not mean that in *Metropolis* the multitudes are absent; but they rather seem to respond to a decorative need; the need of a gigantic "ballet"; they aim to enchant us more by their admirable and balanced evolution than to make us listen to their soul, their exact compliance with more human, more objective motives.[105]

While he had evolved such a political sensibility even before contacting the Surrealists, Buñuel found in Surrealism an affirmation of his beliefs and a particular program to follow:

> Surrealism revealed to me that in life there is a moral direction that man cannot avoid taking. Through it I discovered for the first time that man was not free. I believed in the total liberty of man but I saw surrealism a discipline to follow. That was a great lesson in my life and also a great step, marvellous and poetic.[106]

In *L'Âge d'Or* he proceeded to launch an attack against the bourgeois mentality: "Bourgeois morality is for me immorality against which one must fight: the morality founded on our highly unjust social institutions, such as religion, country, family, culture; in the end what one calls the 'pillars' of society."[107] (In his talk given in Prague in 1935 entitled "Position politique de l'art d'aujourd'hui," André Breton condemned precisely these institutions, when he referred to the "mechanism of oppression based on the family, religion, and

country.''[108]) That Buñuel worked toward a politically rigorous film in shooting *L'Âge d'Or* is perhaps best indicated by the successive titles proposed for it. At first, it was to be called *La Bête Andalouse* since it was to continue in the spirit of *Un Chien Andalou*. Then he had in mind *Abajo la Constitución*, before he settled on its final title.[109] But there was yet another title, affixed to a cut version of the movie, which was to be shown to workingclass audiences. In 1936 Buñuel cut the introductory and concluding passages of the film, leaving the story of the couple, which he entitled *Les Eaux glacées du Calcul égoiste*. The title was taken from Marx's *Communist Manifesto*, which reads "[The bourgeoisie] has drowned religious ecstasy, chivalrous enthusiasm, 'petite bourgeoisie' sentimentality in *the iced waters of selfish calculation*.''[110] This last step in the evolution of the movie as an idea reveals the furthest point of Buñuel's politicization. It demonstrates that he considered at least the main part of his movie as having a highly political content which could be used as a weapon of propaganda. While originally he did not create *L'Âge d'Or* as a propaganda film, he did infuse it with a great deal of political meaning. Buñuel has articulated a definite view of the mission of the artist based on the position of Engels:

> I have made mine the words of Engels which define the role of the novelist as such: "The novelist (filmmaker) will have discharged his duty honestly when, through a faithful description of authentic social relations, he will destroy the conventional ideas on the nature of these relations, will weaken the optimism of the bourgeoisie world, and will force the reader (spectator) to doubt the permanence of the existing order, even though he may not indicate directly a conclusion or even take sides sensibly.''[111]

This position, pronounced by Buñuel many years after the shooting of *L'Âge d'Or*, approximates the real revolutionary intent of the film. We must note, however, that like the Surrealists, whose ranks he joined in 1929, Buñuel's position as expressed by the film includes at once revolt and revolution. The change in direction marked by the Surrealists' changing the name of their journal from *La Révolution Surréaliste* to *Le Surréalisme au Service de la Révolution* between 1929 and 1930 finds its exact parallel in Buñuel progressing from *Un Chien Andalou*, a movie of inner turmoil, to *L'Âge d'Or*, which presents the elements of social conflict.

The story of *L'Âge d'Or* does not end once we have followed it from the collaboration of Dali and Buñuel through an examination of its themes and techniques to the approving nod given it by André Breton. The movie was released in the fall of 1930 and shown for over a month before an unfriendly public first disturbed a performance, then caused the film to be banned completely. The movie became a political issue through a disruption of the showing, which recalls similar incidents that broke out at the screenings of Man Ray's *Le Retour à la raison* and Artaud's *La Coquille et le Clergyman*. While the outburst during the showing of the latter was caused by a matter of personal and aesthetic differences between Antonin Artaud and Germaine Dulac and

the havoc on the night of "Le Coeur à Barbe" was typical of the Dadaists' attempt to arouse their public, the interference with *L'Âge d'Or* was indicative of greater political forces at work. Briefly, on the night of December 3 members of the League of Patriots and Anti-Semitic League came prepared to disrupt the projection. Waiting until the moment in the film when a reliquary was placed on the ground, the group swung into action. Cries of "Down with the Jews!" and "This will teach you there are some Christians left in France" echoed through the hall. Stink bombs exploded and purple ink was thrown on the screen. The audience came under assault, then the furnishings of the theater. Before leaving, the ruffians smashed windows, ransacked the office, looted the library, slashed paintings by Dalí, Ernst, Man Ray, Miró, and Tanguy which were hanging in the lobby, and attempted to cut the telephone wires. Only a few of them were arrested, and even they were released soon afterwards.

Paradoxically, the incident touched off a chain of events which resulted in reprisals being taken against the film itself, rather than against the fascist demonstrators. On December 5 the prefecture of police asked for suppression of the two sequences which featured archbishops. On December 7 the fascist campaign against the film began in earnest with an open letter addressed to the President of the Board of Censors appearing in *Le Figaro*. The writer objected to "so much bolshevik excrement being spread out on a Parisian screen." and added that he "preferred the ink that was hurled upon it by the *French Patriots.*"[112] Although the prefecture of police asked for another alteration in the film on December 8, namely, the elimination from the program of the line "The Duke of Blangis is evidently Jesus Christ," the right wing was not satisfied. The December 10 issue of *Le Figaro* featured on its front page an article demanding the prohibition of the film. The article reprinted a letter by the provost, de Launay, to the police chief, Chiappe, which called the film, "a poisoning which is becoming systematic of society and of French youth" and therefore called for its banning. The columnist added his own support to the disrupters in the following terms: "The demonstrations and protests triggered by *L'Âge d'Or* were not merely legitimate. They appear as the instinctive defense of honest men against an undertaking in which I do not hesitate to discern a Satanic influence." He also appealed to the police chief to take action: "Come on Chiappe, sweep out the trash! You can do it, you should do it."[113] The pressure exerted by the right wing was effective, for the following day the newspapers announced the police action banning the movie.[114] That ban was to last through the Third Republic and the Nazi occupation of France. By coincidence, the furor over the authorization of *L'Âge d'Or* broke out during the same few days that massive demonstrations staged by the Nazis in Berlin against *All Quiet on the Western Front*. Conservative papers carried news concerning the two movies literally side by side without making the least connection between the two events. It was up to Léon Moussinac, film critic for *L'Humanité*, to explain the larger issues that were involved:

[*All Quiet on the Western Front*], shown in Berlin, aroused some racist demonstrations and this was sufficient for the minister of the interior to prohibit it, just as it was enough in Paris for some hoodlums of the *Action Française* or some commonplace anti-Jewish league to have booed Buñuel's film *L'Âge d'Or* to cause Chiappe to censor it. Here and there in the name of public order, naturally.[115]

The fascist hooligans were justified in reacting to the film as a political work, for that is just how the Surrealists considered it. They had written a manifesto which they included in the program and which attempted to explain the significance of the movie. A detailed discussion of the movie's various themes was anchored to a political understanding of the film. Speaking of love, for example, the pamphlet asserted that "the problem of the failure of sentiment, intimately connected to that of capitalism, has not yet been resolved." It is especially in the final section of the manifesto, headed "Social aspect—subversive elements," that the Surrealists threw their support behind the political content of the film and launched into a critique of the existing order.

> Projected at a moment when banks fold, when revolts erupt, when cannons begin to leave the arsenal, *L'Âge d'Or* must be seen by all those who are not yet alarmed by the news that the censor allows to be printed in the newspapers. It is an indispensable moral complement to the alarms of the stock exchange and its impact is all the more direct because it is surrealistic.

They saw the movie as presenting "a society in decomposition which tries to survive by using preachers and policemen as their only means of support." They pointed to the revolutionary role which love assumed in such a decaying bourgeois society.

> The transition from the state of pessimism to action is determined by love, principle of evil in bourgeois demonology, which demands that we sacrifice everything to it: position, family, honor, but whose defeat in social organization introduces the sentiment of revolt.

The person who embodied this struggle most fully in his life and works was the Marquis de Sade, whom the Surrealists held in high regard. Their manifesto ended with an appeal for revolution which was a generalization of de Sade's individual revolt:

> It is not by chance that Buñuel's sacrilegious movie is an echo of the blasphemies roared by the divine marquis across the bars of his prisons. It still remains to be demonstrated that the final outcome of this pessimism will be the struggle and victory of the proletariat, which will mean the abolition of a society made up of different classes. In this age of "prosperity" the social function of *L'Âge d'Or* must be to urge the oppressed to satisfy their hunger for destruction and also perhaps to cater to the masochistic tendencies of the oppressors.[116]

Once *L'Âge d'Or* was banned, the Surrealists continued their political strug-

gle by publishing a rhetorical "Questionnaire" on the main issues that were in-
volved in the suppression of the movie. They demanded to know since when
had the right to question religion been forbidden in France. They pointed out
that the sanctioning of the actions of the League of Patriots by the police
meant an official encouragement of the establishment of fascist methods in
France. They asked ingenuously whether they were now empowered to break
up manifestations of religious propaganda. Finally, they asserted the incom-
patibility of Surrealism with bourgeois society and contended that their dif-
ferences were part of a much larger political struggle.

> This intervention being made under the pretext of protecting childhood,
> youth, the family, the country, and religion—can one for an instant claim
> that this obvious movement towards fascism does not have as its aim the
> destruction of all that tends to oppose it in the coming war? And especially
> the war against the U.S.S.R?[117]

The scandal that broke out around *L'Âge d'Or* was directly related to the
contemporary political scene. The Surrealists' turn toward Communism in the
late 1920s created the political climate within the movement which encouraged
Buñuel to make *L'Âge d'Or* the strongly critical film it is and which made the
group especially approving of that film. To understand the violent reaction
that greeted the movie once it came out, we must turn to the more general
situation of political moods by the year 1930. The military upheavals of World
War I touched off social upheavals which were to be resolved only through the
conflicts of World War II. The specter of Communism became a reality once it
became clear that the Bolsheviks would not lose power in the Soviet Union.
The fear of Communism pushed the middle class under the banners of the
newly formed phalanxes of nationalism throughout Europe. The fragile
stability they found was given a devastating blow by the 1929 stock-exchange
crash. Their economic and psychological dislocation during the depression
years made them cling all the more frantically to the basic values promulgated
by fascist ideology. Their fanaticism led them to build powerful fascist
movements not only in Germany and Italy, but in all European countries, in-
cluding France. Opposing the ultraconservative nationalists were strong
minorities of communists and socialists. Open clashes between the two ex-
tremes became more and more common, especially from the time of the 1929
crash up to the war itself. The *L'Âge d'Or* incident was one of many between
left and right, which usually took on larger proportions as street fights at any
event that had the least bit of political significance. The incident that involved
the ultimate Surrealist film, which was in itself a milestone in the history of the
cinema, caused only a slight ripple in the deep waters of European politics be-
tween the wars. That slight ripple, however, was part of a tidal wave that
would inundate all of Europe within the next fifteen years.

NOTES

1. André Breton, *Entretiens* (Paris, 1952), p. 156.

2. Salvador Dalí, *The Secret Life of Salvador Dalí* (1941), trans. Haakon M. Chevalier (London, 1948), pp. 205-6.

3. "Tomorrow or the day after I am going to Dalí's house for two weeks in order to collaborate on a common idea which is highly cinematic." Louis Buñuel from "Letter to José Bello," Paris, January 1929 as quoted in J. Francisco Aranda, *Luis Buñuel, biografía crítica* (Barcelona, 1969), p. 75.

4. Buñuel defended his initial idea, which he created with Ramón Gómez de la Serna, years later in the Mexican journal *Nuevo Cine*: "In reality the idea of the newspaper *The World for Ten Cents* which he [Dalí] criticized so much, is a good idea: the story would have included not only the dramatized news of newspapers, but also would have recorded in a documentary fashion the process of making a newspaper." Quoted in ibid., p. 76.

5. "Letter to José Bello," Paris, February 10, 1929, reprinted in ibid.

6. Ibid.

7. Ibid., p. 77.

8. Breton, *Entretiens*, p. 159.

9. Dalí, *The Secret Life*, p. 97. It is also revealing that Dalí observed in a footnote of his autobiography the simple fact that "my relatives still call me a child." P. 224.

10. The crisis Dalí went through that summer was also witnessed by his sister who wrote that the summer of 1929 "sufficed to bring about a change in Salvador which removed him from his friends, from us, and also from himself. The flow of his life, as well channeled, deviated under the pressure of these complicated beings, who could understand nothing of the classical landscape of Cadaqués." Ana María Dalí, *Salvador Dalí vu par sa soeur*, trans. Jean Martin (Paris, 1960), p. 178.

11. Dalí, *The Secret Life*, p. 248.

12. Ibid., p. 268.

13. "Conquest of the Irrational" (1935) in ibid., p. 418.

14. Salvador Dalí, *Le Mythe tragique de l'Angelus de Millet* (Paris, 1963), p. 9.

15. Salvador Dalí, *L'Amour et la mémoire* (Paris, 1931), pp. 10-12.

16. Dalí's predilection for the ruling classes is a well-known fact. He wrote, "The aristocratic regime has in fact been one of my passions, and already at that period I thought a great deal about the possibility of giving back to this class of the elite a historic consciousness of the role which it would inevitable be called upon to play in the ultraindividualist Europe that would emerge from the present war." Dalí, *The Secret Life*, p. 262.

17. "Contrary to current opinion, the cinema is infinitely poorer and more limited in the expression of the real functioning of thought than writing, painting, sculpture, and architecture. . . . The cinema is linked by its very nature to the sensorial aspect, low and anecdotal, to abstraction, to rhythmic impressions, in a word, to harmony. And harmony, sublime produce of abstraction, is, by definition, at the antipodes of the concrete and consequently of poetry." Salvador Dalí, *Babaouo* (Paris, 1932), pp. 11-12.

18. Ibid., p. 13.

19. Dalí also entitled an article he wrote a couple of years later, "L'âne pourri," See Salvador Dalí, "L'âne pourri," *Le Surréalisme au Service de la Révolution* 1 (July 1930):9-12.

20. Carlos Fuentes, "The Discreet Charm of Luis Buñuel," *The New York Times Magazine*, March 11, 1973, p. 87.

21. "I wanted to introduce crazy, completely disparate elements into the most realistic scenes. For example, when Jaibo is going to fight and kill the other boy, the movement of the camera reveals in the distance the skeleton of an eleven-story building being constructed, and I would have wanted to put there an orchestra of a hundred musicians. One would have seen it only in passing, in confusion," Jacques Doniol-Valcroze and André Breton, "Entretien avec Luis Buñuel," *Cahiers du Cinéma* 36 (June 1954):6.

22. Aranda, *Buñuel*, p. 77. In spite of Buñuel's statements that *Chien Andalou* signifies nothing, Aranda has suggested that Buñuel and his friends called those members of the Residencia at the University of Madrid "Andalusian dogs" who were writing symbolist poems without a revolutionary content. Ibid., p. 58.

23. Dalí, *The Secret Life*, p. 213.

24. That Vermeer's *Lacemaker* is of special significance to Dalí is borne out by two separate photographs, one taken of him and Gala standing in water while holding up a copy of this painting, the other taken of him sitting in front of the painting in the Louvre "copying" it. (The copy shows nothing but four horns on the canvas.) See photo opposite p. 177 of Salvador Dalí, *Journal d'un génie* (Paris, 1964). Robert Descharnes has made a movie of Dalí's interest in this painting entitled *Histoire prodigieuse de la dentellière et du rhinocéros.*

25. It is of interest to note that he drew a portrait of himself in 1927 without a nose and a mouth. Reproduced in Dalí, *The Secret Life*, p. 9. The unfinished portrait reminds us that Dalí's emergence from himself came only two years later, when he met Gala.

26. "My brother and I resembled each other like two drops of water. . . . My brother was probably a first version of myself, but conceived too much in the abosulute." Ibid., p. 2.

27. That Dalí saw himself as being at the mercy of women is borne out among other things by his preoccupation with the praying mantis. He has readily admitted that the source of his fascination with this insect has been its peculiar mating habit, namely, the female devouring the male after mating.

28. Carlos Fuentes, "The Discreet Charm of Luis Buñuel," p. 87.

29. According to Georges Bataille, "Buñuel himself told me that this episode was Dalí's invention and that it was suggested to him by the actual sight of a long and narrow cloud slicing the surface of the moon," which we find preceding the cutting of the eye in the movie. Georges Bataille, "Le'Jeu Lugubre' " *Documents* (Paris):372.

30. Reported by J.H. Matthews, *Surrealism and Film* (Ann Arbor, 1971), p. 85. A curious similarity to the slashed eye is to be found in Dalí's *Babaouo*. At one point the hero puts a coin in the outheld hands of a criple. Since the hand holds a fried egg, the coin breaks the yolk. This image recalls the cut eyeball, but especially when we remember the association fried eggs had for Dalí. He writes in his autobiography that "already at that time [in the intrauterine period] all pleasure, all enchantment for me was in my eyes, and the most spendid, the most striking vision was that of a pair of eggs fried in a pan, without the pan." He comments that the image must have originated from the pressure of his fists on his orbits in the fetal position. As such, the fried eggs were the luminous sensations experienced by the eyes. Dalí, *The Secret Life*, p. 27.

31. Buñuel discovered Freud in 1921. Aranda, *Buñuel,* p. 23. He has called him "one of the three greatest men of the century," along with Lenin and Einstein. Julio C. Acerete, J.F. Aranda, et al., *Pour Buñuel*, Paris, 1962,p. 30. Dalí first started reading Freud's *Interpretation of Dreams* when he was at the Residencia in the early 1920s and called it "one of the capital discoveries of my life." Dalí, *The Secret Life*, p. 167.

32. Quoted in Aranda, *Buñuel*, p. 86.

33. Dalí, *The Secret Life*, p. 212.

34. Luis Buñuel, *"Un Chien Andalou,"* *La Révolution Surréaliste*, No. 12. (December 15, 1929).

35. "The scenario, like that of *Chien Andalou,* was made in collaboration with Dalí." "Letter to José Bello," Paris, May 11, 1930, in Aranda, *Buñuel*, p. 95.

36. As Dalí himself had written, "Buñuel was going ahead all by himself with the production of *L'Âge d'Or*—thus the film would be executed without my collaboration." Dalí, *The Secret Life*, pp. 276-77.

37. Ibid., p. 282.

38. Ibid., p. 252.

39. Salvador Dalí, "Mes secrets cinématographiques," *La Parisienne*, February 1954, pp. 165-68.

40. Dalí, *The Secret Life*, p. 283.

41. The same novel by de Sade that Buñuel adapted to the end of *L'Âge d'Or* left a profound impression on Dalí as well: "I reread from year to year *120 Days of Sodom* because I have a sublime project. . . . One day I shall rewrite this book in order to make sure of its immortality. I shall inverse all its terms: all that is vice will become virtue; all that is sex will become soul; all that is orgasm; ecstasy; all that is flesh, spirit. I shall make it the saga of chastity, of abstinence, and of spiritual perfection." Salvador Dalí, *Les Passions selon Dalí* (Paris, 1968), p. 163. The similarity of *Babaouo's* opening scene, in which a decapitated hen emerges from a wild party to collapse in its pool of blood, and

the final scene of *L'Âge d'Or*, in which a young girl is brutally murdered at the end of the orgy, suggests that Dalí may have been directly inspired by the film.

42. After complaining about Buñuel's distortions of his ideas, Dalí praised this passage: "The film had produced a considerable impression, especially the scene of unfulfilled love in which one saw the hero, in a state of collapse from unsatisfied desire, erotically sucking the marble big toe of an Apollo." Dalí, *The Secret Life*, p. 282. Dalí remembers incorrectly, because it is the heroine who sucks the statue's toes.

43. Dalí thought that the image of a man with a rock on his head was hilariously funny. During the summer of 1929, when his friends visited him in Cadaqués and he had his laughing fits, it was a similar image that made him laugh—the image of a very respectful person with a stylized owl perched on his head, topped by Dalí's own excerment. In connection with this vision, it is interesting to cite Dalí's comment that 'between the excrement and a piece of rock crystal, by the very fact that they both sprang from the common basis of the unconscious, there could and should be no difference in category." Ibid., p. 219.

44. André Breton, "Manifeste du surréalisme (1924)," *Manifestes du surréalisme* (Paris, 1971), p. 25.

45. Of the many interpretations attempted, the following are to be commended either for the depth or originality of their investigation. François Piazza has carried out a thorough psychoanalytical investigation in which the cutting of the eye symbolizes the man's castration complex vis-à-vis the woman. Further evidence of his lack of virility is seen in his falling with the bicycle. The androgynous woman on the steet symbolizes his homosexual side. The load of pianos and priests is seen as a materialization of the superego, which, joined to the castration complex, prevents him from consummating his relationship. The woman is offended by his deficiencies, which are illustrated by his losing his mouth. The final scene, of insects devouring the bodies of the couple, is interpreted as a symbol of the omnipotence of desire and the permanance of the passion of mad love. François Piazza, "Considérations sur le *Chien Andalou* du Luis Buñuel et Salvador Dalí," *Psyché*, Nos. 27-28 (January-February 1949), pp. 147-56. Mondragon interprets the beginning in an original way but does not know what to do with the rest. He sees in the opening sequence the conception of a child symbolized by the sharpening of the knife on the leather strap, his being totally formed by the full moon, and the birth by the splitting of the eyeball. His attempts to walk are illustrated by the man in child's clothes riding the bicycle and falling. He looks for pleasure in his own body as shown by the ants in his hand. He often regresses and revolts against the part of himself which remains a child. When a woman comes to him, he does not know how to receive her and so she leaves him for another. Mondragon, "Comment j'ai compris *Un Chien Andalou*," *Ciné-Club*, Nos. 8-9, (May-June 1959). Pierre Renaud suggests that the movie is the story of a man struggling with his homosexual instincts and normal desires. For him, the cut eye represents his introduction to sexuality, a violent defloration from which his homosexual tendencies aries. The striped box with the tie inside is further evidence of his ambivalent attitude, for it is a female sexual symbol containing a male. The load he drags toward her is his past, which he is offering to her in order that their love be realized without restrictions. Their meeting by the seashore proves their successful union, while the broken box cast ashore, his triumph over his complexes. Pierre Renaud, "Un Symbolisme au second degré: *Un Chien Andalou*," in *Études cinématographiques*, Nos. 22-23 (Paris, 1963), pp. 147-57. Raymond Durgnat sees the beginning as a fairytale opening suggesting infantile experience. The rest of the film shows the man's attempts to possess the woman, first through violent assault, then with the apparatus of culture as represented by the piano and priests, followed by a sensitive display in the park, and finally an aggressive demonstration in the room of not needing her. All of these attempts fail. The end shows the united couple. He has reached sexual maturity, but he has no joy in it. His earlier sexual struggles were accompanied by desire: now they are resolved and he has reached a respectable stalemate. Raymond Durgnat, *Luis Buñuel* (Berkeley, 1970), pp. 22-38. Curiously, Buñuel has not accepted any interpretation of the movie: " I have heard or read interpretations of *Chien Andalou*, one more ingenious than the other, but false." François Truffaut, "Rencontre avec Luis Buñuel," *Arts*, July 25, 1955, p. 5.

46. Ibid.

47. Although neither Buñuel nor Dalí were members of the Surrealist group before the shooting of *Un Chien Andalou*, they both had followed its activities with great in-

terest. As Buñuel wrote in his preface to the authorized version of the scenario, which appeared in the December 15, 1929 issue of *La Révolution Surréaliste*, "It expresses without any sort of reserve my complete adherence to surrealist thought and activity. *Un Chien Andalou* would not exist if surrealism did not exist."

48. Luis Buñuel, "Notes on the Making of *Un Chien Andalou*," *Art in Cinema*, ed. Frank Stauffacher (New York, 1968), p. 29.

49. Ibid., p. 30.

50. Aranda has pointed out Buñuel's interest in the effects of slow motion, which were already evident in the early years of his cinematic work. He has observed that Buñuel was exposed to this technique in the work of Jean Epstein, under whom he worked as assistant director. But while Epstein used this technique to enchance the aesthetic experience of a particular scene, Buñuel went on to use it in a functional manner to indicate a dream or hallucination. Aranda, *Luis Buñuel*, pp. 64-66. Aranda's observation is verified by the first and only example of slow-motion photography in *Un Chien Andalou*, during the scene of the hero's double going to the desk and soon after being shot. Taken together, the slow-motion photography and the caption "At three o'clock in the morning" define this section as a dream sequence.

51. Buñuel's unpublished autobiography as quoted in ibid., p. 74.

52. Ibid., p. 93. Dalí was of a similar opinion as we have seen from his "Summary of a critical history of the cinema," which served as a preface to *Babaouo*.

53. Like so many of his contemporaries, Buñuel considered the cinema to have reached a high point in the comic film. As the head of a film club in Madrid, he held a "comic movies" evening on May 4, 1930. In his introduction he proclaimed, "People are so absurd, have so many prejudices, that they believe *Faust* and *Potemkin*, etc. are superior to these buffooneries which are not that at all and which I would call the new poetry. The surrealistic equivalent in cinema can be found *only in these films*. Much more surrealistic than those of Man Ray." Quoted by Aranda, *Luis Buñuel*, pp. 66-67. His comments testify to his belief in the surrealistic nature of humor. It is not surprising that humor is such an important part of his brand of Surrealism.

54. The notion was suggested by Parker Tyler, *Classics of the Foreign Film* (London, 1962), p. 65.

55. Raymond Durgnat has pointed out that *avoir les fourmis* (to have ants) means "to have pins and needles," i.e. the sensation resulting from limbs going to sleep. Raymond Durgnat, *Luis Buñuel*, p. 27.

56. Buñuel's unpublished autobiography as quoted in Aranda, *Luis Buñuel*, p. 74.

57. Quoted in Jacques Trébouta, "Luis Buñuel, sa vie, son oeuvre en Espagne et en France," Ph.D. Dissertation, Institut des Hautes Études Cinématographiques, Paris, 1958-59.

58. Quoted by Emilio Garcia Riera, "The Eternal Rebellion of Luis Buñuel," trans. Jack Bolanos, *Film Culture*, No. 21 (Summer 1960), p. 56.

59. I have followed the shot-by-shot analysis of *L'Âge d'Or* as presented in *L'ÂGE D'OR AND UN CHIEN ANDALOU, films by Luis Buñuel*, in *Classic Film Scripts* (New York, 1968). What appears in *L'Avant-Scène du Cinéma*, Nos. 27-28 (June-July 1963) is only the shooting script.

60. Quoted in *Études cinématographiques* 20-21 (Paris: 1962):117.

61. Ibid., p. 122.

62. For the exact difference between the planned and the actual scorpion sequence, see *Classic Film Scripts*, pp. 10-11 and 15-16.

63. In a similar vein Buñuel often starts out from the real in his later movies. *Los Olvidados* begins with shots of big cities taken from the air before it descends into the squalor of the slums of Mexico City. *Subida al Cielo* opens with a demonstration of the coconut industry and priestless marriage on the island. A long, panoramic shot of the port of Bastia introduces *Cela s'appelle l'aurore*. A description of the diamond-mine exploitation sets the tone for *La Mort en ce jardin*.

64. While the sumptuous presentation of the archbishops seems to come from Dalí, the way they are shown delivering their monotonous cant recalls a project Buñuel had for a film entitled *La Sancta Misa Vaticanae*, in which he wanted to show priests standing between the enormous columns of St. Peter's delivering Mass at incredible speeds. Reprinted in Aranda, *Luis Buñuel*, p. 54.

65. Raymond Durgnat has noted the decisive influence of Darwinism on Buñuel's

thought: "His intellectual 'awakening' came from reading Darwin's *The Origin of Species*." Durgnat, Ap. 12. The connection between Darwinist and Marxist thought was noted by Karl Marx himself, who saw in *The Origin of Species* "a basis in natural science for the class struggle in history." Letter of Marx to Lassalle, 1860, as quoted by Donald D. Egbert, *Social Radicalism and the Arts* (New York, 1970), p. 99. This was why he wanted to dedicate *Das Kapital* to Darwin.

66. Buñuel's view of the artist as a proletarian, literally a have-nothing, is also borne out by his choosing Max Ernst to play the captain of the bandits. Many years later Buñuel related how the Beatles reminded him of his bandits in *L'âge d'Or*. As the interviewer reported, "Buñuel was crazy about the current phenomenon, the Beatles. In the Beatles, he said, he saw an incarnation of the dream he had when he made *L'Âge d'Or*. These were the very images of men he wanted to create thirty-five years ago! . . . He saw the Beatles poetically, both as 'an allegory of our time' and as a 'catastrophe of our epoch.'" Kanji Kanesaka, "A Visit to Luis Buñuel," *Film Culture*, no. 41 (Summer 1966), pp. 60-67. Buñuel pokes fun at the arts later on in the film when he shows a pedestrian kicking a violin along the sidewalk, then finally jumping on it to smash it to bits. His image of the artist as a poor wretch was already established in his youth when, seeing himself in that role, he dressed up as a tramp to go to the cafes of Madrid where his friends gathered. Recounted by Dalí in Alain Bosquet, *Entretiens avec Salvador Dalí* (Paris, 1966), p. 98.

67. The Surrealists considered this passage to be one of the high points of the film. In their defense of the movie they wrote, "It is useless to add that one of the culminating points of the *purity* of this film seems to us to crystallize in the vision of the heroine in the toilet where the power of the spirit succeeds in creating out of a generally baroque situation a poetic element of the purest nobility and solitude." "Manifeste des surréalistes à propos de *L'Âge d'Or*," *L'Avant-Scène du Cinéma*, p. 25.

68. Like other elements in Buñuel's films, the cow on the bed has a number of different possible meanings. Jacques Brunius has suggested that the cow is a reference to the policemen who hold the woman's lover, for *vache* (cow) in French is a slang expression for "cops." Raymond Durgnat has taken this idea one step further and sees the cow as an embodiment of the restraints of society placed on the man by the police, on the woman by her mother. Durgnat, *Luis Buñuel*, p. 41. The association of the cow with the maternal instinct was indeed closer to Buñuel's mind. In one of his surrealistic texts he describes a scene with his mother washing clothes in front of a group of cows. Luis Buñuel, "Une Girafe," *Le Surréalisme au Service de la Révolution*, no. 6 (May 15, 1933). The presence of the cow on her bed clearly makes the animal an obstacle to her sexual union with her lover. The bed is once again the scene of frustrated sex at the end of the movie when the man hurls himself on the same bed after witnessing the woman's infidelity with the conductor and tears up a pillow in his rage.

69. The blind man interested Buñuel from his youth. In a story entitled "The Blind Man of the Turtles," written in the late 1920s, Buñuel sketched a character who made up for his lack of sight by having a sixth sense and a conniving quickness. He was a prototype for the depraved blind who later appeared in *Los Olvidados* and *Viridiana*. Buñuel's idea of the debased blind man who could more than take care of himself largely came from the Spanish picaresque tradition, which he read avidly. While he created malevolent blind characters, he was genuinely interested in the lot of the blind. He published the above story in the *Official Review of the Blind*, which was a journal that aimed to help the blind adapt to their handicap. Aranda observed that this aspect of Buñuel's character was only seemingly contradictory: "His attack on charity did not stop him from having a humanitarian sentiment towards the blind; just as his burlesque use of romantic music, symbolizing for Buñuel the ideals of a decadent bourgeoisie, did not stop him from loving the music." Aranda, *Luis Buñuel*, p. 56.

70. In the original screenplay Buñuel specified, "During the shooting the various motions they make towards each other can be completed, but during cutting all their kisses and caresses must be left unfinished, interrupted at the moment of fulfillment." *Classical Film Scripts*, p. 54.

71. The idea of the four Marist monks crossing the bridge comes from one of Buñuel's early poems, "The Rainbow and the Cataplasm" of 1927, which begins with "How many Marists fit on a bridge? Four or five?" Aranda, *Luis Buñuel*, p. 286.

72. The original screenplay noted at this point that "the orchestra must constantly

repeat this part of the musical score, in case the previous love scene takes on more importance than the shots used to show the playing of *Tristan and Isolde.*" *Classic Film Scripts*, p. 65.

73. We notice that he has lost his moustache and beard, a change reminiscent of the man's losing his mouth and growing hair in its place in *Un Chien Andalou.* In both cases the appearance or removal of hair from the face is linked to a sexual impulse.

74. That Buñuel sought to make the appearance of Christ as shocking as possible is indicated by the change he made in his original scenario. He had intended to depict each of the four scoundrels in a historically different costume, but decided to dress three of them in eighteenth-century garb in order to accentuate the difference between them and their leader, Christ.

75. The overpowering effect of the multivalent leit motif is due to its reproduction of a basic mechanism of the subconscious. There is a striking similarity to the process of condensation, the first achievement of the dream-work as described by Freud: "One of the effects of condensation upon the relationship between the manifest and the latent dream is that the connection between the elements of the one and of the other nowhere remains a simple one, for by a kind of interlacing a manifest element represents simultaneously several latent ones." Sigmund Freud, *Introductory Lectures on Psycho-Analysis*, trans. Joan Riviere (London, 1922), p. 146.

76. Quoted in Aranda, *Luis Buñuel*, p. 27.

77. Ibid., p. 18.

78. Buñuel's idea of the poor springs from the picaresque tradition. Already as a child he avidly read Lazarillo de Tormes, the sixteenth-century Spanish picaresque writer. For the close relationship between his work and the picaresque novel, see Carlos Rebolledo, "Buñuel et le roman picaresque" of his *Luis Buñuel* (Paris, 1964).

79. Buñuel's sister, Conchita, has said that Luis became seriously interested in music around the age of thirteen, when he started playing the violin. She recalled that he especially loved Wagnerian music and even formed an orchestra which he conducted in church. Conchita Buñuel-Garcia, "Mon frère Luis," trans. Marcel Oms, *Positif*, no. 42 (November 1961), pp. 19-25. His brother, Alfonso, remembered Luis' musical interest as well: "Very fond of music, he played the violin and piano from the time he was little; I always remember him, in the mornings before breakfast, playing the ocarina. His favorite composer whom he held in profound veneration was Richard Wagner and especially his *Tristan and Isolde.*" Letter of Alfonso Buñuel as quoted in Aranda, *Luis Buñuel*, p. 23.

80. Although the film was made in 1953, Buñuel had originally intended to shoot it soon after *L'Âge d'Or.*

81. Quoted by Truffaut in "Rencontre avec Luis Buñuel."

82. In this sequence a direct link is made between the image on the screen and the accompanying music, as was done before by Man Ray in *Emak Bakia* where the visual equivalent of the accompanying jazz is offered in the shots of a banjo being played and a woman dancing.

83. J. Francisco Aranda, "Surrealist and Spanish Giant," *Films and Filming*, October-November 1961, p. 17.

84. Unpublished notes of the Columbia University Extension Film Study course, Museum of Modern Art, New York, April 10, 1940, p. 8.

85. Quoted by Truffaut in "Rencontre avec Luis Buñuel."

86. Luis Buñuel, Poésie et cinéma," trans. Michèle Firk and Manuel Michel, *Cinéma 59*, no. 37 (June 1959), p.71. The article is the transcription of a tape talk given by Buñuel five years earlier at the University of Mexico.

87. For an examination of the Surrealists' vision of a feminized world, see Ferdinand Alquié, *Philosophie du surréalisme* (Paris, 1955), pp. 26-27.

88. Breton, *Entretiens*, pp. 138-39.

89. Those two questions were: "How would you judge a man who would go as far as to betray his convictions in order to please the woman he loved?" and "Do you believe in the victory of admirable love over sordid life or of sordid life over admirable love?" *La Révolution Surréaliste*, no. 12 (December 15, 1929).

90. Benjamin Péret, Preface to *Anthologie de l'amour sublime* (Paris, 1956), p. 64.

91. André Breton, *L'Amour fou* (Paris, 1937), p. 88.

92. Doniol-Valcroze and Bazin, "Entretien avec Luis Buñuel," p. 10.

93. Resolution of April 2, 1925 as quoted in Maurice Nadeau, *Histoire du surréalisme* (Paris, 1964), p. 74.

94. André Breton, *Arcane 17* (Paris, 1947), p. 174.

95. Albert Camus, *L'homme révolté* (Paris, 1958), p. 123.

96. Quoted by Nadeau, *Histoire du surréalisme*, p. 69.

97. Ibid., p. 76.

98. "La Révolution d'abord et toujours," *La Révolution Surréaliste*, no. 5 (October 15, 1925).

99. André Breton, *Qu'est-ce que le surréalisme?* (Paris, 1934), as quoted in Nadeau, *Histoire du surréalisme*, p. 89.

100. André Breton, "Légitime défense," *La Révolution Surréaliste*, no. 8 (December 1, 1926).

101. André Breton, "Second manifeste du surréalisme," *Manifestes du surréalisme*, p. 76.

102. "Manifeste du surréalisme," in ibid., p. 37.

103. "Seconde manifeste du surréalisme," in ibid., p. 95.

104. *Le Surréalisme au Service de la Révolution*, no. 1 (July 1930).

105. Luis Buñuel, "Metropolis," *Gaceta Literaria* (Madrid: 1927) as reprinted in "Luis Buñuel: Textes 1927-28," *Cahiers du Cinéma*, no. 223 (August-September 1970).

106. Doniol-Valcroze and Bazin, "Entretien avec Luis Buñuel," pp. 11-12.

107. Quoted in Guy Gauthier, "Le petit Buñuel illustré," *Image et Son*, no. 157 (December 1962), p. 13.

108. André Breton, *Position politique du surréalisme* (Paris, 1971).

109. See "Letter to José Bello," Paris, May 11, 1930 in Aranda, *Luis Buñuel*, pp. 94-95.

110. Karl Marx, *Manifeste du parti communiste* (Paris, 1962), p. 23.

111. Quoted in Emilio Garcia Riera, "The External Rebellion of Luis Buñuel," p. 57.

112. Richard Pierre-Bodin, "Lettre ouverte à M. Paul Ginisty, Président de la Censure," *Le Figaro*, December 7, 1930.

113. Gaëtan Sanvoisin, "Pour la fin d'un scandale," *Le Figaro*, December 10, 1930.

114. For a more detailed discussion of the scandal concerning *L'Âge d'Or*, see Ado Kyrou, *Le Surréalisme au cinéma* (Paris, 1953), pp. 223-26.

115. Léon Moussinac, "Guerre," *L'Humanité*, December 14, 1930.

116. "Manifestes des surréalistes à propos de *L'Âge d'Or*," as reprinted in *L'Avant-Scène du Cinéma*, nos. 27-28 (June 15-July 15, 1963), pp. 24-27.

117. "Questionnaire" reprinted in Nadeau, *Histoire du surréalisme*, pp. 322-23.

7
Conclusion: The Dream Vanishes

Despite the several brilliant Surrealist films that came out of the movement, the poets were disappointed with the achievements of the medium. As Benjamin Péret reminisced, "Never had a means of expression witnessed as much hope as the cinema. With it not only is everything possible, but the marvellous itself is placed at hand. And yet never has one observed such disproportion between the immensity of possibilities and the derisory results."[1] André Breton echoed Péret's dissatisfaction in the conclusion of his articles on the cinema: " 'One knows now,' I could say formerly, 'that poetry must *lead somewhere*.' The cinema had all that it needed to join it, but in its entirety—let us specify: as directed activity—the least one say is that it has not taken the road."[2] And really we cannot disagree with them. Regardless of the high quality of the films we have discussed, they are precious few in number. Péret's comment only reiterates a generally known fact: the source of disappointment is related to high expectations that remain unfulfilled. The reason for their unusually high expectations was that the cinema coincided so perfectly with the aims of Surrealism. That is precisely why we have been able to glean so much about the nature of the movement simply by discussing its concern with film.

The movies seemed to embody all the major interests of the Surrealist poets. Being the most modern means of expression, they appealed to young men who believed in the new spirit of their age. Their extreme popularity further endeared them to these egalitarian idealists. By the time the young poets had come of age Paris was sprinkled with movie theaters. Their idealization of Paris as a magic city with her streets offering all the excitement of modern life—modern machines, chance encounters, and erotic rendezvous—included the numerous movie theaters that provided a resting place for these wanderers

of the boulevards. Not only did the theaters offer specific adventures that could be tapped immediately, but they also promised the excitement of chance that Breton used to put into action by entering a theater without checking the program. Besides being a part of the modern Parisian scape, the movies could stir the imagination of the poets precisely in those directions where their research led them. The unfolding of images suggested to them the workings of the imagination. Max Morise, one of the lesser lights of the movement, observed,

> It is more than likely that the succession of images and the flight of ideas are a fundamental condition of all surrealist manifestation. The course of thought cannot be considered as static. . . . We cannot stop ourselves at the process of primitive painters who represented successive scenes that they imagined on various parts of their canvas. The cinema—a perfected cinema that would release us from technical formalities—opens a way toward the solution of this problem.[3]

More than just duplicating the thought process, the cinema seemed to offer the nearest thing to a dream. Dreams were one of the major interests, areas of research, and metaphors of the Surrealists, mainly because they were the most readily available manifestation of the unconscious. They explored the dream state through the dream sessions of Robert Desnos and René Crevel in 1922-23 and through recording their own dreams. Eventually they sought to postulate the existence of a higher reality by integrating the dream experience and the waking state, the unconscious and the conscious. All those who were most involved with the idea of a Surrealist cinema likened the movies to a dream experience: Robert Desnos, Man Ray, Antonin Artaud, and Luis Buñuel all spoke of movies as recreating various aspects of the play of the unconscious as it manifested itself in dreams.[4] But the movies offered even more. They stimulated the imagination, especially toward the erotic. The darkened hall, the spectator's passive state, beautiful stars in gorgeous costumes, the large number of love stories, and the insistent focusing of the camera on love scenes or a desirous face, all combined to make of moviegoing an erotic experience, particularly for the young poets with their inherently romantic inspiration. Also, since the movies treated every subject imaginable, the spectators could acclaim the virtues of whatever suited their fancy. The Surrealists were initially captivated by the representations of comedy, love, adventure, crime, and mystery on the screen. They praised revolutionary cinema later when it arrived in Paris. First enthralled by the medium, they gradually became concerned with the message. For more than a decade the cinema continued to occupy their interest.

Just how perfectly the cinema suited the aims of Surrealism is revealed by a little-known but fundamental essay written immediately after the publication of Breton's *Surrealist Manifesto*. Jean Goudal's "Surréalisme et cinéma" is probably the most thorough and sophisticated discussion which asserts the

connection between the new aesthetic and the medium. Especially remarkable is the fact that Goudal was an outsider to the movement. As a disinterested observer, he determined their affinities with such precision that Breton later referred to his work as a seminal piece. "Twenty-five years have passed since M.J. Goudal in *La Revue hebdomadaire* made obvious the perfect agreement of the means [of the cinema] with the surrealist expression of life, and that *second by second*."[5]

Goudal defined the essential premise of Surrealism to be the unconscious activity of the mind. As such, he observed, "From now on the principal aim of artists should be to search in the dream for a reality superior to that which the exercise of logic proposes."[6] He saw Surrealism as being in part "a complete renewal of the artistic domain and methods and even, perhaps, as a renovation of the most general rules of human activity: in brief, an absolute overthrow of all values."[7] While he empathized with the aims of Surrealism, he discerned two weaknesses in its application to literature. First, he held that the two states of dream and reality, incommunicable by definition, could not be integrated, and second, that the anti-logical aspirations of the movement would lead to an impasse by breaking down communication. These seemingly insurmountable obstacles were resolved by the cinema. Goudal saw movies negate the first of these problems by their very existence as a "conscious hallucination." Experiencing a movie was comparable to the dream state for him, as it was for other Surrealists. He first explained the power of the dream by relying on Taine's observations made about the "reducing mechanism of images." In the waking state the pictures evoked by our imagination seem pale next to our perception of reality because our active senses reduce their strength of impression. When we are asleep, however, the senses are idle, and because of a lack of comparisons, the products of the imagination assume an absolute existence. In short, "Awake, at once we conceive of the real and the possible, while in the dream we only conceive of the possible."[8] Just as the "reducing mechanism of images" was eliminated by the state of sleep, so it was eliminated by the material conditions operating in the movie theater. The darkness of the hall shut out any real images we might see; the music drowned out all realistic noises. Goudal's comparison of movies to dreams went further. Like the images of dreams, those of movies were without relief and appeared in simple black and white. The succession of these images unfolded according to an unnatural rhythm which further removed the movies from real experience. The movies duplicated several key factors of the dream process, but never completely overwhelmed the consciousness of the spectator. "Thus the cinema constitutes a conscious hallucination and utilizes that fusion of dream and of the conscious state that surrealism would want to see realized in the literary domain."[9] The cinema provided a solution to the second apparent problem as well. It presented successive images which impressed themselves on the viewer by their facticity, not by their appeal to abstraction. The progression of images created their own sense, which was totally independent of logical constructs. In fact, even when the movies tried to present a rational story, the images un-

folded with such rapidity that the viewer could barely keep up with the commentary that explained their logic. Again the cinema avoided obstacles that were inherent in the application of the anti-logical to literature. "In language the primary given is the logical plot. The image is born as a result of this plot and adds itself to decorate it, to elucidate it. In the cinema, the primary given is the image which, occasionally, and not necessarily, drags with it some rational shreds. One can see that the two processes are exactly inverse."[10] To avoid the inherent obstacles presented by literature, he proposed that Surrealist poetry be transposed to the screen. Since the cinema naturally solved the problems arising from the application of Surrealist theories, "surreality represents a domain to which the cinema is directed by its technique."[11] Accordingly, he beseeched filmmakers to take cognizance of the surrealistic possibilities of film by making use of dreams. "It is about time that filmmakers clearly see what advantages they will find by opening their art to the unexplored regions of the dream. That has been done until the present only in fragments and by accident. Let them no longer hesitate to mark their productions with three essential characteristics of the dream, namely, being *visual, illogical,* and *penetrating.*"[12] It was the third quality that prevented the film from sinking into total incoherence. Something had to be human and personal in order to be penetrating, as was a dream. The personal quality of a film was lost once it went through the many hands involved in a commercial production. Goudal saw hope only in the film which would reflect the total conception of its creator. His observations proved to be correct, for the Surrealist cinema reached its moments of brilliance in films which displayed an integrity and the personal vision of their author. Of many adjectives, "penetrating" may come closest to expressing the nature of the impact of Surrealist film.

Although only a handful of Surrealist movies had been produced, they testified to the nature of the movement and its transformations through the years. Man Ray's work with film begins in 1923 in typical Dada fashion, putting together various experimental strips to make his first short. It evolves through *Emak Bakia*, where Dada and experimental cinematic concerns are still evident, to *L'Étoile de Mer*, his purest Surrealist effort. In the scheme of Surrealist film, *L'Étoile de Mer* is but the first step in the evolution of the Surrealist aesthetic. In comparison with the early films of Buñuel and the films and scenarios of Artaud, it remains as the most poetic, least disturbing work. It succeeds remarkably well in creating an aura of mystery through a number of unusual associations and intimations of psychosexual forces at work. Yet the very ambience of mystery that is evoked keeps the spectator at a distance and prevents a Surrealist transcendence from taking place. In spite of the extreme liberties taken with the narrative line, the film remains the story of a love affair. Although in conception Surrealist, in execution the film remains unconvincing because it attempts to recreate the ambience of a dream. Both Artaud and Buñuel concerned themselves with the transcendence that the cinema could induce in the spectator by evoking his unconscious. They played on violence, irrationality, humor, allusions to sensations, factors which would

make the unconscious emerge. Instead of creating a dreamlike atmosphere, as did Man Ray in *L'Étoile de Mer*, they set out to assault human sensibility by various shock tactics. They presented emotions and actions in excesses approaching caricature. They dispensed with the narrative effect not simply by taking liberties with the traditional story line but through powerful images and sequences which came to dominate the attention of the spectator to the detriment of the story line. Their recurring elements tended to be more motifs than symbols, more ambivalent than specific, and therefore more a part of human experience and less an aspect of rational, ordering thought. Perhaps because of their innate violence, Artaud and Buñuel succeeded in taking Surrealist film to a higher level of perfection through an aggressive provocation of the unconscious.

In just a few years the Surrealist sensibility had changed so much that Buñuel included Man Ray among the ranks of the commonly detested avant-garde. Talking about *Un Chien Andalou*, he explained:

> Historically, this film represents a violent reaction against what was at that time called "avantgarde cine," which was directed exclusively to the artistic sensibility and to the reason of the spectator, with its play of light and shadow, its photographic effects, its preoccupation with rhythmic montage and technical research, and at times in the direction of the display of a perfectly conventional and reasonable mood. To this avantgarde cinema group belonged Ruttmann, Cavalcanti, Man Ray, Dziga Vertoff, René Clair, Dulac, Ivens, etc.[13]

With all of Artaud's cinematic attempts frustrated—except for the dubious *Seashell and the Clergyman*, which bore the onus of having been directed by the avant-gardist Germaine Dulac—Buñuel's first two films became the Surrealist cinema in the eyes of the group. The scenario of *Un Chien Andalou* was published in the final issue of *La Révolution Surréaliste; Le Surréalisme au Service de la Révolution* published laudatory letters and stills of *L'Âge d'Or*. Their supreme position atop the Surrealist honor list of film in 1931 was stated in the manifesto written after the disruption of the showing of *L'Âge d'Or*.

> From the endless reels of film, presented to our examination until now and today dissolved—of which certain fragments were nothing but diversions for a night to kill; certain others a subject of oppression or of unbelievable cretinization; certain others the motif of a brief and incomprehensible exaltation—what do we retain, if not the voice of the arbitrary perceived in some Mack Sennett comedies; that of defiance in *Entr'acte*; that of a savage love in [Flaherty's] *White Shadows*; that of an equally unbounded hope and despair in the films of Chaplin? Apart from that nothing outside of the irreducible call to revolution of *The Battleship Potemkin*. Nothing outside of *Un Chien Andalou* and *L'Âge d'Or* which are situated beyond everything that exists.[14]

Buñuel's two films answered more than a decade's worth of expectations of the cinema by taking it in a new and aggressive direction.

Undoubtedly Buñuel succeeded best in putting Surrealism on film. His success lay not only in his selection of the Surrealists' favorite themes, but also in the new sensibility he brought to the screen. He rejected avant-garde cinema as did most Surrealists. They condemned the facile camera tricks which called attention to nothing but themselves. Thus Buñuel developed a style which was antithetical to current cinematic usage by its conspicuous avoidance of camera virtuosity. For the most part, he shot in a traditional manner. It was through his choice and treatment of the subject matter that he created a new poetry which caused such excitement among the Surrealists.

No sooner had he created the crowning achievement of Surrealist cinema in *L'Âge d'Or* than Buñuel developed the Surrealist program in still another direction. He turned to the documentary and thus followed a new impulse in movie making. The 1930s saw the blossoming of the documentary film in no small part because of the 1929 stock-market crash that began the depression. With the accentuation of social issues, filmmakers increasingly came to confront the world around them, rather than create their worlds of fantasy. For just as the avant-garde was an adequate expression of the illusionism of the 1920s, the documentary was the appropriate vehicle for the social and economic realities of the 1930s. Remaining perfectly consistent with Surrealism while expressing the hard social truths that were illuminated by the economic crisis, Buñuel produced a Surrealist documentary in *Las Hurdes* of 1932.

The concept of a Surrealist documentary is not a contradiction in terms. The Surrealists, strongly scientific in their research, aimed to penetrate appearances in order to arrive at a more profound understanding of reality. Aragon and Artaud both commented on the ability of film to focus on particular objects and magnify them on the screen, a process which strengthened the confrontation between the viewer and various selected aspects of reality. Desnos and Soupault both claimed the documentary film to be one of the most successful applications of the cinema since it revealed the true workings of things. Buñuel had specifically demonstrated in his first two Surrealist films his penchant for documentaries. His traditional use of the camera was dictated by his view of the filmmaker as an observer of reality. In *Un Chien Andalou* he proposed to examine extreme psychological states, while in *L'Âge d'Or* he extended his scope to social realities as well. To accentuate the realism of his second film, he included documentary footage on scorpions, modern city scenes, disasters, the Vatican. Thus in *L'Âge d'Or* the documentary was an integral part of Buñuel's fully developed Surrealism; in *Las Hurdes* Surrealism became an essential ingredient of his documentary style.

In *Las Hurdes* Buñuel shows people living in the most underdeveloped region of Spain. They live amidst conditions of dire misery which they are powerless to alter. He consistently points out the bitter ironies of their lives. Living in a rocky terrain, they are restricted to cultivating the smallest plots of land available. These lands are often washed away by floods. When they are not, they yield little produce since the villagers have no livestock whose

manure they could use as fertilizer. Bread is unfamiliar to them so that, when teachers in school hand out a few morsels to the children, the parents, fearful of the unknown, throw them away. Living on the edge of starvation, they begin to eat cherries when they first appear and are still green. As a result they get dysentery. Living in a snake-infested area, they are often bitten. Although the bites are never deadly, they become mortal when they try to cure them with herbs which only infect the wound. Isolated from the rest of the world, the people intermarry and, as a result, many of the children are cretins. These people live at the furthest edges of civilization in every sense. They are throwbacks reminiscent of the bandits in *L'Âge d'Or* but more perfect because they are real. Their existence appears unreal to civilized man and that is why Buñuel filmed them. His motivation for making the film must have been similar to that of Edgar Allan Poe in writing his short story "The Thousand-and-Second Tale of Scheherazade." In it Poe had the garrulous girl describe natural wonders that seemed far more improbable to her captive listener than any of the tales she had previously told. Infuriated by her lies, the sultan has her strangled. Thus Poe illustrated the old adage, "Truth is stranger than fiction." In a similar vein Buñuel was drawn to the Hurdanos because they were more exotic, more surrealistic than anything he could have invented. His main reason for filming them was that they exemplified in the extreme the proletariat. His critique of society progressed from showing the rulers in *L'Âge d'Or* to presenting the exploited in *Las Hurdes*. The Spanish republican government, having replaced the monarchy only the year before, banned the movie because it was too embarrassing for it.

Buñuel emphasized both the surrealistic and political aspects of his film by the music and commentary assigned to it. The majestic sweep of Brahms' Fourth Symphony ironically sets off the flow of brutal visions. The terse observations of the commentator clarify the meaning of the images or they insinuate a meaning in conjunction with the images. Declarations are made, as in the beginning, "In the Hurdes region we never heard any song," or with a shot of the church after views of village houses, "In this miserable land, the only luxurious buildings we encountered were churches." In other instances the commentary is less direct. The comment "Monks live as hermits surrounded by some servants" accompanies the image of a pretty young girl. Or the narrator speaks of how goats often fall from the rocks and kill themselves. At that moment we see a hunter in the lower-lefthand corner fire a gun and a goat fall from the cliffs above. The implication that the people are living a similar lie is clear. They do not simply die of themselves: they are victims of bourgeois society.

As a filmmaker Buñuel extracted his message primarily from the images which he selected with a particular Surrealist sensibility. Just before reaching the place where he shot his documentary, he filmed a marriage custom in a neighboring village which consisted of cutting off the head of a rooster as it hung by its legs from a long stick. This bloody spectacle begins the movie. Later we see a donkey carrying a beehive collapse; the bees sting it, and a

hungry dog tears it apart. Buñuel's sense of irony is evident once again. Products of total and abject poverty, children in school copy a sentence over and over from the blackboard: "Respect the rights of others." There is one sequence which by its very nature throws the entire film in sharp relief. Buñuel gives a detailed, encyclopedic explanation of the life process of the anopheles mosquito, replete with illustrations from a book. It appears to be a digression like that on the life of scorpions at the opening of L'Âge d'Or. Like the scorpion introduction, the mosquito sequence is at once rational and irrational. It is absolutely relevant to the life of the Hurdanos, for it is the carrier of malaria, a common disease among them. Yet the explanation is done in such a scientific manner that it stands out from the body of the film. Its very objectivity makes the documentary appear only as a series of subjective impressions, but ironically those subjective impressions are the true state of affairs and it is the sterile school-book exercise that approaches the absurd. The caustic irony that Buñuel developed in L'Âge d'Or seemed to suit his Surrealist documentary even more, for the people he was filming were being oppressed by ironic contradictions.

The affinities between Surrealism and the documentary were further demonstrated by a Surrealist sympathizer. Jean Vigo was the son of a militant anarchist who was murdered in his prison cell when Jean was twelve. His father's struggle and violent death were to haunt him during his short life. He became a favorite of the Surrealists mainly for his Zéro de Conduite of 1932-33, whose zany rebelliousness in depicting a boy's boarding school immediately won the distinction of being banned by the censor.[15] Interestingly enough, he came to create that film by way of À propos de Nice of 1929-30, a documentary with a Surrealist flavor, which was his first endeavor. Vigo had first planned to do a straightforward documentary of the city and accordingly familiarized himself with its diverse aspects. Becoming dissatisfied with the prospect of simply recording the activities of the town, he developed various schemes, one of which consisted of working around the triple theme of earth, sea, and sky. The film was finally based on a plan to show that Nice was primarily a city of play, that everything existed for the tourists, that the natives were no more interesting than the foreigners, and that everything in it led toward death. He opened the film with a cute sequence of a toy train arriving on a roulette table, two puppets alighting with their baggage, and a croupier's stick pulling them away. Vigo then showed the tourists basking in the sun, walking along the Promenade des Anglais, and participating in the carnival. He poked fun at them by showing them lounging in the sun, then switching to a shot of crocodiles for comparison. A gawking old woman is followed by the shot of an ostrich stretching its neck. A man's face to the sun suddenly turns black. A woman sitting nonchalantly in a chair is suddenly shown naked with only a pair of shoes adorning her feet. Interspersed among these shots of people amusing themselves and Vigo amusing himself at their expense are scenes from the poorer section of town. We see women doing the laundry or the sewage canal lined with garbage. All along there is a fascination with the

bizarre, which emerges in a shot like that of a muscleman on the beach snapping the skin around his ribs. That bizarre element appears in the shots of gigantic puppets marching in the procession of the carnival or in the shots of funerary statues in a cemetery. The movie's ominous touches lead to a disturbing finale. Vigo shoots up at factory chimneys as old women are talking and glancing up at them; we look into a grave dug in the cemetery; men argue excitedly; a carnival doll has fallen over in a shop window; the chimney appears with smoke all around it; we see the empty sky.

In connection with this other Surrealist documentary it is of interest to cite a pamphlet prepared by Vigo for the premiere of the film on June 14, 1930. Entitled "Vers un cinéma social," the statement sums up Vigo's ideas about the cinema. A good part of the text praises *Un Chien Andalou*, which Vigo had sought to show along with his film. His enthusiasm for Buñuel's first film was so great that he saw it as a model for the kind of film in which he believed. It qualified as social cinema by virtue of the fact that it treated "a subject that provokes interest: a subject that you can sink your teeth into."[16] No doubt he was greatly influenced by Buñuel's film. He shared the Surrealists' contempt for the two major prevailing cinematic forms: the traditional sentimental movies and the films of the avant-garde.[17] He defined his aims in *À propos de Nice* in the following way:

> This social documentary distinguishes itself from a simple documentary and from the weekly newsreels by the point of view that the author clearly defends in it.
> This documentary demands that one take a position because it dots the i's. *À propos de Nice* is only a rough draft for such a cinema. In this film, through the example of a town whose manifestations are significant, one is present at the trial of a certain world. In fact, as soon as the atmosphere of Nice and the spirit of life one leads there (and elsewhere, alas!) is indicated, the film tends toward the generalization of gross rejoicings of the grotesque, of the flesh, and of death, which are the last somersaults of a society which forgets itself to the point of making you nauseated and thus makes you an accomplice to a revolutionary solution.[18]

Although the Surrealist documentary promised to be a logical step in the evolution of Surrealist film, it only proved to be an intriguing by-product, for the artistic and social conditions were not right for its flowering. Those who were interested in presenting social issues sought to do it in a straightforward, realistic manner. For all leftist sympathizers that factual style was dictated by the Soviet Union, which had officially sanctioned the doctrine of Socialist Realism by 1932. The feverish experimentation with style that followed the October Revolution in all the arts was replaced by a sanitized art that proclaimed the virtues of the new order while denouncing the vices of the old. Complexity, abstraction, violence, sexuality were seen to be so many weapons in the arsenal of reaction. The point is not to cast that development in a negative light—for indeed the polarization between fascism and communism might have justifiably necessitated such an austere program for the arts—but rather to in-

dicate its existence and widespread influence throughout the world at a time when the Soviet Union was still the embodiment of hope for all peoples with a social consciousness and when Stalinist terror was still an unknown. Some of the most subtle documentaries of the 1930s were those made by the British, several Americans, and Joris Ivens, and they partook of a lyrical style wholly different from the aims and methods of Surrealism. Thus, while the Surrealist documentary offered a possible avenue for politically committed filmmakers in the example of these two striking films, they saw their aims best served by more realistic styles. Those who were interested in the continuation of Surrealism, on the other hand, were beset by some of the same problems which had plagued members of the group throughout the 1920s and some new ones.

As we have seen the few Surrealist films that were produced did answer the high hopes the Surrealist poets had of the cinema. That no more than a handful of films was created was due to a number of factors particular to the movement.[19] Since they were writers first and foremost, the Surrealists who expressed an interest in the cinema were not especially committed to working in such a different medium. At most they wrote scenarios which they hoped would be made into movies. None of the men who collaborated in the making of a Surrealist film was primarily a poet. Besides, they considered the cinema to be a stimulant; only later did they begin to regard it as a means of artistic expression. Most of them passed through their "age of the cinema" in a few years. The most tangible result of their initial passion was the large number of young men their movement attracted who were primarily interested in movies. Financial considerations were a major stumbling block to making films. As Soupault remarked, "From the beginnings of Surrealism, we felt that commercial problems would be obstacles."[20] In fact, practically all of the Surrealist films were made possible by wealthy benefactors. It was in response to this restrictive situation that in 1930 Artaud drew up a plan for the establishment of a company to finance low-cost short films.

A similar but much more ambitious project had been outlined at the first meeting of the International Congress of Independent Cinematography held at the Château de la Sarraz in Switzerland in September 1929. Some of the most important exponents of the cinema gathered from all over Europe, men such as Sergei Eisenstein, Walter Ruttmann, Hans Richter, Béla Balázs, Léon Moussinac, Alberto Cavalcanti. They decided to fight commercial cinema by creating an International League of Independent Film at Geneva to form a permanent tie among film clubs and by setting up an International Cooperative Society of Independent Film in Paris with a starting capital of 200,000 francs to finance movies. Even this ambitious project barely got off the ground, for the advent of talkies killed public interest in silent films and made the production costs of sound movies prohibitively high. After distributing a few movies to film clubs, the organization was liquidated the following year.

With the prospects for making independent films completely shattered, the cause of Surrealist cinema suffered a great setback. Although certain lesser

Surrealists pursued their experiments in the 1930s and 1940s, the master of Surrealist cinema, Luis Buñuel, did not succeed in making a movie that suited his taste until *Los Olvidados* in 1950. Since then he has been the single most important figure in the realization of the Surrealist imagination on the screen. But Surrealism has had such a profound impact on modern sensibility that few artists, and few filmmakers among them, have not been touched by it. In its universal proliferation the tenets of Surrealism have been altered by the artists who practiced it and the social conditions which affected it. It was in part to recapture the undiluted spirit of the original movement that I began to write this book.

<div align="center">NOTES</div>

1. Benjamin Péret as quoted in Ferdinand Alquié, ed., *Entretiens sur le surréalisme* (Paris, 1968), p. 424.
2. André Breton, "Comme dans un bois," *L'Âge du cinéma* nos. 4-5 (August-November 1951), p. 30.
3. Max Morise, "Les yeux enchantés," *La Révolution Surréaliste*, no. 1 (December 1924), pp. 26-27.
4. See above, pp. 39, 88, 116,142.
5. Breton, "Comme dans un bois," p. 30.
6. Jean Goudal, "Surréalisme et cinéma," *La Revue hebdomadaire* 34, no. 8 (February 21, 1925):345.
7. Ibid.
8. Ibid., p. 348.
9. Ibid., p. 350.
10. Ibid., p. 351.
11. Ibid.
12. Ibid., p. 352.
13. Luis Buñuel, "Notes on the making of *Un Chien Andalou*," in Frank Stauffacher, ed., *Art in Cinema* (San Francisco, 1947), p. 29.
14. "Manifeste des surréalistes à propos de *L'Âge d'Or*," as reprinted in *L'Avant-Scène du Cinéma*, nos. 27-28 (June 15-July 15, 1963), pp. 24-27.
15. A characteristic opinion of Vigo was offered by Soupault: "I have great admiration for a filmmaker of whom one cannot say that he was surrealist but who was very close to surrealism: Jean Vigo. He found certain possibilities and he utilized them notably in *Zéro de Conduite* which remains, in my opinion, one of the most astonishing films ever shot." Jean-Marie Mabire, "Entretien avec Philippe Soupault," *Études cinématographiques* ("Surréalisme au cinéma") nos. 38-39 (Spring 1965), p. 31.
16. Jean Vigo, "Vers un cinéma social," *Positif* no. 7 (May 1953).
17. Vigo stated what it meant to direct oneself toward a social cinema: "It would be to liberate oneself from the two pairs of lips which take 3000 meters to unite and almost as much to become unglued.

"It would be to avoid that too artistic subtlety of a pure cinema and that super-view of a super-navel seen from an angle, from another angle, and from yet another angle, a super-angle; technique for the sake of technique." Ibid.
18. Ibid.
19. For an intelligent essay on the reasons for the meager results of the Surrealist cinema, see Alain Virmaux, "Une Promesse mal tenue: le film surréaliste (1924-1932)," *Études cinématographiques*, nos 38-39, pp. 103-31.
20. Jean-Marie Mabire, "Entretien avec Philippe Soupault," p. 30.

Appendix: The Films of Man Ray

Scenario of LE RETOUR À LA RAISON, 1923, by Man Ray (5 min.)

1. Shimmering field of dots.
2. Outline of thumbtack jumping around.
3. Moving thumbtack with nails.
4. Nails moving around.[1]
5. Flickering black-and-white field.
6. "Man Ray à tirer 5 fois" appears handwritten across five different frames. It appears in reverse on screen.
7. Thumbtack and nails reappear, with transition from one to the other. (Nails often span more than one frame.)
8. Shimmering black and white field reappears.
9. White bulb moves across top of screen from right to left.
10. A field of white circles with black nuclei, touching at the edges.
11. Shot of merry-go-round at night, first spinning to the left, then to the right.
12. Shot taken from merry-go-round of lights all around. Lights start to move up and down (shot probably taken from horse).[2]
13. A sawtooth circle with "Dancer" written on top, an indistinct object in the center, smoke billowing around, two gears at lower left.[3]
14. A number of wide white strips with corrugated edges.
15. A white circle whose edges overlap the two adjoining frames.
16. A spiral stretched over twenty frames.
17. A field of shredded objects, the larger ones white, the smaller gray.
18. Large black and white areas, sometimes white strips on black ground, part of which are shots of a nude with face (of Kiki?) superimposed and spread over several frames.
19. A long, wide, winding white strip.
20. A letter of long and short dashes flickering.[4]
21. "Man Ray Noir" handwritten across two frames.[5]
22. Close-up of spiral lampshade rotating.[6]
23. A carton from an egg crate revolves on a string with a strong shadow on

the wall. The picture is inverted so that the string is attached at the bottom. The spinning alternately speeds up and slows down. Segments of this strip are superimposed on others to create a third and fourth rotating object.

24. A nude torso faces light coming from a window on the left. Arms are raised. Shot shows area from chin down to below navel. Torso is turned back toward the light. Sequence is repeated once. Negative is shown with torso facing right. Turning is repeated twice. (A clear visual relationship is established between the rotating carton and the turning torso, which seems to move without human effort in the last two shots.)[7]

Notes

1. Man Ray talks about the preparation of the first four shots in his autobiography: "On some strips I sprinkled salt and pepper, like a cook preparing a roast, on other strips I threw pins and thumbtacks at random; then turned on the white light for a second or two, as I had done for my still Rayographs." Man Ray, *Self-Portrait* (Boston/London:1963), p. 260.

2. Man Ray's fascination with merry-go-rounds stems from the time of his arrival in France. Arriving in Paris on Bastille Day of 1921, he looked up his old friend, Marcel Duchamp, that very afternoon. Together they went to a cafe where Man Ray met for the first time Jacques Rigaut, André Breton, Louis Aragon, Paul and Gala Eluard, Theodore Fraenkel, and Philippe Soupault. That night the band went to Montmartre, "where a huge and noisy amusement park had been set up along [the boulevard's] wide center as far as the eye could reach. Elaborate merry-go-rounds, scenic railways, steam swings, midget autos bumping each other, candy booths and sideshows outdid each other in the general cacophony. My friends rushed from one attraction to another like children, enjoying themselves to the utmost, ending up by angling with fishing poles with rings on the ends for bottles of wine, or cheap champagne. I looked on, bewildered by the playfulness and the abandon of all dignity by these people who otherwise took themselves so seriously: people who were having a revolutionary influence on the art and thinking of the new generation. Once I ventured on the dizzy swings with the Eluards; we were violently thrown upon each other and I wondered fleetingly whether they sought a physical extension into the realm of strong sensations. Returning late to my hotel room, my brain in a whirl and exhausted with the day's events, I felt I had been catapulted into a new world." Ray, *Self-Portrait*, p. 109. The merry-go-round thus came to be associated with Paris and Breton's group from Man Ray's very first day in France. Man Ray has captured the dizzying movement of the fair in his active handling of the camera.

3. The shot is of one of Man Ray's creations, *Dancer* 1919: airbrush on glass painting "inspired by the gyrations of a Spanish dancer." Only the swirling smoke in the center has been added. Illustrated in Georges Ribemont-Dessaignes, *Man Ray* (Paris: 1924), p. 41.

4. Man Ray published a similar-looking Dadaist dumb poem in the May 1924 issue of Picabia's magazine *391*.

5. The film was made in two separate sections. Man Ray had already shot sequences of the human torso, rotating carton, etc. Those sections done by the rayograph method were done the evening before the Dada event *Le Coeur à Barbe* at the request of Tristan Tzara. After shot #21 he "simply glued the strips together, adding the few shots first made with my camera to prolong the projection." Ray, *Self-Portrait*, p. 260. Naturally the film broke several times during the projection the following evening.

6. Man Ray had utilized this form before. See *Sheet-Iron Sculpture* of 1919 in Ribemont-Dessaignes, *Man Ray*, p. 37. He had originally taken a broken lampshade and had placed it in the collection of Société Anonyme. After it was thrown out by the janitor, he created the shape from a more sturdy material. The six-foot structure later stood in his studio before being bought by the Vicomte de Noailles. The form reappeared in his large canvas of 1939 entitled *Retour à la Raison* and reappeared as late as 1967 in the form of earrings.

7. A few discrepancies appear between the Museum of Modern Art copy and Man Ray's account. Man Ray writes of the beginning of the film, "It looked like a snowstorm, with the flakes flying in all directions instead of falling, then suddenly becoming a field of daisies as if the snow had crystallized into flowers. This was followed by another sequence of huge white pins crisscrossing and revolving in an epileptic dance, then again by a lone thumbtack making desperate efforts to leave the screen." Ibid., pp. 261-62. The progression he describes appears exactly at the beginning of M.O.M.A.'s copy of his second film, *Emak Bakia*. After a break in the film, Man Ray's description continues: "The next image was of the light-striped torso which called forth the applause of some connoisseurs, but when the spiral and egg-crate carton began to revolve on the screen, there was a catcall, taken up by the audience, as always happens in a gathering," Ibid., p. 262. These sequences appear in a reverse order in the M.O.M.A. copy. These differences are probably caused by a later cutting of the film as the merry-go-round sequence would seem to indicate. Man Ray makes no mention of including the merry-go-round shots, which is all the more striking since he mentions all the other shots of rotating objects. See ibid., p. 259. Since a more complete version of this sequence is presented with traveling news lights in *Emak Bakia,* the later film must be the source for the merry-go-round sequence.

Scenario of EMAK BAKIA[1] 1926, by Man Ray (17 min.)

0. Rotation of words, Emak Bakia, then "cinépoème," followed by "de Man Ray, Paris, 1926."
1. Man Ray appears as cameraman rolling film, with eye to the viewer. Slowly the eye appears in center of shot upside down. (He filmed himself filming by aiming camera at a mirror.)[2]
2. Flickering black and white film from *Le Retour à la raison.*
3. Gently swaying and rotating shot of field of daisies tilted down to get on-

ly the immediate vicinity of cameraman.

4. Nail sequence from *Le Retour à la raison*.

5. Thumbtack sequence from *Le Retour à la raison*.

6. Revolving lights out of focus.

7. Larger revolution of lights of merry-go-round.

8. Shot of traveling news lights: "au milieu du bassin de Neptune au cours de deux grandes fêtes . . . avec Marcel Doret. . . . Le journal annonce . . . Paris . . . un."

9. A vertical triangular prism of mirrors rotates with other mirrors around it reflecting its light. The pace picks up until the movement is quite fast, then the speed fluctuates.

10. A rotating shiny coil or material seen from different angles.

11. Camera scans a field of vertical black and white stripes first slowly, then very fast.[3]

12. Rotating shot of vertical prism and field in which it moves.

13. Distortions of light in mirrors, coming together and separating, while turning around.

14. Closed eye appears. It opens. Headlights of car superimposed on either side of the eye, while eye blinks rapidly.

15. Out-of-focus headlight of car approaches.

16. Camera moves in on convertible with driver wearing goggles. Driver shows a grim stare.

17. Shot pans to rear tire. Car backs up.

18. Low-angle shot of car moving.

19. Tilted shot of speeding car and landscape from behind driver.

20. Close-up shot of sheep moving across road.

21. Car approaches between white walls lining the road and passes over camera. (Camera placed on the ground in the middle of the road.)

22. Shot of sleeping pig.

23. Momentary shot of landscape.

24. Return to the pig. Pig starts.

25. Violently moving trees, then violent blurs. (Camera was thrown up and caught.)[4]

26. Shot of running board of car. Five people get out, then multiple image of the feet walking away.

27. Girl does Charleston on sidewalk. Shot from just above the knee down. Behind her is a flight of stairs, to the right is a record player. Shot alternates with man strumming banjo. Long sequence which fades out at the end.

28. Woman walks up flight of stairs. She is shown from the back.

29. She is in front of mirror, fixing her hair. She puts on lipstick and a long pearl necklace before walking out of the room.

30. Shot of two columns, one on each side. Woman walks out from behind the camera and stops between the columns.

31. Panning shot of trees, then cliff, then the surf as seen from above. (Woman's view, presumably.)

32. Several close-up shots of waves hitting the shore.

33. On the beach a bather is stretched out on her back. She begins to raise her knees.

34. Shot switches to the other side of the legs to silhouette them against the sun. Knees go up and down as the feet push the sand back and forth.

35. Shot from high up of the glare of the sun on the water. Camera slowly rotates until the sky is on the bottom, sea is on top.[5]

36. View of fish swimming under water with top of water undulating. Double exposure of swimming fish.

37. Iris opening from top right, revealing a vertical cork sculpture which starts to rotate, then picks up speed. It casts a clear shadow on the wall. Then double exposure of rotating sculpture.[6]

38. Abstract background with stand in front. A ball appears on stand and moves in jerks to the left. Various geometric objects are added one by one—cones, cylinders, squares—until the group looks like an abstract castle.[7]

39. Seven shapes appear drawn on the background, consisting of lines joined together by large dots. The silhouette of a jumping man is superimposed on each shape in succession, showing seven different stages of a jump.

40. Still life of geometric objects, including cylinders, cones, rectangles, a pair of dice, and the neck and scroll of a violin. They move around in circular patterns. They come together and stop. All objects leave the table except the dice and the truncated violin. Dice are cut in half. The two halves disappear. Remaining two halves come together to form one die, then roll off table, leaving only the truncated violin.[8]

41. Traveling news lights appear: "Chaque soir à Magic-city."

42. Shot of revolving black form with white spotlights.

43. Rotation of indistinct lights, then return to black form with brighter background.

44. A fan is slowly withdrawn from face of woman with eyes closed. She slowly opens eyes and looks up into the camera. Fade-out.

45. Revolving merry-go-round lights appear through fade out.

46. Glass cube rotates with reflecting mirrors around it. Indistinct lights glitter (from mirrors). Fade-out.

47. Woman with eyes closed appears through previous fade-out. She opens her eyes and smiles.

48. Tilt-down shot of coral flower. Dissolve to . . .

49. Shot of woman with her arms resting on table, hand covering hand. Her face is stern, her eyes are closed. She opens her eyes, seems to say something.

50. Rotation of lights and perforated film through distorting mirrors.

51. LA RAISON DE CETTE EXTRAVAGANCE.[9]

52. Tilt-down shot of taxi driving up to house and stopping. Jacques Rigaut gets out.

53. From inside passageway, through glass door Rigaut is seen getting out with suitcase. He looks up.

54. Low-angle shot of side of building as Rigaut walks by. Sequence is placed

on its side so that Rigaut is walking straight up.

55. He walks through glass door.

56. Shot of suitcase being opened. White collars are inside. Rigaut rips backing off and throws one in a circle.

57. Shot of circle. Another collar is thrown into circle.

58. Shot of a whole group of collars in the circle. They gradually all jump back up, one by one. (Shot of collars accumulating run backwards.)

59. Shot of open suitcase with collars inside. Camera moves up to Rigaut's face. He is looking into a mirror out of range of the camera. After throwing down his straw hat, he rips off his own collar without removing his eyes from the mirror.[10]

60. A collar forming an uneven U is slowing rotating on a base.

61. Fade-out to a larger, less distinct shot of a collar rotating. Revolution becomes more complicated as a number of moving white forms appear.

62. Two vague, striplike forms rotate. Mirror-like distortions.

63. The two white forms become clearer. They are two white areas with the shadow of bars and the shadow of a man between them. The two areas fuse into one. The mirror-like distortion and rotation continue.

64. Rotation continues in the form of a supple white strip. Speed of rotation increases resulting in the image of several white strips whose size and position change rapidly.

65. A circular black box is in the center with lights revolving around it and the box reflecting the lights off its surfaces.

66. Strange black and white forms move around rhythmically with only the shadow of a moving hand being recognizable.

67. Shot of a woman's face from above as she is lying down. Her eyes have a blank, artificial look.

68. She gets up, faces the camera, opens her eyes (what we saw before was a pair of eyes painted on her eyelids) and smiles.

69. She closes her eyes and returns to her former position. As she does so, a superimposition of her face with closed eyes appears upside down. It starts to rotate in the customary distorted fashion until it is the only image left on the screen.

Notes

1. The title means "leave me alone" in Basque. Man Ray had shot some of the sequences in the Basque countryside around Biarritz.

2. The eye was to be one of the favorite images of the Surrealists. They saw as their predecessor Odilon Redon, who had depicted haunting eyes combined with balloons, or flowers, or staring from the head of a Cyclops. Perhaps the single most striking image of the Surrealist cinema is the slashing of an eye in the opening of *Un Chien Andalou*. Man Ray was highly instrumental in reviving the eye as a Surrealist image. His *Object To Be Destroyed* of 1923 consisted

of a metronome with the picture of an eye clipped to the arm. His *Snowball* of 1927 is a glass ball on a stand with structures inside and the picture of an eye pasted on the side. In this film he presents a blinking eye with headlights of a car superimposed in shot #14; shots #44, #47, and #49 show a woman opening her eyes; and the film ends with the trick of eyes painted on eyelids disappearing as the woman opens her lids. The opening and closing of an eye was filmed in Léger's *Ballet mécanique* of 1924, while Hans Richter showed a multiple image of an eyeball in his *Filmstudie* of 1926. Man Ray recounted later how he had influenced the Belgian Surrealist René Magritte: "He admired a photographic enlargement I had made of a single eye, offered me a painting in exchange, which I received later: a large eye in which clouds and blue sky filled the whites." Ray, *Self-Portrait*, p. 253.

3. The field of thin black and white stripes had appeared in Man Ray's *Subject for a Poem* of 1924 in the form of corrugated paper. See Ribemont-Dessaignes, *Man Ray* (Paris, 1924), p. 55. He also photographed the human body with black and white stripes across it. The final shot of *Le Retour à la raison* shows a torso turning with light thrown on it in stripes from the blinds on a window. (Only the general effect of these stripes can be distinguished on the screen, however.) Later on he photographed human silhouettes with light stripes on them. See the negative of one such shot in Man Ray, "La photographie qui console," *XXe siècle* 2 (May 1, 1938):16

4. The intent of shots #19-#25 was later described by Man Ray: "One of the most interesting shots I made was while being driven by Rose Wheeler in her Mercedes racing car; I was using my hand camera while she was driving eighty or ninety miles an hour, being pretty badly shaken up, when we came upon a herd of sheep on the road. She braked to within a few feet of the animals. This gave me an idea—why not show a collision? I stepped out of the car, followed the herd while winding up the camera and set it in movement, then threw it thirty feet up into the air, catching it again. The risk I was taking gave me the thrill that most movie makers must experience when doing a difficult shot." Ray, *Self-Portrait*, p. 270.

5. In Man Ray's words, "The sea revolving so that it became sky and the sky sea." Ibid., p. 270.

6. The object is *Cork Sculpture* of 1926, illustrated in Ribemont-Dessaignes, *Man Ray*, p. 57.

7. The abstract background of #38 is Man Ray's *Dance* of 1915 placed on its side. See Patrick Waldberg, "Bonjour Monsieur Man Ray," *Quadrum* (Brussels, 1959) 7:95.

8. Man Ray designed a silver and gold chess set the same year, now in MOMA, based completely on geometric forms except for the knight which was fashioned after the neck and scroll of the violin. The forms, movement, and overall conception we find in #40 are essentially inspired by the game of chess.

9. "I needed something now to finish it with some sort of climax, so that the spectators would not think I was being too arty. This was to be a satire on the movies. A visit from my friend Jacques Rigaut, the dandy of the Dadas,

the handsome one who could have been a movie star if he wanted to, gave me the idea for the ending. As usual, he was impeccably dressed, with his well-cut clothes, a dark Homburg, and a starched white collar with a discreetly patterned tie. I sent out my assistant Boiffard to buy a dozen stiff white collars with which I filled a small attaché case. Then I had Rigaut go out with the case, find a taxi and drive back to the studio. The camera was set up in a window on the balcony overlooking the entrance to the studio; I filmed my man as he arrived in the taxi, stepped out and entered the building. In the studio I made a close-up of Rigaut's hands opening the case, taking the collars out one by one, tearing them in two and dropping them on the floor. (Later I had a reverse print made of the falling collars so that they appeared to jump up again.) I had Rigaut tear off the outside half of his collar, showing the tie around his neck. He looked more dressed up than ever, more formal. That was all for him. When he left I shot some sequences of the torn collars through the revolving deforming mirrors; they pirouetted and danced rhythmically. The entire sequence from the time of Rigaut's arrival was preceded by the only subtitle in the film: THE REASON FOR THIS EXTRAVAGANCE. This was to reassure the spectator, like the title of my first Dada film: to let him think there would be an explanation of the previous disconnected images. To finish the film I did a close-up of Kiki. Her penchant for excessive makeup gave me the idea. On her closed eyelids I painted a pair of artificial eyes which I filmed, having her open her own eyes, gradually disclosing them. Her lips broke into a smile showing her even teeth. FINIS—I added in dissolving letters." Ray, *Self-Portrait*, pp. 270-72.

10. Shot #59 is a crucial moment of the latter part of the film. From the appearance of the subtitle which announces a "rational" progression until #59 a narrative evolves. Shot #60, however, is a return to the revolving dance of objects. With that shot of rotating collars the last hope of the audience that there might be a "reason" for the movie is dispelled. The significance of a collar being torn off the neck was indicated by Man Ray himself: "I could always discern character in a cleanshaven face or through a beard, but this [mustache] was like a disguise, *like a high collar* or a fresh haircut." Ibid., p. 154. Once the disguise is ripped off, the film returns to the irrational dance of forms. Man Ray accentuated this climax by the musical accompaniment he directed the orchestra to provide at the time of the first screening at the Vieux Colombier. The film began with the phonograph playing popular jazz tunes which alternated with the piano and violin playing a tango. After the appearance of the subtitle, there was silence until the collars started rotating, at which point the orchestra launched into the "Merry Widow Waltz." With the accented resumption of the waltz, the playful Dadaism of the film was joyously reaffirmed.

Scenario of L'ÉTOILE DE MER 1928-29, by Man Ray (15 min.)

Une femme: Alice (Kiki) Prin

Un homme: André de la Rivière
Un autre homme: Robert Desnos
Mise-en scène et photographie: Man Ray
Assistant opérateur: J.A. Boiffard

1. A rotating starfish on a highly illuminated white disk with a translucent screen covering part of it.

2. L'ÉTOILE DE MER, POÈME DE ROBERT DESNOS, TEL QUE L'A VU MAN RAY.[1]

3. (G) Shot through an oval glass of a door. The door opens.[2]

4. (G) A man and a woman walk toward the camera on a path. She wears a heavy cloak, he, a suit.

5. A shot of their feet as they are walking. Camera tilts up suddenly.

6. (G) Man and woman continue to come closer to the camera on the path. They stop. She turns to him, looks behind her, and bends down.

7. (G) Shot of his face looking down stays superimposed on shot of her fixing her stocking.

8. LES DENTS DES FEMMES SONT DES OBJETS SI CHARMANTS.[3]

9. (G) She finishes fixing her stocking and lets her skirt fall back in place.

10. . . .QU'ON NE DEVRAIT LES VOIR QU'EN RÊVE OU À L'INSTANT DE L'AMOUR.

11. (G) A door opens.

12. (G) Woman comes into hallway followed by man. They go upstairs. As they do, she leaves her coat on the bannister.

13. (G) Shot of a room with bed against the wall. They come in from the direction of the camera. He sits down. She takes off her dress, puts it down on the chair, sits down, takes off her shoes, rolls down her stockings.[4]

14. (G) Close-up shot of man watching her with a bored look.

15. (G) She stands up and takes off her slip.

16. (G) Another close-up shot of the man, now gazing off.

17. (G) She is on the bed, her arms above her head, adjusting herself on the bed. He gets up. She reaches her hand out to him.

18. ADIEU.

19. (G) He kisses her outstretched hand and walks out.

20. SI BELLE! CYBÈLE!

21. (G) He walks down the stairs, goes to the door, and vanishes.[5]

22. (G) The door is shown closing.

23. NOUS SOMMES À JAMAIS PERDUS DANS LE DÉSERT DE L'ETERNÈBRE.

24. View of a tall chimney. Camera descends to its base, coming to rest showing a narrow, empty street.[6]

25. (G) A woman is selling newspapers in the street. She holds out a flapping paper blown by the wind.

26. (G) Shot of upper half of her body: she has a haughty look.

27. QU'ELLE EST BELLE.

28. A newspaper held up to cover the entire screen is slowly lowered, reveal-

ing her eyes peering into the camera over the paper.

29. (G) Another shot of her selling papers. The man comes up to her, takes her arm, and they start to walk away. They round the corner and come to a barrel, on which she throws her papers.

30. A shot of the top of the barrel. A jar stands next to the papers. Iris closes in on it.

31. (G) She picks up the jar, takes a few steps back as she holds it up, and they both examine it. He takes it from her and looks at it.

32. He stands in profile and she with her back to the camera. He holds the jar on his outstretched palm, gazing at it intently. The starfish can be clearly seen inside the jar. Iris closes in on jar.

33. He is sitting inside his room, cigarette in mouth. He picks up jar, holds it close up to the light, turns it around while examining it.

34. APRÈS TOUT.

35. Close up of a live starfish in water. It move its arms ponderously.

36. Close up blurred shot of rotating newspapers.

37. Newspapers blown and scattered by a strong wind on the beach. Camera follows different sheets on their way. A man's feet appear as he chases papers. He catches one, stoops down and picks it up.

38. (G) Close up shot of man holding up sheet and looking inside.

39. Close up of paper tilted with the following text: "L'ENTREVUE—1er Mars. Varsovie publie le matin la réponse de M. ***maras à la dernière note de M. Zaleski qui était en quelque sorte une mise en demeure. L'homme d'État lithuanien croit de voir, avant de s'exécuter, mettre en . . . "[7]

40. Close-up shot of man folding up paper.

41. (G) Shot of man and woman inside a room. His head is in her lap and she is stroking his hair.

42. Tilt-down shot of rails from quickly moving train. (Rails reflect the gleam of the sun.)

43. Shot of houses being passed from cabin.

44. Similar shot of trees passing.

45. Shot of top of train passing.

46. Shot of harbor with tugboats lined up. (Shot is taken from railing of a ship. A figure is at the side of the frame.)

47. Tilt-down shot at the dock with hands of people at railing showing. The ship is pushing off.

48. Silhouette of ship's chimneys passing by.

49. Shot pans to the left, showing harbor in mist with tall buildings.

50. Shot of flower in flowerpot.

51. SI LES FLEURS ÉTAIENT EN VERRE.

52. The screen is divided into twelve sections, four across, three down, each showing a different action. From left to right, starting with the top row the images, are the following: (1) figurine rotating while bobbing up and down, (2) hand draws sword blade between fingers of other hand, as in testing the blade, (3) rotating mirror, (4) rotating glass jar with what looks like a starfish with

curled-up tentacles inside, (5) stationary top of glass, (6 and 7) two different jars with starfish rotate toward each other, (8) rotating glass cube alternating with white area moving in, (9) same as (4) with a slice of a sphere on top of the jar—rotation while bobbing up and down, (10 and 11) two roulette-like wheels turn toward each other, (12) glass beaker with white powder inside is lifted up by hand and powder is poured out—the reverse print of this action appears.

53. Shot of same flowerpot as in #50. Iris closes in on white flower.

54. SI LES FLEURS ÉTAIENT EN VERRE.

55. (G) Opening iris on black box. Shot reveals a woman lying on the sand with black box in hand. She examines it, puts it down, turns away, only to turn back and pick it up again. A few objects are spread out along with the black object, including a man's hat.

56. Still-life shot of tabletop with newspaper, one corner folded back, on which rest two bananas. Moving counterclockwise, a half-peeled banana with a bite already gone, a starfish, and a bottle of wine. In the center, a glass of wine. (The focus is at first unclear, then it becomes sharp.)

57. (G) Woman lying in bed folds back covers and steps out with left foot onto the open page of a large book. Camera pans from her to follow her leg.

58. Same shot as #57 without gelatin and with a starfish next to the book.

59. (G) Woman walks down the same path as in #4 by herself toward the camera.

60. BELLE, BELLE COMME UNE FLEUR DE VERRE.

61. Starfish.

62. (G) Man and woman stand on the path. They look at each other. She has mask on. She begins to take it off.

63. (G) She continues taking mask off as camera pans to her exclusively.

64. Shot of mask alone.[8]

65. BELLE COMME UNE FLEUR DE CHAIR.

66. Man is in his room with starfish in the jar, examining his hands. Iris closes in or jar.

67. Close-up shot of hands. Palms are turned out to show dark-inked lines on hands approximating the natural lines of the hand. Dissolve to . . .

68. . . . shot of one hand held up with lines.

69. IL FAUT BATTRE LES MORTS QUAND ILS SONT FROIDS.[9]

70. (G) Door opening and closing.

71. (G) Woman walks upstairs, seen from below.

72. (G) Shot of woman walking up continued from the top of the stairs. She stops, pulls out long knife, holds it up in a stabbing hold in her right hand, and continues.

73. Shot of bottom of the stairs with starfish on first step.

74. She continues toward the camera, brandishing her knife. When she gets close to the camera, she stops and turns the knife so that the blade catches the light.

75. Her hand holds the knife as starfish is superimposed over it.

76. LES MURS DE LA SANTÉ.

77. Shot of street, camera pans upward to show a massive wall, then moving to show full sky.

78. Shot of sky at night with stars and shooting star.

79. ET SI TU TROUVES SUR CETTE TERRE UNE FEMME À L'AMOUR SINCÈRE . . .

80. Tilt-down shot of river with tree at right, water reflecting the sun's rays.

81. Shot of flowing water with sun reflected.

82. (G) Shot of woman gazing across the fire into the camera.

83. BELLE COMME UNE FLEUR DE FEU.

84. Woman stands, with a haughty expression, clothed in a tunic and a Phrygian cap, left hand on hip, right hand resting on spear.

85. Flames.

86. Narrow empty street. Camera pans up following the length of the chimney. (Reverse of shot #24.)

87. LE SOLEIL, UN PIED À L'ÉTRIER, NICHE UN ROSSIGNOL DANS UN DE CRÊPE.

88. (G) Full shot of woman lying on bed.

89. Close-up of her face, her eyes closed, hands at her head.

90. Full shot of her nude on bed.

91. VOUS NE RÊVEZ PAS.

92. (G) She walks down path alone. Man comes up to her from the direction of the camera. They seem to be talking. Second man comes in from right, stands between them, then leads her away to the left. He remains standing.

93. (G) Close-up of his head and shoulders, as he slowly turns to look after them. Stern look on his face.

94. QU'ELLE ÉTAIT BELLE.

95. (G) Inside his room, he looks at jar with starfish in front of him, then looks up into camera. Iris closes in on jar.

96. QU'ELLE EST BELLE.

97. Starfish emerges from behind letters of #96.

98. She appears from bust up with haughty look at camera. She is seen through translucent glass with word "belle" on it. She starts to put her hands up to her ears.

99. Same scene but glass is shattered. She continues movement of putting hands up to cover her ears. She turns away, then looks back into the camera.

100. (G) Door with oval window is closed on room.

Notes

1. There is no record of Desnos' poem by this name; however, Man Ray describes the poem in his autobiography: "Desnos's poem was like a scenario for a film, consisting of fifteen or twenty lines, each line presenting a clear, detached image of a place or of a man and woman. There was no dramatic action, yet all the elements for a possible action. . . . A woman is selling newspapers in the street. On a small stand beside her is the pile of papers, held

down with a glass jar containing a starfish. A man appears, he picks up the jar, she her pile of papers; they leave together. Entering a house they go up a flight of stairs and into a room. A cot stands in a corner. Dropping her papers, the woman undresses in front of the man, lies down on the cot completely nude. He watches her, then rises from his chair, takes her hand and kisses it, saying adieu—farewell—and leaves taking the starfish with him. At home he examines the jar with its contents, carefully. There follow images of a train in movement, a steamer docking, a prison wall, a river flowing under a bridge. There are images of the woman stretched out on the couch, nude, with a glass of wine in her hand, of her hands caressing a man's head in her lap, of her walking up the stairs with a dagger in her hand, of her standing wrapped in a sheet with a Phrygian bonnet on her head—symbol of liberty, an image of the woman sitting in front of a fireplace, suppressing a yawn. A phrase keeps recurring: 'she is beautiful, she is beautiful.' Other phrases, irrelevant, as 'If only flowers were made of glass,' and 'One must beat the dead while they are cold,' appear in the poem. In one line the man picks up a newspaper lying in the street and scans a political headline. The poem ends with the man and woman meeting again in an alley. A newcomer appears, takes the woman by the arm and leads her away, leaving the first man standing in bewilderment. The woman's face appears again, alone, in front of a mirror, which cracks suddenly, and on which appears the word: 'beautiful.' '' Ray, *Self-Portrait*, pp. 275-76.

2. The letter (G) appears with those shots which were shot through gelatine. Man Ray explains how he came to use the gelatine: "There were one or two rather delicate points to consider: the portrayal of absolute nudes would never get by the censors. I would not resort to the usual devices of partial concealment in such cases as practiced by movie directors. There would be no soft-focus, nor artistic silhouette effects. I prepared some pieces of gelatine by soaking, obtaining a mottled or cathedral-glass effect through which the photography would look like sketchy drawing or painting. This required some arduous experimenting, but I finally attained the desired result." Ibid., p. 277. Man Ray's attitufe toward the distortion of a visual image is further revealed by Ado Kyrou, who recalled, "Man Ray would tell me that if a film bored him, he transformed it voluntarily by blinking his eyes at a rapid pace, by passing his fingers in front of his eyes, by forming grates, or by placing a semi-transparent cloth over his face." Ado Kyrou, *Le surréalisme au cinéma* (Paris: 1953), p. 248.

3. There is a play on the word *dents*, for while it means "teeth," *dentelure* means "indentation," which makes the oblique reference quite specific.

4. The censors, although upset by the apparent incoherence of the film, approved it, objecting only to two shots. One was shot #13, where the woman's undergarment passes over her head; the other was #69, the caption "One must beat the dead while they are cold."

5. Man Ray has said in an interview, "I would often go to the theatre and I would notice that in plays two-thirds of the action consists in the fact that peo-

ple enter and leave through doors. In my first film [sic] *L'Étoile de mer* there are no doors. Doors have disappeared. People disappear without passing through doors, because there are none." Pierre Bourgeade, *Bonsoir Man Ray* (Paris: 1972), p. 52. Man Ray's memory was obviously faulty. There are doors in the film, shown opening and closing, but the characters are never shown going through them. Man Ray thus sabotaged reality in his customary way by showing all of the elements of passing through a door (character approaching and door closing) without actually showing the passage itself. Is this avoidance of an obvious and expected action perhaps analogous to his build-up to the act of love without showing its consummation?

6. Man Ray's painting of the street where he found his new apartment upon his return to France in 1952, *Rue Férou*, shows a very similar street seen from a similar angle. He has said that he painted the canvas, "in a manner in which I would have photographed it." Ray, *Self-Portrait*, p. 340.

7. Perhaps the selection of this particular article was suggested by Jarry's *Ubu Roi*, which was a great favorite of the Surrealists. In in Père Ubu assassinates the King of Poland to become king himself. His right-hand man is Capitaine Bordure, Duke of Lithuania. Once Père Ubu is overthrown, he escapes through Lithuania, where the cave scene of Acts IV and V take place.

8. The idea of masking people runs through three of Man Ray's films. In *Emak Bakia* shot #16 shows the driver wearing goggles which appear as a mask. In shot #44 the woman is hidden by a fan which she slowly pulls away. The film ends with the masking effect of the eyes painted on the eyelids. In *L'Étoile de mer*, aside from the specific scenes showing the woman with a mask, the effect of the gelatine filter is to hide the characters. In *Le Mystère du Château de Dés* all the characters wear silk stockings over their head to distort their features.

The masks appear in Man Ray's later work as well. In 1932 he created a mask of himself which was like a death mask with glasses propped on the nose. From the late 1930s four different drawings of masks remain, with some of the features distorted. In the early 1950s he created his "Indicators," which are simple wooden planar masks and four painted carton masks, one with iron covering it, another with a butterfly painted on the flesh-colored carton. The idea for these painted masks seems to have come from the party Man Ray had given the day he met Henry Miller. He recalls, "We pretended to be Chinese. We didn't say a word, we contented ourselves with making noise: I was drumming on pots, as in a Chinese play; we yelled and screamed, and from time to time uttered some obscenities. It was very gay. I had painted masks for the women, to make them a little impersonal. . . . The men thought that this was make-up right on the face, because the mask was skin-colored, and only the drawing on the mask changed the face completely." Bourgeade, *Bon Soir Man Ray*, pp. 47-48. Thus Man Ray was even masking his own masks. Man Ray's propensity for utilizing small wooden figures such as "Mr. and Mrs. Woodman" and for drawing faceless people is another indication of his attempt to mask the identities of people. In a wider sense Man Ray also "masks" his ob-

jects insofar as masking implies the existence of a multiple and ambiguous identity.

9. The phrases are similar in spirit to some of the "proverbs" created by the Surrealist poets. Compare, for example, the following: "Il faut battre sa mère pendant qu'elle est jeune," in Paul Éluard and Benjamin Péret, *152 Proverbes mis au goût de jour* (Paris: 1925), p. 11.

Scenario of LE MYSTÈRE DU CHÂTEAU DE DÉS, 1929, by Man Ray (25 min.)

1. COMMENT DEUX VOYAGEURS ARRIVÈRENT À SAINT-BERNARD, ET CE QU'ILS VIRENT DANS LES RUINES D'UN VIEUX CHÂTEAU, AU-DESSUS DESQUELLES S'ÉLEVE UN AUTRE CHÂTEAU, DE NOTRE ÉPOQUE.

Les Voyageurs: Man Ray
 J.-A. Boiffard

2. At night, the headlights of a car approach.
3. UN COUP DE DÉS JAMAIS N'ABOLIRA LE HASARD.[1]
4. A wooden hand. It draws away to show another wooden hand holding a pair of dice.
5. A shot of the castles. Five succeeding dissolves, each showing the site a little closer than the preceding one. Below is the new villa, above, the ruins.[2]
6. LOIN DE LÀ, À PARIS.
7. Two men with stockings over their faces stand on either side of a bar. They alternate rolling the dice, twice each.[3]
8. ON PART?
9. Taller man shakes head back and forth.
10. ON NE PART PAS.
11. Dice are rolled again.
12. ON PART!
13. They get up to go.
14. A view of their backs as they go out the gate to a car.
15. A shot from the other side of the car shows them getting in.
16. OÙ ALLONS-NOUS?
17. Head-on shot of the two seated in the car. Driver opens and closes glass windshield.
18. A shot from the other side of the car leaving.
19. LES PORTES DE PARIS S'OUVRENT SUR L'INCONNU . . .
20. They drive through a gate. A street peddler is shown on the corner.
21. Shot of large concrete blocks being passed on the right.
22. . . . À TOUTE VITESSE, PAR MONTS ET PAR VAUX, À TRAVERS LA FRANCE.
23. Car comes in from the left, passes in front of the camera, and continues on. Snowy countryside.

Shots #24-#41 are taken from the moving car.

24. Shot of passing train on the left.

25. Jerky shot aimed front left of the countryside passing by.

26. Jerky shot of the road ahead.

27. Jerky shot front left of smokestack and power lines.

28. Jerky shot front right of town with the ruins of the castle on top of the mountain.

29. Shot straight ahead of the road lined by a row of trees. (The light is much stronger since they are in the south of France.)

30. Shot straight ahead of modern bridge as they cross it.

31. Shot front left of trees by the side of the road. Camera gradually pans to straight ahead.

32. Very bouncy shot of entering a village.

33. Back on the open road following a truck.

34. Bouncy shot of approaching and passing a medieval gate.

35. Shot of the road with hill in front.

36. A quick and jerky shot of a sign with arrow pointing to the left: "Noailles St. Bernard, Propriété et Chemin Privé." Camera swings up into the trees.

37. Shot front left. Car takes a sharp curve to the left. Camera is swung into the sun, then it is aimed at the fence along the road.

38. Camera catches the rays of the sun, then it focuses down on the road, settling aimed to the front left.

39. Shot of road straight ahead with glimmering hood of car at the bottom of the screen.

40. Dizzying shot of trees passing by very close to the left.

41. Tilt-down shot of the road ahead. Car takes another sharp left.

Shots #42-#44 are taken from a stationary position, but the fast panning continues the speed of the moving car.

42. At the entrance to the castle camera pans up hill to show ruins on top, then pans down to show shrubbery.

43. Shot of driveway with garage at the end. Camera pans up to show the sky.

44. Camera pans left along a wall to end at a statue.

45. Close-up of the abstract statue. Camera slowly pans up it in a rotating motion.

46. An even closer shot, again panning up and rotating.

47. A similar shot, panning up and down the length of the sculpture, still rotating, but showing the other side.

48. PRESTIGIEUX, COMME MARQUÉ PAR LE SCEAU D'UN ÉTRANGE DESTIN, UN CHÂTEAU . . .

49. A nearly 360⁰ panning of area around the mansion, with the mansion itself occupying the center of the shot. Shot starts and ends with view from a wall surrounding a garden next to the house.

50. A pan of the wall enclosing the garden. (The wall sports large, rectangular openings at regular intervals.)

51. Shot of meteorological instument.

52. Tilt-up shot of wind sock flapping on top of pole. Camera pans down the pole, down the outside of the building to the ground floor. It continues to pan right, showing a telescope and a door with checkered pattern.

53. Tilt-down shot of inside of wall enclosing the garden, panning from left to right.

54. Pan of outside of wall from left to right. Then, pan down and to the right, following an architectural pattern.

55. Close-up shot of wall. Camera tracks left to reveal garden through one of the large windows in the wall, then catches the continuation of the wall.

56. ÉTOILE DU JOUR.

57. Shot of star-shaped polyhedron, made of paper and hanging by a string, seen through the panes of a door. Camera is in motion.

58. Shot through door of sculpture in the garden. Camera slowly pans up.

59. Camera slides very close to the floor, down a corridor, through a door, and stops next to a chair. It starts to move up and to the left at medium speed, showing the rest of the room. Once the end of the room is reached, camera starts back to the right. (The room is a combination den and study, with desk, chairs, easy chairs, sofa, and a piano.)

60. Rightward movement is continued in pan of ceiling. (The ceiling consists of rectangular patterns of translucent glass to let light in.) Camera pans down to show vase of flowers on desk. It pans to the right to show a mirror and a countertop covered by a roller top.

61. L'INTRUS.

62. Shot of roller top rolling back automatically.

63. Long shot of wire sculpture outside. The sculpture is of a woman holding a metal disk which moves slightly, catching reflection of light.

64. Inside, camera pans left slowly between walls. It shows an abstract stained-glass window.

65. Camera pans up from floor to show instruments on the wall.

66. Upward panning continues up the stairs to abstract stained-glass door, where camera veers up and to the right.

67. Camera pans new room from easy chair in front across the room to the sofa and up the walls. Movement is up and to the left. (The room is more comfortable than the previous study in #59.)

68. Panning shot from floor of library up bookstacks to the clock near the ceiling.

69. Tracking shot down dark stairs toward a Ping-Pong table at the bottom in the light.

70. PERSONNE.

71. Camera travels close to the ground toward easy chair. Once it is reached, camera veers to the left and travels toward another.

72. PERSONNE.

73. Slow panning shot, from left to right of another room, darkened by curtains. Camera ends up focused on African statue standing on desk in bright sunlight.

74. PERSONNE, *PERSONNE!*

75. Camera in middle of room panning up from back of sofa to fireplace to large mirror above.

76. LES SECRETS DE LA PEINTURE.

77. In storage room, shot of a screen with the backs of paintings. The screen slides to the right, revealing another. Ten screens slide by. Then, the last two slide away together in alternating jerks. Finally we see the open door of the room.[4]

78. C'EST ALORS QUE RETENTIT, POUR LA PREMIÈRE FOIS, DANS CES SALLES, CETTE QUESTION, CETTE HUMAINE QUESTION: "OÙ SOMMES-NOUS?"

79. Camera travels close to the floor through a door.

80. "ALLONS-NOUS-EN, SORTONS."

81. Tilt-down pan of walls of garden.

82. AINSI VINT LA NUIT.

83. Camera travels up road in car toward the gate. The sun is setting straight ahead.

84. Shot of the night sky.[5]

85. MAIS QUAND PARUT LE MATIN.

86. 180° panning shot of countryside in the morning.

87. INSOLITES, DANS UN COIN OUBLIÉ:

88. Four people lie in a semicircle on the floor, in robes, with silk stockings over their faces. They roll a pair of large dice. (First appearance of people since shot #17.)

89. "UN COUP DE DÉS . . .

90. Continuation of #88.

91. . . . JAMAIS N'ABOLIRA . . .

92. Continuation of #90.

93. . . . LE HASARD."

94. The four jump up, take off their robes, and leave the room in their bathing suits.

95. A close-up of the pair of dice and robes left on the floor.

96. "EXISTE-T-IL DES FANTÔMES D'ACTION? . . .DES FANTÔMES DE NOS ACTIONS PASSÉES? LES MINUTES VÉCUES NE LAISSENT-ELLES PAS DE TRACES CONCRÈTES DANS L'AIR ET SUR LA TERRE?"

97. Shot of indoor swimming pool from high up. The four run in from the opposite side down the length of the pool and back. Three jump into the water while the fourth jumps up on a rope. (Film speed is slightly increased.)

98. Shot of swimmer from the back finishing a dive and disappearing in the water.

99. Shot of man from the back starting and completing a dive.

100. Close-up of legs of swimmer who is starting a dive.

101. Shot of swimmer doing a handstand in shallow water. (Because of the juxtaposition, it seems that the diver of the previous shot finishes the dive in a handstand.)

102. Repeat of shot #100.

103. Shot of pool from high up. Man takes a dive from the diving board.

104. A similar shot, but the view also includes a man on the ropes. After the diver dives, man on the rope climbs to the top.

105. Shot of pool from high up. Three people are swimming around, a fourth is on a swing above the water.

106. Shot of woman diving under the water taken from right above her.

107. LA FEMME . . . LA JONGLEUSE.

108. She floats on top of the water, face down. Three balls float on the surface. She pushes one down, lets it bounce up, and catches it with the other hand, as if she were juggling them in the air.

109. ÈVE SOUS-MARINE.

110. Medium shot from above. She swims with face in water holding a dumbbell in either hand. She drops both.

111. Close-up shot of her in the water. With face in water and top of head sticking out, she combs her hair.

112. She wrestles under water with a giant hose.

113. LES DÉITÉS DES EAUX VIVES LAISSENT COULER LEURS CHEVEUX.

114. Panning shot of man with mask swimming a half-circle, then getting out by way of the stairs.

115. PISCINÉMA.

116. Reverse shot of woman diving from diving board.

117. Panning shot of wall of pool building, first to the left, then back. Shadows of equipment appear on wall amidst play of light reflected by the moving water.

118. MANE-THECEL-PHARES.[6]

119. Panning shot down from the ceiling to the shadows cast by steps shown in #117. They look like three monkeys sitting erect.

120. REGRETTEZ—VOUS LE TEMPS OÙ LE CIEL SUR LA TERRE MARCHAIT ET RESPIRAIT DANS UN PEUPLE DE DIEUX OÙ VÉNUS ASTARTÉ, FILLE DE L'ONDE AMÈRE . . .

121. Waist-high shot of side of pool next to windows with bathers getting out, walking toward camera, and passing by it.

122. PASSE, IL FAUT QUE TU SUIVES CETTE BELLE OMBRE QUE TU VEUX.

123. Panning shot of the shadows of two figures with upraised arms passing along the wall of the pool amidst shadows and reflections from the water. At the end they walk up several steps. (The shot is tilted at a right angle so that the shadows face and move straight down.)

124. Panning shot left and back, showing yard outside of the pool building.

Staccato movement of camera. Cross-hatching superimposed on picture. Four bathers stand erect with arms raised on stools in front of piers which separate the windows of the pool. They present a statue-like effect, a take-off on caryatids.

125. Pan of garden wall from left to right and into the sky.

126. Tilt-down shot of medicine ball rolling toward the camera. A number of bowling balls follow it. (A reverse print of balls being rolled away from camera.)

127. Tilt-down shot of two barbells rolling toward camera, one from the left, the other from the right. Pendular movement of punching bag is superimposed.

128. Man in bathing suit with arms reaching up runs backward. (Reverse print.)

129. Man spread-eagled in wheel rolling away from camera, then rolling back. (Rolling back is speeded up.)

130. Man runs back to camera. (Straight print of #128.)

131. The four bathers run from behind the camera to the climbing bars. They climb up, hang on to the top bar, and turn around. They vanish from the ladders.

132. The four bathers are seated in a square facing each other. They pass a medicine ball around clockwise. They throw the ball higher and higher. The film is speeded up. Cross-hatching is superimposed on the picture.

133. Slightly tilted shot of two bathers arching their backs while three others hold up a medicine ball and turn around with it. Cross-hatching is superimposed. Dissolve.

134. MINERVE CASQUÉE.

135. Shot of metal apparatus. Panning shot down to focus on sitting man wearing the apparatus, consisting of metal collar, helmet, shoulder harness. Camera slowly rotates to put man sideways.

136. Shot of pool from passageway. Bathers come toward door in single file, pass through it, and pass by camera.

137. Tilt-down shot of mats with light streaming onto them through windows. Bathers come in from left, lie down, and roll to the right, one after another. They end up lying on their backs, still, head and feet alternating.

138. O! SOMMEIL, O! SOLEIL, MA VIE SERA SOUMISE À TES LOIS, ET JE FERMERAI LES YEUX QUAND TU DISPARAITRAS.

139. Tilt-up shot at garden wall, then panning to the right.

140. BELLE ÉTOILE D'AMOUR, BELLE ÉTOILE D'IVRESSE . . . [7]

141. Close-up shot of ground, then pan to the right. Camera pauses when it comes to the paper star of #57, then it moves on.

142. Almost imperceptible change of ground to wall. Panning continues to the right, showing garden wall, then stops at window. Panning resumes down, stops at ground floor, and continues to the right.

143. ALORS, DEUX VOYAGEURS ARRIVÈRENT DANS CES LIEUX.

144. Long shot of road leading to house. A man and a woman approach

from a distance. As they near the camera, we notice the stockings on their faces. They turn toward the house (to go in a door).

145. QUI MONTÈRENT SUR MES TERRASSES.

146. Tilt-down shot of stepped gardens. Camera pans up past frist floor to second floor of garden wall and stops. Panning resumes to the right.

147. Camera travels rather quickly and close to the ground into the walled garden. It is aimed front right. (The direction of its aim is changed once.)

148. DEUX VOYAGEURS QUI CHERCHÈRENT . . .

149. Shot of garden with man and woman coming in on path at the left, looking about. As they walk on to the lawn, camera pans them. They find a pair of large dice, at which they stop.

150. DEUX VOYAGEURS QUI RESTÈRENT?

151. Man gently kicks one die.

152. DEUX VOYAGEURS QUI NE RESTÈRENT PAS?

153. Woman kicks the other and gestures with her hand.

154. DEUX VOYAGUERS QUI RESTÈRENT.

155. They walk away to the left, camera panning them.

156. "MAIS QUAND VINT LA SECONDE NUIT . . ."

157. Pan of house and surrounding area from the rooftop left.

158. Panning shot to the right along rooftops, stopping when a statue comes into view. At beginning of shot camera is tilted.

159. Shot of rooftop with statue of a woman at the left. Man and woman come in from the right. They take off their overcoats, hats, and shoes, and remain with only bathing suits on. They grab each other's arms and take several steps together in what is half dance, half calisthenics. They end with him holding her as she leans back on one knee. This final shot changes into its negative.

160. . . . QUI RESTÈRENT.

161. Shot of walled garden from roof. Camera is slowly turned upside down, making garden also turn around.

162. Camera travels out from tunnel with a square end to the light. Once it reaches the light, it pans right, showing the scenery until it faces the black wall of the tunnel.

163. Shot of wooden hand of #4. It is drawn away, revealing another wooden hand, holding a pair of dice. The hand turns over, letting the dice fall. The hand turns back, palm up.

Notes

1. Man Ray writes that the cubic forms of the chateau reminded him of Mallarmé's poem by that name. Ray, *Self-Portrait*, p. 280.

2. The Vicomte de Noailles commissioned Man Ray to make this film of a private gathering at his mansion in Hyères, which was executed by the architect Mallet-Stevens.

3. "I acquired some accessories, nothing cumbersome, a pair of small and a pair of very large dice, also six pairs of silk stockings. The latter I intended to pull over the heads of any persons that appeared in the film to help create mystery and anonymity." Ibid., p.280.

4. Man Ray remembers: "Going down into the basement, I came upon a row of large wire mesh panels fitted into the wall. Pulling one out on its rollers I found it covered with paintings of all sizes. So were the dozen other panels. My host explained that was his surplus collection for which he had no room on his walls. He had befriended every painter he had met or who needed assistance. But the panels were originally part of the laundry installation, for drying the wash. I filmed them coming out one after the other, without the intervention of human hands; a simple movie trick. But I filmed them showing only the backs of the paintings. In mounting the film I added this caption: *The secrets of painting*. Whether the sequence was too short or badly filmed, I'm afraid I was the only one to appreciate the bit of satire." Ibid., p. 282.

5. Although the screen is absolutely dark, we can safely say that this is a shot of the night sky because of the context of the shot. In *L'Étoile de mer* shot #78 was also of the night sky.

6. This is the famed writing on the wall which appears during the festival of Balthazar. The King calls Daniel to him, who translates the words as meaning God "has numbered" Balthazar's reign, which will thus come to an end; Balthazar "has been weighed" on the scales and found wanting; and his kingdom "had been divided" and given to the Medes and the Persians. Daniel 5:25.

7. Throughout his life Man Ray returns again and again to ideas or images that he once used, always treating them in new ways but with reference to the original use. The star is one such object. His film *L'Étoile de mer* had presented a starfish as well as a shooting star. In shots #56-#57 of *Le Mystère du Château de Dés* he shows a mathematical star to which he refers as "Étoile du jour" as opposed to the stars of the night sky seen in the previous film. The star is shown again in shots #140-#141, where it is called "Belle étoile d'amour, belle étoile d'ivresse . . . " emphasizing the connection between the woman in *L'Étoile de mer* (referred to as "Belle" again and again) and the star. He creates an object called *L'Étoile de verre* in 1965, which is a piece of polished glass inserted into a sheet of sandpaper (in French, *papier de verre*) and, with the greatest sparseness of line, made to look like a star casting its reflection on water. The picture is thus of a "L'Étoile de mer" as well, with which the title rhymes, and whose glass flower and starfish it also combines in the title.

Selected Bibliography

À NOUS LA LIBERTÉ and ENTR'ACTE, films by René Clair. Classic Film Scripts. New York, 1970.

Acerete, Julio C., et al. *Pour Buñuel.* Paris, 1962.

Achard, Paul. "Picabia m'a dit." *L'Action,* January 1, 1925, p. 4.

Adhémar, Jean, and Cain, Julien. *Man Ray, L'Exposition de l'oeuvre photographique à la Bibliothèque Nationale.* Paris, 1962.

L'ÂGE D'OR and UN CHIEN ANDALOU, films by Luis Buñuel. Classic Film Scripts. New York, 1968.

Albert-Birot, Pierre. *Cinéma, poèmes et drames dans l'espace.* Paris, 1920.

———. "Du cinéma." *SIC,* nos. 49-50 (October 15-30, 1919).

———. "Interview Albert-Birot—Apollinaire." *SIC,* nos. 8-10 (August-October 1915).

Alquié, Ferdinand, ed. *Entretiens sur le surréalisme.* Paris, 1968.

———. *Philosophie du surréalisme.* Paris, 1955.

Amberg, George. "The Rationale of the Irrational." *The Minnesota Review* 3, no. 3 (Spring 1963):323-47.

Apollinaire, Guillaume. "L'Amphion faux-messie ou histoires et aventures du baron d'Ormesan," *L'Hérésiarque et cie.* Paris, 1910.

———. "Avant le cinéma." *Nord-Sud,* no. 2 (April 15, 1917).

———. *L'Esprit nouveau et les poètes.* Paris, 1946.

———. *Les Mamelles de Tirésias.* Paris, 1918.

———. In *Paris-Journal,* July 15, 1914.

——— and André Billy. "La Bréhatine, cinéma-drame." *Archives des lettres modernes,* no. 126 (1971).

"Appel à la curiosité." *Le Théâtre et Comoedia Illustré,* March 1923.

Aragon, Louis. *Anicet ou le panorama.* Paris, 1964

———. "Beautés de la guerre et leurs reflets dans la littérature." *Europe* (December 1935), p. 474.

———. "Charlot mystique." *Nord-Sud,* no. 15 (May 1918).

———. "Charlot sentimental." *Le Film,* March 18, 1918.

———. "Le croiseur *Potemkine." Clarté* 5, no. 4 (October-December 1926).

———. "Du décor." *Le Film,* September 16, 1918.

———. *Vampires.* Unpublished MS. 7206-10 of the Bibliothèque Littéraire

Jacques Doucet, Paris. Partially quoted by Roger Garaudy, *L'Itinéraire d'Aragon*. Paris, 1961.

—— and André Breton. "Le Trésor des Jésuites." *Variétés* (June 1929), pp. 47-61.

Aranda, J. Francisco. *Luis Buñuel, biografía crítica*. Barcelona, 1969.

———. "Surrealist and Spanish Giant." *Films and Filming* (October-November 1961).

Artaud, Antonin. *Oeuvres complètes d'Antonin Artaud*. 7 vols. Paris: Gallimard, 1956-1967. Vol. 3 contains Artaud's writings on the cinema.

L'Avant-scène du cinéma, nos. 27-28 (June 15-July 15, 1963).

L'Avant-scène du cinéma, no. 86 (November 1968).

Bataille, Georges, "Le 'Jeu Lugubre.' " *Documents*, no. 7, p. 372.

Belz, Carl. "The Film Poetry of Man Ray." *Criticism* (Spring 1965), pp. 117-30.

Berger, Pierre. *Robert Desnos*. Paris, 1970.

Bosquet, Alain. *Entretiens avec Salvador Dalí*. Paris, 1966.

Bourgeade, Pierre. *Bonsoir Man Ray*. Paris, 1972.

Breton, André. *L'Amour fou*. Paris, 1937.

———. *Arcane 17*. Paris, 1947.

———. "Comme dans un bois." *L'Âge du cinéma*, nos. 4-5 (August-November 1951).

———. *Entretiens*. Paris, 1952.

———. *Manifestes du surréalisme*. Paris, 1971.

———. *Nadja*. Paris, 1949.

———. *Les Pas perdus*. Paris, 1924.

———. *Position politique du surréalisme*. Paris, 1971.

———. *Les Vases communicants*. Paris, 1955.

Buache, Freddy. *Luis Buñuel*. Lausanne, 1970.

Buñuel, Luis. "Metropolis." *Gaceta Literaria*. Madrid, 1927. Reprinted in "Luis Buñuel: Textes 1927-1928." *Cahiers du cinéma*, no. 223 (August-September 1970).

———. "Poésie et ciméma," trans. Michèle Firk and Manuel Michel, *Cinéma 59*, no. 37 (June 1959).

———. "Un Chien andalou," *La Révolution surréaliste*, no. 12 (December 15, 1929).

———. "Une girafe." *La Surréalisme au service de la révolution*, no. 6 (May 15, 1933).

———. Unpublished notes of the Columbia University Extension Film Study course, Museum of Modern Art, New York, April 10, 1940.

Buñuel-Garcia, Conchita. "Mon frère Luis." Translated by Marcel Oms. *Positif*, no. 42 (November 1961), pp. 19-25.

Les Cahiers du mois. "Cinéma," nos. 16-17 (1925).

Camfield, William A. *Francis Picabia*. New York, 1970. (Catalog of the Solomon R. Guggenheim Museum.)

Canudo, Ricciotto. "Manifeste des sept arts." *L'Usine aux images*. Paris, 1927.

Clair, René. *Adams*. Paris, 1926.

———. *Cinéma d'hier, cinéma d'aujourd'hui*. Paris, 1970.

Crevel, René. "*Drame de cinéma*, par Louis Delluc." *La Revue Européenne,* no. 3 (May 1, 1923), 109-10.

——— and Paul Éluard. "Un film commercial." *Le Surréalisme au service de la révolution*, no. 4 (December 1931), p. 29.

Dalí, Ana Maria. *Salvador Dalí vu par sa soeur*. Translated by Jean Martin. Paris, 1960.

Dalí, Salvador. *L'Amour et la mémoire*. Paris, 1931.

———. "L'Âne pourri." *Le Surréalisme au service de la révolution,* no. 1 (July 1930), 9-12.

———. *Babaouo*. Paris, 1932.

———. *Journal d'un génie*. Paris, 1964.

———. "Mes Secrets cinématographiques." *La Parisienne* (February 1954), pp. 165-168.

———. *Le Mythe tragique de l'Angelus de Millet*. Paris, 1963.

———. *Les Passions selon Dalí*. Paris, 1968.

———. *The Secret Life of Salvador Dalí*. Translated by Haakon M. Chevalier. London, 1948.

Daven, André-L. "*Entr'acte.*" *Comoedia*, October 31, 1924.

De Maré, Rolf. "À Propos de *Relâche.*" *Comoedia*, November 27, 1924.

Delluc, Louis. *Charlot*. Paris, 1921.

———. *Cinéma et cie*. Paris, 1919.

———. *Photogénie*. Paris, 1920.

Demaitre, Ann. "The Theatre of Cruelty and Alchemy." *Journal of the History of Ideas* 33, no. 2 (April-June 1972):237-50.

Dermée, Paul. *Films*. Paris, 1919.

Desnos, Robert. *Cinema*. Edited by André Tchernia. Paris, 1966.

———. "Confession d'un enfant du siècle, I." *La Révolution surréaliste*, no. 6 (March 1926), pp. 18-20.

———. "Confession d'un enfant du siécle, II. "*La Révolution surréaliste,* no. 8 (December 1, 1926), pp. 21-22.

———. *De l'érotisme, considéré dans ses manifestations écrites et du point de vue de l'esprit moderne*. Paris, 1953.

———. "Description d'une révolte prochaine." *La Révolution surréaliste,* no. 3 (April 1925), pp. 25-27.

———. "Imagerie moderne." *Documents*, no. 7 (1929), pp. 377-78.

———. "Journal d'un apparition." *La Révolution surréaliste,* nos. 9-10 (October 1, 1927), pp. 9-11.

———. "Le Mystère d'Abraham juif." *Documents*, no. 5 (1929), p. 237.

———. "Pygmalion et le sphinx." *Documents* 2, no. 1 (1930): 33-38.

———. "La Rédaction publicitaire radiophonique." *Publicité 1939* (1939), pp. 43-44.

Desnos, Youki. *Les Confidences de Youki*. Paris, 1957.

Doniol-Valcroze, Jacques, and André Bazin. "Entretien avec Luis Buñuel."

Cahiers du cinéma, no. 36 (June 1954), p. 6.

Durgnat, Raymond. *Luis Buñuel*. Berkeley, 1970.

Éluard, Paul, and Benjamin Péret. *152 proverbes mis au goût du jour.* Paris, 1925.

Études cinématographiques, nos. 20-21 (1962). Issue "Luis Buñuel."

———, nos. 22-23 (1963). Issue "Luis Buñuel."

———, nos. 38-39 (Spring 1965). Issue "Surréalisme au cinéma."

Europe. "Desnos," nos. 517-18 (May-June 1972).

Faure-Favier, Lucie. "Ceux que mes yeux ont vu. . . ."*Le Film,* November 19, 1918.

Le Film. Edited by Louis Delluc, 1917-18, especially his columns "Notes pour moi."

Freud, Sigmund. *The Basic Writings of Sigmund Freud.* Edited and translated by Dr. A.A. Brill. New York, 1938.

Fuentes, Carlos. "The Discreet Charm of Luis Buñuel." *The New York Times Magazine*, March 11, 1973.

Gauthier, Guy. "Le petit Buñuel illustré." *Image et son*, no. 157 (December 1962).

Gauthier, Xavière. *Surréalisme et sexualité*. Paris, 1971.

Goudal, Jean. "Surréalisme et cinéma." *La Revue hebdomadaire* 34, no. 8 (February 21, 1925).

"Hands off Love!" *La Révolution surréaliste,* nos. 9-10 (October 1, 1927): 34-37.

Jacob, Max. *Cinématoma*. Paris, 1920.

———. "Printemps et cinématographe mêlés." *Les Soirées de Paris*, no. 23 (April 15, 1914).

———. "Théâtre et cinéma." *Nord-Sud*, no. 12 (February 1918).

Kanesaka, Kenji. "A visit to Luis Buñuel." *Film Culture*, no. 41 (Summer 1966), pp. 60-67.

Knapp, Bettina L. *Antonin Artaud, Man of Vision*. New York, 1969.

Kyrou, Ado. *Luis Buñuel*. Paris, 1962.

———. *Le surréalisme au cinéma*. Paris, 1965.

Léger, Fernand. "Spécial Charlot." *Chroniques du jour,* nos. 7-8 (December 1926).

Littérature. 1919-1924 (Old and new series).

Man Ray. *Self-Portrait*. Boston/London, 1963.

Man Ray à la Librairie Six. Paris, 1921.

Man Ray Retrospective of the Los Angeles County Museum of Art. Los Angeles, 1966.

Matthews, J.H. *Surrealism and Film*. Ann Arbor, 1971.

Mitry, Jean. *René Clair*. Paris, 1960.

Mondragon. "Comment j'ai compris *Un Chien Andalou.*" *Ciné-Club,* nos. 8-9 (May-June 1959).

Moussinac, Léon. "Guerre." *L'Humanité,* December 14, 1930.

Nadeau, Maurice. *Histoire du surréalisme.* 2 vols. Paris, 1964.

Péret, Benjamin. *Anthologie de l'amour sublime.* Paris, 1956.

———. "L'Escalier aux cent marches." *De derrière les fagots.* Paris, 1934.

———. "Pulchérie veut une auto (film)." *Littérature,* n.s., no. 10 (May 1, 1923).

Peyre, Henri. "The Significance of Surrealism." *Yale French Studies* 1, no. 2 (Fall-Winter 1948):34-49. Reprinted in *Yale French Studies* 31 (May 1964):23-36.

Piazza, François. "Considérations sur le *Chien Andalou* de Luis Buñuel et Salvador Dali." *Psyché,* nos. 27-28 (January-February 1949), pp. 147-56.

Picabia Dossiers. Bibliothèque Littéraire Jacques Doucet, Paris.

Picabia, Francis. *"Entr'acte."* *Orbes,* no. 3 (Spring 1932), pp. 131-32.

———. *"Entr'acte."* *This Quarter* 1, no. 3 (1927):301-302.

———. "Instantanéisme." *Comoedia,* November 21, 1924, p. 4.

———. *Jésus-Christ rastaquouère.* Paris, 1920.

———. *La Loi d'accommodation chez les borgnes.* Paris, 1928.

———. *Poèmes et dessins de la fille née sans mère.* Lausanne, 1918.

———. "Première heure." *Mouvement accelérée,* November 1924.

———. *Relâche."* *La Revue hébdomadaire,* December 27, 1924.

———. *Réveil-Matin.* Paris, 1954.

Pierre-Bodin, Richard. "Lettre ouverte à M. Paul Ginisty, Président de la Censure." *Le Figaro,* December 7, 1930.

Rebolledo, Carlos. *Luis Buñuel.* Paris, 1964

Reverdy, Pierre. "Cinématographe." *Nord-Sud,* no. 16 (October 1918).

La Révolution surréaliste. 1924-29.

Riera, Emilio Garcia. "The Eternal Rebellion of Luis Buñuel." Translated by Jack Bolanos. *Film Culture,* no. 21 (Summer 1960).

Sadoul, Georges. *Le cinéma français.* Paris, 1962.

Sanouillet, Michel. *Dada à Paris.* Paris, 1965.

———. *Francis Picabia et "391."* 2 vols. Paris, 1960.

———. *Picabia.* Paris, 1964.

Sanvoisin, Gaëtan. "Pour la fin d'un scandale." *Le Figaro,* December 10, 1930.

SIC (special memorial edition honoring Apollinaire), nos. 37-39 (January and February 15, 1919).

Simoun. "Robert Desnos." nos. 22-23 (1956).

Soby, James Thrall, ed. *Man Ray/Photographies/1920-1934.* Paris/New York, 1934.

Les Soirées de Paris, 1913-14, especially Maurice Raynal's column "Chronique cinématographique."

Soupault, Philippe. *Charlot.* Paris, 1957.

———. "Le Coeur volé." In *Hommage à Jean Vigo,* Lausanne, 1962 pp. 29-38.

———. Film reviews in *L'Europe nouvelle,* a weekly column from the end of

1929 through 1932; in *Littérature*, 1919-22; in *La Revue des vivants* (October 1931); in *Revue de cinéma*, February and December 1928, March, April and November 1931.

————. *Guillaume Apollinaire*. Marseille, 1957.

————. "Guillaume Apollinaire." *La Revue Européenne*, January 1, 1926, pp. 1-10.

————. Introduction to Guillaume Apollinaire. *Les Épingles*. Paris, 1928.

————. "Note 1 sur le cinéma," *SIC*, no. 25 (January 1918).

————. "Photographies animées," *SIC* (October-November 1918).

————. "Le Vogue des films policiers—*La Maison de la flèche*." *L'Europe nouvelle*, January 31, 1931.

Stauffacher, Frank, ed. *Art in Cinema*. San Francisco, 1947.

Surréalisme. Edited by Ivan Goll, October 1924, especially "Manifeste du surréalisme" and "Exemple du surréalisme: le cinéma."

Le Surréalisme au service de la révolution. 1930-33.

Tariol, Marcel. *Louis Delluc*. Paris, 1965.

Trébouta, Jacques. "Luis Buñuel, sa vie, son oeuvre en Espagne et en France." Ph.D dissertation, Institut des Hautes Etudes Cinématographiques. Paris, 1958-1959.

Truffaut, François. "Recontre avec Luis Buñuel." *Arts*, July 25, 1955, p. 5.

Tyler, Parker. *Classics of the Foreign Film*. London, 1962.

Tzara, Tristan. *Cinéma calendrier du coeur abstrait*. Paris, 1920.

Vaché, Jacques. *Les Lettres de guerre*. Paris, 1949.

Vigo, Jean. "Vers un cinéma social." *Positif*, no. 7 (May 1953).

Virmaux, Alain. "Artaud and Film." Translated by Simone Sanzenbach. *Tulane Drama Review* 2, no. 1 (Fall 1966):154-65.

————. "*La Bréhatine* et le cinéma: Apollinaire en quête d'un langage neuf." *Archives des lettres modernes*, no. 126 (1971).

Vitrac, Roger. "Photographies animées." *Aventure*, no. 2 (December 1921).

Vovelle, José. "Magritte et le cinéma." *Cahiers de l'association pour l'étude de dada et surréalisme*, no. 4 (1970), pp. 103-13.

Index

Film titles are printed in CAPITALS. Titles of periodicals, books, film scenarios, paintings, photographs, musical compositions, plays, ballets, and events appear in *italics*, periodicals followed by (p).

Abstraction, 10-11, 41, 95, 258; Artaud on, 167-68; in EMAK BAKIA, 124-30, 132-33; in LE RETOUR À LA RAISON, 119-22; Survage's project on, 24
Action Française, 241
Adams (Clair), 89-91
ÂGE D'OR, L' (Buñuel), 10, 37, 147, 183, 254; analysis of, 210-33; Artaud's attack of, 177; Dali's part in, 189-90, 193-95; issues in, 234-35, 238-42; relationshp to LAS HURDES, 255-57
Albert-Birot, Pierre, 22-23, 25
Allain, Marcel and Pierre Souvestre, *Fantômas*, 26-27
Allendy, Yvonne, 169, 172, 174
ALL QUIET ON THE WESTERN FRONT (Milestone), 240-41
Amour fou, L' (Breton), 235
Anarchy, 71, 110 n.8
ANEMIC CINEMA (Duchamp), 10, 122, 152 n.13
Anicet ou le panorama (Aragon), 34
Animation (Picabia), 72
À NOUS LA LIBERTÉ (Clair), 39, 93
An-ski [Solomon Rappoport], *Le Dibbouk*, 181 n.60
Anthologie de l'humour noir (Breton), 84

Anti-Semitic League, 240
Apollinaire, Guillaume, 22-27, 29, 31-33, 36-37
Après-dîner (Cendrars), 79-80
À PROPOS DE NICE (Vigo), 210, 257-58
Aragon, Louis, 22-23, 27; on film, 16, 19-20, 28-32, 34-37, 39, 47 n.98, 255; the politics of, 169, 236
Aranda, J. Francisco, 231-32
Aron, Robert, 169
Artaud, Antonin, 10-11, 251, 253-55, 259; alchemy, 179 n.18; commercial cinema, 169, 174, 176-77, 181 n.64; LA COQUILLE ET LE CLERGYMAN, 155, 161-69, 209-10, 228, 239; film scenarios, 157-60, 163-64, 169-73, 175-76, 181 n.60; sound, 175-76; as a Surrealist, 156-57, 169, 236; theater of cruelty, 159, 178; theme of flying, 170-71, 180-81 n.54
Athanasiou, Génica, 159, 180-81 n.54
Athlète des pompes funebres, L' (Picabia), 83
Auric, Georges, 66, 80
Autant-Lara, Claude, 58
Automatism, 22, 123-24, 196, 233, 236-37
Avant-garde: artistic and literary movements, 22-23, 30-32, 56, 79; Surrealists'

reaction against the films of, 37, 40-41, 58, 74, 109, 133, 193, 232, 254, 258

Babaouo (Dalí), 187-90, 195, 244 n.30
Balázs, Béla, 259
BALLET MEĆANIQUE (Léger), 122, 266-67 n.2
Barbey d'Aurevilly, Jules, *Rideau cramoisi*, 47 n.98
Baron, Jacques, 234
Bataille, Georges, 191
Batcheff, Pierre, 199-200, 203, 206-7, 211
BATTLESHIP POTEMKIN, THE (Eisenstein), 10, 39, 55, 58, 238, 254
Baudelaire, Charles, 23, 27
Beaumont, Count Étienne de, 77, 110-11 n.21
Beauvoir, Simone de, 66
BELLE DE JOUR (Buñuel), 230
Bernhardt, Sarah, 92
Billy, André and Guillaume Apollinaire, *La Bréhatine*, 24
Biograph films, 104
BIRTH OF A NATION, THE (Griffith), 104
BLACK SECRET, THE, 18
BLUE ANGEL, THE (Sternberg), 62 n.1
Bluebeard (Perrault), 172
Boiffard, Jacques-André, 268 n.9, 269, 275
Bonheur de l'aveuglement, Le (Picabia), 76
Bonnard, Pierre, 79
BONSOIR MESDAMES, BONSOIR MESSIEURS (Taul), 61
Bordeaux, Henry, 77
Borlin, Jean, 77, 111 n.38
Boulanger, General, 84
Brahms, Johannes, *Fourth Symphony*, 256
Braque, Georges, 29
Bréhatine, La (Apollinaire and Billy), 24
Breton, André, 9, 22-23, 116, 123, 187, 195, 233; in Aragon's *Anicet ou le panorama*, 34; *Anthologie de l'humour noir*, 84; attitudes on film, 16, 18-21, 36-40, 183, 192, 250-52; denouncing of Artaud, 169; friendship with Vaché, 27-29; on love, 234-35; on Mallarmé's poem, 153 n.37; Picabia's disagreement with, 71, 74, 109; plans for films, 47 n.98, 147-51; political position of, 169, 236-39

Brillancourt studios, 174
Brontë, Emily, *Wuthering Heights*, 231, 235
Brunius, Jacques, 10, 40, 61
Buffalo Bill, 26, 51
Buñuel, Luis, 10-11, 40, 58, 251, 258, 260; L'ÂGE D'OR, 147, 177, 210-35, 241, 253-54; on the artist, 247 n.66; on avant-garde films, 37, 133; on the blind, 247 n.69; UN CHIEN ANDALOU, 95, 97, 196-210; collaboration with Dalí, 183-86, 189-95; on comic films, 246 n.53; LAS HURDES, 255-57; on music, 248 n.79; political position, 189, 238-39; on reality in films, 246 n.63; style in the films of, 41, 231-32, 246 n.50

CABINET OF DR. CALIGARI, THE (Wiene), 10, 26, 31-32, 45-46 n.66, 55-56
Cadavre (p), 84
Calder, Alexander, 10
Camera Work (p), 68
Camus, Albert, 235
Cannibale (p), 72
Canudo, Ricciotto, 29
Cavalcanti, Alberto, 10, 58, 254, 259
CELA S'APPELLE L'AURORE (Buñuel), 246 n.63
Cenci (Artaud), 178
Cendrars, Blaise, 26, 79-80
Censorship, 54-55, 164, 240, 257, 273 n.4
Champs délicieux, Les (Man Ray), 116
Champs magnétiques, Les (Breton and Soupault), 116
Chance, 41, 43, 116, 123-24, 143-45, 151, 178, 250-51
Chanson nègre (Picabia), 72
Chaplin, Charles, 10, 24, 28, 53, 92, 168, 254; Aragon's admiration of, 29-31, 34-35; defense of, in "Hands off love!," 39, 234; THE GOLD RUSH, 58
Chiappe, 240-41
CHIEN ANDALOU, UN (Buñuel), 10-11, 37, 41, 58, 95, 97, 224-25, 227, 232-33, 239, 243 n.22, 254-55, 266 n.2; analysis of, 196-211; Artaud on, 174, 177; collaboration of Buñuel and Dalí on, 183-85, 190-95; connections with L'ÂGE D'OR, 224-25, 229-31; interpretations of, 245 n.45; Vigo on, 258
Chomette, Henri, 10
Christ, Jesus, 70, 72, 81-82, 227-28, 240,

248 n.74

Cinéa (p), 92

"Cinéma pur," 10, 167-68

Cinésketch (Picabia), 73, 85-86, 111 n.38

Cinquante-deux miroirs (Picabia), 69

Clair, René, 65, 77; *Adams*, 89-91; criticism of, by Surrealists, 39, 254; Desnos on, 55-56, 58; ENTR'ACTE, 80-81, 84-88, 95-109; fantasy in the films of, 91-92; as film critic, 21, 92-94; Pirandello's influence on, 92; revolutionary vision of, 88

Clarté (p), 236

Claudel, Paul, 79

"Cliché-verre," 151 n.2

Cliff-hanger, 16

Cocteau, Jean, 58, 79; LE SANG D'UN POÈTE, 11, 64 n.51, 53, 147, 177

Coeur à Barbe, Le, 117-23, 240, 263 n.5

Coeur volé, Le (Soupault), 62 n.1

Cohl, Emile, THE PUMPKIN RACE, 104-5

Communist Manifesto (Marx and Engels), 239

Communist party, 169, 235-38

Conquest of Mexico, The (Artaud), 173, 178

Conversation (Picabia), 70-71

COQUILLE ET LE CLERGYMAN, LA (Dulac), 10-11, 60, 155, 161-69, 171, 173-74, 177, 209-10, 228, 239, 254

Cork Sculpture (Man Ray), 265, 267 n.6

"Corps exquis," 123

Correspondance (p), 236

Crevel, René, 25, 31-32, 39, 84, 251

Cubism, 23, 42

Culture physique (Picabia), 72

CUMBRES BORRASCOSAS (Buñuel), 231, 235

CURTAIN POLE, THE (Griffith), 104

Dada, 10, 22, 25; black humor in, 83-84, 100-102, 106; *Le Coeur à Barbe* as an event of, 117-22, 240; ENTR'ACTE as a film of, 80-81, 83-88, 97, 101-2, 107-9; in Man Ray's works, 114, 116-24, 131-32, 136, 253, 267-68 n.9; other humor in, 67, 76, 83, 98, 136; Picabia as prophet of, 65, 68-75; *Relâche* as performance of, 77-80, 84-86

Dalí, Gala, 186-87

Dalí, Salvador, 10-11, 40, 204-5, 239-40; *Babaouo*, 187-90; collaboration with Buñuel, 183-96, 210-11, 230

DAME AUX CAMÉLIAS, LA, 92

Dancer (Man Ray), 120, 261, 262 n.3

Danses à la source (Picabia), 72

Danthon, 67

Darwinism, 214, 229, 246-47 n.65

Davanne, Maurice, 73

De Chirico, Giorgio, 79

Dehorme, Lise, 147

Delaunay, Robert, 25

Delluc, Louis: aesthetics of, 92-94; Desnos on, 55-56; FIÈVRE, 93; as an "impressionist," 36-37; influence on younger poets and Clair, 29-32, 92-94

Demain (Man Ray), 116

Dermée, Paul, 25, 74

Dernières Nuits de Paris (Soupault), 142

Desnos, Robert, 15, 155; on the avant-garde, 58; as broadcaster, 52; on captions, 56; on censorship, 54; as a child, 49; on documentaries, 57, 61, 255; on eroticism, 20, 49-51, 53-54; L'ÉTOILE DE MER, 134, 160, 269, 272; as film critic, 52-59; *La Liberté ou l'amour!*, 234; *Minuit à quatorze heures*, 59-60, 228; on modern phenomena, 51; on movie theaters, 57; on music, 56-57, 59; *Les Mystères du métropolitain*, 60-61; on the Orient, 236; *Les Récifs de l'amour*, 60; the revolutionary, 50, 54-55; on Romanticism, 49-50; in a trance, 48, 251; *Y a des punaises dans le rôti de porc*, 61

Desnos, Youki, 49, 52

Detective novel, 23, 26-27

DETECTIVE STORY, 232

Diaghilev, Sergei, 79, 110-11 n.21

Dibbouk, Le (An-ski), 181 n.60

DISCREET CHARM OF THE BOURGEOISIE, THE (Buñuel), 211, 221

Documentary, 61, 143; lyrical, 259; social, 258; Surrealist, 190, 255-59; Surrealists' views of, 57, 62 n.1, 177

Doucet, Jacques, 34, 77

Dream, 10, 22, 25, 41-42, 48-49, 51-54, 59, 62-63 n.2, 90-92, 130, 133, 140, 163-64, 166-67, 172, 196, 202, 219, 235, 237, 251-53

DREAMS THAT MONEY CAN BUY (Richter), 10, 154 n.44

Dr. Jekyll and Mr. Hyde (Stevenson), 172

DRUNKEN COACHMAN, THE, 104

Duchamp, Marcel: in ENTR'ACTE, 80, 95-97, 111 n.38; as filmmaker, 10,

122, 152 n.10; as influence on Picabia, 67-68, 109-10 n.5
Dulac, Germaine, 10-11, 37, 93, 155-56, 165, 167, 171, 239, 254
Dullin, Charles, 156
Durand, Jean, 104-5

Eddie, William R.G., 28
Eighteen Seconds (Artaud), 159-60, 163-65, 171, 174
Eisenstein, Sergei, 10, 39, 55, 58, 238, 254, 259
EL (Buñuel), 211
Éluard, Paul, 39, 147, 151, 169, 186, 234
EMAK BAKIA (Man Ray): discussion of, 122-34, 137-38, 140-41, 143, 152-53 n.21, 205, 253; shot-by-shot analysis of, 263-68
Engels, Friedrich, 239
ENTR'ACTE (Clair), 9-10, 58, 70, 254; analysis of, 95-109, 112 n.60, 63; chase in, 60, 101-3, 106; definitive version of, 112 n.59; ending of, 61, 107, 132; funeral procession in, 83-84, 100-102, 106; gags in, 95, 97-98; genesis of, 80-81; lyricism of, 97-98; similarities to *Relâche*, 84-85
"Épitaphes" (Soupault), 84
Epstein, Jean, 37, 58, 185, 246 n.50
Ernst, Max, 10, 240, 247 n.66
ESPACE D'UNE PENSÉE, L' (Magritte and Nougé), 11
Essai de simulation de délire cinématographique (Man Ray), 147-51
ÉTOILE DE MER, L' (Man Ray): discussion of, 10, 41, 58, 60, 130, 132, 134-42, 146, 160, 163, 209-10, 228, 253, 282 n.7; shot-by-shot analysis of, 268-75
Étoile de verre, L' (Man Ray), 282 n.7
Everling, Germaine, 70, 73
EXTERMINATING ANGEL, THE (Buñuel), 220-21
Eye, as Surrealist image, 124-25, 130, 132-33, 191, 196-98, 205, 266-67 n.2

FANTÔMAS: the book (Souvestre and Allain), 26-27, 51; the film (Feuillade), 10, 15-19, 24, 26, 37, 58; poem by Cendrars, 26; radio program, 52; "La Société des Amis de," 26
FANTÔME DU MOULIN ROUGE, LE (Clair), 91
Fascists, 240-42

Female, the mysterious, 20, 39, 41, 44 n.13, 48-49, 126, 130-33, 136-37, 141, 233
Ferry, Jean, 40
Feuillade, Louis: FANTÔMAS, 26, 37, 104; LES VAMPIRES, 10, 19, 37
FIÈVRE (Delluc), 93
Film: American, 30, 34-36, 45 n.61, 53, 55, 60-61, 62 n.1, 92-93; "d'art," 92; captions in, 56; characteristics of Surrealist, 40-43; the chase in, 60, 101-6; close-up in, 30; comedy, 10, 34-36, 40, 55-56, 60-61, 98-99, 168, 246 n.53, 251; crime in, 16, 18-21, 24, 30, 36-37; "dépaysement" in, 37-38; as dream, 38, 41, 52-53, 62, 90, 166, 251-53; as epic, 23-24; eroticism in, 15, 20-21, 36-37, 41, 54, 202, 205-6, 208-9, 215-19, 221-27, 251; flight in, 170-71, 180-81 n.54; French, 37-38, 55, 92-93, 104; German, 10, 36, 55, 92-93; humor in, 200, 206-8, 222-23, 228, 231; as medium of movement, 93-94, 105; music in, 56-57, 126, 132-34, 152-53 n.21, 208, 222, 224, 230-31, 247-48 n.72, 256, 268 n.10; mystery in, 16-17, 21, 36, 41, 43, 57, 62, 137, 143, 166, 178, 251; as a narcotic, 28, 158; poetry in, 15-17, 21, 30, 41; reality in, 16, 31, 34, 43, 57-58; as religion, 38, 90-91; revolt in, 15, 41; revolutionary, 10, 39-40, 54-55, 88, 251, 258; serials, 10, 16, 18-19, 21, 27, 37, 40, 55; sound effects in, 175-76, 219, 224, 227, 230-31; Soviet, 10, 39-40, 55; space in, 33, 205; surprise in, 25, 44, n.28, 62, 98, 103; as surreal, 25, 250-53; suspense in, 16, 21, Swedish, 92-93; theaters, 57; time in, 33, 42, 205; versus theater, 25, 30-31, 33, 45, n.61, 55-56, 158, 169; Westerns, 28, 77
Film, Le (p), 29
FILMSTUDIE (Richter), 10, 266-67 n.2
Flaherty, Robert: MOANA, 53; WHITE SHADOWS, 254
FLEURS MEURTRIES (Livet), 11
Flights (Artaud), 169, 180 n.50
Foujita, Tsugouharu, 77, 79
Fourth Symphony, (Brahms), 256
France, Anatole, 84
Freud, Sigmund, 124, 180-81 n.54, 191, 195-96, 204, 206, 210, 244 n.31

Gance, Abel, 36-37, 58, 93, 157

Gasnier, Louis, LES MYSTÈRES DE
 NEW YORK, 15-17
Gaumont films, 104
GENERAL LINE, THE (Eisenstein), 55,
 58
Georges, Yvonne, 49
Ghost of Vermeer of Delft, The (Dalí),
 191
GHOSTS BEFORE BREAKFAST (Rich-
 ter), 10
Gide, André, 77
GOLD RUSH, THE (Chaplin), 58
Goll, Ivan, 25-26
Goudal, Jean, 251-53
Grand masturbateur, Le (Dalí), 190
Griffith, D.W., 55, 104
Gris, Juan, 29

HALLELUJAH! (Vidor), 39, 62 n.1
Hébertot, Jacques, 80, 92
HEINZE'S RESURRECTION (Sennett),
 105-6
Honegger, Arthur, 80
Houdini, Harry, 16, 43 n.2
Hugnet, Georges, 10, 18-19, 40
Hugo, Victor, 50
Humanité, L' (p), 40, 240-41
HURDES, LAS (Buñuel), 40, 190, 214,
 217, 255-57

Idylle (Picabia), 74
Impressionistic film, 10-11, 37, 58, 93
Ince, Thomas, 92
Indicators (Man Ray), 274 n.8
INHUMAINE (L'Herbier), 80
International Congress of Independent
 Cinematography, 259
INTOLERANCE (Griffith), 104
I see in my memory my dear Udnie
 (Picabia), 72, 109-10 n.5
Ivens, Joris, 254, 259

Jacob, Max, 22, 24-26
Jarry, Alfred, 27, 30, 274 n.7
Jeanson, Henri, 61
Jésus-Christ rastaquouère (Picabia), 70,
 81-82
Justine (Sade), 36-37

Kalinga (Picabia), 110 n.13
Kaufman, Boris, 58
Keaton, Buster, 36, 168
Kerensky, Alexander, 147
Keystone Comedies, 10, 104-6

Kiki [Alice Prin], 115, 134-35, 139-40,
 261, 268
Knapp, Bettina L., 164

Labisse, Felix and Henri Storck, LA
 MORT DE VÉNUS, 11
Lacemaker (Vermeer), 191-92, 244 n.24
Lampshade [Sheet-Iron Sculpture] (Man
 Ray), 121, 261, 263 n.6
Lang, Fritz: METROPOLIS, 238
Large Glass (Duchamp), 109-10 n.5
LAUGHING MASK, THE [LE MASQUE
 AUX DENTS BLANCHES], 43 n.2
Lautréamont, Comte de, 27, 42, 233
League of Patriots, 240, 242
Leblanc, Georgette, 80
Léger, Fernand, 10, 24, 77, 79-80, 122,
 266-67 n.2
Lenin, Vladimir Ilyich, 244 n.31
L'Herbier, Marcel, 36-37, 58, 80, 93
Liberté ou l'amour!, La (Desnos), 50,
 234
Linder, Max, 92
Littérature (p), 9-10, 22-23, 32-34
Livet, Roger, FLEURS MEURTRIES, 11
Lloyd, Harold, 35
Loi d'accommodation chez les borgnes,
 La (Picabia), 73, 86
Love, sublime, 15, 41, 49, 51, 54, 233-
 35
Lumière, Louis, 15, 92-93

Magritte, René, 11, 19, 186, 266-67 n.2
Mallarmé, Stéphane, "Un Coup de dés
 jamais n'abolira le hasard," 143, 145,
 153 n.37, 39, 281 n.1
Mallet-Stevens, Robert, 80, 281 n.2
Mamelles de Tirésias, Les (Apollinaire),
 23, 25, 27, 112 n.60
Manifeste cannibale Dada (Picabia), 72
Man Ray, 10, 80, 97, 240, 251, 253;
 condemnation of, by Buñuel, 246 n.53,
 254; DREAMS THAT MONEY CAN
 BUY, 154 n.44; EMAK BAKIA, 122-
 34, 137-38, 140-41, 143, 152-53 n.21,
 205, 253; Essai de simulation de dé-
 lire cinématographique, 147-51; L'ÉT-
 OILE DE MER, 41, 58, 60, 130, 132,
 134-42, 146, 160, 163, 209-10, 228, 253,
 282 n.7; masks in the works of, 125,
 274-75 n.8; LE MYSTÈRE DU CHÂ-
 TEAU DE DÉS, 132, 142-47, 153 n.39;
 as photographer, 114-19, 151 n.2, 152
 n.4,5,7, 267 n.3; rayographs, 116-17,

119, 262 n.2, 263 n.5; LE RETOUR
À LA RAISON, 95, 116-22, 132, 239,
253; shot-by-shot analysis of the films
of, 261-82; speed and movement in the
life and films of, 153 n.40,41, 267 n.4
Maré, Rolf de, 79-80, 107
Marvellous, the, 37-38, 51, 53, 59, 63
n.18, 158
Marx brothers, 177
Marxism, 214, 233, 235-37, 239, 246-47
n.65
Master of Ballantrae of Stevenson, The
(Artaud), 172-76, 181 n.64
MASTER OF MYSTERY, THE, 43 n.2
Médéa (Picabia), 75
Méliès, Georges, 93-94, 104, 106
Merry Widow Waltz (Lehar), 132, 268
n.10
METROPOLIS (Lang), 238
Milestone, Lewis, ALL QUIET ON THE
WESTERN FRONT, 240-41
Milhaud, Darius, 80
Miller, Henry, 274 n.8
MILLION, LE (Clair), 93
Minuit à quatorze heures (Desnos), 59,
64 n.55, 228
Miró, Joan, 240
MOANA (Flaherty), 53
Modernity, 23, 26-27, 29, 31-33, 36, 38,
51, 53-54, 57
Modot, Gaston, 211, 225-26
Mohler, Olga, 73
Morise, Max, 251
MORT DE VÉNUS, LA (Storck and La-
bisse), 11
MORT EN CE JARDIN, LA (Buñuel),
211, 246 n.63
Moussinac, Léon, 29, 40, 240-41, 259
Mr. and Mrs. Woodman (Man Ray),
274 n.8
Murnau, F.W., NOSFERATU, 18, 55
Murphy, Dudley, 122
Murray, Mae, 21
Musidora, 16, 18-20, 60
Musset, Alfred de, 49-50, 61
MYSTÈRE DU CHÂTEAU DE DÉS,
LE (Man Ray): discussion of, 10, 132,
142-47, 253 n.39; shot-by-shot analysis
of, 275-82
MYSTÈRES DE NEW YORK, LES
[THE EXPLOITS OF ELAINE] (Gas-
nier), 15-17
Mystères du métropolitain, Les (Desnos),
60-61

Nadeau, Maurice, 9, 236
"Namouna" (Musset), 61
Napierkowska, Mlle., 77-78
Narcotics, 20, 27-28, 66, 69, 77, 158
NAZARIN (Buñuel), 230
Niagara (Picabia), 110 n.13
Nick Carter, 26, 46 n.80, 51
Noailles, Vicomte de, 132, 142-43, 146-
47, 210, 263 n.6, 281 n.2
Nord-Sud (p), 25
NOSFERATU (Murnau), 18, 55
Nougé, Paul and René Magritte, L'ES-
PACE D'UNE PENSÉE, 11
Nouveau, Germain, 27
Nuit espagnole, La (Picabia), 69-70, 81,
111 n.26

Object to be Destroyed (Man Ray), 266-
67 n.2
"Objet trouvé," 124
Oeil cacodylate, L' (Picabia), 70
OLVIDADOS, LOS (Buñuel), 190, 214-
15, 230, 246 n.63, 260
120 Days of Sodom (Sade), 227, 244 n.41
ONÉSIME HORLOGER (Durand), 105
Onze mille verges (Apollinaire), 36-37
Optophone I (Picabia), 81-82, 111 n.25

Pabst, G.W., THE THREE-PENNY
OPERA, 62 n.1
Parade amoureuse (Picabia), 68
"Paranoiac critical activity," 186
PARIS QUI DORT (Clair), 91, 102, 105
Passage of the Virgin to the Bride (Du-
champ), 109-10 n.5
Pathé studios, 104
Paulhan, Jean, 165
Paysan de Paris, Le (Aragon), 34
Pensées sans langage (Picabia), 70
Péret, Benjamin, 169, 234, 250; *Pulch-
érie veut une auto*, 34-35, 60
PERLE, LA (Hugnet), 10
Philosopher's Stone, The (Artaud), 164,
173
Philosophies (p), 236
Picabia, Francis: black humor, 83-84;
Cinésketch, 73, 85-86, 111 n.38; Dada
poet, painter, and publisher, 9-10, 68-
74; Duchamp's influence, 67-68, 109-
10 n.5; ENTR'ACTE, 70, 73, 80-81,
83-88, 94-95, 97, 102, 106-8; and guns,
81-83, 99-100; "Instantaneism," 74-76,
84; *Jésus-Christ rastaquouère*, 70, 81-
82; *La Loi d'accommodation chez les*

borgnes, 73, 86; "machinist" phase, 68, 70, 73; "monster" phase, 73-74; Orphic phase, 67, 72-73; painting in phases, 110 n.6,13; *Relâche*, 70, 73-74, 76-81, 84-86, 107-8; satiety and abstention, 71-73; youth, 65-67
Picasso, Pablo, 26, 29, 77; work for the stage, 79, 110-11 n.21
Pickford, Mary, 39
Pirandello, Luigi, 79; *Six Characters in Search of an Author*, 92
Plaisirs illuminés, Les (Dalí), 194-95
Poèmes et dessins de la fille née sans mère (Picabia), 70
POÈTE MALHEUREUX, 24
"Poison ou revolver" (Picabia), 82
Poulenc, Francis, 80
Porter, Edwin S., 104
Prévert, Jacques, 40, 66, 147
Prévert, Pierre, 40
Projet pour une tapisserie (Man Ray), 116-17
Pudovkin, Vsevolod I., STORM OVER ASIA, 55, 62 n.1, 220
Pulchérie veut une auto (Péret), 34-35, 60
PUMPKIN RACE, THE (Cohl), 104
Puteaux group, 67

QUATORZE JUILLET (Clair), 93

Raynal, Maurice, 23, 26
Rayographs (Man Ray), 116-17, 119, 262 n.2, 263 n.5
Récifs de l'amour, Les (Desnos), 60
RECORDS 37 (Brunius), 61
Redon, Odilon, 266 n.2
Reinhardt, Django, 126
Relâche (Picabia), 70, 73-74, 76-81, 107-8; similarities to ENTR'ACTE, 84-86
Renoir, Jean, THE RULES OF THE GAME, 220
RETOUR À LA RAISON, LE (Man Ray): discussion of, 10, 95, 116-22, 132, 239, 253; shot-by-shot analysis of, 261-63
Rêve, Le (Dalí), 191, 193
Réveil-Matin (Picabia), 85
Reverdy, Pierre, 25
Revolt, 25, 27-28, 41, 54, 210, 233, 235-36, 239, 241
Revolt of the Butcher, The (Artaud), 174-76
Revolution, 50, 54-55, 88, 91, 160, 235-39, 241, 258
Révolution Surréaliste, La (p), 9, 22, 26, 39, 50, 84, 123, 157, 210, 234, 236-37, 239, 254
Richter, Hans, 10, 259, 266-67 n.2
Rideau cramoisi (Berbey d'Aurevilly), 47 n.98
RIEN QUE LES HEURES (Cavalcanti), 10
Rigaut, Jacques, 21, 84, 265-68
Rimbaud, Arthur, 27
Rivière, André de la, 269
Rivière, Jacques, 159, 174
Rocca, Countess de la, 77
Rothschild, Baroness Henri de, 77
Romanticism, 42, 49-50, 233
Rue Férou (Man Ray), 274 n.6
RULES OF THE GAME, THE (Renoir), 220
RUNAWAY HORSE, THE (Zecca), 104
RUNAWAY MOTHER-IN-LAW, THE, 104
Ruttmann, Walter, 33, 174, 254, 259

Sade, Marquis de, 54, 234, 241; *Justine*, 36-37; 120 Days of Sodom, 225, 227, 231, 244 n.41
Sadoul, Georges, 37, 39-40
Salmon, André, 22
SANG D'UN POÈTE, LE (Cocteau), 11, 64 n.51,53, 147, 177
Sang est plus doux que le miel, Le (Dalí), 190
Sanouillet, Michel, 70, 83
Sâr Dubnotal, 51
Satie, Erik, 79-80, 85, 94, 107, 114
Sauvage, André, 58
Second Surrealist Manifesto (Breton), 9, 27, 237
Sennett, Mack, 10, 31, 36, 56, 58, 254; HEINZE'S RESURRECTION, 105-6; Keystone Comedies, 104-6
SIC (p), 22, 25, 29, 33
SIMON OF THE DESERT (Buñuel), 230
Sisley, Alfred, 66-67
Six Characters in Search of an Author (Pirandello), 92
Sjöstrom, Victor, 92
SLIPPERY JIM (Zecca), 104
Snowball (Man Ray), 266-67 n.2
Socialist Realism, 258
Soirées de Paris, Les (p), 23-24, 26
Solar Airplane, The (Artaud), 170-71
Solarized Self-portrait (Man Ray), 118

Soupault, Philippe: on Apollinaire, 23, 27; and André Breton, *Les Champs magnétiques*, 116; *Dernières nuits de Paris*, 142; on documentaries, 57, 62 n.1, 255; "Épitaphes," 84; as film critic, 17-18, 48, 62 n.1, 64 n.53, 259; scenarios and "poèmes cinématographiques," 32-35, 62 n.1, 157-58; and the Surrealists, 22, 169
SOURCES NOIRES (Brunius), 61
SOUS LES TOITS DE PARIS (Clair), 62 n.1, 93
Souvestre, Pierre and Marcel Allain, *Fantômas*, 26-27
Soviet Union, 39, 238, 242, 258-59
Steichen, Edward, 151 n.2
Steinlen, Théophile Alexandre, 79
Sternberg, Josef von, THE BLUE ANGEL, 62 n.1
Stevenson, Robert Louis: *Dr. Jekyll and Mr. Hyde*, 172; *The Master of Ballantree*, 172-73
Stieglitz, Alfred, 68, 151 n.2
Storck, Henri and Felix Labisse, LA MORT DE VÉNUS, 11
STORM OVER ASIA (Pudovkin), 55, 62 n.1, 220
Stroheim, Erich von, THE WEDDING MARCH, 58
SUBIDA AL CIELO (Buñuel), 246 n.63
Subject for a Poem (Man Ray), 267 n.3
Surrealism: Belgian, 11; elements of, 41-43; film as the natural medium of, 251-53; humor in, 34-35, 60-61, 84, 140, 200, 206-8, 216, 222-23, 246 n.53; objects of, 209-10; the Orient as inspiration for, 55, 236; origins of, 22-23; politicization of, 169, 235-38
Surréalisme (p), 25-26
Surréalisme au Service de la Révolution, Le (p), 9, 32, 237-39, 254
Surrealist Manifesto (Breton), 9, 22, 26, 233, 235, 251
Survage, Léopold, 24
Swedish Ballet, 73, 78-80, 108

Taine, Hippolyte, 252
Tallier, Armand, 155
Tanguy, Yves, 240
Texas Jack, 51
Theater, Alfred Jarry, 169
Theater and Its Double, The (Artaud), 166, 173, 178
Théâtre de l'Atelier, 156

Théâtre et Comoedia Illustré, Le (p), 36, 92
Thirty-two, The (Artaud), 169, 171-72
THREE MUSKETEERS, THE (Diamant-Berger), 156
391 (p), 69, 74
THREE-PENNY OPERA, THE (Pabst), 62n.1
Trésor des Jesuites, Le (Aragon and Breton), 16, 19
Tristan and Isolde (Wagner), 222, 224, 230-31
Troisième Faust, Le (Aragon), 47 n.98
Trotsky, Leon, 147
Tual, Roland, 40; BONSOIR MESDAMES, BONSOIR MESSIEURS, 61
Two Nations on the Confines of Mongolia (Artaud), 157-58, 170
Tzara, Tristan: association with Man Ray, 116-17, 263 n.5; association with Picabia, 70-71

Ubu Roi (Jarry), 274 n.7
Unik, Pierre, 40, 169
Unique eunuque (Picabia), 70

Vaché, Jacques, 27-29, 34, 84
Valentin, Albert, 40, 47 n.98
Vampires (Aagon), 19
VAMPIRES, LES (Feuillade), 10, 15-16, 19, 37, 60
Vermeer, Johannes, *Lacemaker*, 191-92, 244 n.24
Vertov, Dziga, 254
Vidor, King, HALLELUJAH!, 39, 62 n.1
Vigo, Jean, 62 n.1, 210, 257-58
Violon d'Ingres (Man Ray), 115
Virmaux, Alain, 165
Vitrac, Roger, 169
Voilà elle (Picabia), 81-82
VOYAGE IMAGINAIRE, LE (Clair), 91-92

Wagner, Richard, 222, 224, 230-31
War, 242; Surrealists' opposition to, 19-22, 84, 236; Vaché's reaction to, 28
WEDDING MARCH, THE (Stroheim), 58
Wheeler, Arthur, 122-23
Wheeler, Rose, 267 n.4
White, Pearl, 16-18, 34, 43 n.2
WHITE SHADOWS (Flaherty), 254
Wiene, Robert, THE CABINET OF DOCTOR CALIGARI, 10, 31-32

Wilde, Oscar, 58
Wuthering Heights (Bronte), 231, 235

Y a des punaises dans le rôti de porc
(Desnos), 61

YOUNG ONE, THE (Buñuel), 211

Zecca, Ferdinand, 104-5
ZÉRO DE CONDUITE (Vigo), 257